The Lost Chalice

The
Lost Chalice

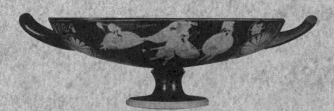

The Epic Hunt
for a Priceless Masterpiece

VERNON SILVER

WM
WILLIAM MORROW
An Imprint of HarperCollins*Publishers*

HarperCollins books may be purchased for educational, business, or sales promotional use. For information please write: Special Markets Department, HarperCollins Publishers, 10 East 53rd Street, New York, NY 10022.

FIRST EDITION

Designed by Janet M. Evans

Library of Congress Cataloging-in-Publication Data has been applied for.

ISBN 978-0-06-155828-3

09 10 11 12 13 OV/RRD 10 9 8 7 6 5 4 3 2 1

To Nikie, for everything

CONTENTS

The Anonymous Bidder

Even before the Sotheby's auctioneer started taking bids, Lot 6 was guaranteed to make history. Nothing of its kind—a twenty-five-hundred-year-old pot by the Greek artist Euphronios—had been sold to the public in more than a century. And this specimen was exceptional: not only was the dainty, earthen grail the earliest recorded work by a craftsman renowned as the Leonardo da Vinci of vases, but it was among the oldest known, signed artworks in history. And the cup's larger match was already the world's most famous bowl, the Euphronios krater, a centerpiece of the Metropolitan Museum of Art's collection.

Everyone agreed that Sotheby's was about to sell the rarest type of pot on the planet. Scholars knew of just eight other vases painted and signed by Euphronios, and just five of those were even close to being intact. This one made six. So it was no surprise on that rainy evening of June 19, 1990, that nearly every dealer, collector, or curator concerned with art of the ancient world was crammed into the showroom on Manhattan's Upper East Side to learn what was going to happen to the Euphronios wine cup, known by its Greek name, *kylix,* or chalice.

After being lost for two millennia, the kylix had appeared without any records in the hands of a Hollywood producer who then sold it in 1979 to a Texas billionaire. The oilman, Bunker Hunt, had gone bankrupt and was selling his treasures to pay taxes. But mystery surrounded the cup. Nobody knew where it had come from. An old, secretive collection? A newly looted tomb? Hunt's Hollywood supplier had never revealed the vase's origin.

As the potential buyers shuffled into Sotheby's from York Avenue, some Euphronios fans joined them in the auction hall just to catch a glimpse of the black-and-ocher-hued cup, painted with figures of Trojan War soldiers and deities. Others, including mutual-fund magnate Leon Levy, hoped they would be lucky or rich enough to actually take the kylix home. Reporters from the international press, from the *New York Times* to the *Economist,* readied their notebooks for a record-breaking sale. Sotheby's executives prepared to mark a milestone: the first work signed by any ancient artist ever to be sold by the auction house. Among the museum curators, it was probably Dietrich von Bothmer, the Met's chief of Greek and Roman art, who most coveted the cup as his prize: if the Met won the bidding, he'd reunite the kylix with its bigger twin, the Euphronios krater, which sat spotlighted under glass in the Met's ground-floor galleries.

The similarities between the museum's celebrated krater and the four-inch-high chalice were so striking that the auction drew the attention of another interested party: the Italian police.

The pots had surfaced at the same time, in the early 1970s, after decades without a single discovery of a new Euphronios. And both masterpieces depicted the identical scene: the death of Zeus's son Sarpedon, who is carried Christ-like and bleeding from the battlefield, looking very much like another, more fa-

mous, son of God. All signs pointed to tomb robbers as the source of the kylix and krater, though Bunker Hunt's dealer claimed to have legal title, and the Met's supplier had produced paperwork tracing the pot to an old Lebanese collection. The odds were impossible that both the wine cup and the pot for mixing wine and water would emerge simultaneously from old, private collections. The Italians even had testimony from an admitted tomb robber—or *tombarolo*—who claimed he'd been part of the team that spent a week clearing out a treasure trove that included a pot shard with the image of a bleeding warrior. But his memory was too hazy for the police to make a case. For the moment. So the auction proceeded.

Around 7:00 P.M., the crowd filled the seats. American dealer Robert Hecht, dressed in a suit and tie, took a chair on the aisle. Hecht, an heir to the eponymous Baltimore department store chain, had a personal interest in Euphronios; he had sold the Met its krater for $1 million in 1972. London dealer Robin Symes, one of Hecht's greatest rivals in supplying artifacts to museums and rich collectors, sat on the left side of the hall, away from his competition. Symes was a lanky Brit who favored tuxedos and ran a London gallery with his partner, the son of a Greek shipping tycoon. He'd all but dethroned Hecht as the king of top-end antiquities dealing, having wooed away Hecht's biggest clients and his best underworld sources for artifacts.

Despite their rivalry, Hecht and Symes shared a secret. They each knew the identity of a man in a green Lacoste sweater who would become the auction's anonymous star that day. Tanned and balding, sitting a few rows behind Hecht, the man in the Lacoste wasn't a familiar face in New York's art circles, and he liked keeping it that way.

With Sotheby's chairman and chief auctioneer for North America, John L. Marion, brandishing the hammer, bidding got

under way. Greek vases were to take up the first half of the sale, followed by Greek, Roman, and Etruscan bronze statues. The first lot, a Corinthian pot dating to 600 B.C., stirred little enthusiasm, failing to make the top of its estimated price range by selling for just $40,700. The next vase did better, topping estimates, but the room hadn't yet built up the buzz worthy of what was to come. Then the man in the green Lacoste entered the fray. On Lot 3, he picked up an Athenian wine cup painted with a bust of the god Dionysus for $82,500, shy of the high estimate of $90,000. This was just his warm-up for Lot 6.

Sotheby's expected the Euphronios cup depicting Sarpedon's death to go for somewhere between $300,000 and $400,000, a bargain only made possible by a looming recession in 1990 that pushed the art market into a slump. As bidding began, the man in the Lacoste launched a bidding war against one of the few people in the room who recognized him, Robin Symes. But the British dealer wasn't going to give up easily, for he was doing the bidding of a very important client: the Metropolitan Museum of Art.

The Met curator, von Bothmer, had had a chance to buy the kylix in 1973 from one of the museum's best overseas suppliers, but it slipped through his hands. The price had been just $70,000 then, but the museum's director at the time, Thomas Hoving, had believed that any Euphronios acquisition would have been radioactive, coming so soon after his controversial purchase of the matching, million-dollar krater. Capturing the krater had been the pinnacle of von Bothmer's career, but archaeologists and the Italian police said the vase was the product of an illicit dig north of Rome; Hoving turned down von Bothmer's request to buy the Sarpedon cup.

Seventeen years later, the controversy had passed (or so it seemed), and the German-born, Oxford-educated curator had a second chance. If von Bothmer won, the chalice would end up on

public display with its bigger twin at the Met. He could rescue the cup from obscurity. This was his chance at redemption.

It became clear as the bids mounted that this would be a contest between the Met, fronted by Symes, and the man in the Lacoste sweater, who took the early lead. The casually dressed bidder had no intention of losing, for reasons only one other person in the room could fully grasp. Was he determined to invest in a masterpiece during a slump in the art market? Or was he driven by some other personal affinity for the kylix—a connection that went back much further in history?

First the two bidders doubled the low estimate, and then they approached three-quarters of a million dollars, an unheard-of sum at the time for a tiny, clay cup. As Symes reached his client's price limit, it became clear that the kylix would not journey across town to the Met and be reunited with the krater. The man in the Lacoste kept raising his paddle, and at $742,500, he captured his prize. And then, as other lots came up, he kept buying. By the end of the evening, he'd scooped up not just the Euphronios kylix, but a handful of ancient vases. In one day, he became the owner of one of the finest collections of Greek pots to be found outside a museum—and had spent just $1.29 million.

In the following days, the Met's von Bothmer would use back channels to try to wrangle the kylix for the Fifth Avenue temple to the arts. He relayed an offer to the man in the Lacoste sweater, promising him an instant profit. But the anonymous new owner sent back his apologies to the Met. The chalice was not for sale. Von Bothmer was crushed, and he would be haunted for the rest of his career by the one that got away.

"You do not regret pieces you acquire, but only those you do not acquire," he said years later.

A few months after the auction, curators at the Louvre in Paris, which has one of the six rare pots Euphronios signed as

painter, tried to convince the kylix's new owner to loan the piece for a temporary exhibit in September 1990. Again, the man in the Lacoste said no.

The kylix was slipping away from public view. Reporters who asked Sotheby's the identity of the winning bidder had no luck. In the auction house's after-sale report, Sotheby's listed the buyer only as "European Dealer," a smokescreen that would obscure the cup's path and frustrate scholars, police, and prosecutors who tried to track the masterpiece.

Some twenty-five hundred years earlier, Euphronios had used fine lines and vivid colors to show the death of a hero who couldn't be saved by his father, the greatest god on Olympus. Now, as quickly and mysteriously as the chalice had surfaced, an anonymous dealer in green golf gear was dragging it back into hiding.

The tale of how a humble wine cup arrived at Sotheby's that day, and the quest to find where it's been since is the story of the whole modern antiquities trade writ small: it shines light on the dealings of tomb robbers, smugglers, wealthy collectors, ambitious archaeologists, and corrupt curators. It's also a stunning tale of how the world's most powerful and prestigious institutions— from the Metropolitan Museum of Art to Oxford University to Sotheby's—have knowingly enmeshed themselves in the shadowy trade.

But mostly it's about the epic life of a cup, its famous twin, and the smuggler who set in motion their modern journeys.

Since June 19, 1990, nobody has seen the chalice in public. The Sarpedon cup is the only Euphronios vase listed with an unknown location by Oxford's Beazley Archive database, the standard reference for Greek vessels. Its whereabouts are an art world mystery.

Until now.

Burying Sarpedon

Hidden in the Western world's greatest epic lies the tragic story of an obscure prince named Sarpedon. His fight to the death is often forgotten amid the star-studded cast of Homer's *Iliad*. But seven centuries after the fabled Trojan War, Sarpedon's blood-drenched demise inspired Euphronios to create ceramic masterpieces in his Athens workshop. One was the krater pot depicting Sarpedon that would end up in New York's Metropolitan Museum of Art. The other, a kylix drinking cup bearing the same decoration, would become the lost chalice.

During his career, in the years just before 500 B.C., Euphronios's works were possessions that were prized far from Greece's shores. Like most of his known vases, the Sarpedon cup and its bigger match made their way across the Mediterranean on ships sailed either by Greeks or their foreign trading partners, the Etruscans, who inhabited a land called Etruria in what is today modern Italy. Comparatively little is known about the Etruscans, a civilization predating the Romans. Their remains have been found in the part of Italy now know as Tuscany, and in Rome's northern suburbs. The word *Tuscany* even comes from "Etruscan."

The Etruscans imported so many Greek vases—and buried so many of them in their tombs—that archaeologists once mistakenly believed these pots had been made in Italy. Of all the known works by Euphronios with documented archaeological origins, only one turned up in Athens. All the others were dug up in Etruria. And of those, most came from sites in the city of Caere, which today is an Italian town called Cerveteri. The wealthier, social-climbing Etruscans in Caere built collections, snapping up imported vases by Euphronios and his Athenian competitors. When these Etruscan connoisseurs died, they and their collections of goblets and statues were buried in stone tombs modeled after the layouts of their homes.

In tracing the exact path of Euphronios's greatest works, the trail largely goes cold in the necropolis of ancient Cerveteri. Over the past century, tomb robbers have destroyed almost all evidence of the pots' ancient life stories—and by extension, our ability to decipher the history of the Etruscans.

But not all is lost. We do know that sometime around 400 B.C., the Etruscans who had been lucky enough to own Euphronios's Sarpedon krater and kylix buried them in the soil of Caere. Although the Etruscans who bought the chalice and krater may remain an enigma, we know the journey of the twin pots starts at a burial ground of stone tombs north of Rome, where the Etruscans sealed their treasures behind simple sepulcher doors. The Sarpedon chalice and its bigger twin sat in darkness for twenty-four hundred years.

Young Dietrich von Bothmer was twelve years old when he saw his first Euphronios vase, a krater pot for mixing wine, painted with a scene of nude athletes at a gymnasium. What von Bothmer saw during that visit to the Berlin Antikensammlung museum, prob-

ably in 1931, was a tableau of young men getting dressed and undressed amid equally naked servant boys. On one side of the two-handled keg, on which the clay-colored figures glow against a black background, a youth holds a jar out of which he pours oil for rubdowns. An athlete plays with his discus while a toga-wearing pal extends an index finger toward the discus thrower's penis. In all, they seem to be having a fine time at the gym.

Von Bothmer decided on the spot to become an archaeologist. And the discipline certainly could use passionate, new talent to help bridge the gaps in knowledge of the past that centuries of treasure hunting and tomb robbing had left.

One example of the challenges facing archaeology sat in front of von Bothmer at the Berlin museum. Little was known at the time about the krater that had captured his imagination; it had been dug up just north of Naples in Capua, an ancient city on the Appian Way, one of the longer roads that famously lead to Rome. But its earlier origins were a matter of interpretation. Even the attribution of the vase to Euphronios was an educated guess, as the krater bore no signature.

Without signatures or without knowing where such pots were found, museums, collectors, and scholars relied on stylistic comparisons. This pot looked like a Euphronios. And the man who had the final say was at Oxford. Sir John Beazley, professor of archaeology and the world's leading authority on Greek pots, declared that the krater was a Euphronios. And so it was.

Confronted with collections and museums packed with pots of unknown origins, Beazley devised a system for grouping and attributing ancient vases that was based largely on interpreting styles. That remains the standard today. With so few vases having signatures, Beazley and his colleagues had to invent names for the artists. The painter of one particularly fine vase, which sits near the Euphronios that inspired young von Bothmer, was

dubbed the Berlin Painter, after the German museum. Now, following Beazley's system, any vase that resembles the technique of the original "Berlin Painter" is given the same attribution.

Even in his native Germany, Dietrich von Bothmer learned of Beazley's mastery of Greek pots. It was just a matter of time before von Bothmer followed his youthful fascination all the way to Beazley's office. In 1938, the promising archaeologist sailed to England and went up to Oxford as one of Germany's last Rhodes scholars admitted before war erupted.

Oxford was, and is, a place as confusing as it is fascinating, a conglomeration of a few dozen semiautonomous colleges and as many academic departments, museums, and labs. The nineteen-year-old von Bothmer was lost as soon as he arrived.

Oxford's Wadham College had admitted him as a student for the diploma in classical archaeology, but when von Bothmer got to Wadham, a fellow of the college said he needed to hike over to Christ Church, the college where his tutor—the faculty member responsible for preparing him for his exams—was based. Map in hand, young Dietrich, speaking imperfect English, made his way to the edge of the campus and learned from his alleged tutor at Christ Church that he'd be supervised by Professor Beazley. Beazley, said the Christ Church don, was expecting von Bothmer at the university's Ashmolean Museum.

Von Bothmer found Beazley in the museum's library—where the professor was writing out excerpts from the latest issue of the journal *Monumenti Antichi*—and began the most important relationship of his career.

Almost every working day, from the start of the Michaelmas term, through the following two trimesters that composed the academic year, Beazley and von Bothmer slipped into a routine. Just before 1:00 P.M., Beazley would get up from his chair in the library and ask his student, "Are you going back to Wadham?"

Von Bothmer was, of course, returning for lunch at his college, which was in the same direction as Beazley's house at 100 Holywell Street. The student took the extra five minutes to accompany the world's top expert in Greek vases all the way to the two-story stone house at the bottom of the narrow lane.

The two would talk freely, and almost no subject was off-limits. Beazley would catch and correct von Bothmer's mistakes in English, but in a way that made the young man see that he would some day master this foreign tongue. On Fridays von Bothmer would return to 100 Holywell for an added treat, tea at 4:00 P.M. Beazley, his wife, and an assortment of guests would gather in the dining room for snacks, and for an entire hour Beazley would say nothing.

Then, at 5:00 P.M. sharp, the professor would stand and lead his three or four students into the study, where for two hours they pored over photographs and actual fragments of ancient vases, which they could handle and turn in their own hands. Beazley would ask the students questions and fill in the gaps in their knowledge. But it was the physical connection to the decorated pot shards that von Bothmer would recall as the most rewarding part of his education at Oxford. In fact, the mentorship he built with Beazley would prove to have the biggest payoff. For in just one year, he managed to position himself as Beazley's eventual successor as the world's top authority on the authenticity and artistry of Greek vessels.

The same year von Bothmer left for Oxford, the man who would some day determine the fate of the Sarpedon chalice came into the world in Rome. On July 6, 1938, Giuseppa Frisoni gave birth to her son, Giacomo, in an apartment on Via della Lupa, a cobblestoned alley where she lived with her husband, Guido Medici,

and their two older children in a building with ancient founda-
tions next to the hulking Palazzo Borghese. Guido eked out a
living digging up ancient tombs and temples. He wasn't an ar-
chaeologist, and it wasn't entirely clear if his treasure hunting
was legal. But harvesting statues and vases from the lumpy fields
north of Rome was a reliable way to feed a growing family.

It went without saying that the infant Giacomo Medici would
probably go into the family business. What nobody in their
crowded walk-up could know is that young Giacomo, the boy
with the green eyes, would uncover the greatest treasures ever
found on Italian soil. That he would rise through the profession
to provide ancient loot to the world's biggest museums and rich-
est private collections was beyond their imaginations.

These Medici—the Medici of Rome—could never be confused
with the noble Medici of Florence. Five centuries earlier, those
Medici had financed the Renaissance, produced three popes, and
hired Michelangelo and Botticelli as their interior designers.
Giacomo Medici, on the other hand, had only the name and its
contrast with his current station in life, perched above a dark
alleyway in Rome's rabbit warren of medieval streets.

Men like Giacomo Medici and his father had made a living off
antiquities for centuries. During the Grand Tour of the 1700s
and 1800s, his predecessors guided acquisitive Englishmen on
shopping sprees amid the ruins of ancient civilizations. The
tourist-explorers hauled off the contents of newly cracked tombs
and built collections that furnished stately country homes and
London sitting rooms. Little had changed by 1938. Guido's cli-
ents were rich Italian families, and his excavation was often
done with permits from the government's cultural authorities.
He worked the land with a shovel and spillo, the long, steel spear
with which antiquities diggers probe the soil in hopes of hearing
the telltale *clink* from the top of a buried tomb.

A year after young Giacomo's birth, Italy's dictator, Benito Mussolini, pushed through a law that would doom the Medici family business. His government declared that any artifact found on Italian soil was the property of the state. A similar law had already been on the books since 1909, but the 1939 legislation— based on Mussolini's brand of militaristic nationalism—made the issue crystal clear. Mussolini knew his ancient civilizations, and he fancied himself a modern Caesar.

For the Medici family, the antiquities law was an annoyance compared with the real hardships they faced as Mussolini allied with Hitler and drew Italy into war with the British and Americans. Rome became a target for Allied invasion, so by 1940, Guido Medici evacuated his family to the countryside.

The Medici clan ventured twenty-five miles north to Giuseppa's hometown, Fiano Romano, where they joined Giacomo's grandparents, Luigi and Luigia. Being situated in the middle of ancient Etruscan territory was perfect for Guido's digging. And the kids—Roberto, the eldest; Caterina, known as Rina; and Giacomo, the youngest—had fields to play in, animals to feed, and doting grandparents to look after them. The hardship and brutality of war were kept at bay a little longer and crept up slowly.

Fiano Romano sits on a hill surrounded by farmland. Atop the hill, in the oldest part of the town, a fifteenth-century duke's castle lords over the terrain. Giacomo Medici's grandparents lived just a hundred yards from the castle, which German troops had occupied. Guido, his wife, and three kids lived nearby, above a shop that pressed olives into olive oil, in a two-bedroom home.

At first the war seemed like a spectator sport to the kids. After dark, Giacomo and his friends climbed onto roofs at the highest points in Fiano Romano to take in the panorama. In the distance they could see bombs falling. Allied aircraft dropped flares that turned night into day, illuminating the fields and surrounding

hills. American B-17 Flying Fortress bombers came over the horizon in V-shaped formations, the four engines of each plane combining to create a low-pitched hum of an approaching swarm.

As the spring of 1944 began, the bombs always dropped on someone else's city. For Giacomo, the fireworks were a diversion. Then, on the morning of May 27, 1944, Giacomo learned war was anything but a game.

After breakfast on that Saturday, he was roaming the neighborhood with the independence of a boy his age, two months shy of six. His grandmother was at home caring for the newest member of the family, her eleven-month-old granddaughter, named Luigia after her. Around 10:00 A.M., the air sirens sounded.

As he'd done many times before, Giacomo jogged over to the bomb shelter, a wine cellar deep beneath a neighbor's house, but opened for communal use in emergencies. From inside he could hear the familiar sound of the low-flying bombers—a droning hum of propellers—followed by the whistle of dozens of small missiles dropping through the sky. A quick series of explosions followed, *boomboomboomboom,* as the carpet of ordnance hit the ancient landscape. Luckily for Giacomo, those sounds were distant. The bombs had fallen far from the town.

After the racket drifted away, the lookouts sounded an all-clear siren. The doors to the shelter flung open and Giacomo, tired of being cooped up and just spooked enough to seek the security of his grandmother, skipped toward her red-roofed house to see what fun he could find.

That's when the sound came back. The Allied aircraft had turned around. Nobody had time to raise the alarm before the bombs started to drop. Giacomo raced for his grandmother's home as the Flying Fortresses took aim at the castle at the top of the hill in which the Nazis were ensconced. But the tiny Frisoni house wasn't far from the target—and the bombers' aim wasn't good.

Inside, fifty-eight-year-old Luigia scooped up her infant namesake to shelter the baby from the onslaught. Outside, Giacomo made his last dash for the front door. One of the bombs scored a direct hit on the house.

A few blocks away, another bomb smashed into the two-story building where Giacomo lived with his parents and siblings. In the fields below Fiano Romano, the carpet bombing hit a farm about a mile away where Giacomo's grandfather, Luigi, was working. The explosions killed the sheep and goats he was tending and left him gravely injured. The Medici house was crushed, but it had been empty and nobody was hurt.

The bomb that hit the grandmother's house took the greatest toll. It smashed down, first through the clay roof tiles and then through the heavy wooden beams. A pile of terra-cotta and timber engulfed the two Luigias. It would take three days to dig out their bodies. When they did, they found the baby still wrapped tight in her grandmother's protective embrace.

Giacomo never made it into the house. When the bomb exploded, it sent a six-inch slice of hot shrapnel into his skull. The last thing he saw was the front door. And then everything went black.

The war also put Dietrich von Bothmer's life in grave danger. After just a year of studies, Oxford awarded him a diploma in classical studies. Then, as Germany and England prepared for battle, the fighting-age von Bothmer left for the United States, sailing on June 28, 1939, from Southampton to New York on the *Queen Mary*. His mission was to visit museums on behalf of Beazley, gathering data that his mentor would include in his definitive catalogs of Athenian red-figure and black-figure vases.

America teemed with new and growing museums and rich

collectors such as newspaper baron William Randolph Hearst. Here was a fresh frontier for finding newly excavated Greek pots that had crossed the Atlantic. Europe's collections were already well documented, its collectors too poor and its museum curators mostly concerned with protecting their treasures from wartime bombardment. Von Bothmer had come to the right place at the right time.

He spent the next few years trying to solidify his credentials so that Beazley could eventually pass the torch to him. From 1940 to 1942, von Bothmer studied at the University of California at Berkeley. He then spent a year at the University of Chicago before hopping back to Berkeley. Since the ongoing fighting on the Atlantic prevented him from returning home, and he also had his eye on eventual U.S. citizenship, von Bothmer enlisted in the army in San Francisco on October 26, 1943. A few months later, the University of California awarded him his PhD, and then he shipped out to the Pacific for a tour through New Guinea, the Dutch East Indies, and the Philippines.

In 1944, as bombs fell on the countryside around Rome, von Bothmer was fighting the Japanese in the Pacific, as a private in the Thirty-first Infantry Division of the U.S. Army. On August 11, twenty-five-year-old von Bothmer joined a patrol behind enemy lines in Dutch New Guinea, near Sarmi, a town on the north coast of what is today the Papua province of Indonesia. The patrol took fire, and von Bothmer was hit in both legs. The other soldier with him was wounded even worse. And the two of them were stuck five miles inside Japanese territory.

Giacomo Medici lay on the ground beside the rubble of his grandparents' house when the bombs stopped falling just before 11:00 A.M. Blood streamed from the gash in his skull where the shrapnel

had embedded. Even worse, blood gushed from the boy's nose, and pink foam frothed from his ears.

"It's brain matter, brain matter!" Giacomo's mother heard a horrified neighbor scream as she rushed to his side. "He's going to die, he's going to die." As villagers tried to dig through the rubble that had buried Giacomo's grandmother and baby sister, hoping to find survivors, they debated whether they should even bother seeking help for the boy.

As Giacomo's limbs flinched spasmodically and blood continued to flow from his ears, the crowed decided to haul the boy down to the pharmacy, the closest thing Fiano Romano had to a medical clinic. Giacomo would probably die at the pharmacy, but at least they would have tried something. From the pharmacy, his family managed to flag down a U.S. Army jeep, whose soldiers agreed to drive the boy thirteen miles south to the hospital in the small city of Monterotondo. When they dropped him off, Giacomo was unconscious but still breathing.

As the day wore on, it became clear that the nearly six-year-old boy had fallen into a coma. One day passed, and then another. The bleeding stopped, and nurses covered the slice in his head with gauze. Finally, a week after Allied forces bombed his house and then helped save his life, Giacomo's senses returned. On June 4, a few days after Giacomo regained consciousness, Allied troops took the Italian capital. But for the boy whose wound wouldn't heal, the war was far from over.

Under the bandages, Giacomo's head was a pool of pus. Antibiotics were scarce. After a month, with the gash still open, a man from Fiano Romano came to collect him, driving a wooden cart pulled by a single horse. The *paesano* loaded him in, hopped up into his seat, grabbed the reins, and headed north.

As they climbed the hill into Fiano Romano, neighbors on the side of the road cheered for the boy.

• • •

In the Pacific, from five miles behind the Japanese front line, the wounded von Bothmer managed to carry his fellow GI to safety. For his heroics, the U.S. Army awarded him the Bronze Star. He might have won a greater honor, the Silver Star, but that would have required two witnesses and von Bothmer had only one—the man whose life he'd saved. The United States did, however, make him a citizen.

After he recovered from his wounds in a military hospital, the U.S. Army discharged von Bothmer in March 1946. Armed with a PhD and references from the famous Beazley, von Bothmer headed east to New York. The job hunt was a cinch for the decorated war hero and credentialed classicist. By the next month, he landed a spot at the Metropolitan Museum of Art as an assistant in the Greek and Roman department.

He's been there ever since, for better and, sometimes, worse.

Left homeless by the bombing, the Medici family moved to the edge of town into an improvised shelter crafted from a cave. Giacomo, normally a chubby kid, became thin from lack of food. At the same time, the swelling from his injury had the disturbing effect of making his green eyes bulge out of his skull.

Crime was rampant, and Medici and his family were often victims. Giacomo lived in fear of having his bread stolen, or worse, as desperation drove some villagers to violence in the quest for scarce resources. Giacomo's recovery didn't go well. It would be several years before his eyeballs would shrink back into his head. He fell four years behind in his studies, partly due to the interruptions of war and partly because he hadn't regained all his mental and physical abilities. When his parents

reenrolled him in school at age ten, Giacomo could barely function as a student. At a time when his cohort could write words, his attempts to draw the letters of the alphabet came out as incoherent scribbles.

The hardships made it more important than ever for Giacomo's father to find steady work excavating antiquities. His best chance came in the late 1940s when he went to work digging for Prince Vittorio Massimo, the head of Rome's oldest noble family.

The Massimo family traces its roots back twenty-two hundred years—and its properties contained ruins, tombs, and treasures even older than the ancient dynasty itself. Among the projects that Prince Massimo hired Guido Medici to excavate was Lucus Feroniae, a shrine surrounded by ruins of a Roman amphitheater, baths, basilica, and other buildings. Worshippers at this shrine had made offerings of statuettes made of stone, clay, and bronze. Guido and Prince Massimo set about collecting them.

For the curly-haired prince, these were excavations into his own family's past. He was descended from a general, Fabius Maximus, who'd saved Rome from Hannibal's advancing army by using delay tactics that wore out the Carthaginian troops from 217 to 214 B.C. Going back even further in time, the modern prince could trace his lineage into the haze of mythology. His ancestor Fabius Maximus was said to be the great-great-grandson of none other than Heracles, the muscular hero of Greek and Roman myth, also known as Hercules. (Heracles, according to the Greek biographer Plutarch's *The Parallel Lives,* had consorted with a nymph next to the Tiber River, and she gave birth to a boy, Fabius.) But the family tree didn't stop there. Heracles, in turn, was a son of Zeus.

That, of course, makes Heracles a half brother of Sarpedon, the Lycian prince whom Euphronios painted on both the krater

and the lost chalice. Or to put it another way: the modern prince who hired Guido Medici to dig up his fields was related to the ancient prince whose death was depicted on a vase hidden somewhere in the ground nearby.

Giacomo saw some of his first dig sites during his father's collaboration with the prince in the decade after the war. He inherited his father's passion for antiquities. And the time he spent around Prince Massimo showed him what it meant to be rich, to have a grand heritage, and, by extension, how to live up to the Medici name. Giacomo surmised from Prince Massimo's example that antiquities were a mark of aristocracy. An artifact could give a man a material connection to a past he could call his own.

Giacomo was in awe of the prince and his possessions. When not at his residence in Rome, Prince Massimo lived in a castle on the edge of Fiano Romano, a real crenellated heap with a tower and a big central courtyard, called Castello di Scorano. To Giacomo's delight, his father often brought him along on visits to the castle to conduct business. When the massive doors of Castello di Scorano swung open, what he discovered was something out of Ali Baba's cave. Prince Massimo had piled his archaeological finds in the open-air quadrangle. Indoor storerooms burst with artifacts big and small that the prince had stacked to the ceilings.

As if that didn't make a big enough impression, on April 29, 1954, Giacomo got his first taste of the international high life. Prince Massimo married the British film actress Dawn Addams, who had starred in B movies such as that year's science fiction feature *Riders to the Stars*. After a ceremony in Rome, the couple rode their black sedan up to the castle in Fiano Romano for a buffet reception in the courtyard. Giacomo watched from the sidelines, agog.

A bowtied Charlie Chaplin sat at a round table in the garden

with his wife, Oona O'Neill, daughter of the playwright Eugene O'Neill. American and Italian actors mingled with a former Miss Italy and members of the minor Italian royalty. Giacomo, wearing shorts, mingled with the kitchen staff and ate leftovers.

Giacomo was fifteen years old and he was seeing what he wanted in life in a neat package of celebrity, riches, and antiquities.

Now he'd just have to grab it.

Giacomo and his older brother, Roberto, learned more and more about the antiquities trade as their father got deeper into his work as a digger and, increasingly, as a dealer with his own stall at Rome's outdoor antiquarian market on Piazza Borghese.

One impediment to the family's progress in the years just after the war was that legally their profession was becoming riskier. The police started to apply Mussolini's antiquities law on occasion, but more often they would look the other way. Private landowners could apply to the cultural authorities for permits to dig on their own land. When a landowner found a statue or pot of significant value and turned it over to the government, he'd be paid a *premio,* or reward, to compensate him. The landowner would also hold on to some of the stash, even if he wasn't supposed to. As long as the government got material for its museums, everyone stayed happy.

This informal system lacked archaeological rigor and record keeping. Beautiful works of art sprung from the ground, but even if they ended up in museums, nobody would ever know exactly where they'd been found or what other objects or human remains they had been buried alongside.

In the decade following the war, the flawed but orderly tra-

ditional system of rich men looting off their own estates in collaboration with the authorities fell apart. Post-Fascist agrarian reforms chopped up feudal landholdings and handed them over to the people. Instead of one rich family conducting digs in official or unofficial concert with the authorities, thousands of poor families suddenly owned land from which they needed to make a living by planting and harvesting food. The antiquities beneath their plows were either riches to secretly sell or, if they got the police involved, potential obstacles to their farming livelihoods. There was the risk the government would seize the land if the find was important enough. The compensation could be paltry.

As the antiquities trade began its transition from a nineteenth-century gentleman's game, and the authorities started to clamp down, the Medici family managed to squeeze some good out of the government. Giacomo's shrapnel gash qualified him for state benefits as a war invalid. In 1956, the government awarded Giacomo a scholarship that gave him housing and food at a dormitory in L'Aquila, a town in the neighboring region of Abruzzi. He enrolled at the Istituto Tecnico Industriale Amedeo di Savoia Duca D'Aosta—a technical school. Giacomo was already eighteen years old when he started his high school training as an electrician, a profession he would never take up.

In New York, the other men whose lives would intersect with Medici's were also carving out careers. On July 2, 1959, the Metropolitan Museum of Art announced it was promoting von Bothmer to curator of Greek and Roman art. At the bottom of the announcement, which included several other promotions and was carried in the *New York Times,* was this news: "Also added to the Cloisters' staff is Thomas P. F. Hoving, curatorial assistant."

Hoving was twenty-eight years old at the time and had already had his share of adventures. A rich kid whose father was chairman and controlling shareholder of the legendary jewelers Tiffany & Co., he had been kicked out of two prep schools before coasting into Princeton. By his own account, after drinking too much and nearly flunking out there, too, he stumbled upon a class on medieval art and found his passion. He excelled, graduated, and after a stint in the Marine Corps, returned to Princeton for graduate school in art history and archaeology.

As part of his studies, Hoving excavated in Sicily and studied in Rome, where he first met the American antiquities scholar and art dealer Robert Hecht in 1956. Hoving had just earned his PhD from Princeton when his Manhattan social connections got him his job on the bottom rung at the Met in 1959.

For Hoving, Hecht, and von Bothmer, those formative years would be the beginning of the greatest, and possibly most traumatic, adventure of their careers.

During Giacomo's summer vacations from technical school, he helped his father selling artifacts at Piazza Borghese. He was now selling antiquities in the center of Rome, making connections, meeting rich collectors, and learning the market for the artifacts he already knew so well. The business did well enough that Guido Medici, now a father of six, moved the family back to Rome in 1960. The following year, Giacomo passed his exams and graduated, at age twenty-two, from the technical school with an electrician's diploma.

But before he could start working in the family business, Medici had to perform his mandatory military service. For most of his year and a half in the Italian army, Medici was based at Bracciano, near Cerveteri, the heart of Etruscan tomb territory.

In fact, after his officers learned of Medici's background in excavation, they put him to work identifying spots for the soldiers to unearth tombs within the vast grounds of the base.

In all, he helped his squad find two or three tombs. But they turned out to be just the burial sites of poorer Etruscans and yielded little more than common *buccheri,* little black Etruscan pots. These discoveries may not have been much, but they satisfied Medici's officers enough that they gave him permits to leave the base and allowed him to keep his car near the barracks—and keep up his social life. In 1962, he met a girl named Maria Luisa Renzi at a friend's party in Monterotondo, the same city where the U.S. troops had taken him after the bombing. Maria Luisa was from Civitavecchia, a port city on the Etruscan coast north of Rome. Her parents owned shops, including tobacco and stationery stores. He was smitten at the sight of her "simple looks and sunny face," by which he meant she was the marrying type.

While Giacomo Medici's mind was on romance, the police started paying attention to what was going on at his father's stall. The elder Medici had sold an Etruscan vase to a law professor of the University of Perugia; when the police later asked the professor where he'd gotten his pot, the law expert fingered his source. The Guardia di Finanza—the finance police—paid a visit to Piazza Borghese in the autumn of 1963 while Giacomo was on duty. When Giacomo and his father failed to provide the Finanza with a legitimate source for some of the clay vessels, prosecutors charged the men with receiving looted antiquities. They went on trial, a process that in Italy can last years due to the sporadic court dates and judges' overbooked schedules.

As the trial hung over them, Giacomo pulled himself away from his work with his father, and instead tried to build his own business. While his older brother, Roberto, set up his own business selling antique furniture at the Porta Portese bazaar on the

other side of the Tiber River, Giacomo stuck to ancient art. The antiquities market was more liquid and the goods were more portable than wardrobes and sideboards.

Through his own work and his father's connections, Giacomo got to know the network of buyers who would pull the young man from subsistence into affluence. He earned enough that on May 22, 1966, he could marry Maria Luisa at the Church of San Giuseppe in Santa Marinella, a seaside town in the heart of Medici's Etruscan stomping grounds north of Rome. The following day the newlyweds drove off in Giacomo's Ford for a two-week honeymoon in Venice and the French Riviera.

Upon his return to Rome, business was so good he became part of the art establishment, helping several wealthy Romans build antiquities collections and getting to know government curators and archaeologists. The biggest fish among Medici's clients was a pharmaceutical industrialist named Angelo Pesciotti. Pesciotti was free to build his collection because he had an understanding with the culture officials that he would eventually cede his trove to the government's Villa Giulia Etruscan museum in Rome, which was overseen by Mario Moretti, the government superintendent for all the Etruscan land around Rome. When Pesciotti died on September 13, 1966, his estate began negotiating the sale of most of the collection to the Italian government. As Pesciotti planned, the bulk of it ended up in Villa Giulia, which today has an entire gallery named for him. The man who actually gathered the artifacts, Giacomo Medici, never won such an honor.

The Tomb

If anyone in Rome understood the perils and profits Medici faced, it was Robert Hecht, a scion of the Hecht's department store family. Hecht had studied the classics—the art, literature, and language of the ancient Mediterranean world—at Haverford College in Pennsylvania, served in the navy during World War II, and then bounced around Europe, first as an interpreter for war crimes investigators, and then briefly attending the University of Zurich. Hecht landed at the American Academy in Rome, lasting there as a fellow until 1949. Afterward he spent a year or so on Ischia, an island off Naples, studying the first Greek settlement in Italy. Most of all, the Baltimore native—a hard-drinking, antiquities-dealing gambler with a legendary temper—quickly figured out how to use his education to make money. With Rome as a base, he began gathering artifacts from across the Mediterranean and selling them to museums and collectors in Europe and the United States.

Through the 1950s and 1960s, Hecht had been practically alone at the top of the antiquities market, supplying hundreds of vases and coins to Boston's Museum of Fine Arts, dozens of treasures to

the Metropolitan Museum of Art, including a solid gold Greek cup, and a pot by Euphronios and pieces of an Etruscan chariot to museums in Germany and Denmark. His fluent Italian, French, and German—not to mention a smattering of Modern Greek he'd picked up in his classical studies—allowed him to cut deals with merchants and collectors across Europe. Hecht and his American wife, Elizabeth, and their two daughters lived in an apartment on Rome's Aventine Hill. Hecht enjoyed the expat life, playing tennis in Spain during the summer, skiing in the Alps in the winter, and partaking of abundant, inexpensive wine year-round. But he also enjoyed making money, and he knew that Italy's soil would be a source of valuable antiquities for years to come.

Medici was just twenty-eight years old when he first met Hecht in the spring of 1967. Hecht was forty-seven and had a lot to teach the young dealer.

Hecht was traveling outside Italy when his wife called him to say that an antiquities middleman he knew had phoned to offer a good kylix wine cup that had just surfaced. His message also said that Hecht should be prepared to pay up. Hecht made a hasty return to Rome and arranged to meet the dealer on a street near the Capitoline Hill's Campidoglio, the hilltop plaza designed by Michelangelo, where city hall overlooks the ruins of the Roman Forum. Keenly aware that they shouldn't be seen together, the middleman quickly sketched a pencil drawing of each side of the vase. The decoration of the kylix's tondo—or round painting that covered the cup's outer surface—was a forest of olive branches. An inscription indicated it was probably by the painter Skythes, who was, along with Euphronios, a pioneer of the red-figure style. Hecht was impressed, just from this pencil drawing, and authorized his buyer to pay up to 2.5 million lire, the equivalent of about $4,200, or more than $26,000 today in inflation-adjusted dollars.

But when Hecht's contact tried to negotiate the purchase with the suppliers, another middleman stepped in and ruined the deal: Giacomo Medici, who bought the vase before Hecht could and sold it to one of his most loyal clients. When Hecht sent Medici a message that he would top whatever price Medici had gotten, Medici wasted no time betraying his regular customer. He concocted a story about the cops being after the cup, and he offered a refund. With the kylix back in his possession, Medici arranged his first meeting with Hecht.

It was past dark when Hecht's middleman drove Medici to the rendezvous point in front of the hulking, stone Supreme Court building on the Lungotevere, the busy artery that runs along the Tiber River. They parked their car alongside Hecht's, and Medici presented the cup. Hecht closed the deal with a flourish, asking Medici if he'd be happy with 2.2 million lire—700,000 lire more than Medici had paid for it.

Medici, showing little discretion, jumped for joy. "*Si!*" Medici had no idea how badly he'd been suckered.

Soon after, Hecht sold the cup to a chemist in Basel for 60,000 Swiss francs—the equivalent of 8.5 million lire. Hecht had tripled his money, earning $9,500. At the same time, the wily American opened Medici's eyes to an important principle of the trade: selling a single, high-quality object can bring much higher profit than pushing an endless string of minor antiquities—and with much lower risk because a single sale is less likely to be discovered by the police than a series of sales.

About two months after the deal with Hecht, Medici's trial for handling looted artifacts for his father finally ended. On July 6, 1967, the Rome court convicted him of receiving looted antiquities. A judge sentenced Giacomo to three months in jail and his father to four, but suspended their prison time because they had no previous convictions. Giacomo Medici had suffered an ordeal

and earned a criminal record for pots that were little more than trinkets. If he were going to take such legal risks in the future, he would have to make it worth his while and deal in the good stuff instead—like Hecht did.

Hecht wasn't just selling pots as a commodity. He was selling vases as masterpieces to collectors who could become obsessed. Their need to possess meant they would always eventually pay whatever Hecht asked. Seeing the light, "Giacomo Medici quickly turned into a faithful supplier," Hecht later wrote in a journal entry that would come back to haunt him.

Joining the American dealer in the antiquities trade would be anything but safe. Even in an era of lax enforcement, Italian police and customs officials had their eyes on Hecht. As far back as 1961, Rome prosecutors had charged him with a series of offenses, including the undeclared import to Italy of a vase, ancient glass pieces, a Roman gold ring, and twenty-four collectible coins, and the illegal export of three statuettes from Italy to Switzerland.

The charges of smuggling to Switzerland (eventually dismissed in 1978, in part for lack of evidence) were particularly important, because they exposed how dealers moved the loot they'd bought from tomb robbers out of Italy and onto the international market. Switzerland, just over the border to the north, was the ideal first stop, because it lacked restrictions on selling antiquities. London and New York were the ultimate destinations, because that's where the artifacts commanded the highest prices. There was almost no way to prove the loot had come from Italy because the Greek and Roman spheres of influence extended across what are now dozens of modern nations and their art can be buried in these territories and trade routes.

In some cases, proof of exact illicit origins did exist, even if it

would take decades to surface. In 1968, Hecht made a small sale to Dietrich von Bothmer, the Met's curator of Greek and Roman art. The sale, of a silver dollar–sized vase fragment, would later have big implications, not just for Hecht, but for Medici, the Met, and the newest major American repository for antiquities, the J. Paul Getty Museum.

As a sideline to his work at the Met, von Bothmer bought vase fragments for his own collection. Whereas museums wanted pots that were as intact as possible, the curator sought shards. They were puzzle pieces that might complete an unknown, broken vase at some later date, orphans that he cared for until they found their original homes. As he had learned from Sir John Beazley at Oxford, the fragments were also wonderful teaching tools for his students.

Von Bothmer bought this particular fragment from Hecht because of its pedigree. He could tell from its style and shape that it was probably from Euphronios's workshop and formed part of a kylix wine chalice. The square-jawed curator was intimate with the details of every known pot either painted or potted by the master, and this orphaned fragment had no documented home. The cup to which it belonged had yet to surface (and it might not ever appear). He'd wait.

Von Bothmer scrawled a note on a bit of paper: "B.H. '68." He stuck the paper on the fragment and then filed the piece away in his office at the museum, along with the rest of the jetsam that jammed his bookshelves waiting to make sense.

For as long as humans have buried valuables in tombs, there have been tomb robbers. So it wasn't long after the Etruscans buried their dead alongside masterpieces such as Euphronios's Sarpedon krater and chalice that pillagers targeted the necropolises of

Caere, the ancient city that would become modern Cerveteri. Later generations of Etruscans, followed by their conquerors, the Romans, stole from the burial grounds, mostly to obtain the precious metals buried there, leaving behind other materials. Under Roman rule the residents of Caere abandoned the ancient city and its mortuary monuments, which were left exposed to scavengers and the natural elements.

A thousand years later, the art of classical antiquity helped inspire the cultural reawakening of the Renaissance. The Italian painters and sculptors who brought Western art out of the Middle Ages drew upon the graceful human forms of Greek craftsmen and their Roman imitators. The flowering in Athens, of which Euphronios had been a part, gave birth in Tuscany—the land of the Etruscans—to the flowering of the Renaissance and its leaders, from Leonardo da Vinci to Michelangelo.

From the 1700s, treasure hunters again targeted the burial grounds. A century later, as modern archaeology began to develop as a discipline, the Cerveteri necropolis finally benefited from fully documented excavation. The results were a stunning sign of what can be learned about the past when an intact tomb is found, recorded, and its contents preserved as a single burial unit—each object in the context of the other.

On April 21, 1836, the archpriest of Cerveteri, Alessandro Regolini, and General Vincenzo Galassi uncovered a tomb that for two and a half millennia had evaded detection and pillage. Excavating under the authority of the pontifical government, the men found what's known as a corridor tomb, for its arrangement along a single line, cut into the rock under a mound just behind Cerveteri's old city. Inside they discovered two intact burials, one of a royal woman and another of a cremated man. They also found a third occupant, without his own burial chamber, on a bronze bed.

The burial goods the men cataloged included precious items made of gold and silver, decorated with miniature designs in a lost technique of metalworking, and everyday objects made of ivory, silver, and bronze, imported from elsewhere in the Mediterranean, including huge bronze urns and a set of silver jugs made in Phoenicia and Cyprus. The royal woman was wearing a gold breastplate embossed with a series of pictures, including a winged lion, a woman in a tunic, and grazing deer. Regolini and Galassi also found a chariot, ceramics, and, finally, sacred ornaments of various shapes and uses that gave evidence of the beliefs of the otherwise mysterious Etruscans.

Taken together, the contents of the tomb exposed a range of information, from trade routes and religion to gender roles and local artistic abilities. If such a tomb were found today and excavated with modern methods and lab work, it would yield even more information, including data about animal and vegetable remains buried in the tomb, and the health of the human occupants.

This one Cerveteri tomb found in 1836 remains one of the best tools for continuing to learn about the Etruscans. Instead of breaking up the find and shipping the finest pieces to various collectors and museums, as tomb robbers do, the archpriest and the general sent the tomb's contents to Rome, where today they form the nucleus of the Vatican Museums' Etruscan collection.

But once word got out that there was gold to be found in the burial mounds of Cerveteri, the unauthorized pillaging began and the chances of further reconstructing Etruscan life became harder. This enthusiasm to find buried treasure did bring to light the work of an artist whose name probably hadn't been uttered since many centuries before the birth of Jesus: Euphronios.

Unheard since antiquity, the name Euphronios made its modern debut in 1828 in the ancient town of Vulci, north of

Cerveteri. In that year, oxen plowing the land of Napoleon's younger brother, Lucien Bonaparte, Prince of Canino, uncovered an Etruscan tomb. The prince took charge of the dig and quickly amassed a collection of thousands of antiquities, including two cups that bore Euphronios's name as potter.

Euphronios's vocation as a painter, however, wasn't discovered until 1830, when a dig elsewhere on the Vulci property turned up a kylix wine cup portraying Heracles accomplishing his tenth labor: slaying Geryon, a three-bodied monster whose cattle the Greek hero needed to steal. One side of the cup's outer surface shows the bloody confrontation, while the other bears a herd of cows drawn in fine, detailed lines. After failing to get high enough bids for the cup at auction in Paris in 1837, Prince Canino offered it on the London market in 1838 as part of a lot of 117 vases, two Etruscan candelabra, and a mirror, known as his *Reserve Etrusque*. But Canino's asking price for the haul was 4,000 pounds sterling—more than anyone was willing to pay.

Finally, in 1841, the year after the Bonaparte prince died, King Ludwig I of Bavaria bought the cup, along with fifty others, at a spectacular auction in Frankfurt. It was the last time a Euphronios would be offered at public auction until the 1990 Hunt sale at Sotheby's in New York. The Bavarian king's purchase, the only vase known at the time to be painted by Euphronios, ended up in Munich's state antiquities museum.

Soon three other vases with Euphronios's signature as painter surfaced—this time at Cerveteri—in a collection that the Marchese Campana built by excavating on his landholdings between 1840 and 1848. One pot was a nearly complete krater for mixing wine and water; another was just an assortment of several fragments of what had once been a krater. Each portrayed Heracles. The Louvre bought both in 1861, and they remain at the Paris museum. Campana's third signed vase painted by Euphronios was a

psykter for cooling wine; it showed a scene of a symposium drinking party, including a picture of a reclining nude woman with kylix wine cup in hand. The Hermitage museum in St. Petersburg bought that vase in 1862, and it has remained there ever since.

The fifth vase signed by Euphronios as painter—and the last to appear for nearly a century—turned up at the Acropolis in Athens during an excavation in 1882. This wine cup was the rare find of a Euphronios that actually stayed in the city where it was made, rather than being exported to Cerveteri or Vulci where the other four had been brought and then buried by Etruscans. Only a few fragments remained of the cup found in Greece, but they included a trace of Euphronios's name and pictures of Athena and other figures. Today it is in the Athens National Archaeological Museum.

Over the past century, Euphronios's fame and the rarity of his works made his kraters and cups a valuable commodity, traded only in secrecy, and usually just for the consumption of the great European museums. Until the 1990 Hunt auction, the chase for Euphronios would be a game played by tomb robbers, smugglers, university professors, and, crucially, curators from museums in Berlin, Boston, Paris, Malibu, Munich, and, eventually, New York.

In Rome, Giacomo Medici had made enough money by 1968 that he finally opened his own gallery, Antiquaria Romana, at Via del Babuino 94, a block from Piazza di Spagna. Medici quickly started to mix with the art elite and found no official resistance to the business he was doing. Medici was on cordial terms with Superintendent Moretti, in part through Medici's late client, the pharmaceutical executive Pesciotti. Moretti's assistant, Giuseppe

Proietti, a freshly graduated archaeologist from Rome's top public university, La Sapienza, gave Medici research bulletins of stolen items that dealers and the police should be on the lookout for. With a gallery of his own, Medici traveled to Switzerland on business for the first time.

However, at some point in the late 1960s, the national Carabinieri paramilitary police decided to get even more serious about art crime. On May 3, 1969, they formed an art and cultural heritage unit, and they were out to show results. The timing of Medici's debut as an international dealer couldn't have been worse.

As Medici took his first steps into the high-stakes international market, he found he needed more protection in the form of more and better documentation that could lend a sheen of clean provenance to objects with illicit origins. Fortunately for Medici, Oxford—which Professor Beazley had made a center of vase studies—had recently gotten into the trade. Around 1970, the university's Research Laboratory for Archaeology and the History of Art began supplementing its meager budget by charging private clients to date ceramic pots and statues through thermoluminescence, or TL, a procedure Oxford had pioneered. TL could measure how much radiation a clay object had absorbed since the day its creator originally fired it in a kiln—a procedure that resets its radiation content to zero. Based on the amount of naturally occurring radiation that it had absorbed since, the Oxford archaeologists could estimate the date of manufacture.

The Oxford scientists, running the business out of the lab's redbrick Victorian row house, collected powdery samples that had been drilled out of the bases of the artworks. For the right price, they would even make house calls to clients in Switzerland. Crucially, they would issue a stamped certificate bearing

the Oxford University name and attesting to the artifact's age. An undocumented, looted antiquity could now have a pedigree of sorts, having passed through the oldest university in the English-speaking world.

For Medici and the other merchants, the Oxford certificate became obligatory for any vase that lacked information about its origins. Medici's buyers could be free to assume, incorrectly, that Oxford would only test objects with legitimate origins. Over the years, Medici ran about a hundred such tests at Oxford, paying the university some $400,000.

No amount of documentation, however, could stop the transformation that was sweeping the antiquities industry. The era of digging and dealing that had made Giacomo Medici an antiquarian officially ended in 1970, just as he was about to make it big.

In Paris, what should have been an otherwise obscure session of a UN cultural panel convened on October 12, 1970. Delegates to the United Nations Education, Scientific and Cultural Organization's general conference spent a month hammering out ways to answer a question that was becoming increasingly important to countries from South America to Asia to Europe: how to block the smuggling of cultural property.

For the first time, an international body put in writing what source countries such as Italy had been trying in vain to tell the rest of the world: wealthy collectors and museums should stop acquiring antiquities that had been ripped from their archaeological contexts.

UNESCO declared that cultural property "constitutes one of the basic elements of civilization and national culture, and that its true value can be appreciated only in relation to the fullest possible information regarding its origin." And it decreed that nations should halt the illicit export or import of cultural property

removed from source countries. The convention only applied to nations that agreed to become signatories, and UNESCO couldn't bring prosecutions. But as an ethical matter, the 1970 UNESCO convention became the new moral standard.

It was ratified in Paris on November 17, 1970, and that date became the dividing line: dealers and collectors who bought or sold artifacts unearthed after that day knew they were doing something they shouldn't. But they also knew that anything that had been in circulation before that date was kosher on the international market, even if local laws had been broken in acquiring it.

For Giacomo Medici, Robert Hecht, and Dietrich von Bothmer, everything changed that day in Paris when UNESCO signed the agreement and shut the door on illicit antiquities. The only wiggle room in the pact was that, technically, the convention wouldn't go into force until April 24, 1972.

Medici would soon learn that he needed as much wiggle room as he could get. Just before Christmas 1971, a band of his diggers north of Rome discovered a tomb complex unlike any ever seen.

For the tomb robbers in late 1971, the clink, clink, clink *of their long,* steel probes was the sound they'd been waiting for. After systematically combing the countryside north of Rome for potential ancient riches, they had found the stone roofs of buried Etruscan tombs.

All signs had pointed to this remote corner of Cerveteri as good hunting grounds. This particular spot—known both as Greppe Sant'Angelo for a nearby shrine bearing the image of an angel, and Sant'Antonio, after a nearby rural chapel by that name—sat smack on the central path that had cut through the center of the ancient city. Another draw was that Greppe Sant'Angelo was haunted.

The evening shadows in Cerveteri always fall first in Sant'Angelo, which sits on the steep slope of a long, craggy cliff that faces southeast, away from the sunset. For generations, these shadows had given rise to local legend. According to tradition, no inhabitant of Cerveteri will venture into Sant'Angelo after dusk, for fear of the ghost spirit known as the Shadow or the Demon of Greppe Sant'Angelo. The Shadow, who only appears after sundown, has just one job: to guard the ancient Etruscan tombs there, scaring away trespassers with his horrendous apparitions.

The long-dead occupants of the tombs needed the Shadow's services because, according to legend, incredible treasures lay beneath the ground of Sant'Angelo.

Anyone experienced at clandestine digs could tell from Sant'Angelo's rough terrain that the anomalous curves in the ground and patterns in the undergrowth were signs that something man-made sat beneath the surface. Like pro golfers reading a putting green, experienced *tombaroli* could see the hidden hills and troughs. On a night in November 1971, the tomb robbers explored a patch of land that had promise. It lay near the edge of the clifflike *greppe* ridge, and it had a strange, curved mound poking ever so slightly from the soil.

An Italian tomb robber's tool kit includes two key pieces: a shovel and a spillo (a spike), a yard or two long with a handle on one end. The team at Greppe Sant'Angelo paced back and forth around the overgrown turf, jamming their spillos into the soil. Again and again the spikes drove through the soil, failing to hit any underground chambers. Over the years, mud and gravel had run off from the town and fields just above the spot where the men were exploring. Century after century, sludge had come down the ridge during rainfalls and filled in the ravine that, according to legend, contained lost tombs. Crucially to the *tom-*

baroli, the soil had obscured the true location of the face of the ridge, which was where they knew they might find tomb openings.

A man known as Peppe the Calabrese—actually Giuseppe Montaspro, a thirty-seven-year-old originally from the southern region of Calabria—led what started out as a core group of three excavators and two assistants who would mostly serve as lookouts. It was a tight-knit crew, some related to each other by marriage. They all lived in the neighborhood just a few blocks away from Greppe Sant'Angelo, on the edge of the Etruscan wilderness. As they poked the ground again and again, finding nothing but soil beneath, they occasionally came up with the much-awaited, satisfying sensation vibrating up the steel shaft: the *clink* of something hard lying deep under their feet.

Clink, the spillo went, and they took note of the spot, walking a couple of paces, with their backs to the center of Cerveteri, toward what they believed was the ancient edge of the ridge. *Clink,* the pole went again, and again they stepped forward, repeating the procedure until they found a spot with just soil. Slowly, as they kept track of which spots clinked and which spots mushed, Peppe and his team made a mental map of the underground terrain. When they could reliably trace the stone line that marked the face of the buried ridge, they started to dig.

It was one thing for Peppe and his two other excavators, forty-year-old Adriano Presciutti and forty-one-year-old Giuseppe Padroni, to wander around poking the ground, but this adventure took on a whole new level of risk once they started removing soil. Although the land where they dug seemed like undeveloped wilderness, it wasn't completely off the radar. In fact, they were trespassing on private property. They assumed correctly that there was little chance that the land's owner, an old and prosperous Roman, would stumble upon them. But what

they hadn't counted on was that the owner's caretaker, forty-six-year-old Cerveteri native Giovanni Temperi, might come by looking for intruders.

Making his rounds, Temperi reached the *tombaroli* just as they were beginning their work. But instead of this becoming a disaster, it turned out that Temperi was a man who could be reasoned with. Instead of ratting on the robbers, he joined the digging. In exchange they would pay him a cut from whatever they found and sold.

Theirs was a huge undertaking. Having identified a spot on the face of the ridge, they dug straight down. At first the hole looked like any pit, surrounded on all sides by soil. Then, a couple yards below the surface, the stone they had clinked from above emerged on one side. To their delight, it wasn't a naturally occurring ridge, but a stack of cinder-block-like bricks quarried thousands of years before from yellowish, porous rock. As they had suspected, based on formations in other parts of Cerveteri, the Etruscans had built tombs atop the ridge—and Peppe and his men had found the beginnings of a tomb's outer wall. Locating an entrance would take even more digging.

To help with the heavy labor, they enlisted three more men, including a thirty-two-year-old farmer named Francesco Bartocci and an out-of-work farmhand, Armando Cenere. The stocky, thirty-six-year-old Cenere, who'd dropped out of school in first grade to support his widowed mother, had been part of other bands of Cerveteri tomb robbers before. Cenere knew he could expect a share of the haul if he did his job and kept his mouth shut. For the most part they worked at night, but with the caretaker onboard, they also dug in broad daylight.

They dug deeper and deeper, following the stone wall downward more than fifteen feet, a level at which they reckoned they might find a tomb door. Based on their earlier soundings with

their steel spikes, the *tombaroli* took their search westward along the wall. Instead of digging down, they dug sideways, creating a tunnel along the rock, supporting it from the inside with wood planks. Over the years, the tomb walls had only partly held up under the weight of the runoff above them. Some had caved in, and as the diggers made their way, foot by foot, they encountered a scattered assortment of tomb debris. This is when the men made their first sellable discovery: a five-hundred-pound stone lion.

The lion was plain, made out of rough, local stone, and it wasn't a masterpiece. It was a sign, however, that they were on the right track. It could also be a sign to anyone who stumbled on their clandestine dig site—whether competitors or law enforcement—that there might be something of interest there. They had to get the lion out. Bartocci helped the men remove the piece, which was about three feet tall, and loaded it onto his truck and drove it to a plot of land his family owned farther southwest of Greppe Sant'Angelo. They sold the statue within days—so quickly that it was already circulating in the global antiquities market before the men made an even greater discovery—one that for some of them would be the highlight of their lives.

November turned to December as they continued digging. The nights got longer and colder, and Bartocci the farmer donned a wool military overcoat that barely warded off the chill as he stood at his lookout post on the top of the *greppe*. Initially, their plan seemed to be working. First came the lion, and then the door to a tomb, but they found nothing of any worth inside. If someone with rich grave goods had been buried there, another tomb robber from another time—maybe Etruscan or Roman—had gotten there first. So they kept digging their tunnel, always wary of possible cave-ins. At regular intervals they drove narrow air shafts from the surface into the tunnel to provide some oxygen.

They found another tomb door, and then another—with more near-worthless statues, some pottery shards, and some fragmented tombstones with inscriptions of the names of the dead. It was no treasure, but it was getting better and better. The bits of ancient pottery meant the stakes were now higher, and the team would need extra protection against the police and, perhaps even worse, rival gangs of looters. Convinced he'd found a spot worth protecting, Peppe asked Cenere the farmhand to join Bartocci on guard duty. As the two men stood above in the darkness, Peppe's men dug to what was their fourth or fifth tomb opening. From their tunnel they arrived at a doorway standing six feet high and three feet wide. Clearing away a bit of rubble, they entered the somewhat collapsed but mostly intact remains of an Etruscan burial chamber.

For the first time in some two thousand years, light poked through to illuminate the ancient treasures inside. The men hauled out statues of a winged sphinx and a panther. They fished out all manner of painted ceramic vessels—covered in dirt but mostly intact. There were museum-quality pelikes, used in antiquity for transporting liquids such as olive oil, and psykters, vessels that had been used for cooling wine at drinking parties. They even hauled out kylixes—the chalices out of which the participants in those drinking parties would imbibe.

All of those would add up to a nice little income. But sitting on the floor of the tomb's main corridor was a vase that might make them rich.

It was a krater pot for mixing wine, signed by Euphronios as its painter. And it was broken into dozens of fragments as if someone had carelessly dropped it on his way through the hallway a couple thousand years before, and not bothered to sweep up the shards.

Even though it was shattered, Peppe and his men knew they had a masterpiece that would make the whole venture worth-

while. The fact that nobody in antiquity had bothered to clean up the fragments worked to their advantage, too, because at first glance it looked like every single bit of the krater was there. Not wanting to mix up the krater with fragments from other, lesser vases, the men piled the pieces into plastic shopping bags. They dragged the bags out of the tomb into the tunnel and passed them up the entry shaft to the men keeping watch. Bartocci, standing in his military overcoat on top of the ridge, peered inside one of two white shopping bags that he saw the diggers pass up, filled with fragments. By the illumination of his flashlight he saw the glow of a reddish warrior holding a sword.

The men passed around another fragment. About the size of a man's hand, the ocher-and-black hunk of pottery was unusual enough—with its fine lines and detailed anatomy—that Peppe's men had their farmhand guard, Cenere, take a look. Once he saw it, the image was burned in his memory. As he would later tell the police, Armando Cenere saw, depicted in orange against a dark background, "a man who was bleeding."

Sarpedon was neither Trojan nor Greek, but a prince of Lycia, a kingdom to the south of Troy that sent its warriors to help defend the cosmopolitan Trojans from the Greek onslaught. Although he had the fortune of being a son of the most powerful god on Mount Olympus, this child of Zeus had a mortal mother, making him as vulnerable on the battlefield as any other man.

The confrontation that sealed Sarpedon's fate began when the Trojans launched a surprise attack on the Greek ships beached on the shore. They swarmed toward Achilles; his closest friend, Patroclus; and their Greek troops. Patroclus was the first to throw his shiny spear at the advancing troops, and he led the army on a counterattack, wearing Achilles' armor.

Achilles did his part not by taking up weapons—but by taking up a chalice. Achilles stepped into his tent, where he opened a trunk filled with rugs and cloaks and pulled out a wine cup. Achilles' chalice was made of silver. In the courtyard of his camp, Achilles poured the wine into the cup, and staring up at the heavens, prayed to Zeus. Achilles asked Zeus to grant his closest comrade, Patroclus, success in repelling the onslaught that threatened to push the Greeks into the sea. He also prayed that Patroclus would return unharmed.

Zeus would grant only half the prayer. He had other concerns: his son Sarpedon was fast approaching the center of the battle, riding his chariot drawn by a team of three warhorses.

Amid the clanging of swords and stench of battle, Patroclus rallied the Greeks. "Slaughter Trojans!" he cried as he split skulls and severed limbs. The Trojans turned and ran from the beach, if they could. Others found themselves trapped in the Greeks' defensive trench, where Patroclus and his men butchered them. Patroclus, circling his chariot behind the Trojan line, blocked the retreat, piling up corpses. Sarpedon, son of Zeus, might have understood the Trojans running from the fight, but he wouldn't tolerate his own Lycian troops fleeing.

"Lycians, where is your pride? Where are you running?" Sarpedon admonished his men. Then, eyeing Patroclus, he added, "I'll take him on myself."

Sarpedon jumped from his chariot, weapons drawn. As soon as Patroclus saw what was happening, he, too, leapt down. Like two vultures with claws and beaks ablaze, the warriors screamed toward each other with their battle cries. Zeus, watching from the heavens and knowing the future, was distraught. "My cruel fate," he said to his wife, the goddess Hera. "My Sarpedon, the man I love the most, my own son—doomed to die at the hands of Patroclus."

But there was something Zeus could do. As the king of the gods, it was within his power to alter fate and save Sarpedon. Yet at what cost? "My heart is torn in two as I try to weigh all this. Shall I pluck him up now, while he's still alive and set him down in the rich green land of Lycia, far from the war at Troy and all its tears?" Zeus asked his wife, who, importantly, was not the mother of his son Sarpedon.

Hera protested. "What are you saying? A man, a mere mortal, his doom sealed long ago? You'd set him free from the many pains of death?" she asked Zeus. "Do as you please," she said, and then slyly reminded him that he couldn't afford to offend his fellow gods. "If you send Sarpedon home alive, I warn you, then some other god will want to sweep down on the battlefield and rescue his son from the fighting, too," she said. "As precious as he is to you, and your heart grieves for him, leave Sarpedon to die there in the brutal attack.

"But once his soul and final breath have left him, send the god Death to carry him home, and send the soothing god Sleep to help accompany him home to Lycia. There his countrymen will bury prince Sarpedon with full royal rites," Hera said, sealing her argument—and Sarpedon's fate.

Zeus agreed, but not without first making a grand gesture. He showered tears of blood onto the land, drenching the plains of Troy. As the rain of blood poured down in praise of the son who was about to die far from his homeland, Sarpedon and Patroclus closed in on each other. To reach his target, Patroclus had to take out the men running defense for Sarpedon. First he speared the aide on Sarpedon's side, piercing his guts and making his limbs go limp. Sarpedon attacked back, hurling a lance at Patroclus. But he missed, instead hitting one of the stallions from Patroclus's chariot, stabbing the horse's right shoulder and sending it down screaming in the dust. Sarpedon tried again,

throwing his spear at Patroclus. The shaft whizzed over the Greek's left shoulder, never even touching Patroclus.

Patroclus pounced, hurling his spear. The bronze spearhead pierced Sarpedon's midriff, right at the heart. As Homer recounted, the Lycian prince toppled like an oak, or a tall pine that's been cut down by woodsmen for making ships. Sarpedon, like a bull mauled by a lion, raged in the dust, screaming for his men to defend his body and make sure the Greeks wouldn't strip his corpse of its armor in what would be the final indignity. "Fight for me!" he yelled. "You'll hang your head in shame every day of your life if the Greeks strip my armor. Spur our men to battle!"

Those were to be Sarpedon's last words. As the son of Zeus choked on his last breath, Patroclus stepped over to Sarpedon, planted a heel on his chest, grabbed the spear embedded in the fallen hero, and gave it a yank. As Patroclus pulled his weapon from the wound, Sarpedon's innards came with it.

With Sarpedon dead, the fight for his body and its armor began, claiming even more lives. A band of Lycian shieldsmen surrounded the corpse while others, joined by Trojan allies, went on the offensive against the Greeks, who lusted for more of Sarpedon's blood and pride. "If only we could grab his body, mutilate him, shame him, tear his gear off his back," one of the Greek soldiers declared. Both sides battled around and on top of the body. Zeus, who'd done nothing to stop his son's death, turned day into night to make the fight for the body both blind and bloody.

A Greek managed to grab Sarpedon's corpse, but instead of making off with it, he met the fury of Hector, supreme commander of the Trojans and a son of Troy's king. It was now Hector's turn to inflict pain on the Greeks. Hector lifted a rock and smashed it into the head of the Greek, splitting his skull within

his helmet. The Greek fell face-first onto Sarpedon's body. As the slaughter continued, nobody could make out the Lycian prince's lifeless form, which got buried deeper and deeper in a pile of blood, weapons, and dirt. Looking down from the heavens, Zeus mused on the ways to get revenge on his son's killer, Patroclus. Should he have someone finish him off now, over his son's corpse, or let him fight on?

Zeus decided to let Patroclus continue the fight. Hector, the Trojan leader, sounded the retreat back toward the city walls. As Hector took to his chariot and spun around back toward Troy, he left Sarpedon's body defenseless. The Greeks descended, ripping the shiny, bronze armor from his corpse.

Zeus had had enough. Before the dismemberment could start, he ordered the god Apollo to clear the weapons off Sarpedon and to carry him off the battlefield. Apollo took Sarpedon away from the flying arrows and spears to the safety of a river where he washed his body, anointed it with fragrant oil, and wrapped it in robes worthy of the gods. Then, following Zeus's orders, Apollo sent Sarpedon off to his homeland, carried as swift as the wind by the twin brothers Sleep and Death. In his demise, Sarpedon, son of the greatest god, became the Christ figure of Homer's *Iliad,* lifted by Sleep and Death in a scene reminiscent of both the removal from the cross and the resurrection.

The twins set down the corpse in the green fields of Lycia, where Sarpedon could finally find peace.

Christmas came early to the tombaroli *of Cerveteri in 1971. In all, it* took eight days to clear the tomb of the goods that could be sold— and to destroy any of the surrounding archaeological evidence, which had been untouched for millennia yet was ruined in a couple months. The structure of the tomb went unrecorded

along with the placement of the grave goods in it. Peppe and his men discarded any unsellable material they might have found, whether remains of food offerings, shreds of ancient textiles, or human bones. Any such ancient evidence could have provided clues to who had been buried at this site, and it may even have helped make the mysterious Etruscans a little less mysterious.

What the *tombaroli* had found was far more than just a single tomb. It was an entire, previously unknown necropolis that in some places took the form of an apartment building for the dead. The complex boasted the first rock-cut Etruscan tombs ever found; all other known tombs of that era had been constructed from stacking blocks of stone, rather than chiseling into the earth. It also contained the earliest known vaulted arch in Etruria. And the riches inside were unparalleled. Just based on what survived the sacking and made it to public collections, art histories needed to be rewritten.

As the tomb robbers searched for more loot, the destruction went beyond negligence of the historic record and descended to outright vandalism. Having dug more than fifteen feet below the modern surface of Greppe Sant'Angelo, the *tombaroli* found another door, made out of a local, soft speckled stone called pepperino and carved in relief with a geometric decoration of circles and boxes. Behind the door, the men reasoned, might sit another chamber with even more valuable artifacts. So they hacked away at the ancient carving. When they managed to break through, they found only a stone wall behind it. They had smashed a decorative false door for nothing.

Underground, the men kept digging as New Year's approached. Aboveground, in the meantime, they had money to make. They knew the krater depicting the "man who was bleeding" was their biggest prize. The men had driven the plastic bags containing the krater's pieces to the home of the caretaker, Giovanni

Temperi, on Via Toscana, at the edge of Cerveteri. There, in the cellar of the two-story house, the gang recomposed the pieces they had picked up from the floor of the tomb. As the puzzle came together, it appeared that hardly a sliver of clay was missing. They didn't glue the fragments into position, but placed the bits close enough together to tell they had a nearly complete masterpiece.

They didn't want too many people to see what they had or know where they had stored it. However, it didn't seem like much of a problem to allow a twenty-two-year-old blind woman named Pina into the cellar to lay her hands on the fragments. They knew from the inscriptions that the vase had been in the hands of Euphronios himself, and Pina, a sort of hanger-on to the tomb-robbing gang, wanted her hands to pass over the glazed terra-cotta, too. The blond blind woman won access to the hoard because her sister was married to one of the three *tombaroli* leaders, Presciutti, and she was the sister of the lookout Francesco Bartocci. Weeks before, she had already had the chance to touch the rough surface of the stone lion that had been stored at the Bartocci property. Holding the thick shards of the Sarpedon krater between her fingers was an entirely more moving experience, yielding the sensation of a smooth surface that was dotted and crisscrossed by the raised relief lines that Euphronios had applied.

As much as Pina and her friends admired the find, however, the tomb robbers were in this for the money. They needed to move the merchandise out of Cerveteri as quickly as possible. If they were to cash in on their Euphronios krater, they would have to do it now. It was time to call Giacomo Medici.

The "Hot Pot"

Peppe Montaspro's crew gave Medici a call in December 1971, knowing he was a regular buyer of antiquities who had something of a lock on Cerveteri artifacts. Medici was told to meet up at an apartment on Rome's Via Francesco Crispi, a street that runs uphill toward the top of the Spanish Steps, not far from Medici's shop. Arriving at the apartment, Medici saw the magnificent krater, in fragments, and knew he could not pass up what would be the greatest purchase of his career.

Medici bought the krater, for probably around 50 million lire, or about $88,000. The tomb robbers then paid Cenere and Bartocci 5 million lire each, about 10 percent of the krater proceeds per person, for their work on the seven-man team. At about $8,500, it was a considerable cut for barely two months' work, and much more than what anyone in their neighborhood earned in a year. Cenere was happy with the payout—until he learned how much the dig's leaders had made, and how much the krater was really worth on the international market.

According to a slightly different version of events that police gleaned from confidential informants in Cerveteri, the tomb

robbers also had other grave goods to sell, including kylixes, psykters, and panther statues, which they sold directly to Robert Hecht in Temperi's home on Via Toscana, with Medici acting as middleman. Exactly which cups and vases were on the block— and whether they included Euphronios's Sarpedon chalice— wasn't recorded in the police reports taken at the time. Hecht has denied that this transaction ever happened, and police and prosecutors have never successfully brought charges based on that portion of the police intelligence. However, the essence of the story—that Hecht got his hands on terrific merchandise around that time—would bear out.

By contrast, the path that Euphronios's Sarpedon krater took has become much clearer. After buying the krater, Medici photographed it with a Polaroid instant camera. Shooting regular film of a looted artifact and then taking it to a commercial photo shop would have been foolhardy. With the pictures in hand, he could move the actual merchandise out of the country while still being able to market the krater with the Polaroids. As a known antiquities dealer, it would also be foolish for him to try smuggling the vase out of Italy. Instead he turned to one of his trusted mules in the north, a man in Milan who took the heavy box of fragments across the border to Switzerland. There the krater would sit until Medici could find a buyer who could pay enough to bring him a hefty profit on his investment of nearly $90,000.

Medici didn't need to go far. One morning in the final days of 1971, Medici came calling at the Hecht residence at Villa Pepoli. Robert and his wife, Elizabeth, had just finished breakfast when Medici walked in the door and presented them with the photos of the hulking, foot-and-a-half-high krater by Euphronios. Hecht couldn't believe his eyes. His wife was so astounded she thought it might be a fake. "Is this for real?" Elizabeth exclaimed. The American dealer had to see the thing for himself.

Within an hour, Hecht and Medici had caught the next flight to Milan. They ate lunch at Le Colline Pistoiesi, a Tuscan restaurant that decades later would be the focus of the Mafia trial of one of Prime Minister Silvio Berlusconi's closest allies. Then Medici and Hecht hopped a train to Lugano, across the border in Switzerland where Medici had stored the piece beyond the reach of Italian law. Once Hecht saw the fragmented krater at Medici's secure hiding place—a safe-deposit box—the negotiations didn't last long. They settled on 1.5 million Swiss francs, about $350,000 at the time, to be paid in installments. Medici was more than tripling his money.

By that evening Hecht had taken the krater to Zurich, where he dropped it off at the home workshop of Fritz Bürki, his faithful vase restorer, and paid Medici $40,000—all the cash Hecht could get his hands on. The vase was his, and he just had to come up with the rest of the money. For the moment, he could celebrate. Hecht returned to Rome to pick up his family and took them back to northern Italy for their Christmas vacation in the ski resort of Courmayeur, near the French border. As he would later recall in a handwritten memoir, it was truly a good vacation.

When he returned from the break, Hecht tackled the double task of finding a buyer for the krater who would make him a quick profit and getting the remaining money to pay Medici. Along with another dealer, Hecht had bought a life-size bronze eagle that they'd been trying to offload. They had approached the Met, the Los Angeles County Museum, and a museum in Fort Worth, Texas, all with no luck. Hecht got permission from his partner to take what they could for the eagle, and he went ahead and sold the piece to his competitor, London dealer Robin Symes, for $75,000. This extra cash would keep Medici happy as he waited for the final payout.

As for finding a buyer for the krater, the first signs were bad. Hecht tried Sotheby's in London, but the antiquities chief there, Felicity Nicholson, gave the pot an estimate of just $200,000, much too low for Hecht. He tried another option. A Danish ship-owner he knew of might buy it on behalf of Copenhagen's Ny Carlsberg Glyptotek museum. But that deal also fell through. The new year wasn't starting nearly as well as 1971 had ended.

To get a deal rolling, Hecht sent a cryptic, handwritten note in early February 1972 to his old client at the Metropolitan Museum of Art, curator Dietrich von Bothmer.

The note referred to an earlier correspondence the two men had had about Beazley's *Attic Red-Figure Vase-Painters,* 2nd edition, the Oxford don's definitive catalog of Greek pots painted in the style of Euphronios and his cohort. Then Hecht continued: "If something like p. 14, no. 2 were in PERFECT condition & complete, would it merit a gigantic effort, a really gigantic effort?"

Hecht's puzzle made perfect sense to von Bothmer, who gathered all the relevant books and photos that he could and prepared to make the pitch to his boss, the young director of the museum, Thomas Hoving.

Hoving, who was then forty-two years old, had pulled off an improbable rise since originally joining the Met in 1959. After being promoted to head of the Met's uptown Cloisters outpost, his hyperactive charisma, social connections, and political support of New York mayor John Lindsay won him a stint as New York City's parks commissioner—making him, technically, the Met's landlord. In 1967, after the sudden death of the museum's director, James Rorimer, the Met's trustees had hired Hoving back from city government to run the whole place. He did his best to make his mark, in part through acquisitions.

• • •

In Cerveteri, the tomb robbers were laying a puzzle of their own. Gossip about their amazing haul, including the Sarpedon krater by Euphronios, would surely start to spread. By the time they finished their work in February 1972, they'd had a good haul, and it was time to cover up the evidence, literally. The band's last task was to refill the pit and tunnel, shoveling the soil back in. It would be as if the tomb never existed. By randomly mixing in dirt, debris, and archaeological remains at all depths and positions in the site, the *tombaroli* also completed their task of forever destroying the record of the artifacts' original placements in the strata of history, which are so important to archaeologists for dating their finds.

Then, to throw investigators off their trail of the krater, the men purposely abandoned one of their finds—a sphinx made of travertine marble—inside the Greppe Sant'Angelo site. Chatter about the dig had been spreading for months, and it would help cool things down if law enforcement were under the impression that they had cracked the case. So the men tipped off the Guardia di Finanza, the finance police, which in a way was an offering to the gods, or a kickback to the cultural authorities. If the clandestine diggers were lucky, the discovery by the cops would end any investigation before it started. But they couldn't have been more mistaken. Before the end of February, the Finanza organized an emergency excavation of the site.

The finance police didn't have the same level of patience that archaeologists have. They began their excavation using mechanical diggers normally found on construction sites. These officers, who had nothing to do with the competing Carabinieri art squad that was expert in such things, peeled back foot after foot of soil that had been the roof of the *tombaroli* tunnel. By sheer muscle

they sunk a trench five yards deep—as deep as the pit the clandestine diggers had dug—and exposed a section of the ridge face that was dotted with tomb openings.

The spot where the Finanza dug took them right to the front of the decorated false door that the tomb robbers had mutilated with their hammers. And in front of the door, they found the winged sphinx the men had left, along with what appeared to be the detached, curly-haired head of the creature. The finance police, working with Italian state archaeologists whom they had called to the scene, also unearthed a rough statue of a lion, a virtual twin to the five-hundred-pound creature the *tombaroli* had found and sold months before. As they gathered their evidence, the investigators hauled up a mix of archaeological flotsam and jetsam: from stone carvings of two bearded heads to pieces of tombstones that bore fragments of the names of the dead, forever disassociated from their original resting places.

In all, the Finanza took possession of more than seven hundred bits of bronze statues and pottery, which the robbers had discarded, and turned those over to the state antiquities authority. Peppe's gang had already gotten everything that mattered to them. Or so they thought. One of the other hazards of digging without proper archaeological techniques is that a tomb robber is bound to leave behind a fragment or two of ancient pottery. Inconveniently for Peppe and his men, they had left behind a few fragments they shouldn't have.

The morning after von Bothmer received Hecht's coded note, he walked into Hoving's office at 9:00 A.M., a minute after the Met director had gotten there himself. The curator read the note to Hoving and then, following the clues, opened the Beazley tome to page 14. Figure number 2 was a Euphronios. Hoving knew it well: it

was the Louvre's fragmentary krater on which the Athenian master had painted Heracles in a wrestling match. If Hecht's message was to be understood correctly, his reference to "something like" the fragmentary Louvre krater, but "in perfect condition," meant that he had a complete krater by Euphronios to sell, the likes of which had not been seen for thousands of years.

The men from the Met were interested, but Hecht was indulging his competitive side at a tennis camp in Spain. Hoving let the deal percolate. Von Bothmer, however, whose passion for vases had been kindled by Euphronios decades before, couldn't hold back. He sent word to Hecht that they wanted to know the price. Then, a month later, in March 1972, Hecht made his next move. The antiquities dealer wrote to von Bothmer, but the somewhat cryptic pitch was clearly intended for von Bothmer's boss, Hoving:

> Regarding p. 14 of Jackie Dear's red I made a hint asking if you and your trusted associates would make a super gigantic effort. Now please imagine this broken, but COMPLETE and in PERFECT STATE—by complete I mean 99 44/100% and by "perfect state" I mean brilliant, not weathered. It would hardly be incorrect to say that such a thing could be considered the best of its kind—I don't say that necessarily it is, but . . . it's hard to find competitors.
>
> Assuming the first part of above para. to be the case, would it be able to be considered in terms of a specific painting (as, i.e. more or less the flags at that beach resort in France by Monet or someone, rather than a pot). The equivalent might be available and I would then discuss it with you. But if a priori the trusted ones would think in terms of pots, it would be best not to begin.

Hoving could figure this one out himself. "Jackie" was John Beazley, and "red" was a red-figured krater. The beach resort by Monet was *Terrasse à Sainte-Adresse,* for which the Met had paid $1.4 million in 1967. Hoving laughed with disbelief, because Hecht actually seemed to be asking $1.4 million for a Greek vase—about ten times the highest price previously paid for an ancient ceramic pot. He told von Bothmer to press Hecht for photos and further specifications.

It turned out that Hecht had commissioned his restorer, Bürki, to do a rough rebuilding of the krater's many fragments. In his Zurich studio, Bürki was lightly gluing the pieces together so that the vase would stand on its own. It was a jigsaw puzzle in three dimensions, with little slivers missing here and there that he filled in with tiny bits of red plastic. On Hecht's orders, Bürki didn't do a final glue job and he didn't paint in the hairline cracks with black ink the way he would on a finished product. Hecht wanted von Bothmer and Hoving to get an honest look at the vase. And because the puzzle really did appear to come together more than 99 percent complete, the honest look was sure to win Hecht a high price.

In a small town like Cerveteri, it's hard to keep the news of a huge haul quiet. The *tombaroli* who uncovered the Euphronios krater hadn't gotten rich, but they had enough lire to go on shopping sprees, and their neighbors noticed at least one new car cruising the streets of Cerveteri. That, combined with the finance police's discovery of the marble sphinx and other artifacts abandoned at Sant'Angelo, caused the cultural authorities to deduce that this was a patch of land they should get to know a little better.

Under the 1939 antiquities law that declared all ancient artifacts found on Italian soil the property of the state, the government

had broad authority to take possession not just of movable objects, but of land, too. Italy could take over terrain on a temporary basis to make sure none of its underground property was stolen or mistreated, or it could grab real estate on a permanent basis, paying compensation to the owners.

The archaeological superintendency for Etruscan lands around Rome, led by Mario Moretti, suspected that archaeological artifacts were "hidden underground" on six hectares—about fourteen acres—and on March 30, 1972, the Ministry of Public Instruction notified the Piscini family that their land was being put under an archaeological *vincolo*. The government had essentially landmarked the semiwild terrain. The owners couldn't legally build anything there without special permission.

Perhaps more important, Moretti and his protégé in charge of Cerveteri—Giuseppe Proietti—were keeping an eye on what would soon unfold at the site.

Hecht had to wait until the end of the spring before the krater was fixed and photographed, and finally on a Friday at the start of June 1972, he flew to New York with the pictures. Von Bothmer was at his country house in Centre Island, at Oyster Bay on Long Island's north shore, and invited his art-dealer friend out for the weekend. Once inside, he handed over the black-and-white prints to the eager curator. "The Met certainly needs to come into possession of this," von Bothmer let loose.

With his mission already accomplished, Hecht turned his attention to the von Bothmer family. The curator had married Joyce Blaffer, the widow of a French marquis and daughter of Robert Lee Blaffer, a cofounder of Humble Oil, which became part of Exxon. Hecht played tennis against von Bothmer's pretty stepdaughter, Diane, and then took a dip in the pool with the

whole family, which included von Bothmer's precocious son, Bernard, who at about seven years old was already fluent in the arcane details of Greek mythology. Afterward, von Bothmer's wife served dinner, and Hecht spent the night at the house. First thing on Monday, he and von Bothmer drove to the museum together to show the pictures to Hoving.

The Met's director liked what he saw, but seeing pictures was only a first step. Hoving told von Bothmer he wanted to see the vase in person. To do so, they'd have to travel to Zurich, where Hecht had been keeping the pot at Bürki's lab. Hoving flew from New York to Zurich with von Bothmer, who was so consumed with excitement over seeing the new Euphronios that he couldn't shut up during the flight. For four hours von Bothmer yammered on, first about Hecht—presumably to assuage any possible doubts Hoving had about making a major purchase from the dealer—and then about Euphronios and vase painting of the early 500s B.C.

What kept Hoving awake, at least for a while, was von Bothmer's description of how Euphronios had managed to paint the fine lines on the krater with dull, grayish glazes that kept the eventual colors invisible as he worked on the wet clay. "Hundreds upon hundreds of never-overlapping lines, the hair, the outlines of the bodies, he achieved all this complexity—much more than the thousands of lines engraved on a ten-dollar bill—without ever seeing clearly what he'd just drawn," von Bothmer told his incredulous boss.

"Dietrich, you're shitting me," Hoving said before dozing off for a half hour—the only sleep he'd get before having to negotiate what would be the most important acquisition of his career.

As he dozed, Hoving couldn't have dreamed of how the master painter and potter used ancient alchemy to bring to life the krater that

awaited them in Zurich—and its matching kylix wine cup, which Hoving would soon encounter, too.

Euphronios lived in the most dramatic political times in the story of Athens and the world, seeing firsthand the birth of democracy. In the world of art, the Greek master led his own revolution, a creative flourishing that historians say was unrivaled until the Renaissance, some two thousand years later. Euphronios's timing was perfect. For hundreds of years, vase makers had produced unrealistic depictions on their pots, using a color scheme in which the people were painted in black on the orange background of the clay pots. The effect was a backlit silhouette, where the figures had less life to them than their golden surroundings.

Then, shortly after 550 B.C., potters in Athens invented a way to draw black lines on the local red pottery, filling in the background with black and reversing the centuries-old black-figure effect. The resulting red-figure technique brought vase painting to life.

By coincidence, at this same time, Peisistratus, an Athenian tyrant, ordered that Homer's epics, which were recited orally and had spun out into several different versions, be committed to writing. Athenians suddenly had a standard version of the *Iliad* and *Odyssey,* on paper.

Inspired by the works of Homer—and armed with a vase decoration technique that allowed the clay's natural color to shine through to represent the tanned bodies of gods and warriors in more realistic colors—Euphronios and his cohorts established history's earliest known "school" of art. They worked together in a part of Athens called the Kerameikos—a name taken from the word *keramos,* or clay, from which our "ceramic" is derived. Euphronios and his coterie of painters are known today as the Pioneers for the mark they made by popularizing the red-figure style. A dozen painters from the group have been identified from

their inscriptions on vases—some of them inscriptions about one another, accompanied by pictures of them partying together, wine cups in hand. By around 520 B.C., the fiercely competitive Euphronios was beginning his career, perfecting his technique and drawing inspiration from the Homeric account of Sarpedon's death. Euphronios may have still been in his late teens when he painted the first of his two known works portraying Sarpedon. For this first try, he started small, with a dainty kylix wine chalice.

In this ancient art, the clay was the thing, providing everything a painter and potter needed—including the substances that could create all the colors on a vase. Attic clay—the clay of Athens—contains iron, which gives it a reddish brown color when fired in a kiln. The clay used to make Athenian pots was essentially rusty. And a kylix, the most delicate vase in the Athenian repertoire, required the finest grade of this clay. On a day somewhere around 520 B.C., Euphronios set about making such a chalice.

Once the clay was selected, a colleague of Euphronios's, who would actually make the underlying cup, placed the moist lump on his potter's wheel, a disk probably made of stone, wood, or terra-cotta. Unlike pottery wheels commonly known today that allow the potter to move the wheel by kicking an attachment underneath the shaft, these had to be turned by hand. A boy, probably an apprentice, sat on the ground and spun the wheel with his hands. As the wheel picked up speed with the hunk of clay at its center, the potter pressed his thumbs into the mass to create the beginnings of a vessel that rose upward as the force of the spinning pushed outward into the potter's hand. After forming the wide-rimmed cup, they used a glue of wet clay to add a short stem and base, along with two handles that flared from opposite sides of the cup like wings. And then the kylix was stored in a damp room, to harden but not completely dry.

Next came the decoration von Bothmer gushed about. Euphronios and his cohort could "paint" their vases without using a single drop of pigment.

The magic began when Euphronios mixed the glazes that would become the black portions of the cup's decoration. He started with the already purified clay that his workshop used for potting its vases, and then he purified it once more in a glass container, using a process of sedimentation. Impurities such as sand sank to the bottom. At the top floated a layer of the finest particles of clay, suspended in water. That would become the glaze.

But first, Euphronios drew the design's outline, possibly with a charcoal pencil, on the leather-hard but still slightly moist clay cup. The process was akin to painting a fresco on wet plaster, so he had to work fast. The clock was ticking as the surface of the kylix began to dry. The painter sat in a chair with the blank cup on his lap, the base at his knees. On the inside of the cup, known as the tondo, he sketched out a simple floral design of eight palm branches, known as palmettes. During a drinking party, this inside part of the kylix would be obscured by wine, so there was no need for Euphronios to waste a dramatic tableau there.

The outside surface of the cup, however, would be seen by all, whether during the heavy-drinking events known as "symposia," or on display in the home of a faraway foreign collector or in the burial chamber of a rich man's tomb. The two handles poking out of either side of the cup neatly divided Euphronios's canvas into two sides. One side would be the front, to which he would dedicate his greatest effort. The other would be the back, still painted with care, but in a rush to beat the clock as both the pot and the paint dried.

As he sketched, the outlines of a melancholy scene from the Trojan War emerged. It was already some seven hundred years after the fabled battles, and Euphronios began to draw what is

today the first known depiction of the death of Sarpedon. He depicted the warrior prince naked, with a wound to his chest, a full beard, rippling abdominal muscles, and thick eyelashes. The artist drew the deity Death dressed in the disguise of a soldier and carrying a shield, grabbing Sarpedon's arm and heaving him over his shoulder. Sleep, dressed the same, grabbed Sarpedon's legs.

Turning his attention to the back of the cup—and keeping track of the time—Euphronios sketched out the less dramatic scene of a pyrrhic dance, a ritual performed in armor. In a final touch to his outline, the artist filled in the spaces near the handles with designs of flowers and palm fronds, and then he started to paint.

Euphronios's glazes were mostly made of clay, but each of the several mixtures would yield a unique result. The thicker glazes would produce the darkest black colors, which were used to outline the figures of deities and warriors, and the thinner ones would produce the translucent browns used to represent hair and other delicate details. He had paintbrushes for the thin glazes, but for the viscous ones he probably had a contraption similar to a pastry chef's icing bag, which he could squeeze as if he were decorating a birthday cake. For color highlights, he also had at his disposal red ocher to depict blood.

As he painted, Euphronios really was working blind, for the different gray glazes would only turn the correct colors in the kiln. He had to imagine what it would all look like.

When he finished coloring in the cup, Euphronios added a personal touch that was, at the time, revolutionary. He signed the vase. The painter asserted his authorship of the kylix by doing something that's commonplace in the millennia that have since come and gone. On the foot of the cup, along the outside rim, he wrote in Greek, "Euphronios Egraphsen." Put bluntly,

he said, "Euphronios Painted This." Beautiful artifacts had been made by talented artisans for thousands of years, but only until the time of Euphronios and a few of his Athenian predecessors had such works been thought of as art to which their creators should attach their names. The entire Western concept of the artist was just beginning to come to life.

To finish off the chalice, and bring the colors into existence, Euphronios just needed to manage the alchemy of the kiln and its own intricate chemistry.

Inside the hot oven, which had ample air to feed the fire, the clay oxidized, or rusted, turning the whole cup red. Then the kiln's operator plugged up the furnace's air supply. The fire needed oxygen, which it sucked away from the surface of the chalice, causing the whole pot to turn black. The fire burned so hot that it melted the glazes into hard, glassy shells. When the craftsmen pulled out the plug, letting air rush back in, the oxygen tried to combine again with the surface of the cup. However, it could only do so on the parts that hadn't become hardened. The glazed parts retained their black color, while the unglazed portions turned red again. For the first time, the picture of Sarpedon came into view.

A week later, after being allowed to cool, the cup was finished. But this Sarpedon chalice was just the start of Euphronios's tribute to the fallen Lycian prince.

A few years later the Athenian painter would reach the peak of his artistry by creating the chalice's bigger twin, revisiting the death of Sarpedon with a grand krater for mixing wine and water. Around 515 B.C., a colleague of Euphronios's named Euxitheos potted the hefty wine vat in sections and stuck them together with clay slip. This type of krater later became known as a calyx krater because the outward sweep of its rim made it resemble a calyx, the inside of a flower. Then Euphronios did his

best to re-create the drama of his Sarpedon kylix on this grander canvas. The result is almost unanimously considered the most perfect Greek vase, in both its proportion and painting.

This was the pot Hoving would see once he awoke from his nap above the Atlantic.

Before they landed that morning, on June 27, 1972, Hoving had one last question about the vase that awaited them.

"Dietrich, what's your guess on the origin of this astonishing krater? Can't be very likely it's been sitting around on some English Lordy's mantelpiece after great-grandfather got it on the Grand Tour in the eighteenth century, is it?"

Von Bothmer fell silent, and Hoving decided that this would be the last time they would speak about where the krater had really come from.

Hoving and von Bothmer took a taxi to Bürki's suburban Zurich house. Hoving's second in command at the Met, Theodore Rousseau Jr., had traveled separately and arrived soon afterward. Hecht and Bürki had been waiting for the men from the Met and escorted them inside the home, which doubled as Bürki's workshop. In the dining room, Hoving saw the krater sitting on a table, but he averted his eyes. He wanted his first impression to be in broad daylight. "Take it outside," he said, walking out into Bürki's garden. He grabbed a cold beer and, when the vase was in place, turned around to soak in the sight. As he circled the krater, Hoving gazed at Sarpedon's nude body, spouting blood, his teeth clenched in a final agony. "No figure of Christ on the cross I'd ever seen matched this image," Hoving, a medieval art historian by training, later recalled in his memoirs. He vowed to himself that he would get this vase. "This was the single most perfect work of art I had ever encountered."

Hoving sat down and blurted, "Sublime!" He wasn't able to play the role of cool haggler. Hoving took Hecht aside and admitted to him that this was the most beautiful work of art he'd been offered since he'd become director of the museum.

Von Bothmer circled the krater, describing it aloud and picking out details. He pointed out an inscription, *Leagros Kalos*—"Leagros is beautiful"—the same inscription on the krater in Berlin that launched von Bothmer's career during a boyhood museum visit. The Leagros inscription dated the vase to between 520 and 510 B.C., von Bothmer said.

Then the negotiations began. They broke for lunch, with Hecht taking them to Rotisserie de la Muette where they ate grilled beefsteak, Hecht later recalled. (Hoving remembered the lunch in his memoirs as being at a Mövenpick fast-food restaurant.) The American dealer said the Met could have the krater for $1.3 million. Hoving countered that if Hecht would take just $850,000, he could have a registered check to him in a week. Otherwise, the museum was too strapped for cash to come up with any more.

Then Hecht made a suggestion that set in motion a series of events that would make a deal possible. Hecht said he'd give Hoving the krater, plus $350,000, in exchange for two collections of ancient coins that he'd heard the Met was thinking of selling anyway. What Hoving didn't know was that three weeks earlier von Bothmer had told Hecht that the Met was on the verge of putting its Durkee and Ward collections of Greek and Roman coins up for sale through a Zurich firm. And, in turn, what Hecht didn't know is that the offer he'd just made—of the krater plus cash for the whole lot of coins—valued the coins at much more than the price Hoving was about to accept for the coins.

Hoving, realizing he could get more for the coins, would cancel the cheaper Zurich sale and get Sotheby's in London to

guarantee the higher price he could now get. In the meantime, Hoving knew he had to raise the touchy issue of the krater's provenance, no matter how uncomfortable it had made von Bothmer earlier that morning.

"My Finnish grandfather has owned this vase for seventy-five years," Hecht said and then laughed. "Really. The owner has had it—in pieces—since before the First World War, I suppose around 1914."

Hoving asked for a name.

"Dikran Sarrafian. Dikran is an antiquities dealer in Beirut."

Hoving said he doubted this story, and Hecht continued with a tale of how Sarrafian had kept the vase fragments in a shoe box, but because Beirut was getting dangerous, had decided to consign the disassembled pot to Hecht. Hoving didn't buy this, but that didn't mean he wouldn't buy the krater. Hoving told Hecht he could have $1 million for the Euphronios krater—$850,000 in cash and the rest in sculptures from the Met's storeroom, to be selected by von Bothmer.

Hecht said he didn't think Sarrafian would take less than $1.3 million, but he would check. The price was surely negotiable, Hecht said, especially if the Met could come up with the cash quickly. Time was money; the U.S. dollar was weakening against the Swiss franc, the currency in which he'd promised to pay Medici.

And then Hoving added another condition: to do a deal he needed paperwork showing the legitimate origins of the vase. Hecht assured him he'd have all the documents he'd need. With that, the men went their separate ways.

Hoving correctly anticipated he would have no problems coming up with the cash to buy the krater; the Met would eventually collect almost $2.3 million from selling the coins through Sotheby's. From the outset of his negotiations with Hecht, the museum's director knew that he would have plenty of room to

play hard to get. He was right. Hecht made the next move, writing Hoving a letter:

> If you appreciated the garden piece as much as you
> seemed to, there is no reason why we should not come to
> terms somewhere in between your price and my 1.3.

Hoving, still playing it cool and realizing that Hecht was coming down to his million-dollar offer, didn't reply. Through most of July 1972, he let Hecht sweat it out while also putting von Bothmer through the charade of selecting statues from the collection to trade to Hecht. The two negotiators spoke indirectly through von Bothmer. When Hoving was on his summer vacation on Martha's Vineyard, von Bothmer called him with the news that Hecht was making a final offer of $1.1 million and would walk away if the Met didn't pay it.

Hoving called Hecht in Rome. He spoke in code, knowing that Hecht feared the Italian art police were bugging his phone. "For appearances' sake don't want to walk all the kilometers you mention. Can only go one kilometer," Hoving said.

On the other end of the line, Hecht breathed heavily, without uttering a word. And then he broke the silence.

"Agreed," Hecht said.

"I'll talk to your wife on details," Hoving said, and then hung up. Sitting in his office, shuffling through the photos of the krater, Hoving later recalled that he "felt a near-sexual pleasure." Hecht reveled in his own version of rapture at getting the sale done. It was already nighttime in Rome, and he celebrated with a plate of spaghetti with clams and some grilled scampi. He washed it down with a now-rare white Chianti, a more common Tuscan wine at the time, before vineyards feeding the American market largely switched their production to reds.

Von Bothmer, who had feared this krater would be the one that got away, was also thrilled. Still, the deal wasn't exactly finished. They still needed the approval of the acquisitions committee.

Hecht flew the next day from Rome to Zurich to see the vase, which Bürki was rushing to restore. Looking to speed along the approval of the acquisitions committee, Hecht prepared to ship the krater to New York the following Thursday. He bought two first-class tickets—one for him, and one for the pot—on TWA flight 831 from Zurich to JFK, at a cost of about $450 each. Bürki almost didn't complete his work in time for the flight, filling in the slivers of red plastic with black paint and putting on other finishing touches into late Wednesday evening.

The men packed the krater in a wooden case and took it the next day to the Zurich's Kloten Airport, where TWA personnel gave the pot the first-class treatment Hecht had paid for, handling all the security issues in the crowded terminal. Just half an hour before the departure time, Hecht boarded the jet with the krater and strapped the box into the oversized chair next to him using an ordinary seat belt.

Sarpedon, resuming his voyage after a twenty-four-hundred-year break, got the window seat.

Upon their arrival in New York on August 31, 1972, the museum's shipping agent, accompanied by an armed guard who wore a revolver in a holster, met Hecht and the krater. The shipping agent had prepared the paperwork for U.S. Customs, but an officer still had to take a look. When they opened the box, the inspector told Hecht and the man from the Met that they sure had a real beauty. Satisfied with the paperwork, on which Hecht declared the krater's value at $1 million, Customs waved them through. Even Hecht was amazed at how quickly the Met's import system was working. By his timing, it took just forty-five

minutes to get the krater from the jet to the car outside. The museum's shipping agent loaded the box into his station wagon and drove the dealer and his precious cargo into Manhattan and the Fifth Avenue temple to the arts.

As they arrived at the loading bay at the south end of the museum, Hecht's wife and two of his daughters, wearing jeans and T-shirts, ran over to greet him. They opened the box in a museum storeroom and took out the vase, tossing away the packing materials. "I'm going to cry," Hecht's wife said. "It's like a Rembrandt." Hecht handed Hoving a bill that affirmed the vase had come from Dikran Sarrafian. "I bet he doesn't exist," Hoving said, laughing.

Hecht saw no sense hanging out in New York waiting for the acquisitions committee to do its work, especially when he could get back to playing tennis. The next morning he bought tickets on Iberia to fly to Malaga, Spain, just an hour and a half from Lew Hoad's tennis camp in Fuengirola.

During a special meeting of the Met's acquisitions committee on September 12, 1972, Hoving assured the board members that the dealer, Robert Hecht, was known to the museum, and that the owner, Dikran Sarrafian, was a "well-known art dealer" in Beirut. Hoving told the committee—eight of its eleven members were present—that Sarrafian had put in writing that the vase had been in his family since at least World War I. Hoving distributed copies of Sarrafian's letter and described additional documentation that Hecht had promised was on the way.

No one on the committee asked a single question. The vote was unanimous. The Met was buying Euphronios's Sarpedon krater for $1 million.

One member of the acquisitions committee, the *New York Times* publisher Arthur "Punch" Sulzberger, was especially impressed by the vase, Hoving later wrote in his memoir. Sulz-

berger had picked out the places where the krater had been repaired in antiquity by several lead clamps and wanted to be sure the vase wasn't a fake. Hoving assured him that the museum would authenticate the piece through Oxford's labs. As Sulzberger was leaving, Hoving took note of how the *Times* publisher ran his fingers over the krater's shiny, black rim.

"I don't usually get involved in editorial matters, but *this* is so unusual; it's such an opportunity. Well, I can see this vase on the cover of the magazine," Hoving later recalled Sulzberger saying.

Hoving, ever the showman, said he loved the idea.

About five days after Hecht delivered the pot and left New York, von Bothmer called him in Spain with the news of the board's approval. Only a few technical details remained. The Met sent a million-dollar check to Hecht in Zurich, which he immediately cashed and converted into Swiss francs. He was right to want his money as soon as possible; in less than a year the Swiss currency rose by almost 40 percent versus the dollar. Even after paying Medici the rest of his share, Hecht may have walked away from the deal with a cool $1 million profit.

Although money and a vase had already been exchanged, the deal wasn't exactly done yet. The Met needed to know that the vase was genuine by testing it at Oxford. In late September, museum personnel took small samples from the krater, drilling tiny parts that would never be noticed by the public. They sent the filings off to Oxford's Research Laboratory for Archaeology and the History of Art. The lab's S. J. Fleming conducted a thermoluminescence test that measured how much naturally occurring radiation the pot had absorbed since it had been fired in a kiln. He concluded the krater was at least 2,790 years old and had been

made sometime between 820 B.C. and 467 B.C. Von Bothmer's estimate of 515 B.C., based partly on the "Leagros is beautiful" inscription, had been spot-on.

Sulzberger did follow through on recommending that the Times *magazine* feature something about the krater, and the story was assigned to freelance writer James Mellow, who interviewed Hoving and von Bothmer. Anticipating controversy—but grossly underestimating how bad it would get—Hoving and von Bothmer decided to say nothing about Sarrafian, mostly because Hoving thought the scholarly community would "snicker."

Before the article came out on November 12, 1972, exactly two months after the official purchase date, not a word had gotten out about the Met's record-breaking acquisition. And when it did, Euphronios's Sarpedon krater got a coming out that no work of art has ever had—or probably ever will. The entire front cover of the *New York Times Magazine* was a color photograph of the vase. Across the top was the magazine's title in its familiar typeface, and the date. On the bottom of the page, in small letters, was printed, "A new (6th century B.C.) Greek vase for New York," and "Contents: Page 30." That was it. The cover was the krater. Sarpedon practically bled onto brunch tables across the Northeast that Sunday morning.

The story on the inside was just as dramatic, and it included one shot of von Bothmer seated next to the vase, which sat atop a radiator in a museum office. The curator and his boss had spoken at length with the journalist about Euphronios, but they didn't budge on modern details, not even the price they had paid for the pot. Mellow may not have gotten Sarrafian's or even Hecht's name out of von Bothmer and Hoving, but he did suggest that the krater's provenance might not be clean.

Mellow recounted how he asked the Met curator three different ways how such an important, signed vase could have escaped notice for all these years, with nary a mention of it in all the books lining von Bothmer's office, including the catalogs by his mentor, Beazley. "The interviewer is left with the mild suspicion that the Metropolitan's new masterpiece might have materialized out of thin air," he wrote.

Sarpedon's Sunday as the cover boy was just the start of his stardom. The following week, he went on national television where he was interviewed by Barbara Walters.

Hoving, von Bothmer, and a team of Met technicians accompanied the krater downtown to the Rockefeller Center studios of NBC's *Today Show,* upstairs in what was then the RCA Building. Walters referred to the object before her as a "vaahz." Her co-host, Frank McGee, called it a "vayze," before asking, "Now, how did you get it, who did you buy it from and how much did it cost?"

"Three of the questions the museum in its crafty way never answers," Hoving responded, "but I'll try to give you some information on it. The poor people have to know about this."

Hoving then said the krater had come from an agent for a collector who had had the pot in his family since before World War I. He declined to say more because "they have other things that we might want to buy in the future. People prefer to remain anonymous in this type of business."

If it had no previously disclosed or published history before the Met had bought it, McGee asked, how did the museum even know it was an authentic Euphronios?

"By looking at it," von Bothmer piped up. "Simply by looking at it. I've looked at many."

McGee turned to von Bothmer's boss: "And you're confident with his look, obviously, Mr. Hoving?"

"Well, Dietrich von Bothmer has been involved in the business of Greek vase painting for forty-two years. He was trained by the great Sir John Beazley, who was the man who literally started this science of dating and naming painters of these vases."

By the end of the interview—which included a commercial break and a retelling of the story of Sarpedon's death—about the only question Walters and McGee got a straight answer to was the correct pronunciation of "vase."

"What do you call this, by the way?" Walters asked. "What do you say? Do you say vayze or vaahz?"

Von Bothmer gave her a diplomatic response. "Well, in England I've said 'vaahz,' but here I say 'vayze.' "

At least one mystery had been solved.

The Italian cultural officials who had blocked development on the Piscini family's land at Sant'Angelo in Cerveteri weren't the only ones who knew the site was of great archaeological interest. On November 28—just sixteen days after the Met announced its purchase of the krater—Giacomo Medici and Mario Bruno, an antiquities dealer from Turin, met up in Rome to make the land theirs.

Bruno, who had a residence in Cerveteri and an antiquities gallery in Lugano, Switzerland, went with Medici to the office of the Piscini family's trusted notary on Via d'Aracoeli, at the foot of the Capitoline Hill. They met with the daughter of the elderly Pietro Piscini, Gabriella, who negotiated the sale on behalf of herself and her father.

Medici knew this was the spot from which the Met's Euphronios krater and some other important objects had been dug. He wanted to get at the remaining buried artifacts, and he swears he was planning to do it by eventually applying for permits to

dig officially. He would have offered any of the best pieces to the government in exchange for the *premio* reward.

Sitting at the notary's office, the two sides agreed on a price of 21 million lire, about $35,000, of which Medici and Bruno each paid half. Later they said nobody ever told them about the government's block on their new land.

The Met's Euphronios publicity blitz was bound to backfire. For one, the *New York Times Magazine* story had raised more questions than it answered; eager reporters working for the paper's daily sections, having been scooped by their own Sunday magazine, were more than glad to do some digging.

On the other side of the Atlantic, the Met's announcement alerted the Italian authorities that this new Euphronios existed. Based on the provenance of past Euphronios discoveries, the Rome-based art police knew the pot had probably come from their Etruscan backyard.

Even worse, news of the million-dollar sale started to trickle back to Cerveteri, where the underpaid tomb robbers began to think they were the ones who had been ripped off. And then came the most incredible complication possible. A few weeks after the Met's Euphronios krater had its world debut, the existence of its smaller twin was finally revealed. It turned out that the kylix wine cup that Euphronios had similarly decorated with the death of Sarpedon had also come out of the ground in Cerveteri.

After twenty-four hundred years, the lost chalice had finally seen the light of day, and a photo of it had circulated in the art market. But unlike the krater, the matching chalice's actual whereabouts were still a mystery.

Sarpedon's Lost Twin

The Seventy-fourth General Meeting of the Archaeological Institute of America (AIA) seemed as routine as the previous seventy-three such meetings. Excavators, classicists, curators, language experts, art historians, and the other practitioners of ancient-world study gathered in Philadelphia from December 28 through 30, 1972. Before the conference was over, the members would elect new members to the institute's board of directors. The vote would be a formality, as only six nominees had been put up for the six open seats. One of the candidates was von Bothmer.

But first, the attendees got down to the core of the conference, the presentation of 111 papers—ranging from copper smelting in Cyprus to neutron activation analysis in Near Eastern archaeology to the role of ancient Egyptian tomb robbers in confusing the archaeological record of neighboring Crete through the export of their loot.

Von Bothmer, who had come down from New York, was already taking heat from his colleagues. One faction was angry that the Met was selling its coin collection to pay for the purchase

of the Euphronios krater. Although the museum didn't have much use for the coins, the collection had been on loan to the American Numismatic Society in Manhattan, on Broadway between 155th and 156th Streets, where scholars used it for research. Neither the Met nor the society had ever made copies of the coins—which would soon go back into circulation, unavailable for study.

The other faction lined up against von Bothmer believed the Met had bought a vase whose lack of published provenance pointed to probable origins in a sacked tomb. They were less concerned with how the museum raised the funds than they were with the tremendous sum paid. They figured that the rumored million-dollar price tag would only encourage more such tomb robbing.

When things looked like they couldn't get worse for von Bothmer, it was time for him to make his presentation. The title of his paper was "The Death of Sarpedon." And it read, in part, "One Corinthian and two Attic vases, all unpublished, add considerably to our iconography and help in the correct interpretation of other vases."

One of the unpublished Attic vases—meaning it hadn't been written up in an academic journal—was the now-famous krater. As von Bothmer spoke, he illustrated his talk with slides depicting the death of the Lycian prince. To nobody's surprise, he showed images of his triumphant, career-capping acquisition, which the museum had made just three months earlier. There was Sarpedon, being lifted by Sleep and Death, on the towering krater.

The second unpublished Attic vase also depicted Sarpedon. And von Bothmer had a slide of that one, too. Up it flashed on the screen, in black and white: a kylix wine cup, signed by Euphronios as its painter.

How strange it was that the death of Sarpedon, an obscure

event rarely depicted in Greek art, had somehow suddenly sur-
faced on two different vases by the same artist. For that matter,
the appearance of any signed work by Euphronios was incredi-
ble. To archaeologists, this coincidence was further evidence of a
freshly unearthed tomb. Even worse, von Bothmer's knowledge
of this unpublished, probably looted chalice—and possession of a
photograph of it—proved to his colleagues that the Met curator
had become involved in the illicit trade.

Von Bothmer didn't realize that he had just ruined his career
in archaeology.

Behind the scenes, the highest levels of the AIA—the coun-
try's oldest archaeology group, with some seven thousand mem-
bers—was moving against von Bothmer in the upcoming vote
for the board of directors. The institute's president, Rodney
Young, famous for his excavations of the legendary King Mi-
das's city of Gordion in Turkey, asked James R. McCredie, the
young director of the American School of Classical Studies in
Athens, to place his name in for election as a seventh candidate
for the six open seats.

Arthur Steinberg, an archaeology professor at the Massachu-
setts Institute of Technology, stepped forward as a spokesman for
the two factions bent on censuring von Bothmer. Steinberg de-
livered a speech before the election, artfully leaving out any di-
rect mention of von Bothmer's name or the Met, but making it
clear that many fellow archaeologists were displeased with what
the curator and the museum had done.

"The grave robbers hear about those prices and ransack the
tombs even more feverishly," Steinberg said later. "The vase
should have been treated as a scholarly specimen, not as a spec-
tacle for publicity." A root of the problem, he said, was that
museum curators were not as qualified to guide the AIA as ar-
chaeologists who work in the field. "They don't care if archaeo-

logical contexts are destroyed in the wanton despoliation of tombs," he said.

The MIT professor then nominated McCredie. Von Bothmer, a member of the group since 1946, didn't stand a chance. He was the only losing candidate.

"They don't like me," von Bothmer said afterward. "And I don't like them."

"He was angry for years," says McCredie, the man who defeated him.

The krater was out of Italy's grasp, but investigators in Rome—unaware of von Bothmer's Philadelphia speech—turned up evidence that there was another vase related to the Met's Euphronios that they might still be able to save from the global illicit antiquities market. Not only were they convinced that the Euphronios krater had been taken from an Etruscan tomb, but they had information that the *tombaroli* had found a second vase in the same burial. The search for this second vase was urgent because the Carabinieri hoped to track it down before it was sold and lost to the market like the krater had been.

Around February 1, 1973, the chief of the Carabinieri art squad, Colonel Felice Mambor, called Robert Hecht's home, looking for the American dealer. Hecht was out at the time, and his wife took a message. When he heard that Mambor was looking for him, Hecht didn't bother phoning him back. He just went directly to his office.

The headquarters of the art command—known as the *Tutela Patrimonio Culturale,* or TPC—occupies a baroque, jewel box of a building on Piazza Sant'Ignazio in central Rome, with an elegantly curved façade that looks up at the more imposing Jesuit church of Sant'Ignazio, or Saint Ignatius. The Jesuit church, in

turn, is part of an impressive block of buildings that includes the very chambers in which Galileo faced the Inquisition in the seventeenth century—and the rooms in which the fate of the Met's krater would eventually be determined in the twenty-first.

Colonel Mambor greeted Hecht in his office and began their chat by talking about a well-known antiquities connoisseur. Mambor told Hecht that he should have been helping the Carabinieri recover stolen works, and Hecht responded that if he had ever suspected there were stolen objects in museums or private collections, he would have told the owners to give them back. The American, wanting to make himself perfectly clear, added that he was in the business of dealing in art objects, not being an informant.

With those matters out of the way, Mambor said he wanted to discuss a Euphronios vase. Hecht, whose role in the Met's acquisition had remained a closely guarded secret between him and the museum, tiptoed around the question. He said he had seen the Euphronios on exposition at the Metropolitan Museum of Art, and in the newspapers, and that he thought it was a real "*capolavoro,*" a masterpiece.

But then Mambor interrupted, according to Hecht's version of events, and said he wasn't asking about the Met's Euphronios. He wanted to know about another vase—a kylix wine cup—decorated with the same subject and painted by the same artist. This chalice "had never been seen," the colonel said.

"I've never seen such a thing," Hecht responded with a straight face.

Within two weeks, and an ocean away, Hecht would reveal how untrue that statement was.

Thomas Hoving's office at the Met sat on the mezzanine level of the museum's south wing, facing Fifth Avenue. Among the perks

was a private bathroom, but the view wasn't great. If he bent
over to look out the half-arch window, he could see the awning
of the Stanhope Hotel. He could have seen the M1, M2, M3, and
M4 buses heading downtown while sitting down at his desk, if
he had one. Hoving didn't have a desk—he'd had his predeces-
sor's removed—but rather worked at a round wooden table to-
ward the center of the room. It was ideal for doing what he liked
best: negotiating with art dealers, meeting with pesky curators,
and, quite often, doing both at the same time.

Around Valentine's Day 1973, an excited Dietrich von Both-
mer arrived at Hoving's door with a guest, Robert Hecht. The
American dealer had something to offer the Met. Hoving invited
them in, and the three men stood around the wooden table.
Hecht pulled out a photograph that was just bigger than three by
five inches. And it was in black and white. But even without the
color, when Hecht handed Hoving the picture, the director could
tell what it was.

"How the hell can you possibly be offering this after the stink
we're going through with the krater?" Hoving said. And more
crucially, he asked, how much did Hecht want for it?

"Seventy thousand dollars," Hecht said.

Hoving was mightily tempted.

The object was an Athenian red-figure kylix wine cup, signed
by Euphronios. And it bore the image of Sleep and Death carry-
ing the dead body of Sarpedon. This moment finally revealed the
owner of the mysterious chalice—it was Robert Hecht, the same
man who had sold the matching Euphronios krater to the Met.

To Hoving's eye, this kylix was an earlier work by Eu-
phronios—von Bothmer said it was the earliest work he'd seen by
the master. The proof was in the artistry; Hoving later recalled
that in the single photo he saw that day, Sarpedon looked like a
log of wood, a stiff attempt by a developing painter who would

achieve his full fluency on his Sarpedon krater. As a set, owning the Sarpedon chalice and krater would be like having both a young and a mature painting by Leonardo da Vinci of the same subject. Imagine displaying two versions, side by side—two *Last Supper*s or *Mona Lisa*s, done by a young and an old Leonardo. This is what von Bothmer and Hoving could have for just $70,000.

Perhaps Hecht had gotten the cup from the same place he'd gotten the krater. To Hoving, whose "near-sexual pleasure" at acquiring the bigger Euphronios was turning into the pain of scrutiny over its recent history, buying another such vase with dubious origins would not be a good thing.

"This had better be a big, solid provenance," Hoving said.

"It's a private collection in Norway," Hecht responded. Hoving was not amused.

"Get the hell out of here," Hoving said. The entire meeting lasted no more than five minutes.

Hoving knew the pressure over his krater purchase was only going to increase. On February 14, 1973, he granted an interview to Richard Walter, a reporter for the *Observer* of London. Hoving blabbered on about the kylix that Hecht had offered him, even as he wondered about the reporter's strange look and his odd fiddling with his coat. Hoving wasn't surprised to learn later that the reporter had been wired with a microphone, which captured Hoving's impromptu ode to the chalice.

"Funny thing is, I was offered today a kylix thing, shaped like that, a wine jug, whatever you call it, kylix, by Euphronios, signed by him, in bad fragments in pieces but many great lumps missing, and the subject is the carrying off [of] the dead body of Sarpedon by Sleep and Death done about twenty years before

this, the krater, by the same man—totally different, stiff, awkward looking in the old tradition—so we hope maybe we can acquire it. . . .

"The price is not very high, it's just minuscule compared to the price of the calyx krater, but it still is, for the fragmentary condition of the thing, well, it's a bit, well, off the record, it should be around. . . ." Here the reporter's published notes go off the record; he would later speak with Italian authorities who took note of the number: Hoving could see paying just $15,000, perhaps a lowball sign that he was trying to bargain with Hecht—and that perhaps he was still interested in buying the cup.

Hoving told the *Observer*'s Walter that the chalice's seller wanted a higher price. "He's not trying to go gaga on it, but it's just a little bit off so, because it is, if I had the photograph, which I don't, I sent it back. It is really ripped apart. Maybe we get someone to divide and give it to us."

Walter had been investigating the Met's Euphronios dealings for nearly three months, ever since the museum had announced the krater purchase. Now he had a revelation that took his probe in a fresh direction. Like the Carabinieri who were also trying to track down the cup, he had a missing chalice to pursue. The next step in Walter's investigation was to talk to von Bothmer about the kylix.

When he interviewed him on February 16, von Bothmer confirmed the existence of the cup. He said the vase was ten years older than the matching krater, not twenty as Hoving had said, and he expressed unmistakable passion for the cup.

"I very much want to buy it," von Bothmer said.

"I don't want to have an exclusive on Sarpedon," he said. "On the other hand, it would mean so much more to me."

Walter had already figured out that Hecht had sold the Euphronios krater to the Met, and he was still confirming that

Hecht was also the seller behind the newly surfaced chalice. "I thought I understood that both came from the same—that they were both being handled by the same person?" Walter said.

"That is one of those extraordinary coincidences, but it is literally, once again a coincidence," von Bothmer said, pausing a moment. "There are circumstances in life and I want to make the most of them. In this case, I really do want to get this piece."

"Isn't it a good fortune for Robert Hecht as well, that he manages to have first the vase and then the cup?" the reporter asked.

"The other way round—the cup has been owned for a couple years," von Bothmer said. "I saw this cup in July 1971," he continued. "I stopped in Zurich and I saw the cup and I have my notes and my dates."

If this were true, then the chalice had been out of the ground at least five months before the krater, upending the Italian art squad's theory that tomb robbers had excavated the two vases together from the same grave. If von Bothmer were trying to throw investigators off, then such a date would be a perfect story to make up.

All the same, this was the first time since the Philadelphia talk that von Bothmer had gone on the record about the cup. And for the first time, he revealed where the chalice had been. Since von Bothmer's purported viewing of the kylix in Switzerland in 1971, his museum had purchased the matching krater—making the cup that much more desirable to him. "When you have two of a kind, it takes on greater significance," he said.

While the Observer *chased its Euphronios story in New York and* Europe, the *New York Times* covered some of the same turf. Reporter Nicholas Gage, who specialized in Mafia coverage, had traced the krater's trail back from its arrival at the Met on

August 31, 1972, to Kennedy Airport, where he uncovered the U.S. Customs declaration that Hecht had made on the same day— revealing not just the dealer's name but that he had valued the vase at $1 million—and then back to Zurich, which Hecht had listed as his place of residence. In Switzerland, Gage cultivated sources in the art world and came up with the rumors that *tombaroli* near Rome had uncovered the krater in late 1971 and sold it to Hecht. That led the reporter to Rome, where on Saturday, February 17, 1973, Hecht agreed to meet Gage over a dinner of pasta, wine, fruit, and brownies at the Hecht home on the Aventine Hill.

Hecht was his usual cagey self. When Gage asked him if he had seen the Euphronios krater, Hecht said he had seen it at the Met.

But was that the only time he had seen it?

"No, I've seen it before," Hecht said, and then changed the subject. Gage soon let on that he knew much more—including the date Hecht had brought the krater to New York, and on which TWA flight.

"Have you seen my tax returns, too?" Hecht said, and then did his best to convince Gage that the stories about the vase being smuggled out of Italy were lies. Hecht asked the reporter not to print that he'd been the seller, a plea that Hecht's wife repeated when she drove him home after dinner. Hecht feared the Italians would expel him from the country if they learned about his role.

The following day—a Sunday—Hecht left Italy, heading to the Middle East. That same day, Gage filed his story, and the *Times* ran the front-page scoop on Monday, February 19, 1973, under the headline "How the Metropolitan Acquired 'The Finest Greek Vase There Is,'" publicly naming Hecht for the first time as the seller of the vase. An accompanying piece by art reporter David L. Shirey was devoted to an interview with von Bothmer, who defended the purchase—and belittled the concerns of archaeologists

who feared that tombs had been robbed and archaeological material lost in pursuit of a work of beauty with a high market value.

To von Bothmer, all that mattered was what the vase could tell the world about Euphronios and Greek vases. "I want to know where it was made, who did it and when," he told Shirey. The rich journey it had taken since—from Greece to Italy, to an Etruscan tomb, and all the steps between—seemed irrelevant to the curator. "I want to know whether it is genuine or fake. Its intermediate history is not important to archaeology. Why can't people look at it simply as archaeologists do, as an art object."

When Shirey asked him if he was concerned that the krater had been smuggled from Italy, von Bothmer replied: "I am not suspecting anything. The thing I was concerned about was whether the object was genuine, whether it was worth the money we spent on it."

Hoving knew better and told von Bothmer to stop talking with reporters. But then Hoving the showman couldn't keep his mouth shut either. He granted a television interview while standing next to the krater at the museum. By then the vase was spotlighted in its own vitrine in the round, its own circular gallery designed by a retail display expert whom Hoving had hired from his father's store farther down Fifth Avenue, Tiffany & Co. As Hoving defended his purchase in front of the TV camera, he couldn't resist clowning around, and he coined a nickname for the krater that would stick for years.

He called it the "Hot Pot."

Hecht, in the meantime, was in Beirut on the same day that the Times exposed his role in the krater affair. He needed to see Dikran Sarrafian, and fast. Not only had the Italians started a probe weeks before, but now this media attention was going to force

him to come up with as much paperwork as possible to explain the vase's licit origins. If he could convince the Metropolitan Museum of Art's director that there was nothing to the Italian theory that the krater had been looted, then his problems would be solved. And maybe, if he could persuade the Carabinieri that the krater was from an old collection and not a fresh excavation, then he could return to his family in Rome without fear of arrest.

During the one-day visit to Beirut, Hecht found Sarrafian and had him sign an official-seeming affidavit, dated February 19 and decorated with plenty of stamps and seals. It attested to the origins of a Euphronios vase acquired by his father in 1920 and consigned by Sarrafian to Hecht for sale in Zurich in 1971. "Mr. Robert Hecht was warned that I was not responsible for any missing pieces," it said.

Hecht got what he'd come for. But the document, meant to clear the krater's name, would also raise more doubts. Why had the Met said the vase had been in a private collection since before World War I, when Sarrafian was now saying his father bought it years later, in 1920? And why did Sarrafian write about missing pieces when the Met's krater was virtually intact?

Hecht didn't have time in his frantic, rear-covering globe-trot to iron out such details. The American dealer flew to Zurich, where he checked into the Hotel Savoie. It was no coincidence that Zurich was where he had restored the Euphronios krater, and also where he still stored his most valuable unsold merchandise. Soon the public would learn of the second Euphronios vase that had been buried, many centuries before, not far from the Met's krater.

As Hecht was gathering his paperwork in Lebanon, Nicholas Gage had been working police contacts in Rome, picking up clues to

the existence of the missing Euphronios chalice. "Sources close to the investigation" told him of the efforts to track down a second ancient pot, and he published a brief mention of this in a story published on Tuesday, February 20, 1973. "The police, convinced that the vase came from an Etruscan tomb, believe that the second vase, comparable in importance to the Euphronios krater, was also smuggled out of Italy," he wrote.

The tidbit was all but lost in the sensational stream of revelations about the Met's better-known krater purchase. Later that day, the Met's von Bothmer and Hecht's lawyer in Rome disclosed the name of seller of the vase—Lebanese collector Dikran Sarrafian—for whom Hecht claimed to have acted as a middleman. The Met even gave the *Times* copies of letters said to be from Sarrafian to Hecht, discussing the vase sale. One was dated July 10, 1971—nearly half a year before the Cerveteri dig—and it spoke of wanting to sell a "red-figured crater which I have had so long" for a million dollars. Was the misspelling of krater as "crater" an honest error by Sarrafian or another example of Hecht's coded language? If so, what was the American dealer trying to say?

For the *Times*'s Gage, finally having the name and location of the alleged seller of the krater was enough to get him on a plane to Beirut, as he followed Hecht's path just two days behind. The reporter found Sarrafian, who told him about Hecht's earlier visit ("He came to tell me newspaper people would be calling me"), which added to the muddled picture of contradictions. Among them, he said he never expected the krater to bring him much money, even though one of the letters purportedly from him to Hecht said he wanted a million dollars for it. He said he had never seen the vase intact and had simply sent the hatbox full of fragments to friends in Zurich who had turned them over to Hecht.

Gage's story also included reporting from Rome, which added a tantalizing detail to the slowly emerging picture of a mysterious second vase.

Not only had the Carabinieri art squad chief, Colonel Mambor, finally confirmed that the police were seeking a second pot, but, "The Italian police have said they had information that Mr. Hecht had offered two separate vases for sale last year in Europe and the United States," Gage wrote. The Carabinieri commander was also steamed that Hecht had lied under questioning at his office about knowing nothing about the Euphronios vases. The press and the police were closing in on Hecht and a missing cup.

Sarrafian's comments contradicting Hecht's official story of the pot's origins raised alarms at the Met. Hoving, battered by the bad publicity and needing to coordinate a defense for the krater's legitimacy, demanded that Hecht explain the inconsistencies. Hecht checked out of the Hotel Savoie in Zurich and flew to New York. In just five days, Hecht covered at least four countries on three continents to put out the Euphronios fire.

When Hecht arrived in New York, he got together with Hoving at the museum director's apartment near the Met, along with Hoving's number two, Ted Rousseau, in-house counsel Ashton Hawkins, von Bothmer, and the Met's registrar, John Buchanan. Although the men from the Met were tense, Hecht was "jauntier than I had ever seen him," Hoving recalled. Hecht told the men he had just returned from Beirut with a piece of paper that would solve their problems. He handed over the affidavit, which the Met director read.

Hoving thought Sarrafian's disclaimer about any missing fragments was odd, considering that the Met's krater was complete. Only decades later he would solve the mystery of what

Sarrafian meant. For the moment he was happy to have the paperwork, as dubious as it might be.

The men took a lunch break, and Hecht asked Hoving if he could use a "secure phone" in another room to call his lawyer. Hoving, who not for the first time was short on scruples, practically put his ear to the door. Hecht spoke Italian, but Hoving, who had learned Italian when he dug in Italy as a Princeton graduate student, followed along as the dealer asked his lawyer about the suspected *tombaroli,* both their names and, repeatedly, when the alleged dig had occurred.

"*Hanno le fotografie?*" Hecht asked. Do they have photographs? "*No? Bene,*" Hecht said. Great!

As soon as Hecht finished, he came out, said he had to catch a flight to Zurich, and left.

On Friday, February 23, the day of Hecht's meeting with Hoving, the Times dished out one more clue about the missing, second vase. The detail was buried in a front-page story that said Italian police had identified the tomb robber who delivered the krater to Hecht after digging it up at Sant'Angelo in Cerveteri. "The loot was reported to include the Metropolitan's krater and a Greek cup, smaller but perhaps more precious . . . ," the story said.

This was enough information to jar the memory of an archaeologist who just happened to know of a cup that matched that description. He'd seen a slide of it at a lecture in Philadelphia by the Met curator who had just bought the controversial krater. Maybe, the archaeologist wondered, there was a connection between the black-and-white slide von Bothmer had shown and the missing vase the Italians were now seeking. He decided to find out. He phoned John L. Hess, a reporter at the *Times* who was helping Gage investigate the krater. Hess had been a Paris corre-

spondent and was about to take up a short stint as acting food editor, writing on restaurants and cuisine. He jumped on the tip.

The archaeologist told Hess about von Bothmer's lecture on Sarpedon on ancient vases, and how it had included slides not just of the Met's Euphronios krater, but an earlier Euphronios depiction of Sarpedon on a "lovely little kylix cup." Following the tip, Hess called von Bothmer, who confirmed the story, "sadly and wearily," Hess recalled. Von Bothmer said he had a photo of the cup but declined to comment on where it had come from and "wouldn't know" who owned it. "There is no source to a cup," he said. "A cup is a cup."

In that case, Hess asked, where was it?

"It's supposed to be in Norway," von Bothmer said. This was a new version of the cup's whereabouts that seemingly contradicted the story he had told the *Observer* just days earlier, saying he had seen the cup in Zurich.

Von Bothmer was in no mood to play it straight with reporters. He wouldn't give Hess a copy of the photograph of the kylix, and he complained about the harassment from the press, which had been focusing on the provenance of the Euphronios pots— and not the vases as artworks. "Nobody ever asks me about style," the curator said. In his world, what was important was the decoration on a vase. On that basis, he added his own analysis of the modern Euphronios firestorm, using an ancient source.

"Euphronios had only one serious rival, Euthemydes," he said. "He once wrote on a vase, 'unlike anything Euphronios ever did.' I tell myself that somewhere behind this is Euthemydes, trying to get even."

On February 24, 1973, a Saturday, the Times *ran Hess's report on the* second Euphronios, which he described as a kylix about four

inches high. He wrote, "It was rumored that the cup was on the market for $15,000, that the photograph had been shown to visitors in the Metropolitan and that another museum had refused to buy it."

Hess's colleague Gage, who had flown back from Beirut to Rome, worked to move the story forward. Italian prosecutors had already said that four alleged *tombaroli* were under investigation in the krater case, and he needed to find out who they were. Acting on a tip, he drove to Cerveteri with an interpreter and went door-to-door looking for a man named *il Ciccione*—"fatty." They found him in a two-room stone house, barefoot and with a day's growth of beard. The *New York Times* had tracked down none other than Armando Cenere, one of the lookouts from the dig. Still feeling underpaid for his efforts in uncovering a million-dollar vase, Cenere talked and talked as he sat by the stove in the house.

He told of the eight days it took to clear the tomb, of his work as a lookout, and of the fragment of a vase—bigger than a man's hand—on which he saw the picture of "a man who was bleeding."

Gage showed Cenere a photo of the Met's krater, fully restored. The farmhand picked out the portion with Sarpedon as what he had seen. With crayon he even drew a line, right above Sarpedon's knees, where the fragment had ended. The location of his line was a perfect match to the actual fissure on the vase.

The next day, after having their scoops nibbled away at by the *New York Times,* the reporters from the *Observer* finally came out with the results of their fourteen-week investigation. They splashed photos of the krater, Hecht, Sarrafian, and a scene of "illegal digging" in Etruria across the top of the front page under a headline: "The Million-Dollar Vase . . . The Men Who Sold It to the Met . . . And Where It May Have Come From."

But reporters Richard Walter and Peter Deeley led their story with the revelation about the smaller twin of the Met's vase.

"Police in New York and Rome are being given by the *Observer* a full description of an important Ancient Greek cup that is being offered for sale to the Metropolitan by Robert Emanuel Hecht," they wrote. The cup, like the Met's krater, had been painted by Euphronios with the scene of Sarpedon's death. As a result of their findings, a Rome prosecutor, Domenico Sica, had on the previous day summoned four men to his office who could be charged in the looting of the krater and perhaps the chalice, too. "Until recently the cup was known to be in a safe-deposit box in Zurich in Hecht's name," they wrote.

Unlike the Met's krater, "the cup is not in near perfect condition, lacking base and handles. For this reason, says the museum, the price being asked for it is only 'something in excess' of $15,000," the *Observer* reported, adding other details that would become crucial in tracing the work: the kylix was signed by Euphronios, was about ten inches in diameter, and had its "base stem and handles missing." Unlike the Met's krater, "Sarpedon is bearded and being borne on the shoulders of Sleep and Death." Neither of those two deities was depicted on the cup having wings, also in contrast to the larger vase in New York.

Then the reporters revealed that von Bothmer told them he had first seen the cup in Zurich in July 1971, and that he was now keen to buy it to complement the Met's celebrated krater.

The *Observer* reporters connected some of the dots. ". . . experts believe that both may have come from the same source—an Etruscan tomb north of Rome," they wrote. And they backed up the suspicion, citing unnamed officials at the government's Villa Giulia museum in Rome as having been told that tomb robbers had made a "big find" in 1971 in the Monte Abbatone area of Cerveteri. Monte Abbatone rises above the corner of Cerveteri

known alternately as Sant'Angelo and Sant'Antonio—the spot where the *tombaroli* had uncovered the krater.

Adding another detail, the *Observer* said that a London archaeologist had seen a dealer's price list circulating in Pisa in 1972 that included the kylix. Could that mean the cup was still in Italy? For the moment, the most important development was that the Italian police, having been made aware of the chalice's existence, were now trying to recover the cup, with the Carabinieri art squad's commander, Colonel Mambor, taking the lead. He was even asking the New York Police Department for help getting his hands on the black-and-white slides that von Bothmer had recklessly shown in Philadelphia in December 1972.

For his part, von Bothmer just hurt his archaeological reputation even more: "These objects are not found in tombs. They are found in the alluvial garbage for the most part that has been slowly working its way to the surface from hundreds of years of ploughed fields," the Met curator said. He should have known better. All the reporters needed to do was go to Cerveteri and document any number of freshly looted tombs—which is exactly what they did, describing a half dozen such sites, scattered with shards of discarded pot fragments and other archaeological evidence that had been destroyed forever.

But von Bothmer was a man smitten by a pot. "If you took it away from me," he said of the krater, "I would just have to go where it then is." Maybe he was blinded by love.

In both Italy and the United States, police and prosecutors jumped on the case that the newspapers had cracked open. On the morning of February 25, 1973, the Civitavecchia prosecutor, Sica, visited the site of the allegedly looted tomb, accompanied by the Italian art squad commander Felice Mambor and some of his Carabinieri as-

sistants. The police hoped they could find some stray fragments of the Euphronios krater that they could then use to prove that the Met's vase had come from Cerveteri—and win the krater's return. The prosecutor, for his part, sought to build a case against Hecht and the alleged *tombaroli* that he could bring to trial.

Instead, they wasted their Sunday. The prosecutor and the police failed to find the tomb, which was now beneath at least nine feet of soil, following the literal cover-up of the site, first by the tomb robbers and then by the Guardia di Finanza.

In New York, the Federal Bureau of Investigation joined the New York Police Department in the probe, interrogating von Bothmer, who told them of the other vase by Euphronios that Hecht had offered to the Met for $70,000.

But where was it? Previously, von Bothmer had only pinpointed the location as Zurich, but under the pressure of a police probe, he revealed more. He had seen the cup in 1971 at the home of Fritz Bürki, the man who had restored the Euphronios krater. "It was in a sandbox," von Bothmer told the investigators of the chalice, describing a typical setup of vase restorers who often use a round mound of sand to support the fragments; laying them flat, without the vase's contours, would make it harder to figure out how the shards fit together and how the object originally looked.

"Its condition was not nearly so good as the condition of the Met vase. I haven't seen it since except in photographs," von Bothmer said. He added that he did not know who had given the cup to Bürki to restore—or where it had ended up since.

After following Hecht around the globe for a week and a half, always one step behind, the *Times* finally caught up to him, reaching him by telephone at 7:30 A.M. on February 28, 1973, in his room at

Zurich's Hotel Savoie. The chat with reporter David L. Shirey began with Hecht asking, "How did you find me?" and lasted two hours. Hecht even gave up his plans for a morning round of tennis. Asked if he planned to return to Italy, he joked that it depended on whether he would be sent to jail. "I want to see if they plan to give me free room and board," he said.

Hecht also said he was flummoxed that the Carabinieri art squad commander was calling him a liar for saying he knew nothing about the Met's krater. "He said that he was talking about another Euphronios vase. I said I knew nothing about that," Hecht said.

But what about the *Observer* report that he had offered the Sarpedon kylix to the Met—a report based on interviews with Hoving and von Bothmer?

"I have never seen a Euphronios cup," Hecht said. "I should pressure the *Observer* into proving that I have a cup in my vault. I used to box and accusations of this nature can be called below the belt."

Just when it looked like the investigations into the krater and kylix were making sense, ancient pottery fragments began to appear. The mystery of the matching vases emerged as literal puzzle pieces.

First, on March 5, 1973, Italian police said they seized shards, attributed to Euphronios, from the Cerveteri home of a *tombarolo* who wasn't part of the gang that had excavated at Greppe Sant'Angelo. Then, by another account, Cenere took the prosecutor and investigators to a tomb site where they recovered some other vase fragments, supposedly on Cerveteri's Monte Abbatone, a distinct distance from Sant'Angelo.

The flurry of fragments intensified when an anonymous phone call came in to the Cerveteri Carabinieri station on March 30. Marshal Enea Pontecorvo, the top local officer investigating the Euphronios case, listened to the man on the line.

There was a package that the police should pick up, the man said. It could be found in a church near Cerveteri. And it contained fragments of the Met's Euphronios krater; the caller said the fragments had been found in an Etruscan tomb in 1971. Now the man "wanted to get rid of" them. He had made the drop in the chapel, rather than turning them in himself, because he didn't want to get wrapped up in the Italian legal system.

When the Carabinieri arrived at the small church, they found a bundle wrapped in newspaper. Inside were fragments with the familiar orange glow and black shine of Euphronios's work. Four of the bigger slivers and wedges of pottery were painted with black and gold palmettes that seemed to match the lip of the Met's krater. Some were about as long as a pack of cigarettes, and somewhat narrower.

The Carabinieri turned the fragments over to Italian prosecutors, who decided they needed to win access to the Sarpedon krater to see if the pieces fit anywhere on the Met's vase.

And then there were more. During the second week of May 1973, someone sent the Carabinieri a letter, accompanied by fifteen vase shards painted in Euphronios's distinct style. The letter said the fragments had been excavated in Cerveteri a century before. Taken together, the fragments and letter were meant to give the impression that the krater, the pieces left in the church, and the new fifteen shards had all been dug up before 1939, when Italy enacted its antiquities law.

The police suspected that the person who sent the fifteen

fragments had been involved in the sale of the krater to the Met and was trying to stymie the Italian probe. Whether or not that was the case, the fragments eventually became very useful.

With investigators focusing part of their probe on Greppe Sant'Angelo, it was natural that they would want to speak with one of the men who owned the plot of land, Giacomo Medici. In April 1973, as the vase fragments were surfacing, the Carabinieri art squad commander, Mambor, summoned Medici to talk at the unit's baroque headquarters on Piazza Sant'Ignazio, the same place where Hecht had met with the officer a few months before.

Mambor started with small talk—about Medici's family, about how the Lazio soccer squad was faring—before getting down to business. In the company of two other officers, Mambor questioned Medici as a witness, a status distinct from an interrogation as a suspect—the status that Hecht had had a few months earlier, giving him the right to have a lawyer present.

Mambor wanted to know what Medici knew about the Euphronios krater. Did Medici know if it came from Cerveteri?

"No," Medici said.

Did he know if the vase had come from Robert Hecht?

"No."

Had Medici seen photos of the krater?

"No," Medici said again.

After four hours, Medici was free to go, but his legal odyssey had just begun.

As the evidence piled up, it seemed the police and prosecutors would soon be able to bring Hecht and the suspected tomb robbers to trial. By June 1973, the Italians had even won a warrant for Hecht's arrest on suspicion that he illegally purchased and exported the krater. Hecht, for his part, was nowhere to be found in Italy.

• • •

A year after the Met bought his krater, Medici was beginning to build an international reputation among fellow dealers, having supplied the world's most expensive pot to the Western Hemisphere's biggest art museum. But his moment of triumph was soon spoiled.

Medici's brother Roberto was six years older than Giacomo and owned a stall at the Porta Portese outdoor Sunday market, across the river from Rome's slaughterhouses. He supported his wife and two children, nine-year-old Pina and four-year-old Anna Maria, mostly by selling antique furniture, and on June 7, 1973, he managed to buy a Ford Taunus 1600, the same European-made Ford that Giacomo had already upgraded to in the 1960s. To gather goods for the Sunday market, Roberto, who was forty years old, would make occasional shopping trips to outlying towns where he could find centuries-old treasures. Another merchant from Porta Portese, fifty-year-old Ferdinando Matteucci, often joined him. At most, they were away from Rome for two days. And they always called home if they were going to be late.

On Monday, August 27, with about 10 million lire on them, Roberto and his friend started their drive down to Naples. As far as their spouses knew, they were heading to the south to gather inventory. "We'll be back this evening, don't worry about us," they said as they left.

At the same time, another man left Rome for Naples, an emissary of the Turin antiquities dealer Mario Bruno, named Giovanni Chiselna. Chiselna, a young man from the impoverished Brindisi province in the southern "heel" of Italy, had instructions to meet Roberto Medici to conclude the purchase of an important antiquity on behalf of Bruno—the same man with whom Giacomo Medici owned the tomb site in Cerveteri's Greppe Sant'Angelo.

They all arrived safely in Naples and conducted their meeting around noon—presumably with Chiselna acting for the buyer, Roberto Medici and his friend acting as middlemen, and a third party supplying the artifact. Then they parted ways.

That was Monday. Tuesday and then Wednesday ticked by, and Roberto's wife heard nothing from her husband. Concerned that his older brother hadn't returned from his trip to the south for nearly a week, Giacomo Medici helped lead the two families' search for the missing men. They spent their Sunday on September 2, 1973, searching the two merchants' hangouts around Rome.

The nature of the men's work was immediately suspected as part of the mystery. "The trade in ancient goods has a clandestine market where great interests and contraband intersect," the Rome newspaper, *Il Messaggero,* pointed out as it splashed the news of the disappearance on its front page.

Word eventually came. The Carabinieri left a note for Roberto Medici's wife, Michelina Rossetti, directing her to go to a tiny town outside Rome, called San Cesareo, to pick up Roberto's car. The police hadn't found her husband, but they had found his Ford. When she contacted the Carabinieri to learn more, she got an even odder, and more disturbing bit of news: a farmer had found the car on a narrow country lane, almost completely destroyed by fire.

What little remained of the steel shell included the front license plate, "L94867 ROMA," from which the Carabinieri had traced the car to Roberto Medici. But that plate was the only sign of Medici or his friend. Investigators found no trace of any human remains in the charred chassis.

The police sorted through the possible explanations. If this had been a kidnapping, there would have been a demand for ransom. Highway robbery was a more likely explanation. But the police had another idea of what might be going on. They focused

their investigation on "all the area targeted by *tombaroli* who feed the clandestine traffic in Etruscan objects." The speculation was that Euphronios had something to do with this—and that Roberto had been murdered by Giacomo Medici's rivals who were jealous of the younger brother's sale of the million-dollar krater.

The connection to Euphronios wasn't pure speculation, either, because Roberto had disappeared on a trip to do an antiquities deal that involved Bruno, the co-owner of the plot of land where tomb robbers had found the Met's krater, and where the police also suspected a smaller, matching kylix had been clandestinely excavated. The Carabinieri showed all signs of taking the krater into consideration, extending their probe to Turin, the home of Mario Bruno, and Civitavecchia—the jurisdiction that covers the necropolises of Cerveteri.

On Friday, September 7, 1973, the police flew Bruno from Turin to Rome, where they began questioning him at a Carabinieri station near the Vatican. The interrogation lasted late into the night, but Bruno proved to be a dead end at explaining the missing men and the burned-out car.

Nobody has ever found Roberto Medici or his remains. And since then Giacomo Medici has never traveled south of Rome, except for one trip to the antiquities museum in Naples.

In New York, the krater scandal that had led to von Bothmer's ostracizing by the members of the American Institute of Archaeology had the opposite effect on his career at the Metropolitan Museum of Art. On September 18, 1973, the museum announced his promotion, changing his title from "curator" of the Greek and Roman art department to "chairman."

Von Bothmer's promotion was practically a footnote to a longer list of hirings and retirings in which a generational change in

the museum's leadership began to take shape. Theodore Rousseau, the vice director and curator in chief who had been at Hoving's side for the krater purchase—including that sunny morning in Zurich when they first saw the vase—was stepping down at the end of the year. To take over some of his duties, the Met had hired the director of Houston's Museum of Fine Arts, Philippe de Montebello.

De Montebello, a thirty-seven-year-old who would hold the title of vice director of curatorial affairs, was to start on February 1, 1974. He was no stranger to the Met and its acquisitional adventures, having started his career there in 1963 in the European paintings department, and working for two years under Hoving's directorship until he took the Houston job in 1969. The stint in Texas had been a fine way for the French-born, New York–reared, Harvard-educated curator to get the management experience he would need to help lead the Met. One day he would even get a chance to guide the museum out of the Euphronios mess that had developed while he was away. The incredible thing was how long it would actually take for de Montebello to undo the damage.

As much as the mystery of Roberto Medici's disappearance captured the attention and imagination of Romans and the local newspaper reporters during the summer of 1973, the episode was one in a long string of murders, kidnappings, and other violent crimes that plagued Italy at the time. In 1973, Italy was more like a third-world country than the tourist magnet it has since become. A cholera outbreak in Naples pushed Roberto Medici's disappearance from the front page.

And the kidnapping in Italy of seventeen-year-old Paul Getty—the grandson of the oil billionaire J. Paul Getty—was even more

sensational. In the prolonged ransom negotiations, the elder Getty refused to pay up, fearing it would endanger his other grandchildren. Then the Italian kidnappers cut off the young Getty's ear and mailed it to *Il Messaggero*. The same newspaper that had tried to solve the mystery of Roberto Medici's burned car had turned instead to publishing, on November 11, 1973, a photograph of the severed ear, plus attached hair and blood, in the plastic bag in which the kidnappers had sent it. "We Have Received the Ear of Paul Getty" the headline screamed.

It was no wonder that the Italian police didn't have time or resources to crack down on every tomb robber or smuggler.

After the shock of the severed ear, J. Paul Getty won his grandson's freedom by paying a ransom estimated to be some $2.8 million. And then the billionaire set about building a museum that would be filled with antiquities and make headlines again for the names Medici, Getty, and, of course, Euphronios.

Nearly a year had passed since Medici and Bruno had bought the Cerveteri land. Not surprisingly, they hadn't made any applications to the archaeological authorities to carry out official excavations on the site. They had, however, begun construction there—spending what they claimed was some 40 million lire, or $67,000—to transform the plot into a farm for raising free-range boar.

Was it just a coincidence that two antiquities dealers suddenly decided to invest in pork production on a site that had yielded the world's most expensive work of ancient art? Or were they establishing an elaborate cover story for their interest in the Etruscan necropolis?

The ruse couldn't last. Medici received a registered letter at his home on Viale Vaticano in Rome, sent by the Ministry of Public

Instruction. To Medici's surprise, the ministry had put a block on the land before he bought it, and now it was going a step further. As of October 30, 1973, the ministry exercised its right to "preempt" the property, starting the process of seizing the Cerveteri plot under the 1939 antiquities law. Making matters worse, the government would reimburse Medici and Bruno based on a fake purchase price of just 2.8 million lire, a lowball figure they had declared to avoid taxes on the 21 million lire that they had actually paid.

If the two antiquities dealers wanted to recoup some of the money they were about to lose on their investment in the land, they would need to find a way to profit from the treasures still buried there.

Hollywood and Dallas

In 1973, Douglas Dillon, the Met's chairman, launched an in-house investigation that turned into a mission to dig up materials supporting Hecht's story that he had sold the pot on behalf of the Beirut collector Dikran Sarrafian. The museum was facing investigations in both Italy and America, and the Met's attorney, Ashton Hawkins, and an outside lawyer jetted to Lebanon where they got a man to swear in writing that Sarrafian had shown him the pot's fragments in the 1960s. They then flew to Zurich, where Fritz Bürki signed an affidavit saying he had received the krater's pieces for restoration in August 1971, four months before the alleged illicit dig. Further bolstering their case, the Met's investigators scored an affidavit from a Swiss photographer, Dieter Widmer, who said he had seen the fragments in early September of 1971 as part of his work with Bürki's restoration.

The Met's evidence, which the museum turned over to Hecht's Italian lawyer, weakened the case that the Carabinieri and prosecutors had been building against the American dealer and the accused tomb robbers. In November 1973, an Italian court tossed

out the arrest warrant that had been keeping Hecht out of Italy and away from his family. And later that month, when one of the Italian prosecutors enlisted archaeologists to see if some of the newly found, supposed Euphronios fragments could fit into gaps in the Met's vase, the museum turned over black-and-white photos of the pot. Hoving and his staff knew well that the prerestoration photos, showing every crack, would show that barely a shard was missing. In January, the Italian court's experts ruled that the fragments—including two pieces the size of a cigarette pack—did not belong to the Sarpedon krater in New York.

For the Met, it was time to declare victory. On March 6, 1974, the museum issued the report of its in-house krater investigation. In short, it said, Hecht's version of events was credible. The Metropolitan Museum of Art stood by its purchase.

That, of course, didn't mean that Italian and American law enforcement were done investigating the origins of the krater—and the secret whereabouts of its smaller twin chalice.

In Italy, the finding that the shards didn't fit failed to put an end to the fragment mystery. Cenere's testimony and the confidential police informants' reports of the krater's origin in Cerveteri were too convincing for the police and prosecutors to just walk away. So the Italian magistrates had other archaeologists look at the stray pieces, and instead of just relying on photos, this time two Carabinieri officers visited the New York museum with two fragments to see if they would fit in.

The Italians' krater case against Hecht and the *tombaroli* kept winding its way through the legal system, too, and though the men were not charged with any crime, they were still under investigation. Police and prosecutors in New York also had not made any mention of dropping their interest in the case, which had started with the search for the Sarpedon chalice that von Bothmer had shown slides of in Philadelphia.

Hoving seemed to have closed the door on the krater scandal as a public relations embarrassment, but as a legal issue it was just heating up. So it was to Hoving's great fortune that he received a letter from a Chicago woman named Muriel Newman who said she had visited Lebanon in the 1960s—and had seen some Attic red-figure pottery in the home of a man named Sarrafian.

Bruce McNall, a stocky kid from California, got his start in the antiquities trade in the mid-1960s during a chance encounter with a military veteran who walked into the stamp and coin shop where McNall worked. The man was carrying a metal ammo box filled with coins from Egypt. McNall was just fourteen years old at the time, but this meeting turned him on to deal making and classical history.

The man wanted $3,000 for the lot, and McNall's boss at Coins of the World Etc. in Arcadia, just outside Los Angeles, refused, saying he never spent that much on a single purchase. He also said the old coins would be hard to unload. McNall sensed opportunity. He successfully pleaded with his grandmother for a loan, bought the coins, and then turned around and sold the best of the bunch to a few of L.A.'s biggest coin dealers. By the time he had sold the whole boxful and paid back his grandmother, the teenager had made more than $10,000 profit. He was hooked.

McNall went on to graduate from the University of California at Los Angeles and won a prestigious Regents fellowship to pursue a doctorate in ancient history there—all while continuing to work as a coin dealer on the side. In the end, the faster-paced coin trade won out. He dropped out of UCLA to work full time as a deal maker, and only sometimes looked back at what could have been if he had chosen the less profitable, but ultimately safer,

career as a professor or curator. His exploits would later include stints as a film producer (*War Games, The Fabulous Baker Boys*) and owner of the L.A. Kings hockey team, where he would lure Wayne Gretzky from the Edmonton Oilers. He would also spend years in prison. But it all started with coins—and Greek vases.

By the early 1970s, the twentysomething McNall had built enough demand for coins among his Hollywood clientele that he needed to constantly comb the European auctions and dealerships for new stock. On one trip in the spring of 1974—to London, Zurich, Bern, and, for the first time, to the Arab world, where he dropped into Tunisia—McNall made a connection that would change the course of his career, and ultimately the path of the Sarpedon chalice.

The Los Angeles dealer planned to stop in the Swiss capital of Bern because the dealer Munzen und Medaillen ("Coins and Medals" in English) was holding an auction of coins and other antiquities. The sale was important enough to attract another American: Robert Hecht. The Basel-based dealership held the auction in the ballroom of the Hotel Schweizerhof Bern, a grand landmark built in 1859. But the real action, for someone like Hecht, was on the sidelines.

If Hecht's business hoped to recover from the bad publicity from the krater affair, he needed to meet dealers like McNall who had deep-pocketed clients. When the auction finished, Hecht followed McNall toward the door. "Mr. McNall," said the thin, slightly hunched fifty-four-year-old American, stopping the portly Californian who had just bid up a storm. "I'm Bob Hecht. If you like antiquities and coins, I have some items you might like. Why don't you come up to my room?"

McNall knew Hecht by reputation and accepted the invitation. The danger of entering the underside of the antiquities trade was exciting, and McNall felt a rush of adrenaline as he

walked down the hallway and knocked on Hecht's door. The man himself let McNall into the room.

On the bed, Hecht had arranged the soil-encrusted fragments of a vase, still lying on the newspaper pages in which it had been wrapped. Milling about the room—which was literally smoke filled—were Greeks, Turks, and Italians, all of them swapping objects from their briefcases and pockets as they haggled over prices. This was the traveling bazaar of the artifact trade, and McNall recognized most of these people from the auction. One, a "tough guy," he would later recall, was named Giacomo.

Giacomo always made his rounds with someone named Ugo, a bigger guy who sported bright shirts and lizard-skin boots. Ugo sold coins, but he never had anything good. Still, if you wanted the top-quality material from Giacomo, you had to buy Ugo's junk, too. "It was understood," McNall said.

McNall made the rounds of the room, buying what he could: a few dozen coins, mostly Greek silver, and, for $2,500, a kylix painted with red figures against a black background. This wasn't any masterpiece, but it was pretty, and McNall planned to display it at his apartment. In time, he would get the chance to deal in a much more impressive red-figure kylix, and in the process learn the surname of that tough guy, Giacomo.

Hecht was happy to have included McNall in his movable feast, and shook his hand as he showed him to the door. "We should really get to know each other," Hecht said.

With the heat on in Rome, Medici started spending more and more time in Switzerland during 1974, traveling to Geneva and Zurich two or three times a year and borrowing office space in Geneva from a Swiss dealer, Christian Boursaud. This gave Medici the opportunity to build his contacts in the international networks

that supplied the wealthier collectors and museums far from his native Rome.

Nikolas Koutoulakis, a Greek dealer based in Paris and Geneva, helped Medici get a foothold while also using him to run around and check out merchandise. Koutoulakis had heard about an impressive haul that was just coming to market and reached Medici by telephone in Geneva. Medici was planning to travel to Germany for the World Cup, the soccer championship played every four years, and Koutoulakis wanted him to pay a visit to a Turkish dealer.

"Do me a favor and look at an object for me," Koutoulakis said.

Medici, a rabid soccer fan, made the pilgrimage to Munich for the World Cup to see the star of his beloved Lazio, Giorgio Chinaglia, the lead player on the Italian national team. The Italians easily beat the Haitian squad 3-1 on June 15, but during a break in the World Cup action, Medici went to the Turk's warehouse where he saw a towering statue of the Empress Sabina, the wife of the great Roman emperor Hadrian. It was an impressive, bigger-than-life tribute to the empress carved in white marble, standing six and a half feet tall and wearing a flowing gown. Medici came away with Polaroid photos of the statue—one of the top third, another of the middle, and another of the bottom. Sabina was just too massive to photograph in one frame.

Koutoulakis wanted the statue, but didn't move fast enough, Medici later recalled. Instead, Robert Hecht got it, but Medici held on to the dimly lit pictures, adding them to his evergrowing collection of archaeological photographs.

In Cerveteri, the Carabinieri had been hearing more and more credible talk from the *tombaroli* underworld that something was afoot in Sant'Angelo, that perhaps a new tomb had been located that was

filled with vases and other objects of value. The police, who had already let the Euphronios krater slip through their hands from that very same corner of Cerveteri, weren't about to repeat that episode. Because the land—owned by a certain Giacomo Medici and Mario Bruno—was already protected by the ministry's decree as an archaeological site, the Carabinieri had no trouble obtaining permission from the state's archaeological service to start their own emergency dig at Greppe Sant'Angelo.

The police were already suspicious of this situation: Medici and Bruno owned the land, the men were antiquities dealers, and there was evidence of fresh digging on the site.

Medici recalls the events leading to the Carabinieri intervention differently. He was the one who tipped off the police to the new, unauthorized excavation after arriving at his hog farm one morning and finding that *tombaroli* had been there overnight. "We saw it and called the Carabinieri, but they accused us of clandestine digging," Medici says. The police, finding freshly dug up statues on Medici's land, suspected the art dealer. But Medici had an explanation: the pigs did it.

He said his free-range boar, working like truffle hunters, had spontaneously brought the artifacts to the surface. Not sold on this story, the police wrested control of the land from Medici. The Carabinieri, including Marshal Pontecorvo, the commander of the Cerveteri station, started the salvage dig on Friday, August 30, 1974, along with Mario Moretti, the government's head of archaeology for the region, and Giuseppe Proietti, Moretti's young assistant who had just taken over responsibility for archaeology in Cerveteri. Academically speaking, Proietti, a 1973 winner of the prestigious national competition to become an archaeological inspector, was in charge of the dig, the first he had ever led in his career.

They needed to work fast, both to head off snooping tomb robbers and the coming autumn rains. So, like the finance police

who had been there two years earlier, they brought in the bull-
dozers, which they used to clear away the mounds of dirt that sat
in front of what appeared to be blocks of rock on top of a wall of
natural stone. On the third day the heavy machinery had cleared
away enough soil that the diggers could switch to picks and
shovels. During the night, the Carabinieri, who had closed the
entry to the site with a gate, stood guard. The local commander,
Marshal Pontecorvo, even moved a bed from the barracks to the
dig site so he could establish a twenty-four-hour presence.

Medici had the right to participate in the dig as an owner of
the land; the owners would be entitled to 25 percent of the value
of any artifacts found, and as a result were entitled to hire their
own diggers to assist. It was an unlikely band, with some famil-
iar faces, that excavated Greppe Sant'Angelo this time around.
As much as the government officials would allow him, Medici
bounded around the dig in bell-bottom trousers overseeing a
team of his own that included Giovanni Temperi—the terrain's
caretaker who two years earlier had stumbled upon and then
joined the dig that produced the Met's Euphronios krater.

Alongside them, Carabinieri stood guard while Moretti and
Proietti oversaw government employees who had been pulled off
two other sites to sift through the soil. By archaeological stan-
dards, the dirt practically flew out of the hole. As they dug down-
ward along the face of the tomb, the excavators first encountered
heaps of dirt, about six feet deep, some of it mixed in with frag-
ments of artifacts, some of it covering the blocks of rock that
made the roofs and walls of one part of the complex. They were
clearly looking at a tomb or tombs. On the far edges of the pit,
they even located the doors to tiny chambers, a little more than a
yard below the surface. These rooms were filled with rubble,
which meant somebody else had gotten there before the archae-
ologists.

On the massive front of the main tomb face, the workers discovered bas-relief carvings of animals in a limestone called *macco,* which is only found in nearby Tarquinia. The violent scenes showed panthers and lions shredding deer and boar to pieces.

The archaeologists dug down another six feet and revealed the entryway to a staircase that long ago would have led up to the roof of the tombs, flanked on either side by false doors, decorated with circles and rectangles—and pocked with marks that looked like they could have come from picks or hammers. These decorative doors were an unusual find, matching a style found on the other end of the Mediterranean, in Macedonia, the homeland of Alexander the Great. Because of the doors, the archaeologists began to refer to the site as a "royal" tomb.

Yet another six feet below, they found the entryways to two separate tombs, one whose arched roof could be seen near the modern surface of the terrain, and another of more simple construction. Both were filled with rubble. "Either in ancient times or in more recent times," Proietti said sadly in the days after the discovery, "the nighttime excavators have visited this complex."

At this depth, nearly three stories below the surface, the excavators hit bottom, which was a plaza that extended in front of the wall of tomb doors. The archaeologists deduced that family members of the dead had used this terrace, trapezoidal in shape, as a ceremonial space to carry out funeral rites. From the square they could gaze at the outer wall of the tombs, which still bore traces of having been painted or frescoed.

The unusually fast dig, which lasted six days, yielded its most notable artifacts as the workers cleared the surface of the terrace. First they found two statues of lions made of soft volcanic rock and a Travertine marble statue of a sphinx. Combined with finds

from the previous digs there, the menagerie of mythical figures buried at Greppe Sant'Angelo was growing. The excavators also dug up two men's gravestones that were shaped like phalluses, with the names of the deceased written atop them. Then the workmen uncovered something that terrified them.

First they found a stone torso, its hands broken off, and lacking a head, and then the head itself: a demonic figure with wavy hair blown back, mouth agape, hooked nose, a pointy devil's beard, and blazing eyes opened wide.

The local excavators recoiled in fear, and confusion rippled through the dig. The out-of-town archaeologists wondered what had gotten into the workmen, especially when it seemed they had come up with such a wonderful find. Then some of the Cerveteri natives explained. During the dig, the men had already been mindful that they might be disturbing the Shadow who haunts the area. Now, they feared, they had uncovered the Demon of Sant'Angelo.

The archaeologists explained to the men that they had merely uncovered the only known sculptural representation of the Etruscan god of the afterlife, Tuchulca, or the related deity, Charun, who had previously been seen only on wall paintings. Proietti (whose research would eventually settle on this being Charun) helped reassemble the frightening statue. After he and the Carabinieri announced the existence of the excavation to the public on September 4, 1974, Proietti, wearing a short-sleeved windowpane-patterned shirt, posed next to the demon for photographers.

But what about Euphronios?

Excavators who thought they might find signs that a Euphronios krater or kylix had been buried at the site were puzzled by the evidence found there. The massive tomb, with its rare arched roof, dated by its architectural elements to about 300 B.C.,

the twilight of Etruscan civilization. That meant the tomb was built more than two hundred years after Euphronios painted his vases, making it an unlikely final resting place for the pots. More likely, some of the other smaller, possibly older, nearby tombs in the burial complex had held such vases. It would later turn out that the archaeologists speculated correctly.

At the time, Moretti had a theory. Between posing with the lion statues and chatting with Giacomo Medici, who had come to soak up some of the excitement, the mustachioed Moretti explained his conclusions during a news conference at the site on Tuesday, September 10, 1974.

"Since the last century the farmers who cultivate this area, after finding tombs, would take the vases and hide them, waiting to sell them, in different locations that were almost always other tombs known only to them," Moretti said. "It is almost assured that the Euphronios vase, which has notably ended up at the Metropolitan Museum in New York, could have been left, after being taken from its original tomb, in this warehouse tomb here."

If nineteenth-century tomb robbers had used these chambers as storage space, "Nothing would stop one from thinking that the celebrated Euphronios vase came right from here, even if it was from two centuries earlier," Moretti said.

A week after they had finished the emergency excavation, the archaeologists came up with a surprising finding. They sorted through fragments they had found and determined that they dated from the eighth century B.C. all the way through to the second century B.C. The vast range of dates "signifies that there was a lot of shifting around of the vases that had been there," Moretti said. But who or what had done the shifting?

Cerveteri's necropolises got mighty crowded in the final years of the civilization, making real estate for the dead hard to come

by. There was a history of reuse, and the mixing of strata and artifacts could have happened in antiquity. In the explanation favored by Medici, the Etruscans emptied out older burial chambers to build new ones. In the process they discarded pottery that might have been of little value to them, piling it into smaller tombs nearby and scrap heaps on top of the new structures.

Regardless of which theory would explain where Euphronios's Sarpedon krater was found—a nineteenth-century warehouse tomb, an intact ancient tomb, or the scattered remains of a tomb recycled in antiquity—the truth would be impossible for archaeologists to discern for sure. The tomb robbers, by their very treasure-hunting nature, had destroyed the historical record forever.

That did not mean the Euphronios investigation was anywhere near its end. In the background, the notoriously slow Italian legal system continued to turn, and the state prosecutor's office in Civitavecchia pursued his case against the tomb robbers whom Armando Cenere had fingered, as well as Hecht, for the trafficking of the Sarpedon krater. To get an indictment, the prosecutor, Domenico Sica, needed to convince a judge that Cenere's testimony was worth believing and that Sarrafian's story about being the source of the krater wasn't. He would need to show that the Met's growing dossier on the legitimate origins of the krater was flawed.

If he wanted a slam dunk, he needed to show that at least one of the fragments that had surfaced in Italy—whether found at the Sant'Angelo site or at a *tombarolo*'s house, left in the Cerveteri church, or sent anonymously to the Carabinieri—matched a missing portion of the Euphronios krater in New York. For the moment, Italian archaeologists were unable to make such a match.

As the chances of making a case that the Euphronios krater had been looted diminished, the Met's odds at proving the opposite never looked better.

Thomas Hoving finally convinced Muriel Newman, the woman who had written to him about meeting Dikran Sarrafian in Lebanon, to talk about the pottery he had shown her in the 1960s. Anything Hoving could learn that would back the story that Sarrafian had long owned the museum's Euphronios would help.

Newman, who had been following the krater affair through news reports, would make a credible witness in the art world; she was a member of the twentieth-century acquisitions committee at the Art Institute of Chicago and was an active collector of abstract expressionist paintings. Hoving took her seriously enough that in autumn 1974 he traveled to Chicago and met with Newman at the Drake Hotel, accompanied by Met lawyers who took an affidavit from her. The "attractive widow in her 50s," as Hoving described her, told the story of how she and her husband vacationed in Beirut in 1964. On the advice of a friend, Newman visited Sarrafian at his apartment to buy some archaeological trinkets. At that point, no vases were involved. Satisfied with her purchase, though, she visited with Sarrafian again later in the trip. As they sat on his terrace, Sarrafian told Newman he had something to show her.

The affidavit lays out the details of what happened next: "I followed Mr. Sarrafian into a small room where he opened a large box containing shards. He told me they were pieces of something called a krater—an ancient Greek vase—signed by a great artist named Euphronios, which his father, an art dealer, had acquired in the early '20s. The shards were large—very— and thick and extremely dirty. I have no recollection of any particular designs on them. Mr. Sarrafian explained that the painter

of the vase was one of the important names in history and I always remembered the name, Euphronios. He wanted to know if I might be interested in purchasing them. I told him I wasn't."

Hoving had scored the trump card that nailed his case for buying the krater. Sarrafian *did* have a Euphronios before 1971. Or so he thought.

In the meantime, the matching Sarpedon chalice was still out there, and the Met's Dietrich von Bothmer knew more than he had been saying. The chief of the Met's Greek and Roman department had mostly kept silent on the subject of Euphronios since the krater affair erupted. His impolitic comments to the press and his revelation in Philadelphia that he knew of the matching Sarpedon kylix had only hurt him. But privately, von Bothmer couldn't let go of the subject. So von Bothmer made a speech about the topic in a language most American archaeologists probably couldn't understand—his native German.

He gave the talk at the Berlin Archaeological Society on March 4, 1975, and published it the following year as an article called "Der Euphronioskrater in New York," in an archaeology journal called *Archäologischer Anzeiger*. While the twenty-seven-page piece was, as the title indicated, about the Euphronios krater at the Met, von Bothmer used the lecture to make his first explicit, public reference to the krater's smaller twin chalice.

And he made a revelation that—had it been said or published in English—may have touched off another storm.

"Sarpedon is represented only rarely in ancient art, but we know directly from Euphronios that he had already taken up the topic early in his career," von Bothmer wrote, "because there is a bowl signed by him, with the same subject, which is about five years older than the Krater.

"This bowl, which I once saw in Europe, has the first depiction of Sarpedon's mortuary rites by Sleep and Death."

This was more than he had previously revealed in public, and it confirmed what he had told the FBI in private about seeing the kylix in Europe. The funny thing is, nobody seemed to notice. Not the Italian police or the Manhattan prosecutors. How many of them attended lectures in Germany or were regular readers of *Archäologischer Anzeiger*?

Hoving needed to make the lingering krater investigations in Italy and New York go away. He didn't want this case to spoil the impending visit to his museum of the world's most celebrated collection of ancient materials: the Treasures of Tutankhamun.

The Met director had been waging antiquities battles on two fronts. At the same time that he was fighting the accusations that the Euphronios krater was looted, Hoving had taken charge of organizing the visit of the Egyptian king's tomb remains to the United States. In a process that began during the June 1974 meeting between President Richard Nixon and Egyptian President Anwar Sadat, Hoving had traveled to Cairo to select which of the objects would tour American museums. Hoving even won permission for an after-hours visit to the Egyptian Museum, the Tut treasures' permanent home. Once inside, he had been allowed to open the cases and "fondle" any of the boy king's belongings that he wanted. The first one he touched was Tutankhamun's iconic gold mask, which he lifted from its stand and kissed, full on the lips. He even helped arrange for two U.S. Navy ships, USS *Milwaukee* and USS *Sylvania,* to transport the objects to the United States.

After stops in Washington, Chicago, New Orleans, Los Angeles, and Seattle, the Tut exhibit was due to open in New York for

a four-month stay at the Metropolitan Museum of Art, starting December 15, 1978. As that date approached, Hoving's luck turned again. After a decade running the museum on a fuel of ego, enthusiasm, and questionable acquisitions, it became clear to him and the board of trustees that his time was up. In a last rebuke, while Hoving was out of reach on a yacht race to Bermuda, the board's executive committee voted to override his and the acquisition committee's decision to buy a Duccio di Buoninsegna painting. The seven-hundred-year-old depiction of the Crucifixion, put up for sale by Birmingham University in England, would have been the Met's first Duccio. Hoving angrily began to negotiate his departure. On November 5, 1976, the *New York Times*'s Grace Glueck broke the news that Hoving had agreed to retire. He would step down on June 30, 1977, at the age of forty-six. Philippe de Montebello would replace him.

As his time ran out, Hoving battled back against what seemed like the final threats from the krater affair. In 1977, Dikran Sarrafian and his wife were killed in a car crash in Beirut—before Italian investigators could question Sarrafian about the signed Euphronios fragments he had supposedly once owned. In New York, Manhattan district attorney Robert Morgenthau started an investigation.

Hoving said he was told at the time that Sarrafian's death had triggered the grand jury probe, but he suspected that the prosecutor was ultimately going after him and von Bothmer for buying a looted Euphronios. The assistant district attorneys were about to call the Met director and curator to testify to the grand jury when they learned of Muriel Newman's affidavit and called her first, getting her to come to New York. Soon after hearing her testimony, the grand jury asked the prosecutors to drop the case, which they did.

Then the news came from Italy. On October 13, 1978, Judge

M. Lion, sitting in Civitavecchia, issued his ruling on the evidence that the Carabinieri art squad and local prosecutors had been building against Robert Hecht and the seven accused tomb robbers. Lion outlined the points, both for and against prosecution.

On one hand, the Italian embassy in Lebanon had managed to speak with the daughter of the deceased Sarrafian, and she said she knew nothing of either the vase or a million-dollar payment. On the other hand, Judge Lion wrote, Manhattan district attorney Robert Morgenthau had decided not to prosecute. Yes, Cenere, the admitted *tombarolo* lookout, had testified that he had been part of a clandestine dig. But he had just identified one fragment—"a man who was bleeding"—and that was probably after he had seen photos of the Met's vase. And yes, Cenere had accurately led investigators to an illicit dig site at Sant'Angelo in Cerveteri, and yes, the police had found vase fragments there. But the investigators, using detailed photos of the krater from the Met, failed to match the fragments they had found to any gaps they could find in the massive Sarpedon vase. The judge also took note of testimony taken from Bürki the restorer in Zurich, who said he had started to recompose the krater months before the alleged Christmas 1971 dig in Cerveteri.

Taken all together, Judge Lion wrote of the evidence, "It is declared that the cases should not proceed against" the seven supposed *tombaroli* and Robert Hecht, "for reason of insufficient proof."

That was it. The krater case was closed. Investigators on both sides of the Atlantic had failed to build a convincing case that the Met's vase had been stolen—and they had failed to find the krater's missing twin, the Sarpedon chalice by Euphronios.

For Giacomo Medici, it was time to get out of town. In 1978, he closed down his shop on Via del Babuino in Rome. It was safer

for him to conduct his business outside Italy. Weighing his options for where to hang his shingle, he considered Switzerland—either Geneva, Zurich, or Basel—and possibly even London. Zurich and Basel were the more traditional choices for the art trade, already teeming with galleries and the Swiss banks whose vaults held treasures and the cash for big purchases. But Medici's sometimes colleague, Christian Boursaud, suggested Geneva. The old town there didn't have too many other antiquities businesses to compete with him. And in Geneva he'd still have the advantages of the liberal Swiss export laws.

The two men started making plans to go into business together. Medici's operation was on its way across the Alps.

Seven years had passed since the clandestine Cerveteri excavation. Unless, by some fluke, new evidence could suddenly surface, there was no chance anyone would be brought to justice. There was no chance Italy could win the return of the krater. And there would be no chance the missing chalice could be found.

For the moment, the clouds lifted over Fifth Avenue: Hoving was out, the krater investigations were finished—and King Tut was coming to town.

In New York at the time, the Tutankhamun exhibit was about as exciting as the release of *Star Wars* and the Yankees beating the Los Angeles Dodgers in the World Series. On *Saturday Night Live,* comedian Steve Martin dressed as a pharaoh and sang "King Tut."

Whatever sins Hoving committed against archaeology and customs regulations in his years of acquisitions, he deserves credit for the Tut exhibit. It surely inspired a generation of archaeologists. Visitors to the exhibit learned about the alabaster

canopic jars in which embalmers had stored the boy king's organs, heard ancient details of the coffins within coffins, and soaked up modern tales of how in 1923 Howard Carter had discovered the undisturbed tomb and the heaps of treasure and everyday objects inside.

But what was it about Tutankhamun that inspired so much interest?

It wasn't any one object, but the entire ensemble of related artifacts and the history they collectively recounted. Tutankhamun inspired because he had a story. A simple gold dagger in a display case was much more than a pretty weapon, because museumgoers knew whose it was, when it had been made, where it had been buried, and what had been buried with it. Visitors to the Met understood that scientists had been able to study King Tut's corpse, see what kinds of things he owned, and figure out what sort of food and drink had been left for his journey to the afterlife.

Another story inspired the public and archaeologists alike: the story that all the photos and documentation from Carter's dig told about the adventure of discovering the rarest of all treasures, an undisturbed tomb. King Tut was one of the least powerful pharaohs and had what was probably the smallest tomb in the Valley of the Kings. Yet he continues to inspire.

It's a rare kid like Dietrich von Bothmer who can go to a museum and be propelled on a lifelong obsession just by seeing a beautiful image on a krater—absent the krater's story and context. Sadly, behind every such vase was once an Etruscan King Tut, about whom nothing is known today.

It had been just six years since von Bothmer's presentation in Philadelphia had revealed the chalice's existence and had led to his

exile. Those years had also seen von Bothmer try to buy the cup for the Met—an opportunity that slipped through his hands because his boss, Hoving, couldn't brave the bad publicity from the prior purchase of its larger twin by Euphronios.

But von Bothmer just couldn't let go of his obsession with Euphronios, Sarpedon, or the cup, which had languished all this time somewhere in the antiquities underworld. The Sarpedon chalice still had never been put on public display. The only audience to even catch a glimpse of it had been the archaeologists who attended von Bothmer's December 1972 lecture in Philadelphia, and all they had seen was a black-and-white slide. In his 1975 lecture in Berlin, he had made just a brief mention of the cup. Vase scholars couldn't be blamed if they were to conclude that the kylix had simply disappeared.

Then von Bothmer broke the silence, during the last week of April 1979, at a conference on Greek vases, held at New York's Hudson Valley Community College. The name of the town in which they had gathered was not lost on the participants: Troy, New York. In fact, it seemed to inspire von Bothmer, who named his lecture "The Death of Sarpedon."

He started his talk with the Met's own "unrivalled masterpiece," its krater by Euphronios, decorated with the fallen son of Zeus. Von Bothmer was defiant from the start. Maybe it was because enough time had passed since the original controversy. Perhaps with Hoving gone from the museum, he felt unencumbered. "If our krater still figures in the *Guinness Book of Records* as the most expensive Greek vase ever bought, it is not exactly our fault if, regrettably, no other, more perfect Greek vase has come to light that would command a higher price.

"Speaking on the krater at Troy, it occurs to me that this should be the perfect place to throw a strong light on the iconog-

raphy of the vase and to feature Sarpedon," von Bothmer said. Then he spelled out why, in essence, he was obsessed.

"In art Sarpedon is one of the rarer subjects. The name is inscribed on only five vases, two Corinthian, two Attic, and one South Italian—spanning a period of 250 years," he said. And except for one, they all had prestigious homes. One of the Corinthian vases was at the Vatican, and the other at the royal library in Brussels. The newer, South Italian vase was in a museum in Taranto, Italy. One of the Attic vases was, of course, the Euphronios krater, in New York at the Metropolitan Museum of Art.

But the fifth vase bearing the rare inscription of Sarpedon's name was a different story.

"Thanks to the New York krater, Euphronios can now be credited with having first devised the scheme that shows Sleep and Death facing each other with the body of Sarpedon between them. On an earlier inscribed and signed cup of his which is unpublished and has temporarily disappeared from view, Sleep and Death, dressed like warriors and wingless, carry the body in single file."

In just one sentence, von Bothmer had dropped several tantalizing clues. In case there were any doubts, he confirmed that the chalice, indeed, hadn't yet gone on view anywhere. And then there was the word *temporarily*. What did he know? Had he figured out a way to get his hands on it, now that Hoving was out of the picture? Would he—or someone else—soon publish the full details of the cup, including photos, in a scholarly journal? While the kylix had disappeared, it hadn't vanished. But what had Hecht, its last known owner, done with the chalice?

Von Bothmer continued to indicate that he knew an awful lot about this unpublished work. "The cup with the wingless figures of Sleep and Death is an early work by Euphronios, if not his earliest. The Sarpedon krater shows him at the height of his

mastery. The difference between the two vases, however, is more than mere technical competence. In the very treatment of the subject we see an inner progression from a hesitant composition to a perfect solution."

The evidence of how an artist's genius had developed was contained in just these two vases, von Bothmer said. No wonder the missing chalice had bewitched the curator so profoundly.

At the end of the talk, von Bothmer went as far as saying that Euphronios's two depictions of Sarpedon put the artist on par with Homer. Both the Greek poet and the Greek painter had depicted Sarpedon's death as a tragedy, even though he had battled against the Greeks.

"Looking at dead Sarpedon, we forget what side he fought on," von Bothmer concluded. "If we think of him in historic terms at all, we think of Zeus his father who was unable to save him."

"Little wonder, then, that a great artist like Euphronios was moved, at least in his picture of Sarpedon, to a level that transcends parties and ignores such smaller distinctions as victory or defeat. Through the choice of his subject and its treatment which I take to be totally original rather than copied or adapted, Euphronios the painter has thus become the equal of the poet and achieved his own claim to immortality."

If von Bothmer was right about the cup being "temporarily" off view, immortality for Euphronios might mean that his Sarpedon chalice would live to see another day.

The seeds of the cup's future had already been planted—on Rodeo Drive, of all places. Soon after Bruce McNall met Robert Hecht and Giacomo Medici at the coin auction in Zurich in 1974, he opened a shop on the Los Angeles luxury strip, nestled among the Hermès and Cartier boutiques. McNall named his business

Summa Gallery, with *summa* taken from the Latin for "highest."
McNall had started as a coin collector and dealer, but his intro-
duction to Hecht had given him a new connection to the world of
vases and statues. Hecht became McNall's top supplier of ancient
art, and his business partner.

McNall's timing was good, but his West Coast location was
even better. Following the 1976 death of J. Paul Getty, the Malibu
museum that the billionaire had established began a buying
spree. The Getty Museum's antiquities curator, Jiri Frel, went
into overdrive in an attempt to catch up with the Metropolitan
Museum of Art and the great European museums, which had
already had centuries to amass their Greek, Roman, and Etrus-
can holdings, during times of very different and mostly lax legal
and ethical norms. Frel, a Czech who had briefly worked for von
Bothmer at the Met before Getty himself snatched him away for
his new museum, was everything McNall could want in a new
and nearby client. To start, he had millions to spend and display
cases to fill.

Frel would even accept choice pieces from McNall to display
on loan at the Getty—giving McNall a prestigious setting in
which he could show his merchandise to private Hollywood cli-
ents. In some cases, those clients would buy the vases from Mc-
Nall and then donate them to the museum, making money from
the transactions by taking inflated tax deductions—backed up, of
course, by exaggerated appraisals from Frel and McNall. Every-
one benefited, as long as Hecht kept coming up with more goods,
which he did.

McNall's job was finding more and bigger clients. He didn't
know it at the time, but he had already met his single biggest buyer
in March 1978 at the Hollywood Park racetrack in Inglewood,
California. McNall had just bought a young Thoroughbred in
training named Ruggedness when the agent who handled the

sale introduced him to the seller, fifty-two-year-old Nelson Bunker Hunt, a son of oil tycoon H. L. Hunt.

At that first meeting, Bunker Hunt and Bruce McNall had just exchanged pleasantries. But a year later, at Arcadia California's Santa Anita Park, the billionaire Texan approached McNall, who easily recognized the heavyset Hunt, who towered over him at more than six feet and wore glasses with huge, square lenses. His slicked-back hair made him look like a 1950s executive. Hunt had heard that McNall sold ancient coins, and he peppered him with questions about gold and silver. What Hunt was getting at, amid a recession and the Arab oil embargo, was where he might stash his wealth.

Watching the races together, Hunt told McNall he was worried that communists would take over America with the help of a "Jewish conspiracy" in the government. Either that, or the economy would fall apart, leading to civil unrest, martial law, and the devaluation of paper money. Only hard assets would be worth anything, he told McNall, and so he was buying precious metals. While McNall disagreed with Hunt's views, he could see this would be the beginning of a profitable relationship.

McNall got Bunker Hunt—and his younger brother, William Herbert Hunt—hooked on ancient coins, bronze statues, and, eventually, vases.

"I've got something to knock your socks off," Hecht told McNall. *"It's* another Euphronios."

After all those years, Hecht still had the chalice. Partly because of the whiff of scandal surrounding his sale of the matching krater to the Met, Hecht hadn't found a buyer for the smaller cup in the years since. The way the newspapers had plastered his name and picture all over their pages was a curse for a dealer in

the subterranean antiquities world. On a few occasions, Hecht had teased McNall about having the cup, but had never handed it over to his new partner in America to find a buyer.

Hecht was torn about whether, and how, to sell the smaller twin of the Sarpedon krater. "He was bitter about the hassle that was placed on him with the Euphronios krater at the Met," McNall recalls. Hecht knew that by bringing the cup to market the old dispute might resurface.

But Hecht also figured the heat might finally be off. The Italian courts had found there was not enough evidence to prosecute him, and the Manhattan prosecutors dropped their effort to get the grand jury to hand down an indictment. If indeed enough time had passed, then McNall seemed to have found in the Hunt brothers the sort of buyers who could pay good money. Hecht put the proposed sale in the hands of his new L.A.-based partner. As a classics buff, McNall was thrilled to have the chance to sell a kylix by ancient Greece's greatest vase painter. And then Hecht had one more treat for him: yet another Euphronios.

What incredible luck Hecht seemed to have. First he had come up with the krater to sell to the Met—only the sixth known vase signed by Euphronios as its painter and just the fourth that was anywhere near intact—and then he happened to have its smaller match, also signed. Now, out of the blue, he had a fragmentary krater, also painted by Euphronios, and with the artist's signature on it as proof. What a streak. After a drought of centuries, Hecht had gotten his hands on at least three signed Euphronioses (by the early 1970s an unsigned one also showed up at the Munich antiquities museum, a client of Hecht's), nearly doubling the number of signed vases painted by the ancient master to nine. But where did they come from, and how much of a coincidence could it really be that the same dealer had gotten his hands on all of the newly surfaced vases?

Hecht told McNall that the fragmentary vase, which depicted Heracles killing his foe Kyknos, was a recent acquisition of his. "It was on the market," Hecht told McNall, so he went and bought it for somewhere between $800,000 and $900,000—from Giacomo Medici, according to McNall's account of what Hecht told him. It was a repeat of the original Euphronios krater deal. And as he had done nearly a decade earlier with the Met's complete vase, Hecht sent the fragmentary krater to Fritz Bürki in Zurich to piece together.

But where was the kylix? Hecht told McNall that the cup was "in Norway or something," says McNall, who didn't buy the story as anything more than Hecht speaking, as usual, in his own quirky coded language. "That's his translation that it's on ice," McNall thought of the Scandinavian tale.

McNall believed he knew better. For one, Hecht had already said he'd bought the Met's Sarpedon krater from Medici and explained how it had been smuggled out of Italy. "I was well aware from Bob that the krater was from Giacomo," McNall says. Hecht would even tell McNall stories about a box of fragments and the train ride to Lugano. Strangely, Hecht never specifically told McNall how he'd gotten the matching chalice. McNall only knew that Hecht had had the cup since around the same time that the Met bought its krater in 1972. He just assumed that tomb robbers had found the two matching Sarpedon vases in the same sepulcher, though he had no proof.

Anyhow, it wasn't in McNall's interest to solve such mysteries. He had money to make. Hecht and McNall would pitch the two vases to Bunker Hunt as a package deal.

Hunt was a collector, but not a rabid one. He liked coins, but he wasn't a huge fan of ancient art, unless he could be convinced that what he was looking at was "important stuff." His buying was part of a bigger plan he and his brother had to invest in hard

assets that would survive a world economic collapse, and the antiquities were practically a sideshow to a huge gamble the Hunts were starting to take: an attempt to corner the world's market in raw silver.

As Bunker Hunt and his brother bought up silver, they also wanted to amass a selection of enduring ancient art and coins that would qualify as a great collection. McNall, with Hecht in the background, hoped to take the Hunt holdings up a notch. Hecht sent McNall photos of the two pieces. In the pictures the cup appeared to be restored from fragments, but it was pretty much all there. The krater, which was really just a collection of shards composing a quarter of a complete vase, didn't quite look like much. The painting was stunning, but Bürki hadn't yet done his handiwork because they thought other fragments might come onto the market. There'd be no point gluing it all together if they'd have to take it apart again to stick in extra bits. For the pictures, Hecht had done his best to arrange the pieces in a way that would give potential buyers a sense of the pot's former grandeur. It would have to do.

Photos in hand, McNall flew to Dallas sometime in 1979 and met with Bunker Hunt. "These are great pieces," McNall explained to his client. "They're expensive. You're not getting them for a song. And we're not going to find things of this caliber again."

Hunt took a look at the photos.

"Let's get them," he said.

McNall called Hecht and told him to go ahead and have Bürki glue the vase together.

Bunker Hunt certainly didn't get the vases for a song. The Sarpedon chalice, which Hecht had offered to the Met six years earlier for $70,000, went for about ten times that to the Texas billionaire. McNall sold him the fragmentary krater for a bit more than a million dollars. In all, the pair cost about $2 million.

Normally McNall and Hecht would have split the profit from the sale, but this transaction was different. Sure, for the fragmentary krater, which had netted about $250,000, the two partners could share the profit evenly. Hecht had only recently bought the piece—or at least that's what he'd told McNall—and the return on his investment was modest enough. The Sarpedon chalice was another story. Hecht had owned the cup long enough in the years preceding the partnership with McNall that he would take most of the proceeds. To calculate a theoretical profit, the two dealers made up a wholesale price—something between $600,000 and $700,000. McNall took half of the roughly $200,000 theoretical markup they had charged Bunker Hunt.

Hecht did much better, probably banking a $700,000 profit on the cup for which he'd paid less than $70,000. Euphronios's Sarpedon chalice may have been the smaller twin of his grand krater at the Met, but it brought Hecht almost the same payday. The difference was that Hecht had paid handsomely for the krater, and not nearly as much for the chalice.

But maybe that original seller—whether in Scandinavia, Italy, or Switzerland—would someday get another crack at owning the kylix, and another chance to make the profit Hecht had denied him.

Stranger things have happened in the antiquities trade.

It was a busy time for Robert Hecht. On November 14, 1979, he made a deal for the six-and-a-half-foot-tall statue of the Empress Sabina that Medici had seen in Munich—selling it to Boston's Museum of Fine Arts. According to the museum's official record, none other than Fritz Bürki, the Swiss restorer, had sold it to the MFA, and the marble giant's provenance was the conveniently vague "said to have been in an aristocratic family collection in

Bavaria." The paperwork showed Hecht had simply acted as an agent for the seller, just as he had claimed to have done when he sold the Met its Sarpedon krater.

Bürki's real calling, however, was reassembling smashed vases, and lately he had been toiling on the fragmentary Euphronios krater that Bunker Hunt had agreed to buy from Bruce McNall.

Bürki had done wonderful work before, but the job he did turning a quarter of a krater into an entire vase was in itself a masterpiece. The thing was missing both its handles, almost all its base, all but slivers of its rim, and almost all its back face, save some bigger fragments depicting part of a pipe player and a javelin thrower. The front, which was mostly preserved, showed the stunning scene of a bearded and curly-haired Heracles, wearing his customary lion's skin, as he slays his rival Kyknos with a spear. Rendered in Euphronios's trademark fine lines, a warrior woman strides alongside the Greek hero—who was also worshipped by the Etruscans as Hercle and later by the Romans as Hercules. Working in plastic, and using an imagination largely informed by the architecture of the Met's Sarpedon krater, Bürki managed to set the fragments into a structure that stood on its own, even if most of it was undecorated blackspace.

His work completed, it was time to ship the fragmentary krater and the Sarpedon kylix to America. Fortunately for Hecht, there was no need to trek to Scandinavia for the cup. In fact, Bürki could pack up the vases together. The chalice had been in his home workshop for years.

Making matters even easier, the shipping address for the precious cargo wasn't Hunt's home in Dallas. The two "new" Euphronioses were heading straight to a familiar home for fresh antiquities, the J. Paul Getty Museum in Malibu. The museum's antiquities chief, Jiri Frel, loved having prestige objects on loan

to his growing, but relatively insignificant, collection. And for businessmen like Bunker Hunt and Bruce McNall, there was nothing like a stint in a museum to enhance the commercial value of an art investment.

The chalice and the fragmentary krater arrived at the museum on February 28, 1980. The paperwork for the loans said the two vases were at the museum for study, examination, and display with the permanent collection. Museum staff also recorded that the Getty's conservation department was treating the krater, which Bürki had had a first shot at restoring.

Although the vases were Bunker Hunt's property, McNall and Frel disguised the ownership, registering the loan as being from Bürki or Hecht or McNall—to this day McNall can't keep it straight, mostly because it didn't really matter. For official purposes, the Getty listed the partial krater and the Sarpedon chalice as "anonymous loan."

A year after von Bothmer had declared that the kylix had "temporarily disappeared from view," the earliest known work by Euphronios had reappeared—in Malibu.

It was 1980, and for the first time since Etruscans had buried it in a Cerveteri tomb, the cup went on public view.

CHAPTER SIX

Reversals of Fortune

The Getty and its antiquities chief, Jiri Frel, were honored to have Euphronios's previously unseen Sarpedon chalice—along with the newly surfaced fragmentary krater—because they knew it enhanced the prestige of their fledgling museum. And Bunker Hunt knew that having a cultural institution like the Getty give the vases its stamp of approval enhanced the value of his investment; from then on, the chalice and fragmentary krater would have "J. Paul Getty Museum" as part of their provenance. Bruce McNall simply got points for arranging a loan that pleased both his client, Hunt, and the museum whose prestige he needed to maintain his image in the art trade.

And there was more. One of the antiquities world's odd rituals is the process of publishing an object. If an artifact has never been written about in a scholarly journal—either because it has just been excavated by an archaeologist or has suddenly surfaced on the market—some lucky academic gets to be the first to describe the thing. Such articles usually involve detailed technical data such as the object's dimensions and a systematic accounting of all its decorations. If an artifact is unsigned by its maker, the

scholar who publishes the object gets the first shot at saying which artist he or she thinks most likely painted, potted, or carved the thing. If an artifact is signed—particularly by a superstar like Euphronios—this person gets to bask in the glory of a new masterpiece. In the case of the Sarpedon chalice and the fragmentary krater, the lucky man was Martin Robertson, a former Oxford don who had held the title of the university's Lincoln Professor of Classical Archaeology, Sir John Beazley's old post.

Professor Robertson, who had followed in the footsteps of von Bothmer's mentor, had the good fortune of being a Visiting Scholar at the Getty from January through May 1980. He was present in Malibu when Bunker Hunt's two Euphronioses arrived, and he set about preparing the academic article that would mark their official debut. He soaked up every detail of the Sarpedon chalice, which until then had been described only in vague and sometimes contradictory terms by von Bothmer and Hoving.

He made measurements. The cup stood 11.5 centimeters high, had a diameter of 33.0 centimeters at its rim, and was 11.8 centimeters at its foot. While heavily restored—particularly on the B-side of the cup, opposite the Sarpedon A-side—the chalice was largely intact, missing just half of one of its two handles. Contrary to one of Hoving's descriptions, the kylix was not missing its base. In fact, that was where Euphronios had signed his name. As for who had potted the streamline wine vessel, the Getty's Frel told Robertson that, in his expert opinion, a clay-working contemporary of Euphronios, named Kachrylion, had molded the chalice. Robertson would go with that in his article.

Just as McNall's arrangement to display the chalice at the Getty benefited everyone involved, so would Robertson's publication of the pieces. Not only did he get the scoop, but he pub-

lished it in the *J. Paul Getty Museum Journal*, handing the museum another bit of the glory. Bunker Hunt surely benefited, too, for now his Euphronios vases had an additional pedigree: an association with Oxford, via Robertson's imprimatur, similar to that which the Oxford archaeology lab gave when it tested the Sarpedon krater for the Met. The two new Euphronioses, previously lacking any publicly known life stories, gained some history with the article's publication. The value of modern paper trails for objects missing their ancient origins cannot be underestimated. Robertson's article in the Getty journal scored Bunker Hunt a prestigious bibliography entry for an auction catalog if he ever needed to sell off the pieces.

In all, Bunker Hunt's two Euphronioses spent just less than a year in Malibu. On December 9, 1980, the Getty shipped off the chalice and fragmentary krater together, presumably to Hunt's home in Texas, although to this day the Getty will not say where they sent them.

A few months later, in 1981, the Getty published Robertson's article, showing pictures of the chalice for the first time. The black-and-white photographs couldn't fully depict the red blood oozing from Sarpedon's wounds, just under his right breast and left collarbone. But they did present the drama of the bearded Death, heaving the fallen son of Zeus over his shoulder as the similarly bearded Sleep lifted Sarpedon's legs. The world could finally see an image of the Sarpedon krater's missing twin—even if the cup's ownership was still listed in the article as "anonymous" and the chalice's location was again unknown.

In 1982, Giacomo Medici's sometimes mentor, the Greek dealer Koutoulakis, became enchanted with a type of vase known as a Caeretan hydria, a unique Etruscan-made pot that flourished

briefly and was only made in Caere—today's Cerveteri. At around the same time that Euphronios was starting his career in Athens, two of his faraway counterparts in Italy were potting and painting their own ceramic gems. They used a black-and-white technique, ignoring the red-figure fad coming out of Athens. The motifs took their inspiration from Greek myth, which had been adopted in part by the Etruscans for their belief systems. Heracles was a prime example. The Etruscans imported this foreign hero and his tales, and then transformed him into a god. They dedicated temples to him and popularized his feats of strength on the pots they painted.

One such vase was coming up for sale at Christie's in London on July 2, 1982. It depicted Heracles in one of his famous twelve labors: battling the Hydra, a many-headed monster with the body of a serpent. As pots went, this one was special because its great provenance came from a legitimately old and documented European collection. Its owners had even loaned it for display at the British Museum from 1979 until deciding to sell it.

Medici and Koutoulakis struck a deal. They wouldn't compete with each other at the sale. Instead of driving up the price in a bidding war, Medici would buy it and then trade it to Koutoulakis for other artifacts. The plan worked. Medici won Lot 252, the Caeretan hydria with a Hydra, for just 162,000 pounds. Then, according to Medici's version of events, Koutoulakis gave Medici something he desperately wanted: a set of twenty red-figure plates, made in Athens at the time of Euphronios.

Koutoulakis told Medici that the plates came from an old, unpublished collection, that of the late Charles Gillet of Lausanne, Switzerland, whose name is cited frequently in auction catalogs as a source for antiquities. Toward the end of 1982, Medici says he and Koutoulakis made the swap: the hydria for the twenty plates.

Medici thought he had gotten the better of the deal with the twenty ceramic plates. These were no ordinary bits of dinnerware, but the twenty-five-hundred-year-old cousins of the prized work done by Euphronios and his colleagues in Athens. These twenty plates, most of which were entirely intact, were also done in the style Euphronios popularized. Though not signed by any artist, they were the only such set of plates to survive until modern times. Wiped clean, they'd be ready for a banquet today.

Medici wasn't planning on hosting any dinner parties with his new dishes. He had been increasing his international dealings, and these Attic plates could be his ticket to a deal as big as the Euphronios krater that launched his career. For now, he was making only tentative moves onto the turf of the big dealers such as Robert Hecht. In 1982, Medici's Swiss-based French colleague, Christian Boursaud, a man ten years his junior, started selling artifacts through Sotheby's. He was Medici's front man. Still, Sotheby's wasn't the big leagues. The auction houses did the midsized deals. Medici needed a contact at a rich, American museum.

Having closed down his shop in Rome, Medici put the finishing touches on a new gallery in Geneva, the site where he and Boursaud had settled. Medici needed Boursaud, because Medici didn't have the Swiss residency required to legally run his own business. He also needed someone to mind the shop while he was either home in Italy or out gathering merchandise they would sell. According to the arrangement, the gallery would pay Boursaud a salary for being there during working hours, and he and Medici would split the profit from sales, fifty-fifty, after Medici made back whatever he had spent on the objects in the first place.

They opened for business in February 1983 at 12 Grand'Rue, Geneva—a modest storefront in a ritzy district. As part of Medici's trade for the twenty plates, Koutoulakis even let Medici keep

the hydria with the Hydra in the window of the new gallery, hoping to sell the vase on consignment to the gallery. Medici even named his new shop the Hydra Galerie, after the creature depicted on the vase.

To celebrate the opening, Medici hosted a reception with liquor and mixers arranged on a self-serve bar covered by a white tablecloth—Gordon's gin and Johnnie Walker whiskey alongside rows of glass Coca-Cola, Evian, and Perrier bottles. Spotlights in the ceiling illuminated similarly displayed antiquities: marble statue fragments on pedestals along the walls, ceramics in shelved glass cases. Ashtrays and matchbooks were arranged around the room for Medici's guests. They even printed Hydra Galerie calling cards that were subtitled "Art of Ancient Egypt, the Near East, Greece and Rome" and bore an image of the namesake multiheaded monster that graced the vase in the front window. With his business in place, Medici was ready to negotiate what he hoped would be the biggest payoff of his career. To sell the plates, he would get in touch with his old friend, Robert Hecht.

For the first time since the Getty shipped off the chalice at the end of 1980, the elusive Euphronios surfaced again—and it was going on tour. Along with Bunker Hunt's fragmentary Euphronios krater, the chalice would headline a traveling exhibit of the antiquities collections that Bunker and his brother, William Herbert Hunt, had bought, mostly from Hollywood dealer McNall. The tour of the exhibit, which they dubbed Wealth of the Ancient World, began practically in the Hunts' backyard, at the Kimbell Art Museum in Fort Worth, Texas, where the vases, statues, and coins went on display from June 25 through September 18, 1983. From there the Sarpedon cup went to the Virginia Museum of Fine Arts in Richmond from October 19 through De-

cember 11, 1983, followed by the Detroit Institute of Arts from February 1 through March 22, 1984. The chalice's travels wrapped up nearly a year after they began, landing back near Bunker Hunt's home at the Dallas Museum of Art from April 25 through June 10, 1984.

To promote the exhibit—and to promote the Hunts' investments—McNall also orchestrated a glossy, color catalog, published in 1983 by the Kimbell Art Museum, and featuring essays by scholars including the Met's Dietrich von Bothmer. The Kimbell published the catalog in association with Summa Publications of Beverly Hills—the publishing arm of Summa Gallery, the antiquities shop that McNall ran with Robert Hecht. The catalog deftly managed to take advantage of the boost that the Sarpedon chalice and fragmentary krater had gotten from passing through the Getty and being published by a former Oxford professor; the entries for each of the two Euphronios vases cited Robertson's *J. Paul Getty Museum Journal* article in the bibliographies for the objects. The catalog entry for the Sarpedon chalice even said that von Bothmer had cited the cup in his publications of the speeches he gave in Berlin and Troy, New York, in which he had mentioned that the Met's krater had a missing twin. Suddenly, this chalice of mysterious origin seemed to have an illustrious and well-documented past.

To celebrate the last leg of the exhibit's journey, the Hunt brothers wore black tie, accompanied by their wives in elegant evening-wear, to an event marking the Dallas installation. The vases stood on white pedestals protected with glass cubes while their owners basked in the ancient glory of respectability of the masterpieces they owned. It would be their last chance. Wealth of the Ancient World made one more visit to a public gallery—the High Museum in Atlanta—from December 10, 1985, through February 9, 1986, and then the Hunts saw the chalice slip from their hands.

• • •

By now, the Hunt brothers had pretty much retired as the country's highest-rolling buyers of antiquities. That left the Getty alone at the top, which was its good fortune when another Euphronios popped up on the market. No, this one wasn't in the same league as the Sarpedon krater and chalice, which were two of just nine known vases painted and signed by Euphronios. Rather, this giant kylix wine cup bore his signature as the potter, a more common and less valuable find. Euphronios spent the last years of his career potting, rather than painting, vases, likely because he suffered from failing eyesight. Another artist, named Onesimos, had painted this cup with the sprawling scene of the sack of Troy by Greek forces at the end of the Trojan War. Only a portion of the cup had seemed to survive into modernity—the center, base, and a broad section that included part of the kylix's rim— and a dealer named Frieda Tchacos of the Galerie Nefer in Zurich had offered it to the Getty curator, Jiri Frel. Frel jumped at the chance to pay her $180,000 for the nucleus of the cup, which comprised about two-fifths of the original vessel.

The Met's Dietrich von Bothmer took notice of this purchase and realized that in his own personal collection, he had a missing portion of the Getty's new Onesimos-Euphronios kylix. Now that the Getty had a big chunk of the cup, it made no sense for him to hold on to the piece. So he dug it up, like a boy going through his baseball cards for a player whose team he'll never get to compete anyway. He found the shard. It was just as he had gotten it, so many years before: labeled with a slip of paper that read "B.H. '68."

This was the same fragment the Met curator had bought two decades earlier from Robert Hecht, hoping to find it a home in a broken vase. Measuring just 4 centimeters by 3.4 centimeters,

the piece bore an image from the cast of characters in the sack of Troy. The Getty curators thought it might even be Helen herself, the face that launched a thousand ships. The fragment portrayed a woman in profile, from just below the nose, up through the steely gaze of her eye, an impeccably plucked eyebrow, and a wavy head of hair. The flip side, which originally decorated the outer surface of the cup, had a warrior's helmet. In 1984, von Bothmer donated the shard to the Getty, reuniting it with the other remains of the giant cup, and taking a tax deduction for his generous contribution to the rival museum.

It was a busy time for the Getty's antiquities department as it worked hard to spend the fortune left by its founder, J. Paul Getty, who had died in 1976. The aim was to build a collection, practically from scratch, that would rival those of the Met and the great European museums. The Malibu museum even got its hands on the namesake vase of Medici's Hydra Galerie. Toward the end of 1983, Medici, acting at an agent for Koutoulakis, sold the hydria decorated with the Hydra to the Getty for $400,000.

Through the early 1980s, the Getty bought several more items from Medici's shop, from a Greek amphora to a Roman marble sarcophagus decorated with angels. Some material, however, was not up to the Getty's standards. Starting in 1985, Medici became a good client of Sotheby's London auction hall, putting increasing numbers of vases up for sale.

In June 1985, the weekly Italian magazine Epoca *published an article* titled "*Tombarolo offresi per consulenza*," or "Tomb Robber Offers Himself as Consultant," in which an admitted *tombarolo*, Luigi Perticarari, talked about his trade. The article ran with a color photograph of a vase and the caption, "A splendid Attic vase with red and black figures. Patiently reconstructed from a mosaic of

fragments found in a field, at a burial devastated by a plough, it was 'saved' by a *tombarolo* of Tarquinia, and then sold to an antiquarian for 4 million lire," the equivalent then of about $2,100.

At around the same time, Sotheby's published its catalog for a July 17, 1985, antiquities sale in London. Lot 540 was a red- and black-figure vase from Athens, dating to the sixth century B.C., around the same time that Euphronios was working there, and it drew the attention of the Met's von Bothmer. He knew he'd seen it somewhere, and he soon recalled the *Epoca* story. The Met curator immediately sent a letter to the auction house's London antiquities chief, warning her to pull the vase from the auction.

"In keeping with the usual policy of Sotheby's, I withdrew Lot 540 from the sale," Felicity Nicholson, who was the head of So-theby's antiquities department in London at the time, later told Italian prosecutors. "This wasn't because the owner didn't have title (which hasn't been proved)," she said. "I couldn't be sure that the vase in the article wasn't Lot 540, and enough doubt and preoccupation was expressed by an eminent authority."

As Italian police and the British art media hunted for the source of the tainted Lot 540, these revelations set off a chain reaction that doomed Medici's career and led to upheaval in the art market and museum world. A British journalist, Peter Wat-son, started digging into the Lot 540 affair, and uncovered evi-dence that Medici was supplying hundreds of undocumented objects to Sotheby's. He was even using the auction house to launder vases, buying most of his pieces back himself through the front man at his Geneva gallery. With the Sotheby's pedigree, Medici could provide clear, legal titles for the pots and statues he owned. Sotheby's turned a blind eye to this practice, and because the auction catalogs provided anonymity, nobody in the market knew Medici was both the buyer and seller of some lots.

While the police and press were getting closer to figuring out Medici's methods, the Hydra Galerie did what would become one of its last important deals, selling missing fragments from the huge Onesimos-Euphronios kylix to the Getty. The October 28, 1985, invoice signed by Christian Boursaud shows that the museum paid $100,000 for Attic red-figure kylix fragments, "Onesimos painter—Circa 490 B.C. Dimensions: appx. 26 x 16 cm." They were formerly of the "Zbinden" collection of Geneva—a name Medici had used before.

From Medici's point of view, business was booming—and it was time to quit while he was ahead, or at least to change his business model. The brisk trade was attracting too much attention. On March 25, 1986, a lawyer named Charles-Henri Piguet conducted an inventory of the Hydra Galerie's property as part of dissolving the company and settling the accounts between Medici and his partner, Boursaud. After they disbanded the business, the artifacts became Medici's property. But instead of changing his ways, Medici just took the operation underground.

The antiquities world had its Watergate break-in on April 3, 1986, in San Felice Circeo, a seaside town south of Rome. Like the bungled burglary that toppled Richard Nixon, it didn't seem like much when it happened. But for the mighty to fall, all investigators needed to do was follow the money.

The Torre Paola was an obvious target. Pope Pius IV had the round fortress built in 1563 atop a rocky outcrop. More than five hundred years later, the tower and its more modern living quarters overlooked the busy beach resort of Sabaudia and were often unoccupied. The property's noble-titled owner, the Marchesa Alessandra de Marchi, made her permanent home in Rome on Via Livenza. The stone landmark was in many ways just a store-

house for the family's riches. With a little planning—and a truck—it would be easy pickings for professional burglars.

Sometime between Thursday night on April 3 and the following Friday morning, the men forced open the property's huge doors by sawing through a heavy padlock. Once inside the vacant building complex, they smashed inner doors with axes and set about stripping the interior of its furnishings.

The burglars went out to a patio where they found a two-thousand-year-old treasure: a Roman child's sarcophagus carved from a solid block of white marble. This was the sort of artifact that had made its way into private collections, legally, over the previous centuries. The owners had supported the sarcophagus on two halves of an Ionic capital, the scroll-topped classical columns found in Greece and Rome. The burglars took those, too.

In an entryway, they ripped a marble Roman bust of a man from the wall and tore down other decorations. Using their pickax, they detached a fireplace, removing the front of what had probably been an adult's coffin made of white marble. Unlike the child's coffin, which was incised with a simple geometric pattern, this one bore a carved bas-relief of a dramatic maritime scene depicting sea horses and, near the center, a huge head of Neptune, god of the seas.

The burglars also scooped up carpets, antique furniture, paintings, and two large Roman capitals, one done in the Ionic and the other Doric style. They carted those out along with a collection of twenty-four crystal glasses and a half-dozen bottles of whiskey. They even took cannonballs from the upper fortress of the tower itself. In all, it was an incredibly heavy load and a hard night of labor. It must have taken at least one truck and a team of men to pack up and drive away down the stone-paved access road. And they had worked quickly. By the time the Marchesa's

trusted custodian, Giuseppe Borsa, arrived for work at 7:30 A.M., there was no sign of the burglars except the shattered doors, empty rooms, and scarred walls. The best stuff was already headed north, and some of it would soon cross the border.

When Sotheby's published the catalog for its May 18, 1987, London antiquities sale, at least three items set off alarms among the Italian art police who routinely scanned auction offerings: Lot 268, "A Roman Marble Column Capital, circa 3rd Century A.D."; Lot 291, "A Roman Marble Strigilated Child's Sarcophagus"; and Lot 354, a fragmentary front of a Roman marble sarcophagus, decorated with carvings of sea creatures and the god Neptune's head. Comparing the Sotheby's catalog with descriptions of stolen art in their database, the Carabinieri officers in Rome concluded they had found a match to three artifacts taken from Marchesa de Marchi's country home only a year earlier. The art squad contacted Interpol, the international crime-fighting cooperative, to communicate a request to the British police asking them to block the sale in London.

Just two hours before the sale was to have happened, Felicity Nicholson, chief of Sotheby's London antiquities department, called the man whose company had put the pieces up for sale, telling him that the Italian authorities said they were stolen. The artifacts never made it to the auction block. Sotheby's pulled the column capital and two sarcophagus pieces from the offerings, placing them in storage at its facilities in London.

It may have seemed like a small victory for the Italians. In financial terms, they had taken just a minuscule bite out of the antiquities market; the auctioneers had estimated that the capital and the baby's coffin would sell for little more than 2,000 pounds each, and the carving for 1,000 pounds. But the operation yielded

a piece of information that proved to be several thousand times more valuable.

During Scotland Yard's inquiries on behalf of the Italian art police, Sotheby's gave investigators the name of a Geneva-based company that had consigned the three antiquities for sale. Although it was just a name, it gave the Carabinieri a place to look— Editions Services S.A. Even so, it would take them a decade to figure out what Sotheby's already knew: the name of the man behind Editions.

"Bob, let's make a contract," Giacomo Medici said to his old colleague, Robert Hecht. Medici was pitching him on his plan to sell the twenty red-figure plates he had traded for the hydria jug with the Hydra monster.

Hecht jumped at getting a cut of what would also be one of his biggest deals. The two drew up a contract, dated May 29, 1987, which stipulated that Hecht would get 5 percent of the sale of the plates and also some red-figure fragments of Athenian pottery dating to 490 to 480 B.C. The target price for the plates was $2 million, meaning Hecht would earn an easy $100,000 for brokering the deal. And there was one buyer who had that kind of cash to throw around on ancient dishes: Marion True at the Getty Museum.

True was the rare woman who had made it to the top of the academic antiquities world, which had been dominated by the old boys' club of Beazley, von Bothmer, and their crowd. She had earned her spot there, researching her Harvard PhD in art history while working at the Getty. She also made the right connections, studying under the Met's von Bothmer, who had an additional post at New York University. In 1986, when she completed her Harvard doctorate, the Getty appointed True the new

chief of the museum's antiquities department. Hecht decided he and Giacomo Medici should pay her a visit.

In the spring of 1987, Medici gathered some bubble wrap at his Geneva shop and started to pack up the Attic red-figure plates, one by one, in an oversized, hard-shelled briefcase. The plates fit into the carry-on bag sideways, in two stacks of ten. In case he hadn't packed them well enough, Medici bought insurance to protect his $2 million investment. He also affixed a tag on the side of the case: "Fragile." This trip would be a turning point for Medici, and an adventure he wanted to share with his son, Marco, who was twenty years old at the time. Marco would accompany his father on a whirlwind tour organized by Robert Hecht. They had tickets not just to Los Angeles, but on the way home they planned to stop in New York. For Medici, making this deal for the twenty plates would let him earn the kind of money Hecht had made for himself fifteen years earlier when he resold Medici's Euphronios krater to the Met for nearly a $1 million profit.

With the briefcase always in his sight, Medici and his son boarded a Swiss Air flight from Geneva to Zurich, where they met up with Hecht, their tour guide and translator. Until this trip, Medici had almost never dealt directly with a museum. He was strictly a middleman. That's how the business worked. It wasn't just that Medici didn't speak English. Dealers such as Hecht had the relationships with curators and museum directors. Hecht, as an American who traveled the world, could credibly say that he'd gotten a vase from an old Lebanese collection or found a statue that had been hidden in a Swiss vault by an old Scandinavian family. And museums liked to buy antiquities that way. Medici, on the other hand, wasn't the sort of fellow a museum wanted to have on its acquisition records. Even though he had a gallery in Geneva, the man lived in the heart of Italy's

tomb-robbing country. To pull off the sale of these twenty plates to the Getty on his own account, he needed Hecht, even though he could somewhat account for the provenance of the merchandise in this case. Hecht would hold his hand the whole way. And it would be fun.

After meeting up in Zurich, the trio connected to a Swiss Air flight to Frankfurt. In Germany, they switched to a Lufthansa flight direct to Los Angeles, where Medici would have to clear U.S. Customs with a briefcase filled with dishes five hundred years older than Jesus.

But first Giacomo and Marco had to survive a flight halfway around the globe with Robert Hecht and his infamous temper—which, combined with his love for drink, resulted in a scene that would play out several times during the weeklong road trip. When Hecht asked for a beer, he wanted it so cold that frost would form on the can or bottle. Inevitably—especially on the long flight—it wouldn't come that way. When the chilled yet not frosty can arrived, Hecht unleashed his anger at a hapless stewardess and refused the beer. Medici just kept watch over the bag of ancient plates, and hoped they wouldn't run into any turbulence.

Some twelve hours later, the jet touched down at LAX, where it was almost nighttime. Medici gripped the bag and wondered what Hecht would do to get them across the border. They stepped off the plane, cleared immigration, and headed for customs. The federal agents had been waiting for them. But in a good way. The Customs Service men were joined by another, private customs agency man from a service hired by Hecht. Before they had even left Europe, the American dealer had forwarded all of Medici's information to the private service—including a description of the plates, their value, and an explanation that they were destined "for study" at the Getty. The service, in turn, had already obtained a clearance from the border guards to let the plates into

the country. Giacomo, Marco, and Robert whizzed through like VIPs. At the curb, they were met by a Rolls-Royce loaned by one of Hecht's friends in Los Angeles—none other than Bruce Mc-Nall, through whose hands the Sarpedon chalice had once passed. Hecht traveled in style when he could. A creature of the great pedestrian cities of the world, the resident of Paris and New York normally got around Los Angeles in taxis. The chauffer drove them to their hotel, where they rested before their mission to the Getty the next morning.

The next day, when the Rolls-Royce dropped them off at the museum, Medici finally let go of the plates. He handed them off to Hecht, who took care of the formalities of checking the merchandise in with the museum's experts and obtaining the paperwork certifying the plates were on loan. Medici and his son, given visitors' passes, were free to roam the museum's grounds, which J. Paul Getty had designed as a copy of a Roman villa. As he and Marco toured the museum, Medici saw antiquities, many of which were new to him, and several of which prosecutors would say were very, very familiar. As they toured the galleries, Marco held on to his father's 35 mm Minolta camera. And every so often, Medici, with a white cotton sweater draped around the shoulders of his yellow Lacoste tennis shirt, would pause in front of a display case for a snapshot. In retrospect, he probably shouldn't have.

To cap off the day, Hecht arranged for dinner with Marion True, the antiquities curator, at an Italian restaurant in Malibu called Prego. Medici and True had met only once before, a year earlier at the Bola auction in Basel. On that occasion, they had dined with the Met's von Bothmer. This time around, the legendary vase connoisseur was one of the main subjects of conversation. They spoke in their one common language, French.

To start the meal, Hecht took charge, commandeering the

wine list for ten minutes before settling on a California red. They ate their way through a plate of antipasti, and then a pasta course. Medici had the *tagliolini* with a meat ragu sauce topped with basil. To finish the feast, True, Hecht, and the two Medicis shared a platter of sizzling T-bone steak, known in Italy as a *Fiorentina*. At the end of the meal, True said she'd take a look at the plates, which she hoped to propose to the museum's board for purchase. Hecht paid for dinner. It looked like they might be able to close a sale within months.

For the next couple days, Medici and Hecht took a vacation of sorts, enjoying the hospitality of the American dealer's California friends: driving around in the Rolls with its stocked bar, playing tennis at a mansion overlooking Los Angeles, and enjoying long lunches, accompanied at times by much younger women—friends of friends who had big, 1980s West Coast hair. Medici couldn't communicate with his new acquaintances most of the time, but he had a blast. His career was about to take off, and again it was Hecht who was bringing him to the next level, just like in the old days. Plus, he got to play tennis. Life was good.

After three days, with the plates safely under study at the Getty, the party moved to New York. Hecht and the Medicis flew first class on Pan Am to JFK airport, where they boarded a helicopter that whisked them directly across the East River and into Midtown Manhattan. The chopper landed on the roof of what was still called the Pan Am Building, and the men alighted on the helipad fifty-nine stories above Park Avenue, face-to-face with the pointy spire of the nearby Chrysler Building. Again, Hecht had handled all the details. A car waiting downstairs sped them to the Upper East Side, where Giacomo and Marco checked into the Westbury Hotel on East Sixty-ninth Street—conveniently just steps from Central Park and a ten-minute walk to the Metropolitan Museum of Art.

Medici had only a little bit of business to conduct in his two or three days in New York. He dropped in on the Fifth Avenue antiquities gallery run by Hecht's business partner, Jonathan Rosen. And, of course, Medici and Hecht couldn't pass up the chance to pay a visit together to the Euphronios krater. Medici wore a necktie for the occasion.

Sarpedon awaited the men in the Greek and Roman galleries. After climbing the front steps of the museum, Giacomo, Marco, and Bob stopped at a ticket desk to get their admission pins, the Met's signature color-coded tin circles with bendable tabs on the back and "M" logos on the front. Medici slid the tab of his pin into the left lapel hole of his jacket. Hecht affixed his to the collar of his V-neck sweater. Then they took a left turn and headed past the security guards toward a room labeled "Attic Red-Figure." There, under glass in case 19, they found the Lycian prince, still bleeding from his torso after all these years. Sleep and Death, frozen in time on the face of the grand vase, were lifting Sarpedon's body. Marco, holding the Minolta, waited for his father to pose.

Medici rested his left hand on the edge of the display case, where the glass met the tall base that kept Sarpedon at eye level. He planted his right fist in his waist. When Marco snapped the photo, his father was grinning. Hecht also posed.

It would be both Medici and Hecht's bad luck that the camera and the film inside successfully made their way back to Geneva, along with Giacomo and Marco, on Swiss Air flight 111.

Auction of the Century

Italian investigators took just two weeks to track down Editions Services, the company identified by Sotheby's as the source of the artifacts stolen from the five-hundred-year-old de Marchi tower. The firm's address was 7 Avenue Krieg in Geneva, in the offices of a man named Henri Albert Jacques. On June 2, 1987, Swiss officers questioned the fifty-seven-year-old on behalf of the Italian art police—and had a tough time of it. The Geneva native, it turned out, knew his legal rights, making him the embodiment of Swiss financial secrecy.

"This is an inquest being conducted by Italian authorities in Rome," he reminded the Swiss police at the outset. "Given that, I'll just say that in the first place, as far as I know, no criminal complaint has been transmitted here."

Jacques would cooperate only as much as he wanted to. He explained that he was the administrator of Editions, a company based in Panama and established on September 4, 1981. "As far as the company goes, I only have an administrative function," he said. This assertion wasn't unusual. It's common for firms incorporated or based in jurisdictions such as Switzerland or the

Caribbean to simply use an address, and an administrator such as Jacques, to maintain a legal presence. Several other companies he serviced shared the same 7 Avenue Krieg mailing address.

Jacques did briefly address questions about the three artifacts Sotheby's had pulled from its sale the previous month. He said it would be hard to prove that the column capital and the sarcophagus front had come from the burglary. And, he said, the child's marble coffin had belonged to the person who consigned it to Editions for three years, long before the burglary.

His opinion didn't really matter, however. He was just an administrative front for the antiquities traffickers. What the Italians really wanted to know—and what they hoped the Swiss could squeeze out of Jacques—was the name of the person or people behind the sale.

"As far as the provenance of these objects goes, I don't want to reveal the identity of the people who consigned them to Editions Services S.A.," he said in the written deposition he signed for the police. "And really, in my opinion, this is all just an attempt to identify these people for financial reasons," he said, invoking Swiss financial privacy laws to distinguish this inquiry as a commercial affair, rather than a legitimate criminal probe. "In any case, I'm available to answer any questions formulated by a prosecutor in the context of an official trial.

"I've known my clients for a long time and they are, to my knowledge, very honest," Jacques said. Then he sent the police packing. The Italians would need to get much better evidence if they were ever going to get this front man to reveal his secrets.

Giacomo Medici's attempt to make millions in a single sale to the Getty wasn't looking good. On June 26, 1987, the museum's antiquities

chief, Marion True, broke the bad news. Her bosses didn't want to spend $2 million on twenty plates that all looked essentially the same to the untrained eye. Although she hoped to change the museum director's mind, she wasn't hopeful. The Getty returned the plates to Medici in Geneva.

In Dallas, the Hunt brothers also saw their hopes for a big deal fall apart. Their plan to amass raw silver had backfired. During their spree spanning 1979 and 1980, they had managed to purchase some 59 million ounces of the precious metal—then estimated at a whopping one-third of the world's entire supply. But then the silver market collapsed, making it impossible to unload their holdings and sticking the Hunts with $1.5 billion in losses. Although the brothers denied any wrongdoing in their silver purchases, the losses and lawsuits forced them to file for bankruptcy protection from their creditors in 1988. The following year the Internal Revenue Service said Bunker Hunt owed $730 million in taxes and interest, and his brother owed a bit less than half that much. In all, Bunker owed creditors about $1.5 billion, and his brother owed nearly $1.2 billion.

As the Hunts worked their way out of bankruptcy, they needed money to pay their tax bills. One asset that had retained its value was the antiquities. In November 1989, the brothers announced that Sotheby's would auction their vases, statues, and coins. After being squirreled away in Bunker Hunt's private collection for nearly a decade, the Sarpedon chalice would be brought into public view again.

To drum up interest, Sotheby's flew selected pieces from the collection across Europe, to London, Paris, Frankfurt, Munich, Monte Carlo, Zurich, Geneva, and Asia, hitting Hong Kong, Singapore, and, in Japan—a growing destination for antiquities—both Tokyo and Osaka. Bunker Hunt, who would get to keep some of the auction proceeds if the sales exceeded certain

targets, joined the publicity parade, doing press interviews in New York, lamenting the loss of his collectibles.

"I hate to have to sell them, but that's what life is. Sometimes you buy and sometimes you sell," Hunt said during a preauction interview with Dolores Barclay of the Associated Press. "It's like friends. You hope to make new friends as time goes on, and you hope you won't lose all your old friends. I'll miss them and it's been a great pleasure collecting them and owning them, but I'll just have to go and do the best I can. I don't know if I'll ever be an art collector again, but I enjoy going to museums."

"But," he said with a sigh, "all good things come to an end sometimes, and I know these new buyers will enjoy them."

Despite the Sotheby's scandal involving Lot 540—which Giacomo Medici's Hydra Galerie had put up for sale—Medici was still a client of the auction house. So it was his luck that they were about to stage the most important antiquities sale of the past hundred years, if not longer. Medici wasn't the only one excited at the prospect of bidding on the Hunt collection. "We are hoping for a feeding frenzy," gushed R. Carter Pate, the trustee in charge of liquidating Bunker Hunt's estate.

Although the coin sales would drag on for months, the finest antiquities would take the stage immediately. Sotheby's scheduled the first of the sales for the evening of Tuesday, June 19, 1990, at which they would auction Bunker Hunt's collection of Greek vases and his brother's collection of Greek, Roman, and Etruscan bronze statues and a few other ancient odds and ends. In all, fifty-three lots were up that night. But the Euphronios chalice was the pint-sized star of the auction. Sotheby's even chose "Sarpedon" as the code word that absentee buyers should use when sending in bids for that evening's sale.

Vases such as the two by Euphronios were so rare—and the practice of artists putting their names on their works was so new and unusual back in 520 B.C.—that Sotheby's had never before sold any signed work of ancient art. For fans of Euphronios, this would be a once-in-several-lifetimes chance to buy one of his pots; one hadn't been up for auction since 1841, when King Ludwig I of Bavaria bought Euphronios's Geryon-Heracles cup in Frankfurt from Lucien Bonaparte's princely collection.

To build the hype and boost the sale, the auctioneers courted the media. On June 4, 1990, they gave a private preview to Suzan Mazur, a journalist for the *Economist,* and a photographer working with her, George Obremski. Mazur had come to see Euphronios—both the Sarpedon chalice and the other, fragmentary piece Bunker Hunt had bought from Bruce McNall.

Sotheby's Richard Keresey, a New York–based antiquities expert, helped give the tour. First they took a look at the fragmentary krater, and then they moved on to the Sarpedon kylix. "Here's the cup," Keresey said as they approached the chalice that Euphronios had made some 2,510 years earlier. Mazur was seeing the objects without the customary glass case separating her from these masterworks. The image of Sleep and Death hauling Sarpedon's bleeding corpse peered up at them.

"Quite a lot of wine," Mazur said, eyeing the footwide rim of the shallow cup.

"A lot of wine," the Sotheby's expert said. "They mixed their wine with water."

"And how much of this is reconstructed?" Mazur asked, seeing that the cup had visible fissures and undecorated black areas that showed where the original clay had been patched by restorers.

"Pretty much what you can see, the crackled parts," Keresey said, pointing out that the main artwork, however, hadn't been badly hurt by the millennia of damage.

"Is it heavy?" Mazur asked.

"You can hold it," Keresey offered.

The unexpected and rare treat unnerved the journalist. Her skin would touch the same surface Euphronios's had, the same surface the Etruscans had handled and tomb robbers and smugglers had passed their fingers over. This cup had ruined Dietrich von Bothmer's archaeology career and had made its way from Robert Hecht to Bruce McNall to Bunker Hunt. None of them had damaged the precious kylix. So as much as Mazur wanted to hold the masterpiece, she didn't want to break it.

She steadied her palms, slid them under the cup, and lifted. "I'd better hold it with both hands," she said.

Keresey, sensing what the journalist might be thinking, reassured her. "They broke all the time, I think, in antiquity but they always had repairers," he said. Mazur gently placed the cup back down.

They didn't know it then, as Mazur finished her tour, but both of them had good reason to fear for the cup's safety.

On June 15, 1990, Sotheby's opened its doors, and the general public had its chance to see the chalice and the other treasures of the Hunt collection in an auction preview. The same day, a Friday, Giacomo Medici landed in New York with his wife, Maria Luisa, and daughter, Monica.

First they checked into Medici's usual haunt, the Westbury Hotel, on the Upper East Side, halfway between Sotheby's and the Metropolitan Museum of Art. The family visited the auction house on East Seventy-second Street, where they saw the chalice, sitting under glass atop a white pedestal, spotlighted by the track lighting attached to the ceiling above. And they dropped in on the Met to see the cup's twin, the Euphronios krater, the highlight of

Medici's career almost twenty years earlier. That, too, was spot-lighted in its own glass box, like the vases on sale at Sotheby's.

On the morning of the auction, Tuesday, June 19, 1990, Medici swung by Sotheby's for another look at the merchandise. Out-side, Maria Luisa and Monica posed for Giacomo, who took their photo beneath a sign that said SOTHEBY'S. Inside, Giacomo posed for a snapshot beside the fragmentary krater by Euphronios. In the slightly out-of-focus picture, Medici is smiling. He is also wearing a green Lacoste V-neck sweater.

When he returned that evening for the auction, Medici hadn't changed his outfit. He had also asked that Sotheby's identify him only as a "European dealer," keeping his name private. To those who didn't know him, Medici was simply an anonymous bidder in a green Lacoste.

Monica and Maria Luisa came with Giacomo for the 7:00 P.M. auction, but stood apart as he did his bidding just a few rows back from the front. Robert Hecht was just in front of him, and the Sicilian dealer Gianfranco Becchina sat just behind Medici. Medici wasn't the only collector who was prepared to do battle. Leon Levy, the financier, sat not far away, to Medici's left, on the opposite side of the central aisle of the auction floor, near London dealer Robin Symes.

Levy and his wife, Shelby White, had done their homework and were intent on taking home a Euphronios. In a notebook, Levy had recorded his lot-by-lot overview of the looming sale, based on advice he had gotten from Robert Guy, a vase expert who had been the Princeton University Art Museum's associate curator of ancient art since 1984 (and would hold that post until 1991, when he became a senior research fellow at Oxford Uni-versity's Corpus Christi College).

The notes on the recomposed krater by Euphronios were glowing. "Great jewel—for me it's the star despite its fragmen-

tary condition. Better than the kylix cup," referring to the Sarpedon chalice, adding this comment about the cup: "Having an opportunity at it is so rare—price—less than a $1 million." But Levy was leaning toward the fragmentary krater instead: "Quality of drawing is lovely—Incredibly powerful iconographically remarkable—Athena majestically moving, *an absolute must*."

Robin Symes, who would be bidding for Levy, sat next to his partner, Christos Michaelides. The two worked as a team, with Michaelides doing the actual hand raising for the duo. The auction got off to a quick start, with Medici capturing Lot 3, an Attic black-figure kylix, for a total of $82,500. It was just an appetizer. When Lot 5 came up—the fragmentary krater by Euphronios— Medici and the Symes team squared off, joined by a flurry of competition from the auction room and telephone bidders. Medici stopped bidding at about $1.5 million, just $100,000 shy of the $1.6 million final bid. Including Sotheby's commission, Symes and Michaelides, and by extension, Leon Levy and his wife, Shelby White, won the fragmentary krater depicting Heracles and Athena for $1.76 million.

Medici was steamed. He had only one more shot at getting his hands back on a Euphronios. Over the years, he had seen how valuable these pieces had become, and how much profit he had missed out on.

Lot 6, the Sarpedon chalice, came up next. In his head, Medici egged himself on as he began to bid. "Giacomo, have courage," he told himself, as the price grew. He was tempted to drop out as Symes kept bidding higher, this time on behalf of the Met and its Greek and Roman curator, Dietrich von Bothmer, who desperately wanted the cup. Medici just pushed himself, and the price, higher. "Buy it now and you'll sell it for more at an auction," he told himself.

When the bidding ended, Medici, the man in the green La-coste sweater, had bought the Sarpedon chalice, Euphronios's earliest known work, for $675,000—plus Sotheby's 10 percent commission—for a total of $742,500. To wind down, Medici snapped up another three vases, Lots 11, 12, and 13, for $464,750, before stopping.

Von Bothmer, one of the few people who knew Medici's identity, approached him afterward. The German curator was furious. "We want to buy it," von Bothmer barked, and he even offered "a little bonus" if Medici would immediately flip the chalice and sell it directly to the museum before taking it out of New York. Medici declined.

By the time the evening ended, Sotheby's was crowing about the auction's success. "Tonight's sale was a landmark sale of Antiquities and Ancient coins at auction bringing $20,061,250," the auction house said in its after-sale report, released that night. "The record sale of Antiquities of $11.4 million exceeded the pre-sale estimate of the sale by nearly $4 million and set a record for the sale of a Greek Vase at auction," a reference to the record $1.76 million for the fragmentary Euphronios. Every single lot had sold, making the $11.4 million total a record, too, the most spent at a single auction on antiquities.

On other matters, Sotheby's was less transparent. Although some buyers were made public, it listed the purchasers of the two Euphronios vases as "European Dealer." The term, which masked the identities of Symes and Medici, left open the possibility that the two pots had the same buyer. This would later lead to some confusion over the fate of the Sarpedon chalice. On June 25, 1990, Symes sold the fragmentary krater to Levy, who was not secretive about being its owner. That led some in the art world, including the Met's former director Thomas Hoving, to assume that Levy and White had also bought the chalice. But to the pub-

lic, the whereabouts of the earliest known Euphronios again became hazy.

For Sotheby's the sale was more about transactions than transparency. The auction house issued Invoice No. 6042 015 for Medici's purchases to a company based at 7 Avenue Krieg in Geneva: Editions Services.

Never mind that the Carabinieri were still trying to figure out who was behind Editions, or that the company was being investigated by the Italian police after it allegedly attempted to sell stolen artifacts through the auction house's London office three years earlier. Sotheby's knew Giacomo Medici was behind Editions. Ever since Medici had given up his Geneva gallery, pushed underground by the bad publicity from the botched sale of Lot 540, he had been conducting his business through the shell company, which had become a regular Sotheby's client.

At the end of the Hunt auction, Sotheby's billed Editions Services for $1,289,750 and prepared to ship the rare kylix to Geneva.

In the meantime, others were trying to get their hands on the cup.

Alain Pasquier of the Louvre, who had been at the auction, made a pitch to Medici. He was curating an exhibit on Euphronios in Paris, scheduled for September. "I'd be honored if you could lend me the cup for the show," the Louvre's head of Greek and Roman art said to Medici after the auction. Medici was intrigued by the idea. "I'll do everything possible," he told Pasquier.

Medici's work in New York was done. He placed bids for another Sotheby's auction the following day, arranged the shipping details for his five new acquisitions from the Hunt collection, and then, along with his wife and daughter, drove back to the airport and flew directly to Geneva on Swiss Air. Medici needed

to prepare for the arrival of his masterpieces. He bought a fire-proof safe and had it installed in his Geneva warehouse.

Soon enough, this would be the Sarpedon chalice's new home. On July 17, 1990, Sotheby's Art Transport Department shipped the whole horde to Mat Securitas, Medici's shipping agent in Geneva.

Buying the Sarpedon chalice would have been one of von Bothmer's final acts as the Metropolitan Museum of Art's Greek and Roman curator. Later that year he retired as head of the department, but managed to stay on as Distinguished Research Curator, a position endowed by a group of donors that included Leon Levy and Shelby White. In a way, von Bothmer got the consolation prize from the Hunt auction. Levy and White later agreed to lend their new fragmentary Euphronios in 1999 to the Met, where White has served as a trustee. But sitting under glass not far from the Sarpedon krater, the two vases, each signed by Euphronios as painter, would silently raise a collective question: With so few Euphronios vases known, how could these two, plus the matching Sarpedon chalice, have suddenly surfaced by such similar means?

As the Louvre prepared its Euphronios exhibit three months after the auction, more scholars began to pay more attention to the Greek master than ever before, and the riddles of the Euphronios vases became clearer. In preparation for the Paris show, the Getty and museums across Europe, including in Italy, sent vases signed or attributed to Euphronios to the Louvre. But there were two notable exceptions. The Met declined to send the Euphronios krater. And while Medici planned to attend the exhibit's opening, he declined to loan his chalice. The reason, he said, was that the cup had failed to arrive in Geneva soon enough for him to send it to Paris.

As a result, the cup hasn't been seen in public since, though its odyssey has continued.

Sarpedon was the only no-show in Paris when the usual suspects of the antiquities community—the dealers, curators, and smugglers—gathered for the exhibit. Giacomo Medici checked into the Hotel Normandy, near the Louvre and a block from Rue de Rivoli and the Tuileries gardens. After attending the opening day of the exhibit, along with other members of the general public and the collecting community, Medici hit the Louvre gift shop to buy books on Greek pottery. Though there was no official occasion to mark the start of the Euphronios show, the Louvre curator Alain Pasquier helped arrange a dinner. Giacomo Medici, his old business partner Robert Hecht, the Getty's Marion True, and a few others gathered at a chic hotel restaurant for what would be a last supper of sorts.

Medici and True discussed the latest tidbits by Euphronios to surface on the market: three new fragments that fit into the massive kylix painted by his protégé Onesimos, with scenes from the fall of Troy. The Getty had already bought most of the cup from Frieda Tchacos in 1983, and more from Medici's shop. The Met's von Bothmer had donated to the Getty the fragment that he had bought decades earlier from Robert Hecht. Now these three additional fragments were making the rounds. According to Medici's account of the meal, True told him she had recently been offered the pieces, but declined to buy them because they were too expensive. Medici says he told True that he, too, had heard the fragments were available.

Medici and True also discussed a topic just beginning to make trouble for them: provenance. True told Medici how important it was for museums such as hers to be ever more scrupulous about knowing the origins of the things they bought. Italy had started pestering her and the Getty to return some allegedly sto-

len works. It was time to clean up the antiquities business, she told her dining partners.

As Medici, True, Hecht, and their friends partied in Paris to celebrate Euphronios, their world was about to implode—and the Greek master's finest works would be at the center of the wreckage.

One good thing about publishing antiquities of questionable origin is that such publications can inadvertently prove an artifact was looted. That couldn't have been the Getty's intention when it commissioned Dyfri Williams, keeper of the British Museum's Greek and Roman department, to write a twenty-four-page article on the giant Onesimos-Euphronios kylix that the Getty had been assembling for seven years. However, no single article could have exposed an instance of illicit excavation better than this one did.

Presented in 1991 in a glossy, in-house publication called *Greek Vases in the J. Paul Getty Museum Volume 5,* the kylix's coming out dropped two major clues. The first could be seen in the photographs, some of which exposed the bottom of the cup's base. There, etched into the black foot, were angular letters from a long-unused alphabet. Even though the vase had been made in Athens, the words scratched onto the bottom were not made with the familiar Greek letters still used today. No, this was Etruscan script. Although there is always the chance that a Greek vase could be dug up anywhere in the Mediterranean where ancient Greeks traded or had colonies, the Etruscan writing pinpointed the dig spot. Any archaeologist who glanced at Figure 8k in the article would know this kylix came from Italy.

But Williams's only mention of the scribbling came in the last line of his piece: "The graffito under the foot has been published by Jacques Hergon." And indeed a footnote refers to an article in

the previous volume of the Getty's Greek Vases series, published in 1989, "Graffites étrusque au J. Paul Getty Museum." The Getty, it turned out, had revealed the Etrurian origins of Greek pots in its collection two years earlier—in French.

The Etruscan writing on the bottom of the Onesimos-Euphronios cup was just the Williams article's first clue to illicit origins. The second came just before the footnotes in a passage labeled "ADDENDUM."

"In November 1990, long after the text of this article was written and submitted, I was kindly shown photographs of a further joining fragment of the Getty Onesimos cup. It is a rim fragment, made up of three pieces," Williams wrote before describing the decorations, including Ajax's head and chest on one side and Helen's outstretched hands on the other.

The British Museum curator knew about the same three fragments on the market that Medici and True had privately discussed over dinner in Paris after the opening of the Euphronios exhibit. Now, instead of this being gossip of the antiquities trade, Williams made public—in a Getty publication—that the Getty's massive cup had missing bits that were currently circulating for sale. Add to this the photos showing the cup's Etruscan archaeological origins, and all someone had to do to cause trouble for the Getty would be to decipher the meaning of the graffito on the base and connect it to an actual looting site.

The break came in 1993, when a dig run by Italy's Archaeological Superintendency for Middle Etruria turned up a large cult edifice dedicated to Heracles, the hero worshipped by the Etruscans as a god. The location was the Sant'Antonio zone of Cerveteri, near where tomb robbers had unearthed the Met's Sarpedon krater.

The discovery of the sanctuary in Cerveteri had added relevance to the Italian archaeologists because it was connected both

to Euphronios, by proximity to his other finds, and to Heracles
through the site's dedication to him. There was one other item
that also connected Euphronios to the hero turned god: the giant
kylix at the Getty. Scholars had decoded the graffito on the cup's
base, and in the language of ancient Caere, it said "Ercle." Her-
acles.

The Getty's cup had been an offering at an Etruscan temple to
Heracles, and now the archaeologists had found the spot. One by
one, through scientific excavation, the Italians were closing in
on the Euphronios vases of Cerveteri.

The woman who connected the dots was an Italian archae-
ologist, Maria Antonietta Rizzo, who had worked in Cerveteri.
Rizzo chose to unveil her findings at a conference at the American
Academy in Rome—Robert Hecht's old base of operations. Orga-
nized by both Italians and Americans, the roundtable discussion
on February 18, 1995, was called *Antichita Senza Provenienza*,"
"Antiquities without Provenance." Rizzo's paper was blistering.
She explained how the Getty had slowly built up its cup by ac-
quiring fragments four different times from 1983 through 1990.
Those acquisitions included the piece that Dietrich von Bothmer
donated to the Getty in 1984 and the purchases from Medici's
Geneva gallery. She used the Etruscan inscription "Ercle" on the
bottom of the cup's foot to link the kylix potted by Euphronios to
the Heracles site in Cerveteri's Sant'Antonio zone.

She also presented a partial inventory of other Euphronios
works, their murky histories, and their sudden appearances in
recent decades, including the fragmentary krater in the Levy-
White collection and another partial krater at Munich's antiqui-
ties museum, attributed to Euphronios by the man who sold the
vase to the German museum in 1966—Robert Hecht, of course.
That Munich krater, Rizzo pointed out, had been augmented
with missing fragments as recently as 1988.

"The appearance on the antiquities market of dozens of fragmented vases, and even just fragments themselves, coincides with the most active years of clandestine digging, not just in Cerveteri, but in all the major Etruscan cities," she said. "These excavations have destroyed entire sites in search of material that could satisfy the increasing needs of collectors, or of scholars who, trying to reconstruct the collected works of great artistic personalities of the past or to add another attribution to their lists of accomplishments—without any supporting evidence of historical context—have become participants in the unprecedented destruction of archaeological areas and monuments that until now had been saved through the passage of millennia."

She concluded with an appeal: "Colleagues, scholars, museum directors, may I ask you not to encourage the clandestine market, not to continue buying material with unclear provenance? Only in this way can we stop the market from growing, stop the prices from rising—which induces the quest for more objects to sell—and stop the destruction of entire sites in the name of collecting."

Years would go by before her plea was heard. However, just a few weeks later, the Italian art police in Rome set off a chain reaction that eventually got the world's attention.

On March 8, 1995, the Carabinieri investigating the de Marchi burglary sent a request to the prosecutor in Latina, near the beach resort where the marble coffins, capitals, and other artifacts had been stolen—some of which apparently were put up for sale at Sotheby's by the Swiss-based company called Editions Services. Having failed in their previous attempt to pry information from Editions' administrator, Henri Albert Jacques, the Italians had another strategy. They asked the magistrate, Riccardo Audino, to use his authority to make a cross-border "urgent request for judicial assistance" under the terms of a 1959 European

convention. Carabinieri marshals Serafino Dell'Avvocato and Bruno Cerone pleaded with the prosecutor to ask his Swiss counterparts to interrogate Jacques to find out who had put the stolen antiquities up for sale at Sotheby's and to allow the Italian art police to be present at his questioning and that of any other Swiss resident involved in the attempted sale.

Such an official request from a prosecutor would carry the legal weight the earlier attempt had not. The Latina prosecutor immediately agreed, and on April 8, 1995, he sent his request to Geneva.

Shattered

Though the Italian art police were unaware of this, their investigation of stolen antiquities had led them northward to Switzerland and Sotheby's at the very same time that British journalist Peter Watson's investigation of Sotheby's was leading him southward to Italy. Watson had been looking into this story for a decade. In December 1985 he had reported in the *Observer* about Sotheby's auction of Apulian vases, which the British Museum's Greek and Roman curator Brian Cook said were certainly from recent illicit excavation; practically all of the known vases of that type had already been cataloged, and these were *not* in those catalogs. More recently, Watson had obtained a trove of internal Sotheby's documents in 1991 from a disgruntled former employee of the auctioneer's London office.

The documents gave Watson an unprecedented view of what had really been going on inside Sotheby's. He discovered, for instance, that the newly surfaced Apulian vases Cook had complained about in 1985 had been put up for sale at Sotheby's by Christian Boursaud of Geneva's Hydra Galerie—one of the auction house's biggest clients, who had supplied hundreds of Italian

antiquities to the London saleroom. The documents also showed that soon after the 1985 controversy over the Apulian vases, the Hydra Galerie and Boursaud stopped putting antiquities up for sale—and that another company, called Editions Services, later consigned some of the exact same objects that had failed to sell in the earlier auctions. Watson had figured out by 1995 that the mystery man behind the Hydra Galerie was the same person behind Editions Services. His trove of documents held a clue.

Among the papers was the letter Dietrich von Bothmer sent to Sotheby's, warning that Lot 540 from the July 1985 sale was a match to a vase he had seen in the magazine *Epoca,* in the article about a tomb robber. Now, ten years later, Watson was working on a television documentary about Sotheby's, and his team, including researcher Cecilia Todeschini, tracked down the *tombarolo* from the article who said he had dug up the vase. His name was Luigi Perticarari. When Watson and his crew interviewed the confessed tomb robber on camera, he demonstrated his digging techniques and even said he remembered Lot 540. He had sold it to a man who lived in a big house and was "worth millions." But when asked who this man was, Perticarari refused to answer on camera. They switched off their camera, and he revealed the name of the man to whom he sold the vase: Giacomo Medici.

The camera was off, but as Watson later wrote, "We had left our tape recorder running." He had figured out who the man behind the vase trade was at the exact same time as the Italian police were closing in.

The Italian art squad's attempt to crack open Editions Services with cross-border paperwork seemed to be working. Judge Jean-Pierre Trembley in Geneva agreed to the request, and on September 12,

1995, Inspector Alain Baudin and Inspector Lovo of the Swiss police interviewed Jacques. This time, the administrator of the Panamanian shell company had to cooperate fully, and two Italian Carabinieri would be in the room at Baudin's office to take notes.

Jacques explained again that he was just the administrator of the company, which had been established in 1981, and he reiterated why he hadn't been more helpful during his initial questioning eight years earlier. "At the time of my previous deposition, I essentially refused to reveal the owners of the three pieces consigned to Sotheby's because there wasn't any official criminal case," he said. This time was different.

"Editions Services S.A. still exists. On February 24, 1986, it was bought by Mr. Giacomo Medici," Jacques said, according to his written deposition. That meant that after the de Marchi robbery—and also after Hydra Galerie's kerfluffle with Lot 540 at Sotheby's—Medici had found himself a new vehicle for doing business. Medici's purchase of Editions in 1986 also made him the owner of the company when it put the three alleged de Marchi objects up for sale at Sotheby's in 1987.

But most important, the Carabinieri finally had the name they were looking for behind Editions: Medici.

And Jacques wasn't finished talking. "The aim of this company consists solely of putting antiquities up for sale at Sotheby's. Medici puts them up for sale in the name of the company. The income from the sales goes to Mr. Medici," he said. He even gave the investigators Editions Services' bank account number at UBS in Geneva. If that weren't enough, Jacques, seemingly afraid of getting dragged into the case, coughed up an invaluable detail.

"I can also add that in 1991 Editions Services S.A. rented room number C 4.17.6 at the Geneva Free Port," he said.

This gave the Italian art squad the lead they needed. The Geneva Free Port is a modern warehouse complex with special

customs status. Companies that rent space there can bring goods into Switzerland and then store them or sell them at the Free Port without paying import taxes. Buyers can export the goods, also duty-free. For merchants that used Switzerland as a transshipment point, the arrangement was ideal. They didn't pay tax, and anything they exported appeared to have originated from Swiss soil, as opposed to, say, Italian.

The Carabinieri wasted no time. They knew Jacques could easily let Medici or his associates know he had told them that Medici was behind Editions Services and that Editions had a warehouse space. Immediately after the interrogation, the officers contacted the Latina magistrate, Riccardo Audino. The next day—September 13, 1995—Audino sent another urgent judiciary assistance request to Judge Trembley. "In the course of the investigation," he wrote, "it emerged that the company Editions Services S.A. has used some rooms in the Geneva Free Port.

"Because these rooms could be holding works of art trafficked from the home of Alessandra de Marchi, it is requested that you please issue a search warrant, and that police from Rome's Carabinieri art squad be present for the search," the Latina magistrate wrote.

The Swiss agreed to the search.

*Medici was on vacation in Sardinia with his family at a hotel on th*e Costa Smerelda when the phone rang. A colleague at the Geneva Free Port had bad news. The police had come to the facility and were inside Medici's warehouse. He should come as soon as possible. But it was far too late.

The Swiss-Italian police team entered the Geneva storerooms, four of which were inside the Free Port's duty-free cordon, and one that was outside. In all, the space occupied two hundred

square meters, the size of a huge three- or four-bedroom apartment. The police found thousands of artifacts, many of them still bearing Sotheby's labels, and a trove of documents. Most important, in an office space they found photo albums chock-full of evidence: pictures of pots and statues. They also found a fireproof safe.

They did not, however, stick around long enough to make a full inventory of the warehouse's stash. Inspector Baudin took note of a few details he gleaned from the paperwork: that Medici had been a partner with a certain Christian Boursaud in the former Hydra Galerie antiquities shop in Geneva's historic center; that Medici often did business under the name "Guidos" (which Medici would later explain was a way to disguise his identity in business transactions while also honoring his father, Guido); and that Medici had some connection to a Zurich man named Fritz Bürki, whose credentials the police had found inside Medici's desk.

After the Swiss police, including Baudin, scooped up the photo albums and some other documentation, the officers left the warehouse rooms, locking and sealing them as evidence. Nobody could enter again without a Swiss court order. And nobody did for the next two years.

Medici was driving south into Rome from his house on the coast in Santa Marinella on January 17, 1997—a Friday—when his mobile phone rang. On the other end of the line was an officer from the Carabinieri art squad with whom Medici had dealt before.

"Where are you now?" the officer asked him.

Medici told him, and the Carabinieri asked if he was coming into the center of town, could he stop by the art squad command to sign some papers relating to Sotheby's. Medici, who was driving with his wife, said sure, and headed for the building on the

Tiber River near the Porta Portese street market where his brother, Roberto, had worked until his disappearance two decades earlier.

As he was approaching the police palazzo, Medici's phone rang again. The officer wanted to know where he was. That's when Medici knew something wasn't right. "They're going to arrest me," he told Maria Luisa. "Take the car." Medici's wife told him not to be silly, but he insisted. Making sure he had his Italian identity card and phone with him, Medici got out and walked in alone.

Inside the Carabinieri greeted him with stern looks. Ferdinando Musella stared Medici down and, tugging at his right ear, asked, "How come I can't hear you with this ear?" Medici wasn't sure what Musella was getting at. If he was trying to tell him something, he should tell him directly, Medici said.

"How come you haven't cooperated?" the officer asked. "How long has it been since the Geneva raid?" Medici had failed to give the police any information on the illicit antiquities trade over the previous year and a half, and now he was being punished. "We have a warrant for your arrest."

The investigation of the de Marchi robbery had finally caught up to him. He wasn't being charged, yet, but was officially a suspect, subject to questioning. "Take me out of here now," he demanded of the Carabinieri, who seemed eager to see what they could wrest from him now that they had a warrant. "I don't want to spend any more time in here." If they were going to arrest him, they should do it and get it over with, he said. Medici called his daughter, Monica, to come and get his mobile phone. When Monica arrived, she saw her father handcuffed, a humiliation that burned him inside.

After a brief run around Rome to get him processed for jail and his mug shot taken, the police drove Medici to Latina, south

of the capital, where prosecutors and Carabinieri had been investigating the de Marchi break-in. Medici's timing was terrible. It was a Friday afternoon and the judge was gone. Medici would have to spend the weekend in jail before he could argue for bail. This ordeal was the first time Medici had ever spent the night behind bars. On Monday he finally went free, and he spent the following week under house arrest.

On October 17 and 18, 1997, the Getty's Marion True attended a conference at the University of Viterbo, just north of Rome, that was a follow-up to the 1995 Antiquities Without Provenance roundtable at the American Academy in Rome. As True sat in the audience, Italian archaeologist Maria Antonietta Rizzo, who had made the connection between the inscription on the bottom of the Getty's Onesimos-Euphronios cup and the temple to Heracles in Cerveteri, dug even deeper. She presented two papers: one on the details of the cup's "recontextualization" through her archaeological finds, and another on the massive kylix itself.

And then she laid down her challenge: "Will the P. Getty Museum, here represented in the person of Marion True . . . give back to Italy a work that has been trafficked in such an obvious way?" True, who had no warning that she would be put on the spot like this, stood up. If Rizzo would send her the information about the kylix, True said, she would start the process of returning the object to Italy.

True's willingness to cooperate with the Italian demand was one of many signs in 1997 that the artifact trade was undergoing unprecedented change. The year was a turning point, as prestigious institutions—from museums to universities and auction houses—that had enabled the traffic in undocumented objects faced growing embarrassment and legal troubles and decided to

get out of the racket. After Peter Watson aired his investigations into Sotheby's links to Medici and smuggling, the auction house discontinued its London antiquities sales.

In a sign of how quickly the legal and academic world was turning against the antiquities trade, Oxford's lab—which had authenticated the Sarpedon krater for the Met and many artifacts for Medici as a private client—came under pressure and ended its commercial testing of artifacts, also in 1997. And a University of Cambridge archaeology professor who had helped shame Oxford into cutting its authentication ties to the trade—Colin Renfrew (aka Lord Renfrew of Kaimsthorn)—began operations of the Illicit Antiquities Research Centre, a new unit at the university's archaeology department, in October 1997.

Medici's case also began to get serious. On October 27 of that same year, the court in Latina ruled that it was no longer the proper jurisdiction for the de Marchi case, which had gone from a burglary investigation to a cross-border production involving Italy's national art police. Paolo Ferri, the prosecutor handling the case of Sotheby's Lot 540, won the transfer of Medici's case up to Rome, and had the two files combined. Medici would no longer face trial in a small town court. He was now the target of a seasoned investigative prosecutor based at the central courthouse of Italy's capital city.

Ferri, whose red beard made him stand out among the lawyers at the Rome Tribunal, knew what he was doing. A graduate of Rome's La Sapienza university, he had hunted murderers and drug traffickers in his previous trials. By bringing the Medici case under his wing, Ferri could take control of the vast body of evidence gathered in the Geneva raid. This might not only implicate Medici, but the dealers, restorers, curators, museums, and universities with whom Medici had done business. The real treasure trove—the photos, the documents, and the objects

under seal in the Swiss warehouse—would be within Ferri's reach.

Only a month after he took control of Medici's case, Ferri traveled to Switzerland to try to get his hands on the contents of Medici's warehouse. He had already petitioned the Swiss courts to hand over the Medici haul to Italy—or at least to allow Italian experts to closely study the collection—but had been rebuffed. On December 17, 1997, the Rome prosecutor tried again, meeting face-to-face with the top Swiss prosecutor and federal police officer involved in the case. Ferri was accompanied to the meeting at the justice palace in Geneva by Chief Marshals Salvatore Morando and Serafino Dell'Avvocato from the Carabinieri art squad. Marshal Morando, a thirty-six-year-old native of Ragusa in Sicily, had already spent half his life in the Carabinieri, including the previous ten years with the art squad in Rome. Morando, with his medium build, thick black hair, and mellow demeanor was a quiet presence at almost every step in the Medici investigation, starting with the 1995 raid. The men made their case that, as the prosecutor in Medici's Italian case, Ferri should get a firsthand look at the consistency and quantity of the material in the Free Port. At the end of the meeting, the Swiss officials agreed.

The next morning, the Italians presented themselves at the Geneva Free Port, where the Swiss police inspector, Alain Baudin, who had been the local point man for the raid two years earlier, joined them. First they headed up to the fourth floor, and then to Corridor 23. At 10:05 A.M. they opened Room 6. What they found was a laboratory for storing and processing artifacts, "surely from clandestine digs, a certainty coming from the fact that these objects—a great many in fragments—were found covered in soil residue," the two art-squad officers wrote in their report.

The room included a minilab for printing photos, and a wooden fruit crate, labeled *"Coop. Ort. Cerveteri,"* or Cerveteri

Garden Cooperative. It was filled not with tomatoes and zuc-
chini, but with what appeared to be frescoes from an Etruscan
tomb, wrapped in a copy of Rome's *Il Messaggero* newspaper,
dated January 11, 1994. Nearby they found a bronze helmet, also
wrapped in pages from the same newspaper. The Italian police
also discovered various suitcases, which they hypothesized could
have been used to transport the archaeological material found in
the room. After just seventeen minutes, the group finished their
quick look around and closed the door behind them, which the
Swiss sealed again as crime-scene evidence.

Staying on the fourth floor of the Free Port, Ferri and the po-
lice officers walked over to Corridor 17, the main site of Medici's
operation. Opening Room 4, they found even more archaeologi-
cal riches: marble statues, ceramics, and bronzes. This wasn't an
official inspection by the Italians of all the material, just a look
around, so after five minutes they moved on to the next space,
Room 6. This was the showroom. It had cabinets on the walls
filled with every kind of archaeological artifact, as well as arm-
chairs, sofas, coffee tables, a desk, and other furnishings that
made it seem to the visitors like the sort of place where Medici
might bring potential buyers. Many of the objects still had little
blue labels from Sotheby's on them, an assurance to any poten-
tial buyer that the works had licit origins. The investigators spent
most of their time in this room, enough to get a look through
what appeared to be an archive with some five thousand photos
of artifacts, and documentation, including a check written by
Robert Hecht for $400,000, dated September 4, 1995, and appar-
ently for the purchase of frescoes from Pompeii—the last deal
that the two old colleagues did before the Geneva raid crippled
Medici's business.

But in addition to the photos and documents, which would
prove to be the prosecutor's most important find from a legal

standpoint, the Italians saw something else. "We also note there was a large safe containing very important archaeological vases," the Italian police wrote in their report. Alas, time was short. At 10:55 A.M. they started closing and sealing the doors behind them. As they did, two of Medici's Swiss lawyers, Henri Nanchen and Jacques Roulet, came onto the scene, protesting that they hadn't been advised of the Italians' visit to the warehouse. Inspector Baudin explained to Medici's lawyers that the visit had been authorized and was just a superficial overview, not a search. Then the Swiss inspector finished sealing the room.

In the twenty-four minutes they had spent inside Room 6, the Italians never got a chance to see exactly what those "very important archaeological vases" were in the safe—the very same fireproof safe Medici had bought in 1990. Had they known what was inside, they might have lingered.

On December 23, 1997, Ferri sent a cross-border inquiry to the Swiss authorities requesting a full examination by Italian experts and investigators of the contents of Medici's warehouse at the Free Port. The Swiss magistrate handling the case, Judge Jean-Pierre Trembley, agreed to Ferri's request. But before he could allow them inside to handle the artifacts, the Swiss judge needed someone to inventory the warehouse's contents. In March 1998, the judge put Inspector Baudin, who had been present at the original raid, in charge of the task.

The decision set off alarm bells for Medici, who wanted to make sure he could be in the rooms at the Free Port during Baudin's inspection and to ensure that the people handling his precious goods—especially the Sarpedon chalice—knew what they were doing.

Medici had his Swiss lawyer Henri Nanchen write a long

letter to Judge Trembley explaining why he should be able to attend. For one, the lawyer wrote, many of the items were actually counterfeit, and it would be a help for Medici to be able to point out which ones were fake. But his client was mainly concerned with the genuine, expensive artifacts and their fragility. "Some objects are very fragile and difficult to handle. In the best case, the inventory should be conducted by an expert with the necessary experience to handle this kind of work," Medici's lawyer wrote. "An inventory of this type should be assigned to an archaeologist with a background in museum work or the art market.

"In fact, if these objects are badly handled, it could cause them to break. If this were to happen, the value of these objects, equivalent to many hundreds of thousands of francs, would be reduced by at least 50 percent," the lawyer warned.

To prepare for the inventory, first Inspector Baudin had to undo what Medici would later contend had been a crucial irregularity in the handling of the evidence against him. As part of the investigation, the Swiss police had removed Medici's photo archive from his rented rooms at the Free Port and took the pictures to the police offices in Geneva without first cataloging the archive's contents. On May 8, more than two and a half years after the 1995 raid, Baudin finally numbered the albums, 1 through 83, and made notes of their contents. Three weeks later he shipped the whole archive back to the Free Port, to Room 6 up on Corridor 17 of the fourth floor.

With everything back where it should have been, Baudin was ready to take a closer, hands-on look at the riches inside Medici's warehouse.

To conduct the inventory, which started on May 26, 1998, Baudin brought with him Inspector Nicole Jaulin and classical

archaeologist Michelle Jauguin. They spent two days there comparing the photos taken of the objects during the raid with the actual contents of the warehouse and examining the paperwork found in the offices. They numbered everything, starting where they'd left off with the photo albums, at 84. As they worked their way through the storerooms and gallery space, everything matched what they'd expected—until they found an unopened drawer that had originally escaped their attention. Like *tombaroli* finding a sealed tomb, Baudin and his helpers pulled it open.

Inside they discovered a dazzling assortment of jewels. Realizing that they needed to protect themselves against any claims by Medici of foul play—and needing to add the thirty-one precious objects to the official record—Baudin stopped the inventory and called in a police photographer. Baudin recalled that Medici had complained after the 1995 raid that he hadn't heard any news about the fate of some missing jewelry, which he insisted was in the warehouse. The officer compared his new findings to the documentation of Medici's complaint, and it appeared he had a match. When the photographer arrived, he took photos of each object and the inspection team added new numbers to their inventory. When he finished, the photographer decided to stick around. It was a wise choice. Tragically, his services would be needed again.

As Baudin continued to work his way through the collection he came to Medici's fireproof safe. Inside he found the vases from the 1990 Hunt auction, including the chalice by Euphronios. With the safe door open, Sarpedon's dying face practically stared up at him. And then Baudin did what anyone might do when reaching for a wine cup.

He put his hands on the handles and lifted.

Had Baudin known what others familiar with such works

know, he wouldn't have made that mistake. Just eight years earlier, journalist Suzan Mazur, given the rare chance to lift the cup backstage at Sotheby's before the Hunt auction, knew she should support the fragile vase by its rounded underside. And her tour guide, Sotheby's antiquities expert Richard Keresey, confirmed her trepidation. But Baudin didn't have such luck.

The weight of the cup, which had been repaired before, came out right from under the handles. The problem was that the cup had been previously broken and repaired, and it couldn't handle the load. The clay vessel landed on the wooden parquet floor. As Baudin wrote in his report of the incident, "We should point out that while moving a plate (Kylix-photo No. 435.436), it practically disintegrated."

The Sarpedon chalice had shattered. Its hundreds of pieces, including flakes, grains, and slivers of pottery, littered the floor at Inspector Baudin's feet.

Baudin may or may not have been to blame for shattering the oldest known work by the greatest vase painter of ancient Greece—but he did his best to explain that it wasn't wholly his fault. "This object had been restored and glued in various places," he wrote in his report, pointing out that he was dealing with previously damaged goods. "We have noted that the cracks correspond to parts that were badly glued."

One whole side of the cup entirely shattered. Unfortunately, it was the front side—the one depicting Sarpedon, the slain son of Zeus, being carried off by Sleep and Death. A handle, which should never have been used in the first place, broke off and lay on its own. The sturdy stem and the back side of the kylix, depicting a funeral dance, fared better, surviving the fall practically intact. But the most important half seemed ruined. If a vase

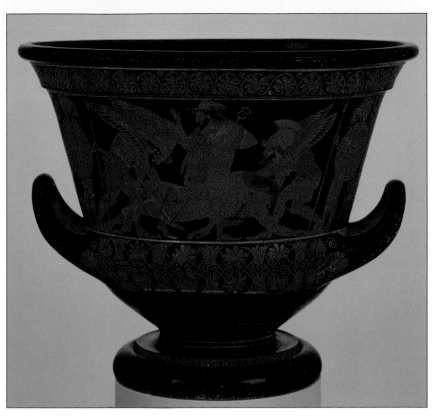

The Euphronios krater.
Metropolitan Museum of Art and the Italian Culture Ministry

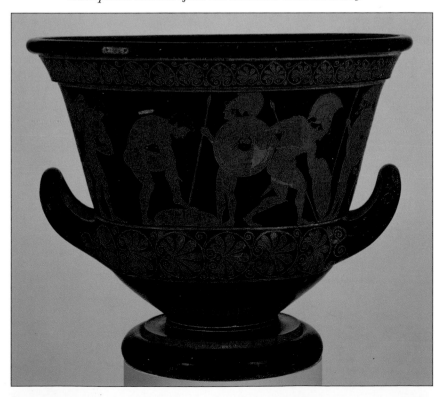

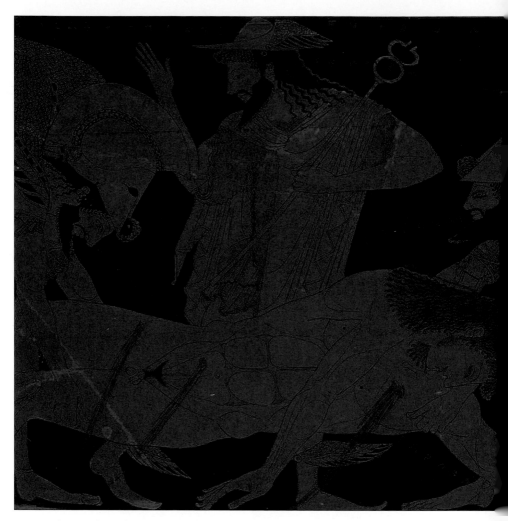

Sleep and Death carry the slain son of Zeus off the Trojan War battlefield, a
turning point in Homer's Iliad in which the most powerful god on Olympus
makes the painful decision to allow his son to die for the greater good.
Metropolitan Museum of Art and the Italian Culture Ministry

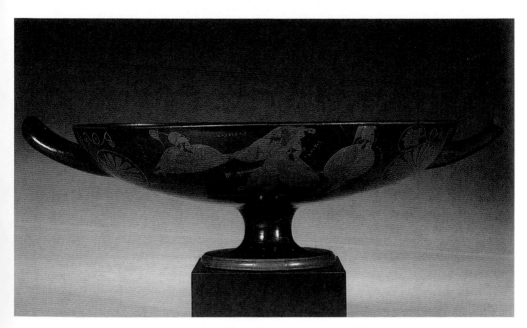

Sarpedon chalice by Euphronios. *Summa Publications*

"Euphronios Painted This" on base of Sarpedon chalice.
Summa Publications

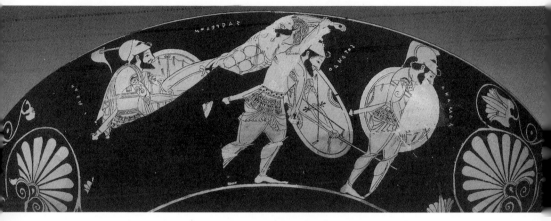

"A" and "B" sides of the chalice. Top photograph depicts Sarpedon being carried by Sleep and Death. *Summa Publications*

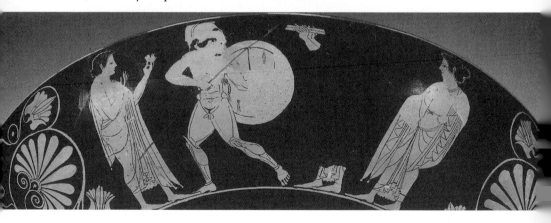

Photographs the Swiss police took of the chalice before dropping it.
Courtesy Giacomo Medici

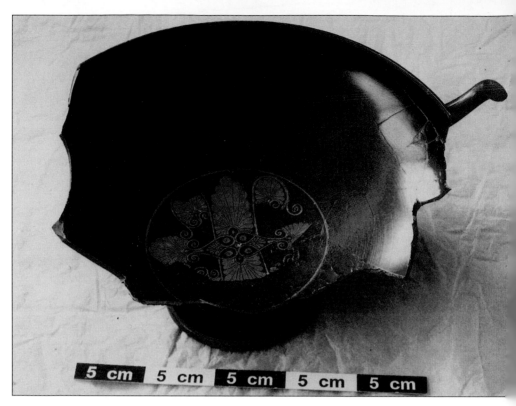

The less-important half of the chalice, which did not break.
Courtesy Giacomo Medici

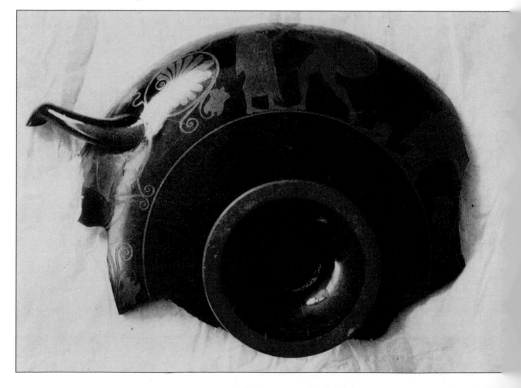

Swiss police swept the shards into bags, which they stored in a cardboard box. *Courtesy Giacomo Medici*

The remains of the Sarpedon half of the chalice, on the floor at Medici's Geneva warehouse, May 1998. *Courtesy Giacomo Medici*

The slain son of Zeus is carried off the Trojan War battlefield by Sleep and Death.
Summa Publications

by Euphronios can be compared to a painting by Leonardo da Vinci, this was as if someone had repeatedly slashed the face and torso of the *Mona Lisa,* leaving the background and frame intact. In essence, Euphronios's Sarpedon cup was destroyed.

Baudin had the police photographer set up what was essentially a crime-scene shot. They swept the tiny fragments and flakes onto a piece of white tissue paper and turned the bigger shards face up so that all the painting could be seen. The photographer made a picture of the assorted fragments, and two others of the half that didn't shatter.

Then the team scooped the loose shards into the kind of plastic bags normally used for sandwiches or other food. They placed the bags in a cardboard box and the box on Shelf 2 of Cabinet 15 in Room 6 of Corridor 17 on the fourth floor of the Geneva Free Port. And there they would sit, lost again to the world.

The reason the Swiss conducted the inventory in the first place was to prepare for the Italian experts' pending visit to Medici's warehouse. They arrived on July 15, 1998, and that afternoon conducted their survey. The cast of more than a dozen cops and archaeologists assembled represented most of the interested parties. Marshal Salvatore Morando of the Carabinieri art squad was there, along with Anna Maria Moretti Sgubini, the daughter of Mario Moretti, the celebrated archaeologist under whose watch the Euphronios krater and chalice had been looted from Cerveteri, and who had ultimately been in charge of the salvage excavation on Medici's property. Now she was the head of Etruscan archaeology and came as a consultant for one of the victims of Medici's alleged crimes, the Italian Culture Ministry.

As thorough as the Italians were, their documentation does not indicate that any of the experts or officers visiting that day

knew about the accident or noticed a box that contained the re-
mains of what had been, by far, the finest work among the thou-
sands of artifacts piled high in Medici's warehouse.

They were not the only ones in the dark. Medici still had no
idea that his chalice had been smashed. It wasn't until Novem-
ber 18, 1998, six months after the cup had shattered, that Medici
received a packet of photocopied papers as part of a routine filing
in his Swiss case. Leafing through them, he saw photocopies of
the photographs the Swiss police had taken. Without any expla-
nation, Medici had been left to discover, by chance, pictures of
what had happened to his cup.

For the moment, all Medici could do was order his lawyer to
write angry letters. "The financial loss is extremely important,
but it cannot compare with the loss in cultural terms, this being
a world-renowned, extremely rare work of art," Medici's law-
yer Nanchen wrote to the Swiss judge, Trembley, on November
26, 1998. "This is the destruction of a portion of the world's ar-
chaeological heritage." For the first time in his career, Medici
could credibly take the moral high ground on the handling of
antiquities. He liked the approach so much that he tried using it
to fend off pending criminal charges by offering his help to pros-
ecutors in the case of the Getty's huge Onesimos-Euphronios
kylix.

After the Getty's Marion True examined the evidence that
the Onesimos-Euphronios cup with the Etruscan inscription
had been looted from Italy, she decided to send the kylix back to
Italy. In February 1999, True brought the cup, along with two
Roman sculptures, to Italy. She arrived at Rome's Villa Giulia
museum late at night to drop off the shipment and returned the
next morning to be present when the Italians opened the crates.
Ferri, the prosecutor, said the cup was worth an estimated 20
billion lire—more than $11.5 million at the time. Even if a bit

exaggerated, that meant the even more important works by Euphronios had become worth many, many millions of dollars in the booming art market. The Sarpedon krater and its matching chalice—if there were any chance at saving and fixing it—were worth a fortune.

As the Italians unpacked the Getty's returned antiquities in True's presence, members of the press were also there to record the event, just a taste of the attention that she and the works of Euphronios would get in the coming decade.

Medici had been paying close attention to the Getty's move to send back the huge cup, portions of which his former gallery had sold to the museum. He saw a chance to be a hero, and to help himself a bit in the process. Two months after the repatriation, Medici somehow located three pieces that fit into the newly reclaimed cup—the same three pieces Dyfri Williams of the British Museum wrote in a Getty publication that he'd seen in 1990. Medici's plan was to exchange the fragments, and his cooperation in the case, for dropped charges. Ferri the prosecutor was interested.

According to Medici's version of events, he called in a favor from a contact in the antiquities trade who agreed to sell the shards to him in Switzerland. Medici packed up the pieces in Geneva, swaddling them individually in white paper and bubble wrap, and closing the entire package in another layer, sealing it with Scotch tape. With the bundle in his hands, Medici boarded a flight to Rome on the morning of April 17, 1999. He landed at Leonardo da Vinci Airport, the capital's main airport, in the coastal town of Fiumicino, and took a taxi into town, where the men from the Carabinieri art squad were expecting him.

They had scheduled a rendezvous at Piazza Risorgimento, a square choked with bus and tram traffic on the edge of the Vatican City walls, just around the corner from the entry to the

Vatican Museums. Among the officers waiting for him was Marshal Salvatore Morando, the soft-spoken, tanned, and not particularly tall investigator who had been on the Medici case for years, slowly exposing the illicit trade. Along with his colleague, Marshal Renato Saitta, the three got into Morando's car—a blue, four-door Alfa-Romeo painted with the Carabinieri logo down the side—and drove to Piazzale Clodio, the vast traffic circle where the vast, modern Rome Tribunal complex sits. They drove through the steel gates of the drab complex and parked on the courthouse's cobblestoned grounds.

With Medici still holding his precious package, they rode the elevator up to the fourth floor and Ferri's office, one of dozens that line a long corridor housing prosecutors in cramped quarters. Medici walked through the doors of his prosecutor's tiny study at 11:35 A.M., bearing his gift to the Republic of Italy—and what he hoped would be his ticket to leniency. Medici placed his offering on Ferri's desk, but the prosecutor wouldn't touch it. "I don't want the responsibility," Ferri said. "You open it."

Medici undid his packing job and laid out the fragments together on the desk where they formed a picture on one side of the outstretched hands of Helen of Troy and the head of her long-lost husband, Menelaus, shining figures in ocher, done in fine lines against a black background. On the other side, forming part of the cup's outer rim, the three fragments came together to show the head and chest of the Greek Trojan War hero Ajax, bearded and with lush eyelashes, next to the head of the god Apollo.

"They're marvelous," Ferri said. But the prosecutor did not let his guard down as he admired the pieces. After all, he was dealing with Giacomo Medici. "Are they fake?" he asked.

"No, these are real," Medici said.

Ferri turned to Marshal Morando. "Call Moretti, immedi-

ately," Ferri barked. He wanted Anna Maria Moretti Sgubini to verify the fragments. Like her father she had become the government's leading expert on all things Etruscan. But Morando didn't want to get her involved yet in what was a coup for the police and prosecutors.

"We need to enjoy these," Morando said. "Let's call her later."

Ferri agreed. He had a better idea. It was time to reward Medici for his cooperation. "Let's write a letter to the judge," he said.

With Medici sitting nearby, Ferri turned to his computer and typed. In one document, Ferri happily took down for the record the "spontaneous declaration" that Medici made when he came into the office. "Having learned that the cup had returned to Italy, I felt the duty to respond to the solicitations of the scientific world and to activate all my connections in the sector to recuperate the missing parts," Medici said. He concluded his statement by saying he had spent his own money to acquire the fragments, and, "I have embarked on this, I repeat, only to do a favor for my Country."

In another letter, this time by Ferri about the Onesimos-Euphronios kylix, the prosecutor wrote that Medici, "worked to recuperate the fragments in question, only for scientific ends, honoring archaeological science with the restitution of the said artifacts that were previously unattainable." Observing also that "it is undoubtable that Medici—as he has asserted—has also faced economic sacrifices all for the benefit of the State of Italy," and there was no proof Medici had violated the 1939 antiquities law, it is "REQUESTED," Ferri typed, "that the case be closed."

The signs were good for Medici. The dropped charges applied only to the one Onesimos-Euphronios kylix, but Medici sensed he could be finding a way out of his overall case. Ferri, who was

prepared to celebrate the event, brought out sparkling wine, popped the cork, and poured the bubbly into four glasses for the men in his office. The prosecutor even let Medici sit in the high-backed chair behind his desk as they toasted and ate from a small platter of sweet breadsticks.

More than a year after Inspector Baudin had shattered the Sarpedon chalice, Medici still hadn't seen exactly how bad the damage was—or under what conditions the broken kylix languished. But with his storerooms sealed by the Swiss police, there was no way for him to take a look. Oddly, however, the slow collapse of his antiquities business and finances would provide Medici a literal foot in the door.

Just before the 1995 raid, Medici had taken delivery of some ancient Roman frescoes. He had stored them in a special depot at Arts Franc, the company that had subleased the warehouse rooms to him. Since the bust, Medici's trading had mostly dried up, and paying rent on multiple storage spaces was eating into his cash. The solution, he decided, was to consolidate, and he petitioned the Swiss police for permission to move his frescoes into his main rooms, the ones under seal.

The Swiss courts granted Medici onetime consent to go into the warehouse, accompanied by Inspector Lovo, a colleague of Baudin's. Medici and Lovo brought the frescoes to Medici's old, sealed storage space, where he was surrounded by his inventory. And he was shocked at what he saw.

During the earlier 1998 inventory, the police had stored the objects terribly. To him, it looked like they'd been crammed into a boxcar. At that moment, storing the frescoes was a second thought. "Where is the Euphronios kylix?" he demanded.

Medici poked around. Scanning a tall cabinet made of steel

shelves, he found the box that contained the broken cup—or what he could recognize of its remains. The jagged fragments were stuffed into plastic freezer bags. Medici had had the foresight to bring his camera with him. His earlier propensity to document everything with photographs may have gotten him in legal trouble, but now the obsession was a good thing. He could now prove that an investigation intended to save antiquities had actually destroyed them. Medici took a few, slightly out-of-focus, snapshots, and then it was time to go.

Five years after the 1995 raid, the Swiss finally decided the case was an Italian matter. This meant the prosecutors and police in Rome could get the documentation the Swiss had seized, the core of which was Medici's photo collection. But the volumes of evidence were more than prosecutor Ferri could digest himself, so he handed that task to Maurizio Pellegrini, a technician from the Villa Giulia museum, taking him on as a consultant. Some images popped out as obviously important to building the case: Medici posing in front of the Sarpedon krater at the Met, and, curiously, American dealer Robert Hecht doing exactly the same; Polaroids of vases in fragments, encrusted with dirt; Polaroids of a tall marble statue of a woman, taken in sections.

The photos of Medici and Hecht with the krater seemed to link both men to the vase that Italy had long given up hope of winning back. The other photos provided leads to other, less celebrated loot. Pellegrini's task was to match each of the hundreds, if not thousands, of photos to known pieces in museums or collections around the world. To do this, he needed to cross-reference exhibit and auction catalogs and develop an eye for making connections between vases or statues in a genre of art where many objects are indistinguishable from one another.

As Pellegrini pored over the photos, he came to images of something he actually had seen before: the Onesimos-Euphronios kylix, the one that bore an inscription on its base. The shocker, however, about the pictures of different fragments of the massive cup, was that one of them—of just the central portion together with another fragment—had written on its margins, "Prop. P.G.M." Pellegrini and the others decided that Medici's markings meant the piece had been proposed to the Getty for purchase. This was the section of the cup that another dealer, Frieda Tchacos, had sold the museum. Did Medici, who had later sold the museum some other bits of the cup, have something to do with the original sale?

Perhaps more important, Pellegrini also found a photo of the three fragments Medici had surrendered to Ferri in a bid for leniency. Contrary to Medici's story of heroically finding, buying, and repatriating the pieces for the sake of the Italian Republic, he had had the fragments all along, Ferri concluded based on the evidence Pellegrini uncovered.

Confronted, Medici was incredulous. If he had the fragments before 1999, wouldn't they have been in his warehouse or his homes, which the police had thoroughly searched? "If I had them, they'd have found them," Medici said.

Ferri didn't buy it and reinstated the charges relating to the giant kylix.

Although the raid on Medici's warehouse had yielded a trove of documents, it also turned up thousands of objects. When the Swiss courts ruled that they should turn the evidence over to the Italians, they turned over to the Rome prosecution anything related to Italy, but they gave Medici most of the rest. He won back hundreds of objects that appeared to be fakes or that clearly came from places such as Egypt, Syria, the Far East, and even Greece.

That could have meant the courts would give Medici the box

containing the shattered, Greek-made Sarpedon chalice. Or they could have shipped it to Rome. The Swiss never said. And in all the press conferences and public pronouncements that followed in Italy, no official involved in the case disclosed the fate of the cup. Several years later when the Carabinieri posted photos from the Geneva raid on the Internet, they included some of Medici's finest purchases from the Hunt auction, but the kylix by Euphronios was missing. Once again—and this time perhaps because it was shattered to bits—the trail of the lost chalice went cold.

Accused

In December 2000, Thomas Hoving saw Robert Hecht at the opening of the Hermitage Rooms in London's Somerset House, an exhibition space the Russian museum used to show highlights of its collection. Hoving had a hunch and decided to confront his former supplier directly. Bob, he asked, was the paperwork you gave the Met to show that the Euphronios krater had come from a Lebanese collector real after all? Had Hecht simply taken the paperwork from another, less-valuable Euphronios pot—perhaps the fragmentary krater from the Hunt collection now owned by Levy and White—and given that to the Met as proof of the krater's origins?

According to Hoving, Hecht turned his face to the side and said, "Of course."

For Hoving, all the conflicting evidence from the Italian investigation and the Met's in-house probe finally could be reconciled with the existence of both the Sarpedon krater and the less complete vase from Sarrafian in Beirut. Hecht really did get a Euphronios from Sarrafian and the Swiss photographer hadn't been lying when he said that he took pictures of a Euphronios

vase in September 1971—before the Christmastime Cerveteri dig turned up the Met's pot.

But what good was Hecht's private confession to Hoving in proving the Sarpedon krater and kylix had been looted from Cerveteri? Hecht denied he ever told Hoving about the paperwork switch. "That's a figment of his imagination or a construction of his evil mind," Hecht said when asked about Hoving's story. "That is a lie, and I never switched any document on any krater."

Hecht's own words were necessary to make a convincing case. Italian investigators got their break on February 16, 2001, when they, along with the French police, raided Hecht's Paris apartment.

Led by Marshal Salvatore Morando from the Carabinieri art squad, and armed with cross-border authorization to poke around, they knocked on the door of Hecht's home. Hecht's wife answered the door. Once inside, the men found some paperwork relevant to the antiquities trade and various ancient-looking vases and other antiquities—but nothing special. This was not a big haul like the one they had gotten from Medici's Swiss warehouse. However, in the study, sitting atop the desk, Morando found a sheaf of papers with line after line written in Hecht's hand. He had found Hecht's memoir. Here was the evidence the Carabinieri had been seeking for three decades.

The diary revealed the story behind the Sarpedon krater's illicit origin. It told how Giacomo Medici came by the Hecht home in Rome with photos of the vase, and how the two men traveled to Switzerland so that Medici could retrieve the krater from a safe-deposit box to sell to Hecht.

Hecht had also made notations indicating how he had been the source of the Sarpedon chalice. Hecht had written about how the Met's Dietrich von Bothmer had exposed the cup's existence

during his Philadelphia lecture in December 1972. "This indiscretion wasn't even as damaging as the betrayal by Hoving, who gave a recorded interview to Walter" (the reporter from London's *Observer* to whom the Met director blabbed) "in which he affirmed that the kylix was the property of the same man who had sold the krater." In another section of the memoir, where Hecht had sketched a simple outline of his tale, he wrote: "Story of the Euphronios cup: 50–75 then Hunt, etc.," a reference to a price that he had paid for the cup or the range at which he had tried to sell it, with the 75 perhaps matching Hoving's story that Hecht wanted $70,000 for the kylix in 1973.

Hecht also quoted from secret Carabinieri reports made to the investigating magistrates, one of which shed light on the Sarpedon chalice's murky archaeological history.

"From a confidential source in Cerveteri we understand that a) Two important archaeological objects signed by Euphronios, one of which is at the Met and the other yet to be located, come from the same tomb of a person of great importance, a tomb that was excavated in 1971 in an area known as S. Antonio above Cerveteri," the report said, going on to name some of the *tombaroli* and saying they tipped off the Guardia di Finanza after finishing the dig to throw off investigators. The tomb robbers "kept the most important pieces, about which the GdF were left in the dark, and among these pieces were two objects of exceptional value, signed by Euphronios."

If the account were correct, the Sarpedon chalice, or another Euphronios, had indeed come from the exact same tomb as the matching krater, a theory that had never been proved with solid evidence. And if Hecht's memoir were to be believed, he had admitted in his own handwriting that he was the one who trafficked the chalice to Bunker Hunt—a secret of the trade that was rarely disputed but something he would not voluntarily admit.

The major breakthrough, of course, was Hecht's detailed account of buying the krater from Medici. But elsewhere in the eighty-nine-page manuscript, Hecht had an entirely different version of events—the Sarrafian version, in which Hecht bought the Met's vase from a Lebanese collector whose family had owned it since the early twentieth century. Although this was a much shorter, less detailed section, it conveniently contradicted Hecht's admission made elsewhere in the memoir. Which version was the truth? Hecht immediately proclaimed the Medici story as a work of fiction, a thriller he was working on, while the Sarrafian version was the one the police should believe.

To sort out everything, Hecht and the prosecutor, Paolo Ferri, arranged to meet in Paris on March 10, 2001.

They gathered in the morning—Hecht; his lawyer, Alessandro Vannucci; Ferri; Morando from the Carabinieri art squad; and Daniela Rizzo from the Villa Giulia museum, a colleague of the archaeologist Maria Antonietta Rizzo, who happened to have the same surname. The court provided Hecht with an English language interpreter, but he declined the services and then used the language difference to sow confusion into his already slippery testimony.

Ferri began, somewhat optimistically. "I would like to know what you have to tell me, seeing as you have come to me spontaneously, and then we will go into some smaller details, when possible, if you agree. So, do you want to make a report of your activities?"

"You want a report?" Hecht asked.

"A report, yes. Or, yes, your story."

"To tell my . . . ?"

"Your life. Your fascinating life," Ferri said. The sarcasm was already thick in the room.

"I was born . . ."

"Before anything, you're named Robert Hecht?"

"Roberto Hecht."

"Junior Hecht," Ferri said, being lawyerly for the record.

"Junior, yes, because my father had the same name," Hecht said, continuing with the details of his birth, schooling, and eventual move to Italy after World War II. And then Ferri dove into the subject that interested him most: Euphronios.

"We would like to talk about the famous Euphronios vase," the prosecutor began.

"Which Euphronios vase?"

"That is for you to say," Ferri said, leaving an open door for any admissions Hecht might slip up and make. "There are several vases."

"No, there are many?" Hecht replied, not taking the bait.

"Yes, yes, the one at the Metropolitan. Go."

"Yes. What should I say?"

"Say a bit about your real version of the facts."

Hecht just went ahead and retold his original Sarrafian story, frustrating the prosecutor, who responded: "Yes, but I repeat, my goodness, I have read your memoir on this point and it is plainly clear, detailed, your memoir, but your memoir also contains another version of the same facts, there are two versions."

"Which?"

"Two versions, one is that in December 1971, Giacomo Medici knocked on your door. Do you recall this part of the memoir?"

"No . . . Ah, yes, the Italians' version?"

"Yes. You remember that part about Giacomo Medici knocking on your door in December 1971?"

"No," Hecht said, and then dragged Ferri into a discussion of the initials he had used to identify different people in his manuscript. As Hecht wriggled out of more questions, Ferri encour-

aged him to make use of the translator and to speak English, even pointing out that Hecht was nearly eighty-two years old and could use the help. Hecht declined. Ferri started to show his frustration.

"If we have to play cat and mouse, we can be here for three days, and I will buy you three lunches, shrimp three times, three spaghettis with clams, and in the end you'll get sick of this. I want something spontaneous, if that's possible. I repeat, I've got nothing against you, nothing against Medici—I just want to put an end to this trafficking," Ferri said. "It would be useful to me to clarify the routes by which the American museums make acquisitions, and also the European ones."

After discussing Marion True and the Getty, Ferri eventually asked about the role of Hollywood producer Bruce McNall and the formation of the Hunt collection. "There were some of those pieces you gave to him," the prosecutor said.

"Some things, yes."

"To form the Hunt collection."

"Yes," Hecht said.

"And some things that Medici gave them."

"Could be . . ."

"What do you mean, could be? Certainly yes," the prosecutor shot back.

"It seems to me Medici bought some things from Hunt," Hecht said, turning the whole line of questioning around.

Ferri tried to put him back on track: "He re-bought his things from Hunt, right?"

Daniela Rizzo, who had sat silently, couldn't hold back any longer. She wanted to know about the Sarpedon chalice. Given the chance to meet Hecht face-to-face after all the years she had spent trying to track his wares, she seemed to need answers urgently. Rizzo interrupted Ferri's interrogation.

"There's a Hunt kylix, that from Medici went to Hunt, right? This is the beautiful Euphronios kylix that has the same subject as the krater, Sarpedon and Hypnos, Sleep and Death transporting the body of Sarpedon, and this kylix went on sale at Sotheby's and was bought by Medici," Rizzo said.

"By Giacomo Medici, yes," Hecht responded.

"You spoke of this kylix in your memoir," Rizzo said.

"Yes."

"It's true, this here, I'll give you the page, wait," Rizzo said, leafing through Hecht's manuscript.

Hecht read aloud the part where he mentioned the *Observer*'s report. "That journalist Walter said I would be the owner of that kylix, yes."

"But you had seen that Euphronios kylix?" Rizzo asked.

"I saw it. I saw it in the New York collections."

"But before it ended up in . . ." Rizzo started before the prosecutor interrupted.

"In the Hunt collection, you never saw it before it ended up in the Hunt collection?" he asked.

"Yes, I saw it at McNall's. Or is it, *I had seen* it at McNall's?" Hecht said, playing with his Italian and creating a distraction.

"In California, then?" Ferri asked.

"Yes."

"And you offered it to Hoving? You offered it to the director of the Metropolitan Museum this here, this kylix, you offered it, you remember this?" Ferri said.

"No," Hecht said, brazenly denying the story.

"You said: you had the nerve to say, 'I also have a kylix that comes from the same tomb furnishings, you want it?'" Ferri said. "You remember saying this to Hoving?"

"No."

"Then there are two Euphronios vases, right? There are two

Euphronios vases, from the same tomb. Right?" Ferri said, fishing for an admission he didn't have nailed down.

Again Rizzo interrupted. "There's the one that went to the Metropolitan," she said.

"*Si*," Hecht agreed.

"Then a second krater by Euphronios with Kyknos, that's in the Levy-White collection?" Rizzo said. She'd muddied the waters a bit in Hecht's favor by veering away from the kylix to the Levy-White fragmentary krater.

"Ah, yes, that they bought at the Hunt sale," Hecht said.

"From the Hunt sale," Rizzo said. "And this krater is now on loan to the Metropolitan."

"Yes."

Ferri steered back to the kylix, linking it to the Levy-White fragmentary Euphronios at the Met. "All that's missing to complete the tomb contents are the kylix," Ferri said, referring to the Sarpedon chalice, "and the sphinx, the two sphinx. In the same tomb there was . . ."

After an exchange with Rizzo about whether a sphinx had been at the tomb, Ferri switched to the most famous find from the Cerveteri site. "This Euphronios vase that later was sold to the Metropolitan Museum, where did you see it for the first time?"

"Which?" Hecht asked

"The Euphronios vase. The Metropolitan's."

"When did I see it the first time? It was . . . I saw it in Switzerland, when it came from Beirut," Hecht said, sticking to his cover story about the krater coming from Sarrafian. Ferri let him expand on this version—and in the process finally scored some damning testimony. If Hecht wasn't going to admit that Medici had been the source of the krater—or even admit he had even tried to sell the Sarpedon chalice to the Met—he could

always trip up when telling the alternate version of the krater
affair. Ferri asked him particulars about the first time he saw the
krater. Hecht said it came in a box.

"A box of what dimensions? A cardboard box or a wooden
box?" Ferri asked.

"Cardboard."

"How big?" Ferri asked.

"I didn't measure it," said Hecht, who used his hands to mo-
tion the rough dimensions of the box.

"Let the record show that he has indicated a box 20 cm by 40
cm and 20 cm high," Ferri said. That's eight inches by sixteen
inches by eight inches—or about the size of a shoe box.

"I don't know how many centimeters," Hecht said.

"You seem to have indicated this, right? More or less. But the
Euphronios vase is big and heavy. It would be hard to fit a Eu-
phronios vase as big as this in a cardboard box so little. Eh?"

"It was in a cardboard . . ." Hecht started to respond.

Ferri recognized a moment to take advantage of Hecht's
defensiveness. "Maybe it was the kylix that was inside?" Ferri
suggested.

"No, I didn't get the kylix from Lebanon. You can ask Mr.
Hoving."

Ferri seemed satisfied with his progress. He'd blown a hole in
the Sarrafian story by getting Hecht to testify to dimensions of a
box that couldn't possibly hold the krater, even if broken into
pieces. And finally Hecht had practically admitted that he had
had the kylix.

At this point, Ferri noticed that Hecht's resolve, or at least his
concentration, was flagging, and he offered Hecht the opportu-
nity to write down the true version of the Euphronios tales, in a
sworn statement.

"I have to ask my lawyer if we'll write anything," Hecht said.

Ferri seemed flabbergasted that Hecht couldn't recount such ancient history without first getting legal advice. "I ask, I ask, for the love of God, I don't . . . this conversation you can have with your lawyer. For the love of God, these are old facts, going back to 1971."

"*Si*," Hecht's lawyer said, "but I need to talk with him about this with a clear head."

Hecht had an even better idea: "We could also take a lunch break."

It was 12:20 P.M., so Ferri agreed. They would continue at 3:00 P.M. For now, it seemed Ferri had Hecht where he wanted him: not as focused as he had been at the start of the questioning and slipping up. Getting Hecht's testimony in writing would seal the day as a success.

When they sat back down at 2:58 P.M., Hecht had regained his composure.

"Lunch brought you good advice?" Ferri asked Hecht. "Tell us about the Euphronios vase. Let's pick up the old plot of the book, of the Metropolitan Museum. Now, what's the *vera storia*, the true story?" he said in English.

Hecht was prepared. "Mr. Vannucci has suggested that perhaps there was a misunderstanding about the measurements of the box, because the box I was talking about was for a fragmented vase, a vase in pieces, and seeing that the vase is 50 centimeters by 52, or whatever it was, the box couldn't be like that," Hecht said. Whether he could be believed or not, Hecht had his correction on the record.

"So then Sarrafian is still the story? The true story is the Sarrafian version?" Ferri asked. His attempt at getting an admission was fading.

"*Si. Si*," Hecht said.

And the other version from Hecht's memoir about Medici selling Hecht the Euphronios krater, Ferri asked, "That's the same one as the Metropolitan's, that vase?"

"That is a vase that doesn't exist," Hecht responded.

"*Va bene,*" Ferri said. Fine.

"Which is to say, it's a fantasy story, based on that vase," Hecht said of the allegedly incriminating passages of his manuscript.

"I get it, an imaginary reconstruction, very close to the truth," Ferri said. "According to the accused."

Marion True was next on Ferri's list, and her deposition was con- ducted, at her convenience, at the Getty Center in Los Angeles on June 20, 2001. The room was filled with lawyers for all sides, including a prosecutor from the U.S. Attorney's Office, Daniel S. Goodman, but there were also a number of Italians who had been building a case against True, Medici, Hecht, and the rest: archaeologist Daniela Rizzo from the Villa Giulia museum; her technician, Maurizio Pellegrini, who was processing the photos and documents from the raid on Medici's Geneva warehouse; and representatives from the Carabinieri art squad. An interpreter would allow the Italians and Americans to speak in their own languages. A transcript would be made in Italian.

Also seated in the room was Giuseppe Proietti, no longer the young archaeologist from his days in Cerveteri during the tomb-robbing heyday that yielded the trafficked treasures by Euphronios. He had since risen to the head of archaeology at Italy's Ministry of Culture, and he was out to undo the damage that had occurred on his watch three decades earlier.

The prosecutor, Ferri, began questioning True at 2:18 P.M. that Wednesday afternoon. He started with the easy stuff—name, date of birth—and then became more pointed.

"The first question is the following," Ferri said. "Do you know Mr. Giacomo Medici, and if so when—how many times have you met and for which reasons have you met?"

"Yes, I know Giacomo Medici," True began. "I believe the first time I met Giacomo was in 19—by 1984 at the sale of the Bolla collection, a collection of Greek amphoras that took place in Basel, Switzerland."

From the start, True messed up—the sale was actually two years later, on November 14, 1986—but the error would be of little consequence in light of the broader picture she painted of her relations with "Giacomo."

"After that meeting," True continued, neglecting to mention the details of a dinner she and Medici had out together in Basel with Robert Hecht and the Met's Dietrich von Bothmer, "I probably saw Medici, if I recall correctly, about five times. The meetings were in Geneva, Switzerland; in Rome; and in Malibu, California. For the most part, when I saw him in Geneva, the scope of our meeting was to offer objects for sale to the museum."

When the matter of Medici and Hecht's road trip to Los Angeles came up, True curiously underplayed the event. "Then there was a trip that he made to Malibu, California. He came to find me at a certain point with Robert Hecht. But that was only a courtesy visit. They were there on vacation."

The details of who else was present at her first meeting with Medici, in Basel, only came out five minutes later under follow-up questions by Ferri, who wanted to know if it was the former Getty antiquities chief, Jiri Frel, who had introduced her to Medici.

"Frel knew Medici," True answered. "Frel didn't introduce me to Medici. When I met Medici it was in Basel, Switzerland, and it was Bob Hecht, or Dietrich von Bothmer or someone who was at the Bolla sale who introduced me to him."

The line of questioning triggered by the mention of Hecht and von Bothmer's names was nearly as important as the discovery of Hecht's manuscript at his Paris apartment. First Ferri sorted out the relationship between Hecht and Bruce McNall, the Los Angeles coin dealer who'd supplied the Sarpedon chalice by Euphronios to Bunker Hunt, and the relationship between Hecht and the vase restorer Fritz Bürki.

"Hecht and von Bothmer, according to you, you believe were good friends?" Ferri asked.

"Yes, I believe so."

"You know von Bothmer?" Ferri asked.

"Yes," True replied. It seemed like an odd question. Was the prosecutor playing dumb?

"Did von Bothmer ever confide in you?" Ferri continued. There was a pause, as True didn't respond. Maybe he'd hit on something. "Why are you perplexed?" he asked her.

"No, I only want to say, yes, that he was my—he was my professor."

"Did he ever confide—did he ever confide in you?" Ferri pressed on. "I insist on this particular point."

"Yes, I think it's fair to say he did."

"When?"

"In terms of important confidences, near the end of his term when he was about to retire, say, it had to be 1990, around then," True said. She was clearly thinking of something specific, and Ferri responded as if he knew exactly what it was.

"He openly confided in you, I have the same information—I have information about a major—about which he openly confided in you. Can you tell me what this is?"

"Only to put this in perspective, Mr.—Professor von Bothmer wanted me to be his successor at the Met. One time I was in his office, and he had a photograph, an aerial photograph, that

showed the necropolises of Cerveteri. And looking at the necropolises, he pointed to a certain spot on the photo and said: This is the place where the Euphronios krater was found."

Marion True had dropped a bomb, and it landed directly on von Bothmer and the Metropolitan Museum of Art. Ferri didn't let go.

"Where was that tomb, was it Sant'Angelo?"

"I don't know. Honestly—it was only this photograph and I . . ."

"Did he tell you why he was in a position to indicate which tomb it was?"

"No," True said, winding down this line of interrogation. "He just said that he had been given the information that that was the place where the krater came from."

On June 25, 2001, the action switched back to Rome, and the beginning of the trial of Medici and Perticarari for Lot 540—the Sotheby's vase sale that started Medici's legal troubles when von Bothmer tipped off the auction house that the amphora had been published in a magazine story about a tomb robber. The case was complex, involving dozens of objects the police had uncovered at Medici's Santa Marinella and Rome homes, and for which he was charged with failing to register with the authorities. But the charge for Lot 540—receiving stolen antiquities—was the most serious and also carried the most symbolic weight, for it represented the core of Medici's old system of dealing through Sotheby's.

The prosecution's task was to prove that the vase in the photos printed in *Epoca* was the same vase whose picture was published in the Sotheby's catalog. Among the problems facing the prosecution was that Sotheby's response to von Bothmer's tip was simply to return the vase to Medici's company, and now it had vanished, at least as a piece of evidence. It was Medici's luck, too,

that the magazine photos and catalog photos were hard to compare, because they were shot at different angles. Crucially, the Sotheby's photo was a head-on picture of the vase's front, whereas the magazine's was taken from above.

In October 2001, the Carabinieri, having already searched Hecht's and Medici's homes, got around to searching the Zurich home of Fritz Bürki, the man who had restored at least three of the newly surfaced Euphronios vases, including the Sarpedon chalice and krater. Working with their Swiss counterparts, the Italian art squad found evidence that made the link between Bürki and Hecht crystal clear. On a bookshelf they found Hecht's expired passport, and on Bürki's desk, a photograph of the Euphronios krater he had restored for the Metropolitan Museum of Art. Among the thousands of ancient objects the Italians were investigating, the works of Euphronios came into focus as the nexus of the underground trade and the criminal charges they were prepared to bring.

The case of Lot 540 was finally decided on February 26, 2003. Judge Enrico Gallucci of the Rome Tribunal found Medici innocent of receiving stolen artifacts under the 1939 antiquities law, saying there wasn't enough evidence to prove that the vase Medici had offered for sale in the 1985 Sotheby's catalog was the same one the admitted tomb robber claimed to have sold. Vases of that type were often made in series, and it was impossible to be sure they were exactly the same pots. Medici had benefited from having the photos in the auction catalog and the ones in the incriminating *Epoca* story taken from different angles.

The verdict was a coup for Medici, but in a way the damage

had already been done, because this case led to much bigger legal troubles. On March 4, 2004, Judge Guglielmo Muntoni of the Rome Tribunal indicted Medici in the broader case that Ferri and the art police had been building, much of it based on the analysis of Medici's photo collection by the Villa Giulia museum technician, Pellegrini. Medici now faced trial not just for one vase, but for smuggling and receiving hundreds of artifacts that had ended up in the world's best-known museums, including the Met, the Getty, Boston's Museum of Fine Arts, Princeton University Art Museum, and a string of others in Germany, Norway, and Japan. Among the objects the indictment accused him of smuggling and trafficking were Euphronios's matching Sarpedon krater and chalice.

Most of the charges, dating to the 1970s and 1980s, should have expired long before under statute of limitations rules. But Medici faced an additional charge of conspiracy—a crime committed over a span of time—which made the actions of his early career part of one single act that had continued up through the present. Conspiracy also required acting with others, and his alleged coconspirators included Robert Hecht, Marion True, Fritz Bürki, and competitors such as Robin Symes and Gianfranco Becchina. Medici was the only one of the bunch being charged, for now.

Unfortunately for Medici, the prosecutor was uncovering more and more evidence that showed Hecht's manuscript was not a work of fiction. London dealer Symes said under questioning in 2003 that in 1971 or 1972 he had bought a large, bronze eagle from Robert Hecht. That exactly matched what Hecht had written to explain how he raised the cash to pay Medici for the Sarpedon krater.

With each new bit of evidence, the Met's ownership of the vase seemed more and more precarious. And while nobody involved

in Medici's case realized it at the time, another seemingly unrelated smuggling investigation was becoming equally important in determining the fate of the Euphronios krater and many other ancient masterpieces. It was the case of a pharaonic statue disguised as a cheap tchotchke, and it would change everything.

The story had begun in 1991, at an unguarded archaeological site in Egypt, where tomb robbers took a saw and separated the face on a 3,375-year-old statue of King Amenhotep III, the pharaoh presumed to be the grandfather of King Tutankhamun, from its torso just above the neck. In 1991, the robbers sold the statue to a British art restorer, Jonathan Tokeley Parry, who sneaked the pharaoh's head past Egyptian customs by coating the gray sculpture with plastic and painting it in gaudy colors—gold for its face and shiny black stripes for its hair—making it look like a cheap souvenir. Once the head was safely smuggled to England, Parry soaked away the plastic layer in the chemical equivalent of nail polish remover.

Later that year, hoping to sell the artifact, Parry showed a photo of the Amenhotep head to a Princeton-educated, New York antiquities dealer named Frederick Schultz. Among the highlights of Schultz's career, he served as president of the National Association of Dealers in Ancient, Oriental and Primitive Art. To sell the bust, he and Parry claimed that a relative of Parry's had exported the sculpture from Egypt in the 1920s. The date was conveniently decades earlier than Egypt's Law 117. Passed in 1983, the law, like Italy's, declared that all artifacts in the ground were the property of the state.

Despite the cover story, Schultz couldn't find a buyer, and he instead bought the king's head himself for $800,000. A year later he resold it to a private collector for $1.2 million. The British

police eventually caught Parry, arresting him in June 1994 for dealing in stolen antiquities. Parry, who was convicted, agreed to testify against Schultz, who went on trial in federal court in New York in January 2002. The jury in United States District Court heard all about the painted bust of King Amenhotep III, and in February 2002 convicted Schultz of the one charge against him: conspiracy to receive stolen property in violation of the National Stolen Property Act. The court sentenced him to thirty-three months in prison.

The verdict posed a mortal threat to the antiquities trade—and a once-in-a-lifetime opportunity for archaeologists—because the National Stolen Property Act said that anything deemed stolen property by a foreign country would also be considered stolen under U.S. law. Additionally, the jury decided that this also applied to looted antiquities.

If the verdict stood up under appeal, all that Italy—or any other country with similar cultural property statutes—needed to do now was demonstrate that under their own laws, the object in question was considered stolen. The untested but logical extension of the *Schultz* decision was that to properly enforce the National Stolen Property Act, federal agents and prosecutors would treat any antiquities theft conviction handed down in Italy or Greece or Turkey or Egypt as if it were a verdict from an American court.

When Schultz appealed, the Archaeological Institute of America organized the opposing amicus brief. This was the same group whose members had rebuked the Met's von Bothmer thirty years earlier after he told them about the existence of the Sarpedon chalice. "The A.I.A. *amici* believe that it is in the interest of the United States and, indeed, all humankind that a comprehensive regime of national and state laws work to encourage the preservation of archaeological sites and the artifacts found therein," the brief said. Because the United States is one of the

world's largest markets for ancient art, "This Court's decision is thus likely to have a direct and real effect on the looting of archaeological sites overseas."

The judges sided with the archaeologists. On June 25, 2003, the United States Court of Appeals for the Second Circuit, in New York, upheld the Schultz conviction, giving new weight to the National Stolen Property Act. "[W]e conclude that the NSPA applies to property that is stolen in violation of a foreign patrimony law," the court wrote. "We see no reason that property stolen from a foreign sovereign should be treated any differently from property stolen from a foreign museum or private home."

When the Supreme Court refused in 2004 to hear Schultz's appeal seeking to overturn his conviction, the appeals court ruling became the law of the land—potentially sealing the fate of the Met's Sarpedon krater and dozens upon dozens of antiquities in American museums and private collections. As far as the international artifacts trade was concerned, the ancient lands ringing the Mediterranean were no longer legal backwaters. If Egypt's Law 117 had been the law of the land to the United States Supreme Court, then surely the same could be true for Italy's 1939 antiquities legislation. Very soon the Metropolitan Museum of Art would care what cases were winding their way through the Rome Tribunal.

Medici went on trial at the start of 2004, essentially on charges that his entire career as an antiquities dealer had been a crime. At the beginning he made a strategic move to limit the time he might have to serve in prison if convicted, choosing what is called the abbreviated rite, under which a trial is conducted quickly, mostly handled on paper via court filings, and with limits to the witnesses and evidence that each side can present. Just one judge,

rather than the customary panel of three, would decide the verdict. In return, any jail time would automatically be reduced by one-third. Medici thought he had a good deal.

The trial lasted nearly a year, spread over just a dozen hearings at the modern Rome Tribunal complex. At 10:30 A.M. on December 13, 2004, Judge Muntoni read the sentence aloud. Medici sat in the front of the courtroom to the right, facing the judge. Ferri the prosecutor sat to the left.

"In the name of the Italian people, The Judge, in view of articles 533, 535, 538, 539, 540, 541 of the penal code, declares Medici Giacomo guilty of conspiracy, continued and aggravated receiving," and a third count of smuggling, "in relation to the archaeological artifacts described in appendix 'a'," a list including hundreds of objects seized in Geneva, only a dozen of which the judge said Medici had been acquitted for.

Judge Muntoni read the names of other objects for which he had found Medici guilty: "Archaeological works that had arrived at the J. P. Getty Museum in Los Angeles through Medici Giacomo and third persons, with the exception of artifact number 9, Caeretan hydria," he said. According to Judge Muntoni, dozens of works at the Getty were now declared "smuggled"—the one exception being the hydria pot that Medici had used as the name of his Geneva gallery. The judge also said Medici was guilty of trafficking hundreds and hundreds of antiquities, including one that started it all—the marble sarcophagus fragment depicting sea monsters, burglarized from the de Marchi home and matching one of the three lots Editions Services had put up for sale at Sotheby's in 1987.

And then the judge came to the crucial line, adding to the guilty verdict the "Artifacts handled by Medici Giacomo that had arrived at New York's Metropolitan Museum of Art through third persons," Muntoni said.

Muntoni did not read the list of objects itself, but it contained seven vases. Images of six of them could be found in Medici's photo archive. The seventh was the "Euphronios krater with the scene of Sarpedon dying."

That was it. In a garble of legalese, the judge had pronounced Medici guilty of smuggling the Met's Sarpedon krater—and declared that the vase was stolen goods. Muntoni sentenced Medici to ten years in prison and slapped him with a 10-million-euro fine.

The entire process lasted little more than fifteen minutes. Afterward Medici, who was free pending his appeal of the conviction, went home to Santa Marinella. But he wasn't completely free. Just after midnight the police arrived at Medici's door and told him to surrender his passport. His days as an international dealer were over, at least for now.

Judge Muntoni later submitted a written sentence in Medici's case, which he filed to the Rome court's clerk on May 12, 2005. In the 659-page document, the judge took aim at the Met and Dietrich von Bothmer, even though the curator had not been charged with any crime and had not even been formally under investigation. Muntoni said von Bothmer was at the center of a web of buying, donating, and authenticating loot that involved the Met, dealers, Getty curators, and private collectors. "The Metropolitan Museum gave Medici and his band their beginnings in the American traffic through Dietrich von Bothmer," he wrote. While working as a curator, von Bothmer purchased smuggled Greek pottery for his private collection, including the piece of the huge Onesimos-Euphronios kylix that the Getty had already returned to Italy.

The phonebook-sized conviction went far beyond the scope of Medici's business dealings and into the galleries of the world's biggest museums. Judge Muntoni had just begun to expose the

web of connections that enmesh the antiquities world. Just three months after convicting Medici, the judge indicted Robert Hecht and the Getty's Marion True, ordering them to stand trial for receiving stolen antiquities and for conspiracy in the artifact trade. Hecht, like Medici, faced an additional charge of smuggling.

"It is clear that Robert Hecht and Marion True were purchasing and dealing with Italian artifacts in Rome. They made their criminal plans together," said the indictment, which also outlined the broader scope of an alleged conspiracy Hecht had founded and that involved restorers and other art dealers. "Medici and Hecht organized this entire illicit trade." Both Hecht and True, who eventually resigned from the museum, have denied the charges.

The indictment of Hecht and True contained long lists of artifacts for which they would stand trial, many of which graced the world's top museums. Taken together with similar lists from Medici's conviction, the tally of alleged loot was astounding. In all, at least fifty-two items the Getty had acquired or handled were looted or came from smugglers, twenty-two were in Boston's Museum of Fine Arts, and one each were in the Princeton University Art Museum and the Cleveland Museum of Art.

The Metropolitan held twenty-two such objects, including a fifteen-piece set of Hellenistic silver, known as the Morgantina Silver, which Hecht was charged with illicitly selling to the Met after looters dug it up at Morgantina in Sicily. The star among the Met's suspect objects, of course, was the Sarpedon krater by Euphronios. Judge Muntoni had already convicted Medici for smuggling it, and now Hecht would face the same charges.

For Italy, Judge Muntoni's written conviction of Medici and the indictment of Hecht and True would become the ultimate weapon for demanding the return of antiquities from abroad.

• • •

On July 6, 2005—Medici's sixty-seventh birthday—his lawyers, Fabrizio Lemme and Susanna Spafford, filed the appeal of his conviction. The seventy-eight-page document outlined thirteen different reasons that the Appeals Court of Rome should overturn Judge Muntoni's sentence. Some of them were technical, procedural reasons that the case should be thrown out for errors made by the judge. They argued that the evidence collected at the Free Port in Geneva shouldn't have been admitted in an Italian court from a foreign jurisdiction—for several reasons, including that Medici wasn't present at the raid and no inventory was conducted for three years, putting the proper chain of custody of the evidence in doubt.

But the heart of the appeal was that prosecutors hadn't proved that Medici committed the crimes. They pointed out that Judge Muntoni, in pronouncing Medici's sentence, drew upon the case of Lot 540 when he wrote, "Already the tale of this single vase shows the cooperation, complicity and modus operandi of the conspirators"—even though Medici had been absolved of any crime involving Lot 540.

Medici's lawyers attacked the judge's logic when he concluded that Medici's possession of photos of fragmented objects proved that Medici had bought or handled recently dug material in Italy. "The possession of photographs does not necessarily imply the possession of the object," they wrote.

And they pointed out an often overlooked fact of the case presented against Medici: "With the exception of Hecht's memoir, which merits its own discussion, none of the evidence has indicated even a single acquisition in Italy by Medici that was subsequently exported from the country." And they added, "None of the pieces mentioned by Hecht are found in Medici's photo archive."

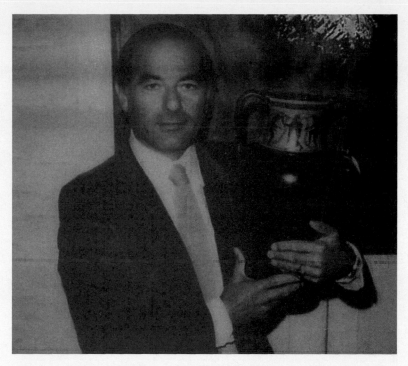

Giacomo Medici in July 1980 at Christie's in London, holding a purchase.
Courtesy Giacomo Medici

Prince Vittorio Massimo, by legend a descendant of Zeus, employed Giacomo
Medici's father for digs on his land north of Rome. He's pictured at the April
29, 1954, party for his wedding to film actress Dawn Addams, which young
Medici attended. *Giuseppe Palmas*

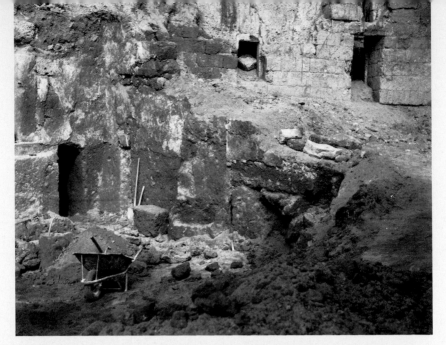

Tomb openings (upper right) at Greppe Sant'Angelo in Cerveteri where tomb robbers found the Sarpedon krater. Photographed during the 1974 salvage excavation. *Soprintendenza per i Beni Archeologici dell'Etruria Meridionale*

The opening of a tomb at Greppe Sant'Angelo in Cerveteri that is likely the find spot of the Sarpedon krater, with a spillo, the tool that tomb robbers use to probe the ground. Photographed during the 1974 salvage excavation. *Soprintendenza per i Beni Archeologici dell'Etruria Meridionale*

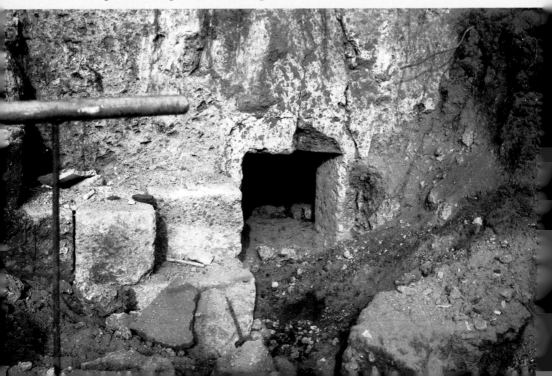

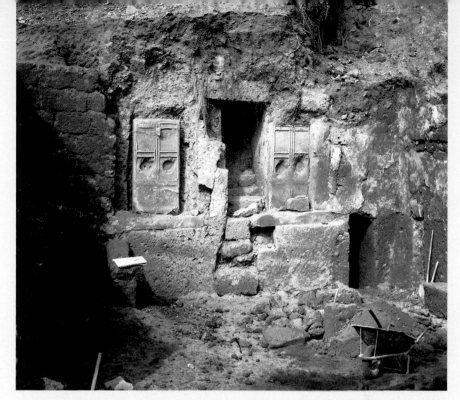

Stone false doors at the Sarpedon krater dig site in Cerveteri, showing damage from being hammered at by tomb robbers. Photographed during the 1974 salvage excavation. *Soprintendenza per i Beni Archeologici dell'Etruria Meridionale*

The site of the Sarpedon krater dig in Cerveteri, with a lion left behind by the tomb robbers. Photographed in 1972 as part of the first of two salvage excavations by police. *Soprintendenza per i Beni Archeologici dell'Etruria Meridionale*

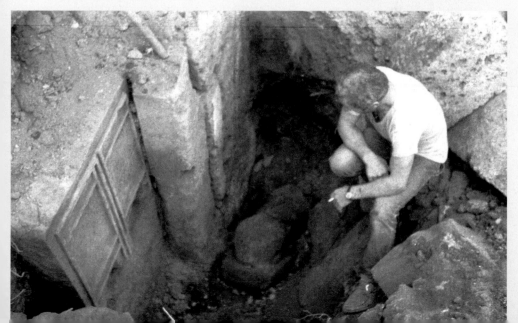

Thomas Hoving's 1972 acquisition of the Euphronios krater for $1 million spurred accusations that the Met's new vase had been freshly looted from a tomb in Italy. *AP Photograph/Marty Lederhandler*

The Met announced its purchase of the Euphronios krater with a cover story in the *New York Times Magazine*. Sarpedon practically bled onto brunch tables up and down the East Coast that Sunday. *© 1972 New York Times; underlying photograph courtesy Metropolitan Museum of Art*

The Met's Greek and Roman curator in 1972 after the museum took delivery of the Sarpedon krater by Euphronios. Dietrich von Bothmer always regretted not buying the vase's twin, the Sarpedon chalice. *Michael Gold*

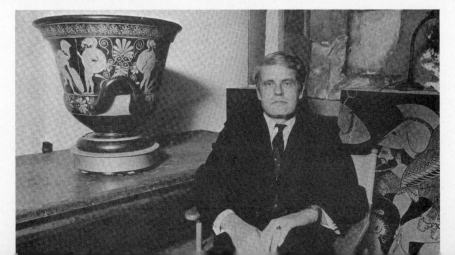

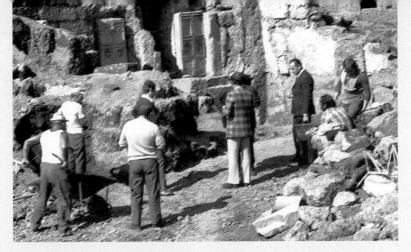

Antiquities dealer Giacomo Medici (center in plaid jacket) during the government's 1974 salvage dig in Cerveteri where tomb robbers had previously excavated the Sarpedon krater and other vases. Medici was co-owner of the land at the time of the salvage dig. To his left, in a dark top with light-colored collar, is state archaeologist Giuseppe Proietti. *Soprintendenza per i Beni Archeologici dell'Etruria Meridionale*

A sphinx that police found left behind at the Sarpedon krater's looting site in Cerveteri. *Soprintendenza per i Beni Archeologici dell'Etruria Meridionale*

Greppe Sant'Angelo in Cerveteri, where tomb robbers had previously excavated the Sarpedon krater and other vases, following a government-ordered salvage dig. The likely find spot for the krater is one of the tomb openings on the upper right. *Soprintendenza per i Beni Archeologici dell'Etruria Meridionale*

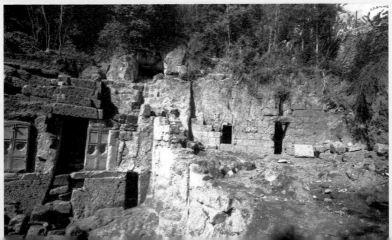

Giuseppe Proietti. As a young archaeologist the first dig he supervised was a salvage operation at the tomb complex from which the Sarpedon krater was looted. Three decades later, as secretary general of the Italian Culture Ministry, he signed the agreement for the krater's return from the Met. *Vernon Silver*

Bruce McNall, Hollywood producer and former owner of the L.A. Kings hockey team, says he sold the Sarpedon chalice to Bunker Hunt in 1979. *Vernon Silver*

Texas billionaire Bunker Hunt (left) owned the Sarpedon chalice until bankruptcy forced him to sell it at Sotheby's in 1990, where an anonymous bidder snapped it up. He is pictured with his brother, William Herbert Hunt, and their wives at an exhibit of their antiquities collection at the Dallas Museum of Art. *Shelly Katz/Time Life Pictures/Getty Images*

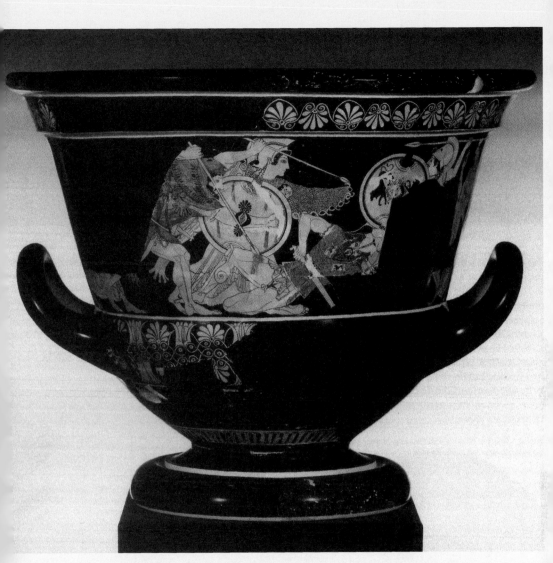

The Sarpedon chalice surfaced in 1980 together with this other previously unknown vase signed by Euphronios as its painter. Bunker Hunt owned the fragmentary krater, followed by New York collectors Leon Levy and Shelby White. *Summa Publications*

Medici poses in front of the Sarpedon krater by Euphronios during a trip he took with Bob Hecht in 1987. Prosecutors would later use the photograph, found in his Geneva warehouse, as evidence that he had smuggled the pot in the 1970s. *Courtesy Giacomo Medici*

A September 13, 1995, raid on Medici's Geneva warehouse turned up an incriminating photograph archive of antiquities that later turned up in the world's biggest museums. *Vernon Silver*

Medici poses at the Met in 1987 in front of an Etruscan chariot, excavated a century ago — proof, he says, that photographs of him with objects in museums are not evidence that he smuggled them, as his prosecutor says. *Courtesy Giacomo Medici*

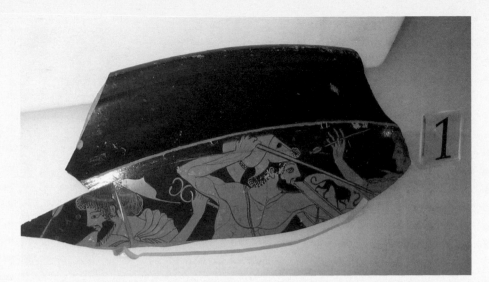

In 1999, Medici handed over these three fragments of a giant cup that had been at the Getty, in a failed attempt to have the smuggling charges against him reduced. *Vernon Silver*

The Etruscan graffito on the bottom of this cup spelling out Ercle was proof it had been looted from a shrine to Heracles in the town of Cerveteri. The Getty returned the cup, potted by Euphronios and painted by Onesimos, in 1999. *Vernon Silver*

Rome prosecutor Paolo Ferri (with beard) won a conviction of Giacomo Medici and an indictment of Robert Hecht for trafficking antiquities, including the Sarpedon chalice and krater by Euphronios. He is pictured with Maurizio Fiorilli, a lawyer for the Culture Ministry. *Vernon Silver*

The Getty's former antiquities chief went on trial in Rome on November 16, 2005, for acquiring looted artifacts. She denies the charges. *AP Photo/Pier Paolo Cito*

Robert Hecht, at his trial in Rome. He sold the Met its Sarpedon krater and offered the matching chalice to the museum, which would not take the risk that it had been illegally excavated. He eventually sold the chalice, via Bruce McNall, to Bunker Hunt. *Vernon Silver*

Maurizio Fiorilli, a lawyer for the Italian Culture Ministry, negotiated the return of objects from American museums, including the Met's Sarpedon krater. He is holding a picture of a statue of Roman Empress Sabina, returned by Boston's Museum of Fine Arts. *Liana Miuccio*

Danny Berger, an employee of both the Met and the Italian Culture Ministry, greased the way for the Sarpedon krater's return. *Vernon Silver*

Met director Philippe de Montebello signs over title to twenty-one objects, including the Sarpedon krater by Euphronios, at the Italian Culture Ministry, February 21, 2006. Rocco Buttiglione, the culture minister who oversaw the negotiations, sits next to him. *Alberto Pizzoli/AFP/Getty Images*

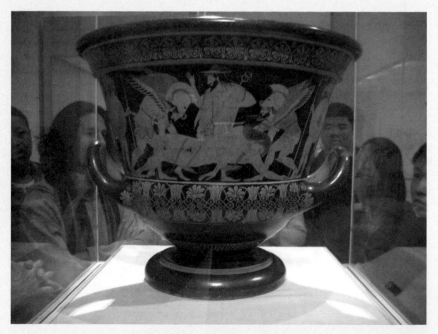

The Sarpedon krater's last days in New York. *Vernon Silver*

Culture minister Francesco Rutelli helped win the return of artifacts from the Getty, seated with state archaeologist Giuseppe Proietti. *Vernon Silver*

Anna Maria Moretti Sgubini, Italy's head of Etruscan archaeology, who helped reclaim looted artifacts. Her father Mario Moretti held the same job when the Euphronios vases were illegally excavated on his watch. *Vernon Silver*

Italy unveiled its newly reclaimed Sarpedon krater by Euphronios in Rome on January 18, 2008. *Vernon Silver*

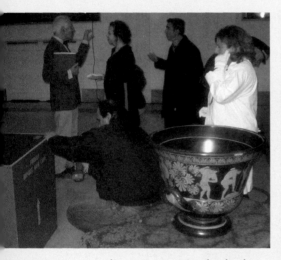

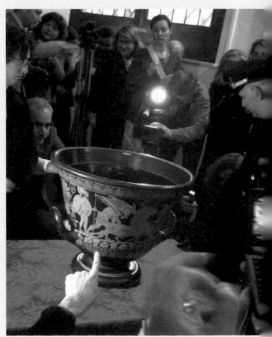

Deliverymen prepared to load the Euphronios krater back into its blue, padded box after its unveiling in Rome on January 18, 2008. In the background, wearing an overcoat, is Marshal Salvatore Morando of the Carabinieri art squad, who uncovered the evidence leading to its return. *Vernon Silver*

Crowds gathered around the krater after its unveiling in Rome at the attorney general's office, January 18, 2008. *Vernon Silver*

Francesco Bartocci, the last known surviving member of the tomb-robbing gang, at the site where they excavated the Sarpedon krater by Euphronios and perhaps the Sarpedon chalice. *Vernon Silver*

Francesco Bartocci draws a map and diagram of how he and six other men excavated at Greppe Sant'Angelo in Cerveteri, north of Rome, discovering a trove of statues and vases, including the Euphronios krater. *Vernon Silver*

The fragments of the Sarpedon chalice are stored in this imitation Etruscan temple on the grounds of Rome's Villa Giulia museum. *Vernon Silver*

They were right on all points. For example, nobody had ever turned up the Polaroid of the Euphronios krater that Hecht had written about in his memoir. Maybe the prosecution hadn't proved its case. But was Medici innocent? One of his assertions stuck out as a potential litmus test of his truth telling: that he hadn't met Hecht until 1974, and therefore couldn't have committed the crimes, including smuggling the krater.

Medici eventually revealed the truth about that date, casting a whole new light on his not-guilty plea.

By the summer of 2005, the Culture Ministry's Giuseppe Proietti had come a long way since his first dig, the one in 1974 at the Sarpedon krater site in Cerveteri. After serving as director general for all Italian archaeology from 2001 through 2004, the ministry promoted him to head of the department of research, innovation, and organization, one of the top nonpolitical posts.

He had most recently made his name leading the Italian efforts at preserving Iraq's archaeological sites after the March 2003 American-led invasion. The Italian military had sent Carabinieri to help protect the sites, which tomb robbers targeted in the lawlessness that followed the overthrow of Saddam Hussein. And while the United States took over such key government agencies as the Central Bank of Iraq and the Finance Ministry, the Italians took over the Culture Ministry as the advisers to the new government that the foreign forces were setting up. Proietti had spent much of the previous two years flying between Rome and Baghdad, where he dealt with issues ranging from the recovery of thousands of artifacts famously stolen from the national museum there, to visiting the monuments and archaeological areas around the country that were vulnerable to looting, aiming to set up security and conservation efforts.

Now sixty years old, he was spending more time on looting issues closer to home. As Marion True's trial approached, he said he hoped the case would pressure the Getty and the Metropolitan Museum of Art to return objects that had been illegally taken from Italy.

"The ministry's objective is to reduce the damage done by clandestine digs and cease the illegitimate commerce," Proietti said. Baghdad behind him, he prepared for a new war.

A Trip to Oxford

To get a better handle on the illicit antiquities trade I headed to familiar ground, Oxford, where I had earned an archaeology master's degree in the late 1990s—and where, it later turned out, I would return to do a doctoral thesis on Euphronios's Sarpedon chalice. Oxford's archaeology lab had come under fire for its commercial authentication service, shutting it down in 1997 while I was studying there. Recalling the episode, I visited the new director of the lab, Professor Mark Pollard, who explained why the university had stopped serving the private trade. This argument made total sense: authentication can increase an object's value tenfold, he said. "The nub of it is, Does that encourage illicit trade in antiquities? I guess it probably does," the bearded Professor Pollard, pipe in one hand, said.

Afterward he showed me around the lab, which was really a ramshackle series of rooms scattered around a Victorian row house. As we walked up and down creaky wooden staircases and snaked through narrow hallways, he explained that the lab would soon have a modern home in the university's nearby science area. He also said it was a funny coincidence that I had come

around asking about the old thermoluminescence testing business. To prepare for the move, he needed to do something with all the records from the now-defunct TL service. Maybe I would have a use for them, he suggested.

We walked up to the building's top floor to see if we could get at the archive, which was boxed away up in the attic. But when we got to the trapdoor that needed to be pulled down if we were to haul ourselves up there, Professor Pollard, who had recently injured his arm, realized he shouldn't try the tricky move. I couldn't imagine I was missing much, so we moved on. As we said good-bye, the professor again said he wasn't sure what would happen with the files—maybe they would move to the new building, or he would give them to someone who could make good use of them. Either way, I should let him know if I was interested.

For the moment, I wasn't. What did I want with stacks of old paperwork on the authentication of ceramics?

In just a matter of months, a few cases being tried at the Rome Tribunal had suddenly made Italy's long-standing demands for artifacts more than just the chatter of Italian bureaucrats whining that the Americans should give back their stolen treasures. Legally, Medici's conviction, and the pending trials of Hecht and True, changed everything. And then the media jumped in.

The *Los Angeles Times* reporters Ralph Frammolino and Jason Felch, who had been digging into unrelated misdeeds at the Getty, followed their reporting to Rome and the piles of evidence the police had uncovered. They even published a front-page story on the Met's Sarpedon krater, detailing the contents of the Hecht manuscript the Carabinieri found in 2001. "Italy Says It's Proven Vase at Met Was Looted," the headline of their October 28, 2005, story read. In it they quoted the Met's former director Thomas

Hoving, who said of the Hecht memoir, "It proves, as the final nail in the coffin, where it came from."

The Euphronios krater, after three decades, was front-page news again. This time around it would be harder for the Metropolitan Museum of Art to dismiss the publicity being generated by the new evidence.

Meanwhile in New York, journalist Suzan Mazur, who had covered the Hunt auction of the Sarpedon chalice in 1990 for the *Economist,* saw the Euphronios news. She e-mailed me, expressing interest in the story that was developing in Italy, and asked what seemed like an odd question: in my reporting on Euphronios, had I run into any news about the kylix?

I had no idea what she was talking about. She explained that the Met's vase had a smaller twin, this kylix wine cup, and that it hadn't been seen in public since a "European Dealer" bought it at the Hunt sale.

In the year following Medici's December 2004 conviction for antiquities smuggling, something changed in him, both physically and mentally. It wasn't one thing in particular, but his troubles seemed to add up and an anguish crept up on him. He'd always smiled, with his wife, children, and friends, but it no longer came naturally. He had trouble falling asleep at night, robbed of the simple joy of rest. Medici stayed up late in his compound overlooking the sea at Santa Marinella, a fifteen-acre plot on which he had built a swimming pool and two tennis courts and cultivated a rustic lifestyle tending to his vegetable garden, three hundred olive trees, and a menagerie that included geese, ducks, horses, eighteen dogs, and an albino pony. The centerpiece of the compound was his pink mansion in which he passed his time surrounded by the library of his case's legal documents, which

he stored on bookshelves in his study and organized in neat piles across the top of his dining room table, annotated with high-lighter markers and color tabs. Sometimes he retreated to his basement, where he had made a virtual shrine to Euphronios, complete with a replica of the Sarpedon krater and a coffee table filled with books on the Greek master.

Eventually he would get sleepy, and he'd say to himself, "Ah, I'm tired, now I'm going to sleep," and then he'd lie down in his bed and wait. Yet the sleep wouldn't come. He would say, "Gia-como, sleep, sleep." But there was another Giacomo inside him who said, "Stay awake."

The psychological forces acting on him were "diabolic," he thought. And he blamed them on the way the judge had con-victed him: with what Medici believed was inconclusive evidence and motivated by politics that aimed to reclaim Italy's treasures from abroad. What bothered him most was that he believed he'd been convicted of trumped-up charges, and he'd otherwise ac-cept the sentence if there were legitimate proof of his guilt. Whether the sentence was right or wrong, it just wasn't fair.

"I'm not here to say I'm innocent," Medici said while trying to explain his state. "In this world, the innocent practically don't exist and everyone has things to account for. I recognize the course I've taken—sometimes good, sometimes bad. But, the thing I'm talking about, the thing that makes me sick is the sources of their proof, how I was condemned. I was condemned by motivations that are the shame of the justice system, a dishonor."

I first met Giacomo Medici on November 5, 2005, after con-vincing one of his lawyers to give me his mobile phone number. Although I was thrilled to interview a real-live convicted antiq-uities smuggler, I was also concerned for my safety. No, he wasn't going to attack me or anything, but meeting Medici made me nervous. Medici, who was out of prison while he appealed, had a

reputation for not abiding those who crossed him; from what I had read of the case documents, some of his detractors cast him as a Mafioso. To my relief, he agreed to see me in public, at the bar of Rosati, a café on Piazza del Popolo. I didn't want him to know where I worked or lived, or anything about my family. I had to remind myself to hold my tongue if we began discussing personal details.

Then he arrived, smiling broadly. Medici was gray and mostly bald, stocky, but fit, looking younger than his sixty-seven years. He wore a blue Lacoste V-neck sweater over a Fay tennis shirt—a brand popular for some reason among Italians seeking to project an upper-class British look.

On his left hand, Medici wore a gold ring etched with the image of Heracles slaying the lion of Nemea. According to myth, the Greek hero was sure to lose his battle against the fierce animal, but Heracles' ingenuity triumphed over the beast's brawn. He stunned the lion and then strangled it.

Medici spent most of our meeting railing against the prosecutor and judge who convicted him on what he said was flawed evidence. When I asked about his ring, he said he saw himself as Heracles in his own fight against the Rome magistrates. "The lion, in this case, is the justice system, and I hope intelligence triumphs," he said.

Then he quickly pointed out that the ring, which he had worn on and off for the previous fifteen or twenty years, was a modern copy of an ancient piece of jewelry. It was not a looted artifact, he said—just in case I was suspicious.

Finally deciding not to ignore Mazur's question about the missing chalice, I turned to the Met's former director Thomas Hoving to see what he knew. I had dealt with him on some earlier

reporting on the krater, and I thought maybe he would know something about the missing cup.

I e-mailed him:

> *What do you know about the kylix by Euphronios that was in the Hunt collection (that like the krater, also depicts Sarpedon). Was it also offered to you at the same time as the krater?*

Hoving responded that he had mentioned the kylix in his 1993 memoir, *Making the Mummies Dance.*

> *Hecht showed it to me and von Bothmer in Feb. 1973 and the price was 70K. I was tempted, for it was like having an early and a mature Leonardo.*

He added the bit about Hecht saying the provenance was a Norwegian collection and that the Met couldn't buy the cup because of the krater controversy. "The kylix was sold by Hecht's secret LA partner Bruce McNall, the hockey mogul and numismatist," Hoving continued.

> *McNall sold it to Bunker and it showed up in the Hunt sale whereupon Levy presumably bought it and also presumably, if he did, it will come to the MMA when the Levy-White collection is finally given.*

Hoving's theory about the current whereabouts of the Sarpedon chalice—the Levy-White collection—was the most plausible that had floated around the art world. After all, Leon Levy had bought the fragmentary Euphronios krater at the Hunt auction, and the chalice had been the subsequent lot up for grabs that June

evening. I had no way of confirming the widely held belief that the chalice sat on White's shelf on Manhattan's East Side, but if I wanted to track down the Sarpedon kylix, there was one daunting resource at my fingertips that I could consult: the 659-page sentence Judge Muntoni had written to convict Medici.

Among its contents were long lists of objects: those contained in museum collections that were linked to Medici, those sold at Sotheby's by Medici, those for which Medici had been accused of smuggling but was found innocent, those he had been suspected of smuggling but turned out to be fakes, those found at Medici's warehouse that turned out not to be from Italy, those seized at his Geneva warehouse that had been shipped to Italy—both those for which he had been convicted of smuggling and those for which he'd been acquitted. It went on and on like that. To find what I was searching for, I had to eyeball the whole thing, looking for the words *kylix* or *Euphronios*.

Page after page, I flipped through Medici's sentence. The word *Euphronios* kept popping up, but nothing matched what I needed. Then I spotted a kylix on page 419. In a section in which the judge discussed objects from the Hunt collection he wrote, "The Euphronios Kylix, registered as no. 955 of the seized works, bought by MEDICI at auction in 1990 as lot 6, and by the same artist, Euphronios, and of the same subject, the death of Sarpedon, as the krater also sold by MEDICI and HECHT to the Metropolitan Museum; together with that work it is evident that they came from the same burial; in the HECHT memoir there is an explicit reference to MEDICI having received that Kylix and that its link to the Krater, being part of the same burial was revealed in a 'betrayal' by Hoving, the director of the Metropolitan Museum."

Mazur really was on to something, I thought, as I learned for the first time that the Sarpedon krater had a smaller twin that

might have also come from the same tomb. Even if Muntoni was making a conclusion about the chalice's origins that was not definitively backed by the evidence, I was intrigued. Where could I find details on the fate of object number 955 from the seized works?

I kept poring over the conviction until I found a list on page 614. "Attic red figure cup," it said. "With Hypnos and Thanatos and the body of Sarpedon. Euphronios."

I'd found it. According to the header on the list, it was among the objects that had been seized from Medici at the Geneva Free Port. I just needed to find out where it was now and how it had ended up there. I called Medici and explained that I was interested in the kylix by Euphronios. He said something about the "broken" one, and I had to correct him; I wasn't talking about the huge, fragmentary kylix painted by Onesimos and potted by Euphronios. I was talking about a cup painted by Euphronios, with Sarpedon on it.

Yes, Medici said, he had not misspoken. The Sarpedon kylix was broken, too. I thought he was making no sense. The cup Bunker Hunt sold in 1990 was in one piece. What was Medici talking about? He agreed to meet me again that weekend to shed some light.

With Marion True's trial looming, the Getty decided to return three objects to Italy—a Southern Italian krater, a stone carving, and an Etruscan bronze—whose illicit origins had been clearly established. Instead of taking the Getty's move as a peace offering, the Italian culture minister, Rocco Buttiglione, used a November 11, 2005, news conference announcing the returns as a moment to declare war on museums that had acquired looted antiquities. "The old spirit will not last," Buttiglione, a right-

wing member of billionaire Prime Minister Silvio Berlusconi's government, said with his trademark lisp. "It's not open territory for stealing."

This was not the first time Italy had demanded that foreign museums send back antiquities, but in the past they didn't have ammunition to back up their indignation. This time was different. For one, the international media started paying attention, causing huge image problems for the museums. And the *Schultz* case showed that the American legal system was available for Italy to use against the museums and other collectors. Not only was Italy willing to drag them all into court, but the Italians could be helped by the Justice Department and agents from the Department of Homeland Security's Immigration and Customs Enforcement, known as ICE. Representatives from both those departments were seated in the first row of the press conference at the Carabinieri Art Squad Operational Headquarters in Rome. "Thanks for what you've done," Buttiglione told them.

The minister had his ammo on display: prosecutor Paolo Ferri, who made a rare press conference appearance just five days before he was to present his opening arguments in the trial of Marion True.

Responding to reporters' questions, Buttiglione made it clear he was just starting. "Contacts with other museums are in course and we'll hopefully have positive results," he said. In exchange for their cooperation, he added, the museums were being offered long-term loans of similar objects and other cultural cooperation. But he did not mince his words about artifacts that had been removed illegally. "That which is the property of Italy should return to the Italian people."

Pressed on what museums he'd pursue after the Getty, Buttiglione dropped a bombshell. "I have asked Mr. de Montebello to come to Rome to talk to experts." The Met was next, and

its director had just been summoned to hear the evidence against his museum.

Breakfast on Saturdays is a quiet time at Rome's Hotel de Russie, a palazzo with an ultramod interior renovation, which caters to high-end business travelers and movie stars. With few people around, it was ideal for meeting with a smuggler about his missing chalice.

After ordering coffee, juice, and some pastries in the hotel bar, Medici ran me through the basics on the Sarpedon chalice. Yes, he revealed, he was the "European Dealer" who bought it at the Hunt auction for $742,500—outbidding the Met's agent in a nail-biting battle—shipped it to the Geneva Free Port, and even bought a fireproof safe where he stored the cup. He described the other four vases he bought at the 1990 auction and how he had insured the whole lot at Lloyds of London.

But Medici cared most about Euphronios, who he said had employed superhuman talent to paint the intricate lines on the small cup, all without being able to see how it would turn out. "To make a piece like this you need the eyes of a falcon," he said. And he regaled me with even more details of the kylix's journey: seized in the 1995 raid and then dropped in the 1998 inventory. Now I understood what he meant about the cup being broken.

But did he know what had happened to the chalice since? He did.

The most recent leg of the cup's twenty-five-hundred-year journey had begun in 2000, when the Swiss turned over to Italy 1,973 artifacts seized from Medici's warehouse. A private moving company drove the cache from Geneva to Rome. The Sarpedon chalice, the earliest known work by Euphronios, sat in pieces onboard the truck among the statues and pots.

When the truck arrived in the Italian capital, its contents became evidence, held under the guardianship of the Rome Tribunal. The shippers unloaded the antiquities at the Villa Giulia museum, which was becoming a holding pen for artifacts in legal limbo. The storage space of choice was not in the main museum building, but an odd edifice on the museum's grounds, the Temple of Alatri, a life-sized reproduction of an Etruscan temple, built there between 1889 and 1890. The windowless shrine was perfect, with a columned portico and triangular roof trimmed in red, green, and gold, decorated all around with terra-cotta antefixes that look like little angels. Crucially, two hulking doors standing nearly two stories high protected the temple. There in that darkness, the Sarpedon kylix—in dozens of fragments—had found its new home.

In early 2002, Medici decided he needed to find out if the chalice's fragments were being properly stored—and if they were actually still at Villa Giulia. After all, the Sarpedon cup had been his single most valuable piece of merchandise. If he ever got out of this legal mess, that kylix was his meal ticket—if it could be fixed.

Medici arranged a meeting with Paolo Ferri, pleading with him at his modern offices near the Vatican for a chance to see his own property. Technically, Medici was within his rights to do so, and Ferri told him to put the request in writing. Medici had hundreds of artifacts under seal of the court, but of them, his lost chalice was the only one he wanted to see.

Medici included with his request his willingness to have Marshal Salvatore Morando from the Carabinieri art squad present for the visit, along with Daniela Rizzo, the archaeologist at the museum who had been busy in recent months directing the examination of the documents and artifacts seized in the Geneva raid. The same day Medici submitted the request, Ferri approved

it, scribbling his instructions that both Rizzo and a member of
the art police be present and stamping it with the seal of the Rome
Tribunal.

Medici visited the museum with a former academic from
Rome University and Palermo University whom Medici had also
brought along as his consultant to the Geneva Free Port in
July 1997.

The museum staff removed the box, which was about two and
a half feet long, a foot wide, and a foot deep, from the ersatz tem-
ple. They walked the box inside the main museum building to an
office surrounded by glass walls. Inside, and under the watchful
eye of Rizzo and Maurizio Pellegrini, the technician who was
working to make sense of Medici's photo archives for the prose-
cution, Medici was able to lay his hands on his missing chalice.

He knew the kylix was broken, but he was shocked to see that
the pieces had been scooped into plastic bags where the jagged
corners of the fragments could rub against the painted surface.
Inside the bags, bits of the twenty-five-hundred-year-old cup—
some the size of tiny pebbles and grains of sand—shifted around
at the bottoms of the plastic sacks. Medici asked the museum staff
for paper in which he would wrap the sharp fragments to protect
them from each other. They brought him some newspapers, and
Medici carefully took each of the Euphronios shards and repack-
aged them, first in the paper, and then back into the plastic
bags.

In the film *Raiders of the Lost Ark,* the most shocking scene is
the final one, in which a government worker nails the golden
Ark of the Covenant into a wooden box, padlocks it, and stencils
it "Top Secret Army Intel 9906753 Do Not Open!" The box is then
wheeled down the corridor of an anonymous government ware-
house. The camera pulls back to reveal an endless sea of such
boxes. The Ark that has been so hard to capture is lost again.

And so it seemed on that day in 2002. The curators put the bags containing the shards of the Sarpedon chalice back in their box and put the box on a shelf with so many other unseen antiquities. After turning out the light in the imitation temple, they locked the massive wooden doors with a single key.

The years had ticked by, yet the fragments remained there, their fate uncertain. In 2004, the chalice had been one of the hundreds of objects that Judge Muntoni convicted Medici of smuggling—and the judge had even ruled that the evidence showed the Sarpedon cup and krater had come from the same tomb. The chalice was also among the dozens for which Hecht was indicted. That meant Medici's upcoming appeal could determine what would happen to the cup's remains; if convicted, the chalice would become the property of Italy, and if Medici was acquitted, it might return to him. If the Sarpedon cup did revert to Medici, he might just turn around and sell the pieces to the highest bidder.

Whether Medici or the government would—or should—win the chalice depended on the strength of the evidence that the kylix had been excavated in Italy and trafficked by Medici and Hecht. So far, though, that evidence was pretty thin. Prosecutors knew Hecht had once owned the cup, according to what Thomas Hoving and Dietrich von Bothmer had said in the past. And they knew Hecht had written in his memoir that the men at the Met had betrayed him by revealing his possession of the cup. The Italians also had the old rumors from Cerveteri that a cup by Euphronios had been found along with the krater.

Some of this barely qualified as circumstantial evidence. Might there be a way to find definitive proof that both the Sarpedon kylix and krater were looted from Cerveteri and trafficked by Medici and Hecht? After all, the only hard evidence Ferri had

used to convict Medici for smuggling the krater was Hecht's
memoir and Marion True's testimony that von Bothmer knew
the tomb site.

Toward the end of our breakfast, Medici mentioned that he had
photographed the kylix fragments during his visit to the Villa
Giulia storeroom. Medici pulled red sheets of construction paper
out of his leather briefcase. He had stapled the photos on the stiff
paper and attached clear plastic over them. I wanted to see them
in better light, in part to photograph them, so we carried the pic-
tures out of the bar and into the terraced inner courtyard of the
hotel. Laying them down on a cocktail table, I took a look in the
bright morning sunshine.

In one set, taken by Medici, the chalice's fragments were
crammed into plastic bags, their famous images visible but
slightly out of focus. This was certainly the cup I had seen in the
Hunt catalog, but in a condition as bad as Medici had described.
Medici displayed another set of pictures, the ones the Swiss
police had taken of his cup after Inspector Baudin dropped it.
Medici had obtained the photos by exercising his right as a
defendant to see all the evidence.

The photos taken right after the accident were much clearer.
Laid out as they were on a sheet of white tissue paper, in no par-
ticular order and turned in different directions, it took some
mental gymnastics to reimagine the front face of the cup they
once composed. The pieces ranged in size from grains of sand and
slivers the dimension of fingernail clippings, to bigger chunks the
size of coins. In all, I counted about a hundred. Turning the photo
around, I could make out bits of deities and warriors.

But the cup appeared to be beyond repair. "Nobody knows
what the level of damage is," Medici said. He couldn't tell, even

from these pictures, whether the eyes on the faces of the figures on the cup had been cracked. The eyes were the most crucial details in determining whether a fragmentary vase could be recomposed as something of artistic and financial value, he said. And the amount of money at stake was huge. If it had never broken, the Sarpedon kylix would have been worth at least $5 million by then, and perhaps as much as $10 million.

But it wasn't intact. The value of the bags of shards depended on whether the cup could be fixed, and if so, how much of it could be saved.

The trial of Robert Hecht and Marion True began at the Rome Tribunal on November 16, 2005. A three-judge panel convened to hear the case, led by its president, Gustavo Barbalinardo, who was flanked by Aurora Cantillo and Patrizia Campolo. The defendants did not need to be there, but just before the hearing began, True showed up. Hecht did not.

True, with a blond-red hairdo and a long black jacket, did everything she could to avoid the crush of reporters who crammed the back of the room.

The hearing was mostly ceremonial. Judge Barbalinardo read the indictment aloud, with some difficulty; sorting through the charges and all its lists of objects was difficult even for the man running the trial.

One person who was eager to talk, and was well informed about the case, was Maurizio Fiorilli, a lawyer from the Italian attorney general's office who was representing the Culture Ministry in the civil portion, which was being tried concurrently with the criminal charges. Speaking in the corridor during a break, he explained what the Italian government was after. "Our intention is to cut off the illicit traffic, and to cut it off we have to

get the American museums to stop buying," he said. This was no idle threat, for as the meeting with the Met's Philippe de Montebello approached, the government had given Fiorilli the additional task of being the chief negotiator in talks with foreign museums.

The day's session ended with little action other than True dashing out of the court complex's gates, trying to avoid the news media. Her lawyer, Franco Coppi, spoke for her instead: "Signora True insists that she bought these objects in good faith."

Two days later, I figured out why Hecht wasn't at his trial's opening. Speaking by phone from his apartment in Paris, he explained he had been in Athens, visiting museums. I called him to see what he might tell me about the origins of the Sarpedon chalice. Had he offered it to the Met for $70,000, as Hoving had claimed?

"It was about that price," Hecht said. "When a friend of mine sold it to Bunker Hunt at a much bigger price, I was considered unfaithful to the Met."

And where exactly had he gotten the chalice?

"I bought it from Medici for $25,000, before the sale of the krater," he said.

I'd never heard him or Medici admit these details before. I asked Hecht when he'd first met Medici?

"In 1967 or '68," Hecht said. This admission was key for two reasons: it contradicted Medici's official plea that he hadn't met Hecht until 1974, and it was consistent with what Hecht wrote in his manuscript. This was further evidence that the manuscript was a true account, and not a work of fiction, as Hecht claimed.

And when Hecht finally did sell the Sarpedon cup, how much did he make? "I don't remember. All I remember is I got a good sum for it."

Hecht, in a few short minutes, had provided the linchpin to the entire mystery of the Sarpedon chalice, and its origins with Giacomo Medici. I immediately phoned Medici. When I told him that Hecht said he'd bought the kylix from him, the line went silent. Then Medici made noises that sounded as if the wind had just been knocked out of him. He stammered: "I don't know what to think anymore. He must have made a pact with the prosecutor," Medici said. "I'm shocked."

If Medici and Hecht had made a deal not to talk about their old deals, Hecht's revelation spoiled it. Ferri was eagerly trying to turn the suspected dealers and curators against one another, and Medici could only imagine that he had succeeded. In the meantime, Medici composed himself and stuck to his story.

"I never sold this kylix. This was never mine," he said. And he denied Hecht's version of their original meeting as being in the late 1960s, as Hecht had written in his manuscript. They first met in 1974 at a coin sale in Zurich, Medici said, reiterating the claim he was making in the appeal of his conviction.

"He's eighty-six, and I don't know about his memory," Medici said. He suggested that perhaps I should remind Hecht that the correct story had the chalice coming from an old Scandinavian collection.

I hung up with Medici and called Hecht in Paris. After explaining Medici's objections to what Hecht had told me, Hecht cheerfully changed his story.

Medici says he didn't sell you the kylix, I told him.

"Maybe he didn't," Hecht said.

Medici says to remind you that the kylix came from a Scandinavian collection, and that you didn't pay him $25,000 for it.

"That is possible. Come to think of it, he would never sell it for $25,000. He was pricey," Hecht said.

I chuckled as I thanked Hecht again for his time and hung up.

It was the weakest denial I had ever heard, and I figured Hecht meant it that way. Most important, I'd finally figured out that Medici had been the missing link—once again—in the path of the chalice. Not only had he been the anonymous buyer at the 1990 Hunt auction, but two decades earlier he had been the original dealer.

I now knew the chain of possession, but where had the chalice come from in the first place, and where would it eventually end up?

Philippe de Montebello, the Metropolitan Museum's director, and the Italian delegation led by Maurizio Fiorilli agreed to meet in Rome on November 22, 2005. The setting was to be a soaring, wood-paneled library in the Culture Ministry's headquarters, the building connected to the very chambers where Galileo had faced the Inquisition.

Fiorilli, the lawyer representing the ministry, was the first to arrive, a little before the meeting's scheduled 2:00 P.M. start. Officers from the Carabinieri art squad arrived next. And then de Montebello, wearing a blue suit, red tie, and a blue V-neck sweater to ward off the November chill. Since taking over from Hoving in 1977, Paris-born de Montebello and his baritone had become the face and voice of the Met. He had managed to stay in the job three times as long as his predecessor, yet he was still grappling with the krater mess that Hoving had gotten the museum into a generation before. Alongside de Montebello walked a shorter man, of almost the same age, sporting a bow tie, buzz cut, and fashionably bookish, round eyeglass frames. This was Danny Berger, a sometimes employee of the Met who under Hoving's reign three decades earlier had helped pioneer the

concept of the ultracommercial gift shop, which had since become a merchandising cash cow for the Met.

Berger now worked as a consultant to both the Italian Ministry of Culture and the Met. His dual roles and fluency in Italian and English made him a perfect facilitator for such negotiations. For the Met it was also convenient that he was trusted and cross-deputized by both sides of the talks.

De Montebello and Berger chatted as they came up the cobblestoned street and turned left into the ministry's grand doorway. Berger waved his neatly folded copy of the *International Herald Tribune* at the woman in the security booth, who pushed a button to let them in through the palazzo's glass inner doors.

Though the minister had summoned him, de Montebello had to talk to underlings for now. In the library he heard the police present their evidence and Rizzo and Pellegrini from the Villa Giulia museum go over their findings from the analysis of the photos and other documents from Medici's warehouse. De Montebello's Italian was good enough that he didn't much need Berger's translation help.

After it looked like things were going well, the minister arrived in his black car with his tiny security entourage. "Let's go to the delivery room," he said as he headed upstairs.

De Montebello never made a statement. Berger, who knew better than most ministry employees how the various buildings on the historic block link together, helped the Met's director find an alternate exit, away from the news photographers and reporters who lingered outside.

As the rest of the participants trickled out, Giuseppe Proietti, the ministry's head of research who had trailed the Euphronios krater for three decades since his days as a young archaeologist

in Cerveteri, was the last to emerge. "It was a very productive meeting," he said. "*Vediamo*." We'll see.

After filing a story about the broken kylix, I sent a copy of Medici's photo of the fragments, with his permission, to journalist Suzan Mazur. She wrote her own story about the Euphronios flap, including the picture I had sent her. Thomas Hoving saw the story and the photo. The former Met chief, who once had the chance to buy the Sarpedon chalice, sent me an e-mail on December 5, 2005.

"There are some very odd things about this kylix," Hoving wrote. For one thing, "The kylix photo Hecht showed me in '73 was INTACT."

Hoving's e-mail continued:

> *The smashed kylix is either NOT the one I saw nor the Hunt one bought by Medici but another something. The fragments as you and Mazur publish them could NOT be put back into the Hunt kylix—for one thing no fragment of the base is there and only one handle.*

He also said the photos from the Hunt auction seemed like a less complete kylix than the one in the photos Hecht had showed him.

> *What is the photo of the vase dropped by the Swiss cop said to be and why? Think about why I saw a photo of an INTACT kylix with Sarpedon being hauled away like a large log in 1973 which then turned into a fragmentary Sarpedon kylix in the Hunt collection and which now is a smashed whatever that could not possibly be turned into either what I saw or the Hunt-Medici kylix. I'd treasure your speculation.*

A little shaken, I started to type out a reply, sorting through the possibilities. What puzzled me most was that Hoving had helped me connect the dots in the first place—from Hecht's kylix to the Hunt kylix to the 1990 auction—and now he was casting doubt on whether we were dealing with the same cup. Maybe he was confused by the photo, which only represented the portion of the chalice that had broken into about a hundred pieces and not the entirety of what Medici had bought.

I replied that there was another portion of the kylix that didn't break, including the base and a second handle, and they weren't in the photo.

Hoving, who was surfing the Internet in his Upper East Side apartment with a touch-screen portable tablet computer, piggybacking on his neighbors' wireless connections, responded quickly. "Okay! so what you published was not the whole thing," he wrote. "Now I believe they're the same."

What a relief. He had simply been thrown by the appearance of only part of the kylix in the photo of the fragments. But he didn't let go of the idea that the Hunt kylix and what Hecht had showed him seemed to be two different cups. I thought Hoving simply needed to see some better pictures of the Hunt-Medici kylix to convince himself that this was the same cup Hecht had showed him a picture of in 1973. Maybe he could find a copy of that old photo. Maybe he could show these newer photos to Dietrich von Bothmer, who lived a few blocks away. The semiretired curator would surely be able to confirm this was the same cup. I told Hoving that I would ship him some good photos of the broken kylix, along with some other documents describing its dimensions.

That should clear things up.

Let's Make a Deal

During his sleepless nights in Santa Marinella, Medici eventually dozed off, but he'd wake before dawn, often as early as 2:00 A.M., and never be able to fall back to sleep. He began most days in darkness. Exactly a year after the verdict, in December 2005, Medici went for a checkup. He knew he needed professional help. He told his doctor, Vito Pansadoro, about his trouble sleeping and said he was ashamed of the smuggling conviction.

Dr. Pansadoro cast a wide net, ordering a full workup. When the blood tests came back, the news was bad. His PSA values, a measure of potential prostate cancer, were higher than normal. The doctor examined Medici's prostate and could feel a hard area he suspected was a tumor. Medici had a biopsy taken from the lump and waited for the results.

In the meantime, Medici felt desperate to do something to relieve the stress—and maybe to resolve his legal troubles. Knowing that the Met was already in talks to clear its name and avoid the Italian courts, he thought that maybe he could use similar back channels. He wasn't about to offer a plea deal, but he did want to talk, without his lawyers present. Maybe there

were options he didn't know about, especially for avoiding the 10-million-euro fine. At the end of December, Medici asked for an appointment with Culture Ministry officials. They agreed and the date was set for January 11, 2006.

Then the test results came. Medici's half-inch-long lump was a malignant tumor. The good news was that it was contained in his prostate. The bad news was he still could die. The diagnosis set in: Medici had cancer. And he blamed Judge Muntoni, prosecutor Paolo Ferri, and the police who had helped build the case against him. "The conviction of Medici comes from the sort of evidence that is truly Kafkaesque, things that made the cancer come," he said.

At the core of that evidence was Hecht's manuscript, which Medici considered a work of "fantasy," a view he said was proved by two glaring errors it contained. First, Hecht incorrectly wrote that Medici was in his twenties when they met in 1967—a date that Medici also disputed, saying they first met in 1974 at an auction in Switzerland. Second, Hecht wrote that Medici owned a Fiat 500, the supertiny tin can of a car nicknamed Topolino, Italian for Mickey Mouse. During one of our meetings in Rome, Medici said indignantly, "I've never owned a 500. A Maserati, yes."

If this was the best appeal Medici could mount, he was in trouble. He had indeed been as young as twenty-eight in 1967, so Hecht wasn't that far off. And while Medici did own a Maserati now, I eventually learned from him that he had, in the past owned a Fiat 600—a slightly larger version of the Fiat 500. Again Hecht's recollections weren't so bad that his whole memoir should be discounted.

As for the purchase of the Euphronios krater, Medici pointed out that although Hecht wrote that he'd bought it from Medici in Switzerland, one of the Carabinieri investigations had found

that Hecht bought it in Cerveteri—a tidbit from the 1970s probe that had been left out of Medici's prosecution and that Judge Muntoni never mentioned in his sentence. "I don't want to argue whether it came from Cerveteri, came from Italy—I just want my name taken out of the story of the Euphronios vase," Medici said.

As the conviction tormented him, Medici weighed the options. Afraid to die, he decided to remove his entire prostate to help ensure the cancer wouldn't return. He was able to schedule his surgery at a private clinic outside Rome for January 10, 2006—the day before his appointment at the Culture Ministry. Medici had to cancel the meeting that might have led to a resolution of his legal odyssey.

I had spoken by phone with Dietrich von Bothmer several times since the run-up to the Hecht-True trial. Now aged eighty-seven, his hearing wasn't what it used to be, and he was not always comfortable carrying on conversations that lasted more than five minutes. He was sharp when our brief chats focused on specific questions, but sometimes he meandered. In a lot of ways he reminded me of Robert Hecht, a man a year younger and much more evasive than his curator colleague. But where Hecht avoided the tough questions, von Bothmer fought back.

I asked von Bothmer about Marion True's testimony that he had shown her an aerial photo of Cerveteri and pointed out the Sarpedon krater's dig site. "That is one of her stories and I do not know where the krater comes from, nor did I identify the site on a photograph," he shot back, speaking with the German accent he retained after more than half a century in the United States. I reminded him that Jiri Frel, who ran the Getty's antiquities department before True, had also given the Italians a similar ver-

sion of events. "He's making it up in the same way Marion True is making it up. If they can blame it on me, who is an older man, that's easily done," von Bothmer said.

In one early chat with von Bothmer, I asked him about the Sarpedon chalice and the fact that it matched the Euphronios krater at his museum. "It's a very rare subject," he said of the scene of the dying son of Zeus. "Euphronios, whatever he did he did with great care, and he took a long time to do what he did. Some people turned out vases, as we used to call, a dime a dozen."

Later, during one of the longest conversations I had with von Bothmer, on January 9, 2006, I asked again about the Sarpedon chalice. My goal was to confirm Hecht's original admission of having bought it from Medici, and to learn anything else about the cup's origins—especially if they were illicit or Italian. He was in a position to know, having admitted in the 1970s that he'd seen it in Europe.

"I remember nothing special," von Bothmer said when I asked about the source of the Sarpedon kylix by Euphronios. "The dealer had a little stand in Rome, the original dealer had a regular stand in Rome."

This was the first time I had heard any of the people involved in the episode actually place the Sarpedon chalice on Italian soil. Maybe this stand in Rome had something to do with Medici. If von Bothmer's recollections were correct, he had just revealed that the cup had been excavated near Rome. But in those 1970s newspaper articles hadn't he said he'd seen the kylix in Switzerland?

"I might even have seen it myself in Italy," he said. "When the museums closed, I would go to the flea markets."

Did he think the krater and kylix had come from the same tomb?

"That's totally wrong," von Bothmer said, because the two vases came from different periods in Euphronios's career. Anyhow, he added, if two vases were found together in the same tomb, they wouldn't have the same designs. "It would be of a different subject," he said.

And what about the fragmentary krater from the Hunt collection, the one Shelby White had loaned to the Met? Did he know the ownership history of that vase?

"The dealers themselves don't keep track. All I can tell you is it comes from Italy," von Bothmer said. The world's greatest living authority on Greek vases had just placed one of the newly surfaced Euphronios vases on Italian soil. He was in a position to know, having worked closely with the dealers and owners of the fragmentary krater over the previous two decades.

If a vase recently came from Italy, didn't this indicate it had illicit origins from a clandestine dig?

"If the Italians don't look after their own things, I'd rather have it in New York than kept somewhere where it's not appreciated," von Bothmer said.

Hecht showed up at the next session of his trial, on January 13, 2006, wearing a gray suit, blue shirt with light blue stripes, and a blue tie. The once-feared American dealer, known for his temper, was now a hunched eighty-six-year-old. A tweed cap covered his mostly bald and waxy head, which was fringed in gray. During the hearing, Hecht cupped his hand over his left ear to hear the proceedings, which he followed in Italian, as Pellegrini testified about his analysis of the documents and photos seized by the Carabinieri.

The morning's questioning focused on the large kylix potted by Euphronios and painted by Onesimos, which the Getty had

surrendered to Italy in 1999, fragments from which Medici had given to Ferri in a failed bid for leniency.

Pellegrini even projected on the courtroom's movie screen a photo of Medici standing next to the kylix at the Getty during his 1987 road trip with his son Marco and Robert Hecht, wearing a yellow Lacoste tennis shirt with a white cotton sweater wrapped around his shoulders. Next in his computer slide show, Pellegrini showed a black-and-white photo taken from Medici's archive of a fragment from the kylix. He also displayed a Polaroid of the fragment with writing on the bottom of the photograph in Medici's hand: "Prop. P.G.M." Proposed to the J. Paul Getty Museum.

As they went over documents in English, the chief judge even asked Hecht for help in translating the correspondence being used to prosecute him. Although Medici didn't attend, his son, Marco, did. During a break, Hecht's lawyer, Alessandro Vannucci, brought them together in the courthouse corridor. "Marco!" Hecht greeted the young man who was still practically a boy when they traveled together to Los Angeles and New York two decades earlier.

"It sounds like you're having fun," I said to Hecht, who knew he'd never do jail time under Italian law because he was far too old for incarceration.

Hecht responded in a mix of English and Italian slang. "Well, you know, *perdonati, perche non sanno che facciano,*" he said. Forgive them, for they know not what they do.

Then I asked about the Metropolitan and its talks on returning the Euphronios krater and the other objects. "If they do decide to give them back, will you give them a refund?"

"What for?" Hecht responded.

"A million bucks for the krater," I said.

Silence. Maybe it had never occurred to Hecht that he might

owe the museum a $1 million refund, plus more than three de-
cades of interest. After a moment he came to and brushed off the
question. "*Che ne sappia?*" he said. Who knows?

"You don't feel one way or another that the Euphronios krater
should stay in New York?" I asked.

"It's out of my hands," he said.

Medici's surgery to remove his prostate went well. He spent a week in
the hospital before moving back up the coast to his compound on
the hill above Santa Marinella, where Maria Luisa cared for
him. Even after an additional week of rest at home, the nor-
mally tanned and fit antiquities dealer was pale and thin. He'd
lost his appetite, and he even gave up his customary wine with
lunch. Haunted by the possibility that the cancer may have
spread beyond the prostate, or that it might somehow come back,
Medici told himself, "I'm sick, maybe I'll die. Before dying, I
want to see if I can put my affairs in order and not leave my fam-
ily out in the street with these problems." He thought he might
have just three months, six months, or maybe a year to live.

Foremost in his mind was the 10-million-euro fine Judge
Muntoni imposed in his December 2004 conviction. Practically
speaking, just like Hecht, there was little chance he'd actually
serve a term in Italy's overburdened prison system, especially for
a nonviolent crime, and certainly as he approached age seventy.
The money was another issue and could leave his wife and kids
no better off than when he started his career in the ashes of World
War II. His house and Maserati were already frozen assets, ready
to be taken by the state to pay his court costs. The best pieces
from his collection—including the fragments of his shattered
Euphronios cup—were locked away at the Villa Giulia museum
in Rome. And even the hundreds of antiquities from his Geneva

warehouse for which he'd been found innocent of smuggling were also sequestered in the Villa Giulia storerooms as collateral to pay off the fine.

Anticipating that he would die, perhaps sooner than later, Medici decided to make concessions in his legal case so he wouldn't leave financial troubles for his family. He tried to set up another appointment with the government lawyers.

As Medici awaited an audience, talks between the Met and the Italian Culture Ministry progressed. Philippe De Montebello asked for details of the Italian case, and on January 12, 2006, the Italian government responded, sending the Met a dossier to back its demand that the museum return the vases, the Morgantina Silver, and the Sarpedon krater.

Those negotiations, along with the press coverage of the True trial, also helped lead the Getty to begin its own dialogue with the Italians. On January 27, 2006, Fiorilli and his committee presented Getty negotiators with a briefing on the evidence for fifty-two objects in its collection that Italy wanted returned, including artifacts of which photos had been found in Medici's Geneva archive.

Behind the scenes, however, talks with the Met were not proceeding as well. De Montebello had said he needed "incontrovertible evidence" that the Euphronios krater and other artifacts were stolen—a standard that frustrated Fiorilli. "I thought we had an agreement," he told me, referring to the outline of a possible deal that had come out of their first meeting. "I'm very worried."

The museum acknowledged that it had, indeed, requested additional documentation, but there was no deal breaker in the works. With Danny Berger working both sides of the talks for each of his two employers, and the Italians sticking to their demands, the Met diffused any potential blowup by making a public offer

to Italy. On February 2, 2006, the museum said it would return the disputed artifacts in its collection, including the Euphronios krater.

Three decades after Hoving defiantly defended the purchase, his successor at the Met had finally given in.

As the Italians formulated a response to the Met's krater offer—which stipulated that Italy would reciprocate by lending the museum artworks of "equivalent beauty and importance"—Medici visited the ministry, ready to strike a deal of his own. He offered to surrender title to the objects for which he had been convicted— including the shattered Sarpedon chalice. The Italians had these items stored at the Villa Giulia museum.

He asked in return that the state drop its civil case against him and that he be given back the hundreds of objects seized in the Geneva raid for which he had been absolved, many of which were not of Italian origin. "The objects that the judge said were legally bought, these I would have to live on," he said. He didn't try to settle the criminal charges at the meeting—he just wanted to strike a deal that would provide for his family. The men he faced—Ferri the prosecutor, Fiorilli the lawyer, and Proietti the archaeologist—took the offer under consideration.

Even as the Met and Italy inched closer to a deal, de Montebello started sending mixed messages about his decision to return the Sarpedon krater. On February 8, 2006, he appeared on *The Charlie Rose Show,* where he staged what amounted to an argument against what his museum had just offered to do. First he cast doubt on whether the krater was necessarily of Italian archaeological origin. "They are found all over the Mediterranean

basin," he said of Greek vases. "The interesting thing about antiquities is they move about."

"If indeed the story that it came from Cerveteri, which is the little town where it was meant to have been found, is true" is how he began his discussion of the Euphronios. Then he added a moment later, "There are many different stories and there are conflicting stories."

As he sowed doubt about the krater's illicit origins, he also raised what had been his overarching justification for a "universal museum," such as the Met, to own such masterpieces. "The vase represents a monument of the shared heritage of mankind and the interesting issue here to a certain degree is the whole issue of when enough documentation . . . has come forward, new information. We became, if not convinced, at least sufficiently persuaded that it had been improperly acquired, that we felt that the right thing to do was obviously to return it," de Montebello said of the Euphronios krater. "We on the other hand had pretty good documentation that it came from a Lebanese collection."

Was he going back on the deal with Italy, which had not yet been signed, or was he just playing to the home audience of donors, trustees, and museumgoers? "The interesting thing is now, and this was not always the case, U.S. law recognized foreign patrimony law."

There it was: the *Schultz* case was the key. Whether or not de Montebello believed there was sufficient proof the Euphronios krater was looted from Cerveteri, Italy had gotten a conviction of Medici and an indictment of Hecht for smuggling the vase. By the formula established under *Schultz,* an artifact was considered stolen property if another country's laws considered it stolen. The *Schultz* case was based around Egypt's 1983 antiquities law, but it also applied to the one Italy enacted in 1939.

"A number of objects are found by chance, a number of objects

by peasants in their fields, others emerge out of building roads and all sorts of things and they end up on the market," the Met's director concluded, sticking to his guns, but also showing he could bend with the times. "Laws change, ethics change, our practices change, but not our fundamental principles."

The interview was just the start, as de Montebello increased his attacks on the Italian side of the Euphronios negotiations. It sent a troubling signal as more and more days drifted by without the Culture Ministry responding to the Met's offer. De Montebello, in an interview with the *New York Times Magazine,* predicted that the Italians would treat the krater's return as a victory for retentionist cultural property policies motivated by "nationalism and misplaced patriotism." "I suspect they're more likely to show it initially as a trophy of conquest in the Etruscan Museum of Villa Giulia, which houses the greatest collection of vases in Rome."

With the Met offering to return its Euphronios, and Medici facing his own mortality as he recovered from his surgery, I hoped that maybe he would finally go on the record about his role in the Euphronios affair. I brought up the krater when we met for lunch in central Rome on February 17, 2006. "If someone were to ask me if Medici sold it to Hecht, I'd have to say . . ."

"Maybe yes," Medici replied, finishing my sentence. But he added that whatever the truth may be, police and prosecutors had failed to discover enough evidence.

"The law needs to demonstrate my guilt," he said. "The truth is what I can tell the priest when I go to confession. I say mea culpa, mea culpa. But now I have the right to defend myself. And my defense is to say I don't know anything.

"When I was a child after the war, we had to do incredible

things. It was called the black market. To buy bread that was one euro, you paid five euros. It wasn't fair. It was illegal. But it was a sad and hard period," he said. "During the 1960s and '70s, there was a period when archaeologists, it's amazing, they didn't care. In Rome they sold artifacts everywhere, at stalls in the square."

And it was out of that changing environment, from postwar lawlessness to an era when authorities turned a blind eye to the antiquities trade, that Medici had made his life and career. "I always said there should be a special law, for the past, a special amnesty, for the future," so that history might record what really happened, Medici said. "We know the truth. We know the truth about the Euphronios krater, we know the truth about this thing or that thing."

If such an amnesty was enacted to help record the histories lost to clandestine digging, "I'd be pleased to have my say," he said.

When we finished lunch and started to leave, Medici brought up Hecht's manuscript, which had been the main evidence used to convict Medici of smuggling the Sarpedon krater—and possibly to win its return. "It's a mystery the things that he wrote," Medici said. "I mean to say, I don't know how an intelligent man like him wrote that and kept it in his house. And the police came. It seems like it was all a joke to him."

Medici wasn't quarreling with the contents of the memoir, just Hecht's indiscretion.

Medici healed quickly after his prostate operation. Further tests showed the cancer hadn't spread to his lymph nodes, which would have been potentially fatal. As he had done as a child after the wartime bombing, Medici seemed to cheat death.

It took forty days from the surgery to return to his daily tennis game, which he plays in the morning at public courts in Santa

Marinella. In his first match, held on February 20, he beat a forty-six-year-old opponent in two sets, 6-4, 6-4. Medici was elated.

The next day, the news for Medici wasn't as good. On February 21, 2006, the Met's de Montebello arrived at the Culture Ministry in Rome. The museum and Italy had agreed to a deal, and de Montebello was about to sign away twenty-one objects, including Euphronios's Sarpedon krater.

According to the terms, Italy waived any civil, administrative, or criminal claims against the museum for its acquisition and holding of the artworks. That didn't mean, however, that Medici and Hecht had solved their own legal troubles. Having the krater back in Italy meant that prosecutors had little incentive to strike a deal with Medici to testify about the pot's origins. At best, Medici hoped the return would reduce the fine he had to pay, on grounds that Italy had already gotten back the stolen goods.

For the signing ceremony, de Montebello and his Italian counterparts gathered at the ministry's library, beneath the two-story-high wooden-beamed ceiling. De Montebello sat at a long table on one narrow end of the room, flanked by Italian officials. Buttiglione, the culture minister, sat directly to the Met director's right. Giuseppe Proietti sat on the other side. Because political appointees cannot sign such agreements—only career civil servants—Proietti would sign the accord to bring back the Euphronios krater, three decades after beginning his career alongside Medici in pursuit of the pot.

The signing was a quick affair that involved news photographers crowding around the table as the men affixed their signatures in silence. Afterward, Buttiglione made a brief statement with both the expected niceties ("We're signing an accord that opens a new era between Italy and the Metropolitan Museum of Art in New York") and driving home that the motivation for

Italy's demands was preserving the "context of excavation" and working "against clandestine digging and illicit trafficking." There was none of the Fascist nationalism de Montebello and his supporters had predicted. Although the krater was now Italy's, the two sides had agreed the Met could hold on to the pot until January 15, 2008.

The terms of the accord would result in a net export of antiquities from Italy to the Met, including loans of antiquities made in exchange for the repatriated works, other future art loans from all periods of Italian history, and even more antiquities on long-term loan from planned joint excavations with the Met in Italy.

De Montebello spoke next, leaving behind, for the moment, the defiant tone he had taken on Charlie Rose's show earlier in the month. "The Metropolitan is extremely pleased to have reached an agreement which puts an end to a very long and vexing dispute," he said, citing "the emergence in recent years of new evidence" as the reason for his coming to this agreement almost thirty-four years after his predecessor had stood up to Italy's first claims.

"The good faith in which both sides have entered into this agreement—an agreement that from our point of view corrects a number of improprieties and errors committed in the past—will pave the road to new legal and ethical norms for the future."

If de Montebello thought he could close the door on the controversy that easily, he was mistaken. As soon as the panel opened the floor to questions from the assembled news media, another work by Euphronios reared its head: the fragmentary krater depicting Heracles that Bunker Hunt sold at his 1990 auction alongside the Sarpedon chalice. The partial krater was now the property of Leon Levy's widow, Shelby White, but it was on loan to the Met. The Italians, led by Culture Ministry lawyer Fiorilli, had nudged de Montebello with no success to include eight vases

from White's collection in the Met's talks, and now the journalists in Rome did some nudging themselves. A reporter from *Il Messaggero* asked about White's collection.

"We are prepared to work with the ministry and with Mrs. White and with her lawyer to try to arrive at a solution to her problem. Mrs. White is eager to reach a solution and, of course, very much in the spirit of the Metropolitan's own negotiations," the Met's director said.

One by one, if not piece by piece, the Euphronioses that Robert Hecht had sold decades before were most likely on their way back to Italy.

Toward the end of the press conference, a reporter from TG Lazio, the local TV news for the region surrounding Rome, asked a question that made sense to only a handful of people in the room. "Now that the Euphronios krater is being turned over to the Italian government, will the state pay the *premio* to compensate the owner of the land for taking the vase?" The assembled Italian officials looked at one another, perplexed, glancing back and forth across the table to see who might answer this odd question. Which of them actually knew that Giacomo Medici had owned that land not long after the krater was looted from it? The culture minister, not knowing that the journalist had asked an ironic question about Medici, tried to field this one.

"My experts say the specific patch of land isn't known, only the zone," Buttiglione said.

Proietti, a serene grin on his face, was the only one who didn't seem flummoxed. Seeing that no one else knew what this was about, he raised his finger and took the microphone.

"The piece of land hasn't been precisely identified," he said. Anyhow, because the vase was the fruit of the illicit trade, it could hardly qualify for the reward.

Incredibly, only moments after the Met signed over title to

the world's most famous vase, Proietti admitted that he and the Italian government did not know where exactly in Cerveteri the krater had been excavated. He had led the postlooting salvage excavation at Medici's Greppe Sant'Angelo property, but didn't know for sure if that land was where the *tombaroli* had made their find.

Baffled that so little could be known about the krater's archaeological origins, I tracked down every book and article Proietti had written about his first dig. None of them referred to a Euphronios vase having originated at the site. That meant no officials had ever conclusively placed the looting, as described by Armando Cenere, at Medici's land.

There had to be a way to solve that mystery. Maybe Medici could help confirm that the tomb raiders had taken the pot from his little slice of Greppe Sant'Angelo. Even better, maybe I could learn the precise find spot of the Sarpedon krater. Doing so could undo the damage the *tombaroli* had done to the archaeological record.

For Italy and its quest for Euphronios vases, the deal with the Met was one down, but there was still one to go. The fate of the matching Sarpedon chalice still hinged on the outcome of Medici's case, and whether the cup would revert to Medici or the Italian government.

So much had been happening that Hoving and I had never had a chance to resolve his questions about the photos of the shattered Sarpedon kylix. During an e-mail exchange on May 16, 2006, he stunned me with news about the picture of a Euphronios cup that Hecht had shown him in his office thirty-two years earlier:

> *I was able to confirm a month ago with Dietrich von Bothmer that the kylix photo we saw showed a very early rendition of*

Sleep and Death carting away the stiff body of Sarpedon held like
a log of wood over their shoulders and that what we saw was
DEFINITELY NOT what Medici bought at the Hunt sale.

That meant only one thing: a second Sarpedon chalice by
Euphronios was still hidden in private hands.

Thomas Hoving had written to me in his earlier e-mails that
the Hunt-Medici kylix didn't exactly look like the one Hecht of-
fered him in 1973, but now he had Dietrich von Bothmer backing
him up that they were indeed two different pieces. My mind was
spinning. I had located the lost chalice and found that it was
smashed to bits in a box in Rome. Now the photos of the broken
cup were leading to another mystery of yet another missing Eu-
phronios that also depicted Sarpedon.

I wrote back to Hoving:

Neat. (Now to find the missing kylix . . .)

Still, I needed Hoving to explain away the evidence that there
was just one cup. Von Bothmer presented a photo of a Sarpedon
chalice in Philadelphia in 1972. The next year, Hecht tried to sell
a Sarpedon chalice to the Met. In 1976, during his Berlin lecture,
von Bothmer referred to a Sarpedon chalice (and did so again in
Troy, New York). He even helped edit the Getty's 1981 publica-
tion of the chalice, with photos. The 1990 Sotheby's Hunt sale
catalog cited von Bothmer's 1976 article in German as the earliest
published reference to the same Sarpedon cup that was up for
auction—and that von Bothmer wanted to buy.

"How do you sort out which is which?" I asked Hoving.

He stuck to his recollection that the one he was offered in 1973
was smaller and not quite as well drawn as the Hunt-Medici
chalice. He believed the cup Hecht showed him was the same one

von Bothmer presented in Philadelphia, but he was confident the kylix that surfaced later with Bunker Hunt was different. Hoving wrote:

> *I am beginning to believe that it's possible that some Euphronios-obsessed wealthy Etruscan did collect the Euphronioses Hecht-Medici dealt with, because it's hard to explain otherwise that after so many years of Euphronios drought, at least 4 went through Medici.*

By Hoving's count, the four Euphronioses handled by Medici and Hecht were the Met's Sarpedon krater, the fragmentary Heracles krater that McNall had sold Hunt and was now on loan to the Met from Shelby White; and, sensationally, *two* chalices depicting Sarpedon.

If Hoving were right, that meant there was a hitherto unknown three-piece Sarpedon set. If there really were a missing work by Euphronios floating around out there, where was it?

The next day, I met Medici for lunch, and as soon as he sat down, I asked about Hoving's claim there was a second cup, fully expecting him to laugh. He didn't.

"There is another kylix," Medici said. "I know at the time there was this kylix on the market."

Medici then launched into a story that vaguely followed Hecht's tale involving Scandinavia. He said the kylix he bought at the Hunt auction had originated in a Swedish collection from the 1960s—a convenient provenance for Medici, who was still fighting the charge that his cup had come from Cerveteri in the 1970s. He said Hecht had bought the chalice from the Swedish collection around 1970. This second kylix was different.

"The other Sarpedon kylix is smaller," he said. Medici said he knew this because he had seen this second Sarpedon kylix on the art market just after the eruption of the Met's scandal with the Euphronios krater. By contrast, the depiction of Sarpedon's death was stronger on the chalice he bought at Sotheby's, and it was also an older work by Euphronios.

I sent Hoving an e-mail right after lunch, telling him that Medici had recalled there were two cups, almost exactly as he and von Bothmer had. But there were some discrepancies, including Medici's belief that the Hunt kylix was older than this other, smaller cup.

Hoving replied: "The smaller kylix (I presume Hecht still has it along with the Sarrafian pieces) was exquisitely drawn with all the tiniest details in the correct overlap positions." However, he and von Bothmer believed it came from the hand of a young painter because, "the body of Sarpedon was rather small and looked like a log of wood on their shoulders. Someone not fully trained in dating styles—Giacomo—might have only looked at the exceptional craftsmanship" and thought the cup was a later work.

He added that the kylix Medici had bought from Hunt was "at least, even more powerful as a drama" than the Met's Euphronios krater, "for there's a great deal more poignant action in the act of lifting the body with some difficulty from the ground" than just beginning to lift it.

Maybe Hecht could clear up some of this—if he was in the mood to speak honestly and openly. It would be incredible if there really were a previously unknown, missing Sarpedon chalice by Euphronios.

Had Hecht actually offered one such cup to Hoving in 1973 and then a similar, but different one, seven years later to Bunker Hunt? If so, it's possible the two chalices had become conflated in

the academic literature because nobody had ever published photos of the one Hecht offered to Hoving at the Met.

If, as Hoving believed, Hecht was still holding on to this other Sarpedon cup, Hecht might be the only one who knew this.

I next found Hecht, on November 31, 2006, sitting in the fixed row of metal chairs outside the courtroom door at the Rome Tribunal. I asked him directly: how many Euphronios kylixes, decorated with Sarpedon, had he ever seen?

"One," he said.

I told him about Hoving's theory and about von Bothmer's belief that the chalice Medici bought at the Hunt auction wasn't the same one Hecht had offered to sell the Met in 1973.

"My knowledge is limited," Hecht responded, neither confirming nor denying Hoving's new twist. Then he just went silent.

Object X

With the start of Medici's appeal just weeks away, he was anxious to try once more to strike a deal that would wipe out his financial debts to the Italian state and get his family future back on firm ground. The October 4 court date was important because the Italian legal system determined that no plea bargaining is allowed after the judges open the first hearing of a case. If Medici was going to do a deal, it was now or never.

In mid-September 2006, he sent his lawyer, Fabrizio Lemme, to meet with Paolo Ferri and make this offer: if Ferri cut his prison sentence to six years from ten, and cut his fine from 10 million euros to zero, Medici would plead guilty to all his charges—smuggling, handling looted antiquities, conspiracy—and he would hand over title to all the seized objects at Villa Giulia for which Judge Muntoni had absolved him. He would also relinquish any claim to the items for which he had been convicted, including the most valuable, the Sarpedon chalice.

And there was more. Medici would sweeten the deal with one other item: Object X, a treasure more beautiful—and more expensive—than Euphronios's Sarpedon krater.

If Ferri took the deal, Medici would surrender this ancient masterpiece of unrivaled beauty, craftsmanship, and monetary value that had never been seen by the public. If Ferri rejected the plea bargain, Object X would remain hidden.

The offer had advantages to all sides. A six-year sentence for Medici would really mean three years of parole, according to new sentencing rules and a provision for nonviolent offenders. He'd never serve a day in prison, and his financial debts would be wiped clean. For Ferri, a guilty plea would be a huge victory, particularly as he proceeded with the prosecutions of Robert Hecht, Marion True, and possibly other coconspirators. For Italy, it would mean owning the Sarpedon chalice and this new Object X.

Ferri sat on the proposal for about a week, before he summoned Lemme to hear his response. At 8:30 A.M., on September 20, 2006, Lemme walked into Ferri's cramped office. Ferri laid out what he was willing to offer Medici in exchange for a guilty plea: on the criminal side, he agreed to reduce the ten-year jail sentence to six years. On the civil portion, he'd reduce the 10-million-euro fine by just 600,000 euros—giving him credit just for the antiquities he'd been found innocent of smuggling. The 600,000 euros, Ferri said, was a fair market valuation calculated by his expert. That expert was the Villa Giulia's Daniela Rizzo, who might get to display the vases and statues in her museum if Medici took the offer.

As for Object X, Ferri wasn't convinced it existed, and he left it out of his offer. He did say he wanted to see it, just to value it.

Lemme took notes and told Ferri he'd get back to him. Then he called Medici and spelled out the deal. Would he take it?

"No," Medici said. If Ferri was so eager to do a deal, maybe he could do better. Not only was the proposed fine essentially the same, but the 600,000-euro valuation for his legal objects, many of which he had bought at public auction from known

collections, was robbery. "The valuation is ridiculous," Medici said. "They're worth at least 10 million."

Then there was Object X. Without a deal in writing, Medici wasn't just going to turn over this masterpiece to the prosecutor, showing all his cards and risking that another of his treasures would be seized. Ferri had to take his word that Object X would more than cancel out his fine. "Let's just say it's worth $20 million," Medici said.

Medici told his lawyer to reject the offer. He'd take his chances on the appeal. Privately, he also thought Ferri might come up with something better before the October 4 date. That meant Object X and the Sarpedon chalice could be back in play.

But what was this Object X? Medici danced around the question.

"How much is the Euphronios krater worth? $20 million? $30 million? The Japanese would pay more," Medici told me over lunch on the same day Ferri made his offer, working up a lather about the great deal the prosecutor was missing. "Then this Mr. X is worth $20 million!" he said, leaning halfway across the table and glaring, holding the pose for a moment to drive home his point.

But what is it?

"It's something they can only dream about," Medici said. "A vase? A bronze? A Praxiteles or Lysippos?" he said, referring to the most esteemed sculptor of ancient Greece and Alexander the Great's court sculptor, respectively. "Who knows?" He added: "Mr. X is a gift. You don't look a gift horse in the mouth."

Could he give any other clues?

"It's by a great author," he said, meaning it was the creation of one of antiquity's finest known artists. And it was originally from Greece.

The more he talked about it, the more convinced he became

that he should press Ferri for an even better deal. "If I return Object X, I deserve a great prize," he said, and that reward should be a three-year prison sentence—in effect no jail time and not even parole.

And then he suggested an additional trade he could make with his prosecutor. To save his skin and bank account, Medici was finally ready to rat out everyone else to the prosecution. "They can use a pact with Giacomo Medici against Marion True, Bob Hecht, and all the others."

"If I tell him the story of the Euphronios krater, he should give me another prize—reduce three years to zero," Medici said.

There it was. Medici had admitted his involvement in the krater affair, thirty-four years later.

Medici's conviction kept working its magic for Maurizio Fiorilli, the government lawyer. Without even having to twist arms, Boston's Museum of Fine Arts flew thirteen antiquities to Rome and handed them over at a ceremony at the Culture Ministry on September 28, 2006. The museum and Italy modeled their agreement on the one pioneered by the Met's Philippe de Montebello; in exchange for the objects, Italy would lend significant works to the MFA and planned future collaboration in archaeology and planning exhibits. All but two of the items were vases. One was a marble carving, and the other was a statue that stood six and a half feet tall.

The statue was covered with a white sheet at the return ceremony, which a new culture minister, former Rome mayor Francesco Rutelli, yanked off with a flourish. Beneath, in her flowing marble robes, was Sabina, wife of the Emperor Hadrian. It was the same statue Medici said he had photographed in Munich and Hecht had sold to the MFA. The Polaroids that Medici

saved in his collection and that had turned up in the Geneva raid had led Italy to convince the Boston museum it should send the statue to Italy.

With such victories, the last thing the Italian negotiators wanted was to have an appeals court overturn the guilty verdict against Medici. Lucky for them, he didn't show up on the morning of his hearing. The appeals court sits in the same justice complex where the True-Hecht trial had been dragging on for almost a year—except this building is newer, with a glass-domed rotunda. Whereas custodians in the main court buildings wander around scraping chewing gum off the dull floors, the janitors of the appeals court buff the beige-and-maroon-colored marble to a mirror shine.

Beyond the rotunda, I found a broad corridor where the characters who usually populated these events had gathered: Ferri the prosecutor; Fiorilli; British journalist Peter Watson's researcher, Cecilia Todeschini; some Carabinieri officers; and Medici's lawyers. But Giacomo Medici was not there.

Medici's lawyers approached the bench. Their client had called in sick, they told the chief judge. They presented him with a medical certificate from Medici's doctor. Technically, the appeal could go on without him, but his lawyers asked the court to set a new date so that Medici could attend, and the judges agreed. Medici had found a way to keep alive his chances at negotiating a deal for Object X and the Sarpedon chalice.

As a result, Fiorilli would have more time to negotiate with museums and collectors—particularly the Getty and Shelby White—without any immediate risk of his main bargaining point, Medici's conviction, being overturned.

The day after Medici's no-show, Fiorilli had a meeting with the Getty's lawyer, Los Angeles heavy hitter Ronald Olson, to discuss a potential agreement for the return of dozens of

antiquities to Italy. Fiorilli, negotiating on behalf of the Culture Ministry, had requested the return of fifty-two vases, statues, frescoes, and other ancient items, based mostly on the evidence contained in Medici's case. By the end of the meeting, Italy had won a partial victory. The Getty agreed to return twenty-five items, but refused to give back twenty-one objects that Italy had demanded. The two sides agreed to disagree, pending further verdicts in the Italian court system. The Getty thought it had a deal. But Fiorilli, backed by the new culture minister, Rutelli, would dig in his heels and hold out for more.

Walking home during the early evening of October 31, 2006, I passed by sites familiar to Giacomo Medici and his life story: Via della Lupa, where he was born; Piazza Borghese, where he and his parents sold antiquities at the open-air market; and the Lungotevere boulevard running along the Tiber River, just across from the hulking justice building, where Medici had done his first deal with Robert Hecht, in 1967. The path also took me within a few blocks of the state attorney's office, the base of operations for Maurizio Fiorilli, the chief negotiator with foreign museums. So I wasn't too surprised when I saw him walking toward me, heading for a gelato shop.

We greeted each other, and I joined him for an ice cream. He recommended the dark chocolate flavored with orange. I told Fiorilli I'd been trying to track histories of the Sarpedon chalice and krater by Euphronios, and his face lit up. He'd just been dealing with an issue involving the Greek master.

I might be interested to know, he said, that there are fifteen fragments of a Euphronios vase in storage at the Villa Giulia museum. Were these the same fragments that mysteriously turned up in May 1973, only to be forgotten?

He said they were, and that the shards had only recently been dug out of storage. They'd become important again after Shelby White's collection came under suspicion through Medici's trial, followed by Philippe de Montebello floating the idea that White was ready to negotiate a deal with Italy. But what was the connection between these forgotten fragments and White?

"We're trying to match them with the Levy-White krater," Fiorilli said. The fragmentary vase by Euphronios, depicting Heracles, was on loan to the Met. This was the same pot Medici had failed to win at the 1990 Hunt auction in New York when he bought the Sarpedon chalice. Amazingly, it was back in play again.

The fragmentary krater in New York was missing its base. The fifteen fragments had mostly come from the base of a krater by Euphronios. It had to be a match.

Later, buried in documents from Medici's legal files, I found another reference to the fifteen fragments. On March 16, 2001, Ferri had written to the U.S. Justice Department asking for help conducting his investigation of the fragmentary krater Levy and White had bought at the 1990 Hunt auction.

"It should be recalled that the noted Levy-White krater came to be known to scholars only in 1981 (even though it was the object of an investigation by the Italian authorities since 1973) when it was displayed for a brief time at the J. P. Getty Museum. From then it disappeared until 1990," Ferri wrote. "However, it can be reported that the Superintendency for Middle Etruria, in storage at Rome's Villa Giulia Museum, has 15 Attic red-figure fragments.

"The great quality of those pieces and some morphological details lead to a concrete hypothesis linking them to the produc-

tion of the great master Euphronios. These pieces have been on record as having come to the Villa Giulia Museum following a criminal investigation dating from 1973, which stemmed from a recovery of the fragments that originated with the criminal side of this sector."

Ferri added, "The most detailed study available today of the great master's works leads archaeologists to link some of these pieces to the Levy-White krater, and especially to the foot of that vase, which is currently in an extremely fragmented state. For this reason it would be particularly useful to verify this hypothesis by examining this artifact, and to better clarify the way in which it was acquired."

In December 2006, I decided to take up Dietrich von Bothmer's offer to see him in his cramped office at the Met. I phoned his office and got voice mail. I phoned his Fifth Avenue apartment, where I reached someone who sounded like a family member. I explained who I was, and the response was grim. I was told that Dr. von Bothmer was in no condition to speak anymore, as his health had deteriorated quickly. Not only could he certainly not come into the museum for a meeting, but he could no longer sustain a phone conversation. I apologized for disturbing them and gave my wishes for his recovery.

Unless he were to leave behind some written record confirming his belief that there were two Sarpedon kylixes, there was probably no way to confirm that Euphronios had made a set of three—and not just two—Sarpedon vases.

Medici's appeal had been rescheduled for February 19, 2007, but as the date approached, the proposals for a settlement—and for

resolving the ownership of Object X and the Sarpedon chalice—
had gone nowhere. As it turned out, the appeal would go no-
where, too.

New legislation passed by Prime Minister Silvio Berlusconi's
government shortened the statute of limitations on many crimes,
as long as the cases were still in their first trial phase. That meant
Medici, having chosen an abbreviated trial and already been
convicted, couldn't take advantage of the law. Meanwhile his al-
leged coconspirators, Robert Hecht and Marion True, could
probably get off on that technicality if they chose to stop pursu-
ing an innocence verdict.

At the appeals court, Medici argued that the shortened statute
of limitations should apply to him, too, as a matter of fairness.
This was something for the Italian Constitutional Court to con-
sider. The appeals court adjourned Medici's case indefinitely
until the higher authority ruled whether the trial should even
continue.

Before Rome emptied out for the summer of 2007, the Getty and the
Italian Culture Ministry finally reached a deal. The museum
would transfer title to forty objects to Italy. All of these objects
would return to Italy by the end of the year, except the so-called
Venus of Morgantina, the goddess statue, probably of Aphrodite,
for which the Getty had paid $18 million in 1988. That statue
would remain in Malibu through 2010. Also both sides agreed
for the time being to put aside the fate of a bronze statue of a
youth, as yet a new court case, concerning just that object,
worked its way through the Italian system.

Rutelli could announce his deal, get his returns, and save face
on backing down on repatriating the bronze. He cast the agree-
ment as a victory against illicit excavation and smuggling. "It

will close the book on an era," the culture minister said at the August 2, 2007, news conference. "Fifteen, twenty years ago a museum could buy works like this. Today they can't. They have to demonstrate the correctness of the purchase." The aim of pressing the Getty and other museums for these artifacts, he said, was to dry up the market for clandestinely dug and exported antiquities. "We want there to be less water in which the traffickers can swim," Rutelli said.

Significantly for Marion True, Fiorilli announced that he would drop the civil portion of the charges against her because of all the returning antiquities included in her case. The criminal charges of conspiracy and receiving stolen goods would remain, but True no longer had the threat of huge fines that had driven Medici to seek a plea agreement. "Dr. True's position will be greatly lightened," Fiorilli said.

I asked Fiorilli if he would also ask the court to drop Medici's civil charges for the items the Getty was returning, those for which Medici had been convicted and fined? He shook his head.

Fiorilli was the hero of the day. At about the midpoint in the ceremony, Rutelli even pinned the government lawyer with a gold medal for his service to the Republic.

After the summer break, I visited the tweedy Fiorilli at his office in the attorney general's headquarters. I wanted an update on the fifteen Euphronios fragments in storage at the Villa Giulia museum that he said might fit into the fragmentary krater from the Hunt collection, now owned by Shelby White and on loan to the Met. During Fiorilli's negotiations to win back the krater from White, Italy claimed the fragments definitely comprised the vase's missing foot.

Fiorilli's office had the terra-cotta roofs of Rome outside its tiny window, and a bust of Hercules—an equal opportunity hero

to all sides of the antiquities showdown—by his side. He said the issue had become more complicated. There was also a fragmentary krater in Munich attributed to Euphronios as its painter—the one Hecht had sold to that museum in 1966—and it, too, was missing its base.

"The fifteen fragments," Fiorilli said, "we don't know if they pertain to the Levy-White krater or Munich's."

The ministry's experts needed to do an up-close examination of both kraters to see which, if either, was a fit. "I asked Philippe de Montebello to do a comparison," Fiorilli said. The Met's director said no, because White's fragmentary pot was on loan and was not the museum's property.

This was even dividing the Italians. Anna Maria Moretti Sgubini, the head of Etruscan archaeology, had determined in her study in 2000 that the fifteen fragments matched White's krater in New York. On the other hand, Daniela Rizzo, a director of the Villa Giulia museum and custodian of the fragments, believed the shards would fit into the bottom of the incomplete krater in Munich.

Either way, Fiorilli said, White was planning to hand over the fragmentary krater in two years as part of a tentative pact in the works. But in the meantime, he was getting in touch with the Munich museum to see if they'd find a match there. If Fiorilli pulled off this maneuver, he could win two Euphronios vases with just one set of fragments.

The hearings in the True-Hecht trial were starting later and later, giving all the usual hangers-on more time to talk. On October 24, 2007, Medici and I chatted in the hallway, and I tried pushing him on the true origins of the Sarpedon kylix.

"The kylix was on the market for one and a half years before

the affair with the krater began," he said. "They came from two different tombs."

They really didn't come from the same tomb that the farmhand, Armando Cenere, had pointed out to the police when he confessed in 1973?

"The tomb that Cenere talked about is the one the krater came from," Medici said, and then he started getting emotional, trying to impress on me that the excavation of the chalice was unrelated to the krater and he had had nothing to do with the cup at the time. Medici even swore on his mother's grave and added that his eyes should be plucked from his head if he wasn't telling the truth.

He really wanted to make his point clear: "If one came from tomb X, the other came from tomb Y," he said. By trying to distance himself from the chalice's origins, he revealed more than he'd ever admitted about the krater. He was more concerned with disassociating the chalice, which he hoped to win back, from the krater, which was now Italy's property. "A year, a year and a half before, the kylix with Sarpedon was already on the market," he said. The chalice came from another tomb on another site, in another part of Cerveteri, Medici said. "The kylix doesn't come from Greppe Sant'Angelo."

Medici had blabbed it all out so fast that it took me awhile to synthesize the many and varied admissions. Without saying how he knew, Medici had confirmed what prosecutors a generation earlier were unable to convince a judge: Cenere had told the truth about digging up the Euphronios krater. And when Medici said the Sarpedon chalice and krater hadn't been found together, he let slip that the chalice was indeed excavated from a tomb in Cerveteri, too.

What was he thinking? Everything he had disclosed about the krater's illicit origins was meant to contrast it with its smaller

twin chalice. The shattered Sarpedon cup was the most valuable object he owned, and he'd never get his hands on it if he was convicted of smuggling it. For a man recently so short on cash that he had started hawking his Rolex wristwatches, the Sarpedon chalice had become more important than ever. Even in fragments, it was his best chance at solvency.

At the end of November, Shelby White and Fiorilli's team struck a deal for her fragmentary krater. She would send it back to Italy, but only after a two-year waiting period. She would keep the pot awhile longer, but it would no longer be hers—even though it had been openly purchased at the Hunt auction in 1990. "If you go to Sotheby's or Christie's and buy something at a public auction, you don't think you are doing anything inappropriate," said White, who isn't accused of any wrongdoing and isn't even under investigation in the Italian cases. "It is legal to buy antiquities. It is hard to apply current standards to something that happened thirty years ago."

In two separate, private events, White, in New York, signed over the krater to Italy, while Proietti, sitting in Rome, signed Italy's half of the accord. Soon after, White pulled the fragmentary Euphronios off view at the Met, where it had been on loan in the Greek and Roman galleries since 1999.

She took it home to her Sutton Place apartment and displayed it atop her grand piano.

A couple weeks later, in early December 2007, I met Bruce McNall at a country club in Los Angeles, not far from the Getty's main site. A lot had happened to him since his days selling antiquities to the Hunt brothers, most of it not good. Back on December 15, 1994,

he had pleaded guilty to bank fraud, conspiracy, and wire fraud related to cheating several banks of more than $236 million during the collapse of his coin business and other ventures. A federal judge had sentenced him to five years and ten months in prison. He had served a few days short of four years (some of which he spent in solitary confinement) before being released early, on March 7, 2001. Now he was free and making movies again, such as 2005's *Asylum,* starring Natasha Richardson.

In prison, he had taken a course that forced him to own up to the harm he had done to others and to recognize his narcissism. McNall no longer had anything to hide, and he felt better that way, too. So over a lunch of a cheeseburger, fries, and two glasses of red wine, he went over the history of the Sarpedon kylix. He said Fritz Bürki had shipped the cup from Zurich after Bunker Hunt bought it—along with the fragmentary krater that White now had on her piano. Although he didn't have much information about where Hecht had gotten the chalice, he said Hecht had told him many times about buying the Sarpedon krater from Medici. As for where Hecht had come up with White's partly reconstructed Euphronios, "He told me he got the fragments from Giacomo," McNall said.

Meanwhile, the countdown to the Sarpedon krater's return began. In Rome, the Culture Ministry enlisted the presidential palace on the Quirinale Hill for a display of some seventy antiquities that Italy had recovered from museums and private collectors. They called the exhibit Nostoi, a Greek word for homecomings. When it opened on December 19, 2007, its star Greek vase had not come home yet.

In New York, the city began its good-byes. In the Euphronios krater's final days on Fifth Avenue, well-wishers had their last

glimpse. Some recited verses from the *Iliad* in front of the glass case. Just after New Year's, Thomas Hoving, the Met chief who had brought the krater to America, came by to pay his last respects to the vase that was leaving the museum on his seventy-seventh birthday.

Then, on January 8, 2008, the Met announced that its longest-serving director, Philippe de Montebello, now aged seventy-one, would retire by the end of 2008. A troubled but colorful era in the art world was coming to an end all at once.

On Sunday, January 13, 2008, the Italians arrived in New York to take possession of the krater. The delegation included Maurizio Fiorilli, the Carabinieri art squad's Marshal Salvatore Morando, and a government archaeologist. They brought with them three vases to leave on loan at the Met, including an Attic red-figure cup potted, according to its signature, by Euxitheos— the same Greek craftsman who made the blank krater on which Euphronios famously depicted the death of Sarpedon.

That Sunday was the last day when the public could see the krater. Fiorilli and the Italian delegation arrived at the Met on January 15 to make the exchange. There, the museum staff and a shipping company specializing in artworks packed the krater in a blue, wooden crate lined with custom-fit foam, and then packed that box into yet another crate, stenciled with white letters: FRAGILE HANDLE WITH CARE.

Once they had packed the precious cargo, a diplomat from the Italian consulate on Park Avenue transformed the crate into a special entity under international law. By affixing a seal, the consular official turned the box into a diplomatic pouch.

On Wednesday, January 16, 2008, the Sarpedon krater boarded Alitalia flight 611 at John F. Kennedy Airport. Nearly thirty-six years earlier it had flown into JFK on TWA, strapped into a first-class seat. On its way out, Sarpedon traveled in the cargo hold.

The Last *Tombarolo*

The krater and its delegation arrived the next day at Rome's Fiumicino Airport at around 11:20 A.M. Led by the Carabinieri art squad, employees of an Italian shipping company loaded the vase into a truck equipped with satellite tracking, and Carabinieri cars escorted the truck to the art squad's headquarters in Rome's Trastevere neighborhood. By coincidence, the building—a former monastery where St. Francis of Assisi stayed when he first came to Rome—was crawling with journalists. Francesco Rutelli, the culture minister, was there, too. They were gathered for the art squad's annual presentation of its cases solved, *tombaroli* busted, churches robbed, and clandestine digs discovered. Many of the reporters, knowing the Sarpedon krater had been taken off view at the Met a few days earlier, had come hoping to see a homecoming.

Where was the Euphronios krater now, a reporter from the Associated Press, Marta Falcone, asked. "It's traveling," Rutelli said, laughing. "It's *in arrivo*." It's arriving. The journalists couldn't know this, but it had already arrived, and they were the ones who were blocking it from reaching its destination.

Outside on Via Anicia, the Carabinieri had directed the white truck to park on the street along the wall that circles the police compound. There, near the front gate, they waited. Once everyone left the news conference, they could finally drive the krater onto the grounds. It had gone from *in arrivo* to arrived.

Pulling up near the door to the building, the shippers slipped the inner blue box out of its crate and placed it on a mechanical lift at the back of the truck. After lowering it to the ground, they placed it on wheels and pushed it inside. Some of the usual suspects gathered around to see the prize they had worked so hard for over so many years. Anna Maria Moretti Sgubini, on whose father's watch the krater had been stolen, stood alongside Maurizio Fiorilli, who had negotiated the deal, and Marshal Salvatore Morando, the Carabinieri officer who discovered the Hecht manuscript that became the key evidence to win the krater's return. Paolo Ferri, the prosecutor who had won Giacomo Medici's conviction for smuggling the krater and was now prosecuting Robert Hecht for the same alleged crime, also joined the group. Danny Berger, the bow-tied Met employee and Culture Ministry consultant who greased the way for Italy's accords, was also there.

Before they could have their moment of satisfaction, several different people had to perform arcane alchemy on the box.

A representative of the Foreign Ministry had come down from the north of the city to remove the seal to this "diplomatic pouch." With that, the contents were technically inside Italy. This immediately raised a legal issue for which the Carabinieri were prepared. The krater, once out of the pouch, was stolen property that fell under their jurisdiction. As far back as 1972 the Carabinieri and various state prosecutors had investigated the krater and tried to bring to justice those involved in its excava-

tion and smuggling. So there in the corridor—after thirty-six years—the Carabinieri were able to seize the Euphronios krater.

And then, as quickly as they had taken it, the Carabinieri un-seized the vase and turned it over to the Culture Ministry in a flash of pomp and paperwork.

That was it. It was time for Sarpedon to get his beauty sleep. After spending his first night back in Italy in the monastery-turned-police-station, the following day, Friday, January 18, he would have to meet his adoring public.

The Culture Ministry called the hastily organized debut for 1:00 P.M. at the Italian attorney general's office on Via dei Portoghesi. Not that Giacomo Medici would have gone anywhere near the event, but that morning he was stuck at home in Santa Marinella with the flu and couldn't even manage to eat lunch.

I headed to the krater presentation. One by one, the players in the saga arrived beneath a sunny, blue sky with just a few wisps of white clouds. Marshal Morando was among the first to enter and helped to set up the event. At one point before the doors opened to guests, the policeman found himself alone for the first time with the krater. He couldn't resist; Morando opened his bare hand and placed it flush across the image of Sarpedon's bleeding body. He felt a shiver run through his body. Then he quickly pulled away.

Once the room was prepared, General Giovanni Nistri, the current Carabinieri art squad commander, pulled up in a dark Alfa Romeo sedan at 12:25 P.M., followed eight minutes later by Ferri, who hopped out of a modest government car, sporting a blue police light. Inside they were joined by about a hundred others—including police, archaeologists, journalists, and family

members of the men and women who had won back the trea-
sure—in the grand, frescoed Sala Vanvitelli, a towering room
bathed in sunlight.

The room was arranged with tall-backed wooden chairs in a
V formation. To the left of the front row, the Culture Ministry
press office had set up a section for television and still cameras.
To the right, on a wooden table covered with a red cloth was an
object with a circular top, hidden by a white sheet. Two Cara-
binieri stood guard next to the object, which was further pro-
tected by a braided red rope, suspended by two brass poles, each
topped with a decorative brass ball.

Along the room's back wall, at a long table, were the seats for
Rocco Buttiglione, the former culture minister who had led the
agreement with the Met; the current minister, Rutelli; and the
attorney general, Oscar Fiumara, who was the host of the event.
That role had fallen to him by default through the protocol of
needing neutral ground in which the former and current minis-
ters could take credit as equals.

The invited guests filed in, kissing on cheeks and shaking
hands, as 1:00 P.M. approached. As the ceremony began, some of
the honored guests took assigned seats. In the front row left of
the aisle, opposite the krater, sat Fiorilli at the far end, with Ferri,
Giuseppe Proietti, and Giovanni Nistri, the new art squad com-
mander, filling in the spots toward the middle. The other half of
the front row included the American embassy's cultural attaché
and Franco Bile, the seventy-eight-year-old president of the
Constitutional Court, which just three days earlier had heard
Medici's request that the court dismiss the charges against him—
including his conviction for smuggling the very krater in front
of them.

The krater, of course, was under the white sheet. Before any-
one could see it, the culture minister delivered opening remarks,

first thanking Fiorilli, and then the man who had brought the criminal charges. "Next to him there is Dr. Ferri, who has pulled off a function truly decisive with his actions," Rutelli said, as the crowd applauded Ferri. After adding thanks to Proietti the archaeologist and the leaders of the Carabinieri art squad, he introduced his predecessor, Buttiglione, who had been in charge when the Met agreed to hand back the Sarpedon krater.

Buttiglione took the microphone. "I have to first thank your exquisite courtesy to allow me to give a word," he said, lisping as usual, to the sitting culture minister, and then turning to the audience.

"We're reflecting on a success story. The Italian state has won," he declared—to absolutely no applause. Phillippe de Montebello had predicted the Italians would take home the krater as a nationalist trophy, but he had been wrong. The Italians exhibited some pride, for sure, but it wasn't about winning. It was, in a mundane way, simply about the Italian government's ability, despite its revolving door of leadership, to actually get something done.

"The Chinese vice minister of culture, when I arrived in China, gave me his congratulations, saying to me, 'You've won the war with the United States,'" Buttiglione continued, drawing a laugh from the room. "It was a war, but not against the United States. Most of all it was a war within our public administration to insure effective coordination."

When Buttiglione finished, Rutelli took the microphone: "Now let us uncover what is hidden here, the Euphronios krater." There was an excited rumble in the crowd as guests readied their cameras and craned their necks. "To introduce it, I will read how this celebrated episode of the Trojan War came to be explained in the words, of perhaps unsurpassed beauty, that come to us from Homer."

He cleared his throat and began. "Father Zeus . . ." A white-coated archaeologist from the Culture Ministry, and a delivery-man in blue jeans who had brought the krater from the airport, stood on either side of the squat table and lifted the sheet. Applause erupted, drowning out the minister's recital, as camera flashes illuminated the scene of Sleep and Death lifting the body of Sarpedon. All but those in the first rows rose to their feet, greeting the krater with a round of applause. The culture minister paused before starting his Homeric ode once again:

> *Father Zeus's strong desires Apollo did not disobey.*
> *From the slopes of Mount Ida he dove to the bloody field*
> *and lifting Prince Sarpedon clear of the weapons,*
> *bore him far from the fighting, off and away,*
> *and bathed him well in a river's running tides*
> *and anointed him with deathless oils . . .*
> *dressed his body in deathless, ambrosial robes*
> *then sent him on his way with the wind-swift escorts,*
> *twin brothers Sleep and Death, who with all god speed*
> *set him down in Lycia's broad green land . . .*

". . . and that, now, we have had the occasion to see," Rutelli concluded. "*Grazie a tutti voi.*" Thank you all, he said, as the room again burst into cheers for the return of Prince Sarpedon's krater to the land where it had been buried more than two millennia before.

The current and former culture ministers stepped down from the dais and circled the krater, bending over slightly as they took in their prize. For a celebratory photo op, they lined up behind the vase with Ferri and Fiorilli, his boss; the attorney general; and the president of the Constitutional Court.

After the ceremony, as the guests rushed to the front of the

room to crowd around the krater with their cell phone cameras, I approached Proietti. "What are you thinking right now?"

"It's a great satisfaction, largely for the spirit of collaboration that took us to this point, a collaboration among scholars," Proietti said, "and on the part of Dr. Montebello." It was mostly diplomatic speak and hewed to the theme of the day.

"But for you personally?" I asked.

"*Si,*" Proietti said. He smiled his broad, arched smile, "I began to direct the excavations in Cerveteri in 1972, my first assignment," he said. "Right when I got this assignment, all the newspapers had photos of this thing. And after thirty-seven years . . ." Proietti trailed off wistfully.

The krater resonated for Proietti in many ways, being linked to his early career, to his unsuccessful intermediate efforts as a ministry functionary to win its return, and ultimately to his role as Italy's signatory to the February 2006 agreement with the Met.

A few yards away, the scene around the krater bordered on chaos. After three decades of resting safely behind glass, the vase sat largely unprotected, balanced at waist height on a table covered with red damask cloth. Nothing but a Carabinieri sentry and a velvet rope, suspended by two brass stands, kept the crush of onlookers and television cameras at bay. Some paid their quiet respects, kneeling before the image of Sarpedon's bleeding corpse.

But the crowd also did its share of jostling, and in the crush, someone toppled one of the brass stands holding the velvet rope. The pole, topped with a brass ball, swung away from the spectators and toward the krater. The hard ball passed within two feet of the front face of the Euphronios masterpiece before crashing to the floor with a clang. One of the minders from the Culture Ministry quickly helped pick up the pole, and the event continued, with the incident barely noticed.

After about half an hour, the room all but emptied out, and the technicians and deliverymen boxed up the krater. Once again, Sarpedon was on the move. They wheeled the blue box out to the street, hoisted it into the white truck, strapped it in, closed the back, and then pulled out onto Rome's cobblestones. The krater was headed for the studios of RAI 1, the main state-run television channel.

On the 8:00 P.M. national news, Sarpedon had a repeat of his 1972 Today Show interview. The krater sat on the news desk, next to anchorwoman Tiziana Ferrario. Sarpedon had his half hour of fame. For logistical reasons—you just don't pick up and put down the Euphronios krater on cue—the vase was in place, on the far end of the TG1 anchor desk, for the entire broadcast.

Ferrario began the news by introducing the vase during a tease for a story on its return. The Sarpedon krater, looking itself like an interviewee, glowed orange under the TV lights. Then, at 8:27 P.M., Sarpedon came on screen again with Francesco Rutelli. The ancient hero was ready for his close-up.

"We're talking about this marvelous archaeological work, the Euphronios vase, which we exceptionally have this evening in the studio," the anchorwoman said, "a great emotion, I have to say, to have this archaeological artifact that is twenty-five hundred years old, a Greek vase . . ."

The culture minister interrupted: "Imagine if anyone had said to Euphronios twenty-five hundred years ago that he'd find himself in the TG1 studio. It's the most beautiful work of someone who is considered one of the best artists of Attica. But more than anything it's a victory by Italy against the traffickers. Against those . . ."

"It was dug up clandestinely, in fact, illegally, it was found in

Cerveteri, this vase," the interviewer interjected, as Rutelli picked up on the point.

"It was robbed from our country. We waged a battle, over two governments, and today we brought something back to our country, something which isn't the sort of bad news from Italy that the rest of the world talks about."

"When will it be possible for everyone to admire this vase?"

"Starting tomorrow," the minister said, giving a plug for the Nostoi exhibit at the presidential palace. "Free admission."

"*Grazie, grazie* for this opportunity to have this marvelous vase here in the studio."

For the final goodnight and credits, Rutelli was off the set, and the camera pulled back to show both the newswoman and Sarpedon as if they were coanchors. But Sarpedon's media tour of Rome had to wrap up. After spending the night again at the art squad's Trastevere headquarters, it was time once again to go under glass.

The next morning, the deliverymen drove the krater up the Quirinale Hill and into the gates of the presidential palace, where curators prepared it for display among the other repatriated goodies in the Nostoi exhibit. The line of visitors in front of the palace snaked down the hill as people waited for the gates to open at 9:00 A.M. When they did, the crowd passed through metal detectors and made its way upstairs to the makeshift gallery, where visitors found the Sarpedon krater in its own, waist-high glass case. Some people, expecting a more prominent, trophylike display, even walked past the krater without noticing and had to return and look for it.

With Euphronios's Sarpedon krater safely back in Italy, maybe the tomb robbers of Cerveteri would reveal what happened there thirty-six years ago.

All I had to go on was the legal documents from the 1970s that listed the names and addresses of the seven suspected members of the *tombarolo* gang that had unearthed the vase. The men had escaped indictment when Judge Lion in Civitavecchia ruled in 1978 that there wasn't enough evidence to bring them to trial. Before that, only one of them, the lookout Armando Cenere, had spoken about the clandestine excavation; and his credibility had been put in doubt because the other six had claimed innocence. Since then none of them had admitted anything or granted any interviews.

I ran all the names through the telephone directory, and not a single one was listed in Cerveteri or anywhere around Rome. For each of their last names, however, a few people were listed, possibly spouses or siblings. Or perhaps descendants. The 1970s legal documents had birth dates, and if still alive, the oldest of the gang was eighty-two years old; the youngest was sixty-four. I feared I might be too late. Medici gave me little hope, saying the tomb robbers had all but died off, some within the past few years.

I mapped out the 1970s addresses of the suspected *tombaroli* and the addresses of the dozen or so current Cerveteri residents with the same surnames and set out. I rang a doorbell at a house that looked barely inhabited, stepped back, and rang again. Nobody answered. People passing by and sitting on street corners gave me funny looks. It wasn't exactly a rough neighborhood, but it was clear that unfamiliar faces rarely came knocking. I moved on. I tried an address the court records had given for Cenere, the confessed lookout whose story had been taken as a sour grapes tale. The building didn't even exist anymore.

Turning to the list of current inhabitants with family names that matched those of the suspected gang members, I headed for the address of a woman named Bartocci. Maybe she was related to Francesco Bartocci, the Roman-born farmer whom investiga-

tors placed at the dig. Bartocci had just turned thirty-two when the tomb robbers pulled the Sarpedon krater from the ground. If he were still alive, Bartocci was almost seventy years old.

I saw that her house was one of the nicest houses on the block, set back from the street with its driveway guarded by a mechanical, metal fence. I approached the intercom and saw two buzzers. One bore a woman's name. The other said "Francesco Bartocci." My heart jumped. Had I actually found him? Then it sank. Maybe this was his son's house, a younger namesake. I pushed the button and heard a bell ring inside. An older woman emerged, looking as if she'd just stepped from the kitchen, and pushed a switch by her front door. The gate slid open as she shot me a look of "What do you want?" I explained that I was looking for Francesco Bartocci. I was investigating the origins of the Euphronios krater.

She smiled. I knew I was in the right place. "He's the last one left from that bunch," she said.

I'd found the right guy, and this was his wife. Was her husband around? I told her I hoped he could tell his story now that the krater was back in Italy.

Yes, Bartocci's wife said, they knew the vase had returned, and Francesco had even considered going to see it on display in Rome. But whether he would talk about it was another matter. Right now Francesco was at work in the nearby countryside, she said, and tried to give me directions. Did I know where the playing field was? Was I familiar with the road toward Lake Bracciano?

I was sure I would get lost. "Does he have a mobile phone?" I asked.

"Yes," she said holding up her cell phone, "but I have the number, not you." This wasn't going to be easy.

"Is he coming home for lunch?" I asked. But of course, she said.

I suggested I should just come back then. She did not object and said her husband would be back by 1:00 P.M. I thanked her and left to continue checking out my list of addresses.

When I returned, I found Francesco Bartocci at home. He had parked his truck—loaded with eggplant, zucchini, tomatoes, lettuce, and other produce he had just harvested—in the driveway and was changing from muddy work shoes into a clean pair of Velcro-topped sneakers for use in the house. Bartocci had a bushy head of white hair and was wearing a plaid shirt, blue jeans, and chrome-rimmed glasses. He had trouble walking, but he seemed strong, particularly in his big, calloused hands. Mostly he seemed shy.

I gave him my pitch about now being the time to finally tell his story. He didn't buy it. What would he know about the Euphronios krater?, he asked, clearly not comfortable with the idea that I knew the truth. This was old news, he said, what could he add? The krater was back, forget about it, he said.

But people would surely be interested, I pleaded.

Bartocci didn't say anything. He was itching to get to his lunch and I was keeping him in the driveway. "Can you just sit down with me for a moment?" I asked, gesturing to a chair at the bottom of his front stoop. He considered it. I made another offer "If you want to have your lunch, I can talk to you while you eat," I said, adding that I had already eaten.

Bartocci was running out of options, and I had brought a bag of fresh, local sugar cookies, not wanting to show up at lunchtime empty-handed, and said I would munch on them for my dessert.

"Do you have something you want to record this with?" he asked. It turned out he was confused about what I wanted from him. "I have this pen," I explained. "And I'll write down what you say."

Bartocci motioned me inside. At the back of the house, his

wife had set a long kitchen table with place settings of knives, forks, glasses, and napkins. A couple bottles of mineral water sat in the middle of the table. Pasta was cooking on the stove. Bartocci took the head of the table, and I sat next to him. As other family members and friends took their places and plates of food arrived, Bartocci began to tell the story of Euphronios's Sarpedon krater.

"Some friends and I went to dig," he said, and the rest spilled forth: how they excavated all winter; how they probed the earth to find the front of the tomb complex; how they found a stone lion early in the dig; how he wore a military overcoat against the harsh cold; how he stood watch at the top of the ridge; how he saw the Euphronios krater emerge from the ground in two plastic bags. He wanted to illustrate the workings of the illicit operation so he took out a pad of paper and drew how they had dug a hole more than fifteen feet deep, and then tunneled sideways along the face of the stone mortuary monument. Along the tunnel he drew five openings that represented the tombs that they had pillaged in order to come up with a masterpiece. On a map I had brought, he pinpointed the location of the tombs.

I showed him a postcard of the krater that I had bought at the Nostoi exhibit in Rome. The picture depicted the front of the vase, with the death of Sarpedon—the scene that decades earlier Armando Cenere had said he remembered as "a man who was bleeding." At the time, defenders of the Met's purchase said the *New York Times* reporters had led Cenere on by showing him photos of the krater's Sarpedon side. But now, at this lunch table, Bartocci the sixty-nine-year-old farmer made an offhand comment that provided a missing corroboration. Standing above the tomb just before Christmas 1971, he hadn't seen the Sarpedon side that I was showing him now, but instead the back side. In particular, he remembered a warrior with a sword.

Bartocci's memory appeared to be sharp, for the other side of the krater did depict warriors, one of whom carried a sword as he described. (Marshal Morando of the art squad later told me he believes the fragment that Bartocci described to me was probably from Shelby White's fragmentary krater, which would place both works by Euphronios at the same illicit dig.) Bartocci added that he recalled from the talk among his fellow excavators that the vase had a total of eleven red figures. Again he had correctly described the pot the Met bought, not just about the terminology of "red-figure" but indeed there are exactly eleven figures on the krater, including Sarpedon, Sleep, Death, and the others.

As we talked, a neatly dressed blind woman with a perfect hairdo and a pressed, orange tennis shirt took her place at the table. When someone alerted her to my presence—and my mission—she interrupted.

"I touched the Euphronios krater," she said.

This was Pina Bartocci, who had managed to get her hands on the masterpiece as a twenty-two-year-old hanger-on to the *tombaroli* scene and was the sister-in-law of Adriano Presciutti, one of the other suspected diggers named in the 1970s legal documents. The whole story and all its characters came together. All the men whom the prosecutors had suspected of looting the krater? Yes, they had done it, Francesco Bartocci said as he tucked into some marinated sardines. And yes, Giacomo Medici—or "Giacomino," as the older folks at lunch referred to him—had acquired it from them. "Giacomo Medici bought it and then he trafficked it to America to the Metropolitan," Bartocci said.

His blind, yet ever observant, sister, Pina, said it was unfortunate what had happened to Medici's brother, Roberto. I said it wasn't clear what had happened, and she just laughed. Of course

he had been killed, Pina said. At this one table in Cerveteri, none of the great mysteries surrounding the Euphronios krater were mysterious at all.

Then I took out photos of the krater's smaller twin, the chalice depicting Sarpedon. Francesco Bartocci took a close look. At first he quickly said he had never seen the cup, or any like it. Then, a few minutes later when I asked if he was sure, Bartocci said he had seen it—but then quickly added that he meant he had seen cups like it. They had pulled out lots of other vases from the tombs of Greppe Sant'Angelo, and he couldn't remember the specifics of any of them except the famous krater. They had known from the moment they discovered the krater that it was an exceptional piece.

"Signed by Euphronios as its painter," Pina chimed in again. "We knew it was of great value."

When the Met paid $1 million for the krater in 1972, Francesco Bartocci had already been married for eight years. He had three children to support. His share had been just 5 million lire, barely $8,500. "They gave me the crumbs," he said.

To further check out the story, I wanted to see if Bartocci's dig spot matched the one I had been researching, the site that Medici had been part owner of and that the Culture Ministry's Giuseppe Proietti had excavated at the start of his career. As lunch finished, I asked Bartocci if he could take me to the tomb. At first he indicated that maybe his son could take me, but Bartocci's wife sensed my excitement and urged her husband to do it himself. We walked out to the street and got into his blue Renault utility vehicle, which was covered inside with a layer of soil.

It was just a few blocks to Via Sant'Antonio, which we followed until it turned into a dirt road carved into the side of the stone shelf that runs through Cerveteri. Just past the

Sant'Angelo shrine, he pulled up to the gate of the very same tomb complex that Medici had owned. The sign outside the iron fence announced that we were at Greppe Sant'Angelo, and it bore a reproduction of the schematic drawings of the tomb complex Proietti had published decades before. It all matched up. The stories had checked out.

On the way back to his house, I asked Bartocci how big a deal, in the scope of his long life, finding the Euphronios krater had been.

"It was very important," he said. "And it doesn't bother me that we didn't make a lot of money.

"We made a great discovery."

The krater had a twin, of course, a dainty chalice, shattered to bits.

As it turns out, the damage done by the Swiss police inspector wasn't fatal. The chalice's custodian, Daniela Rizzo at the Villa Giulia museum, examined the hundred or so fragments of the Sarpedon cup. She found that most of the breaks were along the old fissures that had already been glued. There was no crack crossing Sarpedon's face.

"I don't think it will be a big problem to fix this kylix," Rizzo said when I asked for a prognosis. A few missing chips of paint and grains of clay will never rejoin the cup, but it will mostly be the same.

Any repairs will have to wait until the Italian courts resolve the legal status of the kylix. In all likelihood the chalice will become property of the Republic of Italy, won either through a final guilty verdict or a plea bargain with Medici.

Then the two matching vases will be together again, as Sarpedon and Euphronios continue their epic travels.

The Chalice

I never was able to get Dietrich von Bothmer to confirm the two-chalice theory, which, according to Thomas Hoving, meant another Euphronios was somewhere waiting to surface. Without von Bothmer's help, where does one go to track down a lost Euphronios chalice? I had already found the one buried in the reams of Medici's court papers. There had to be some other documentation hidden away somewhere.

Oxford.

In 2005, when the head of the archaeology lab tossed out the idea of offloading the files from the old thermoluminescence testing business, I had no idea what those boxes might contain. Since then I had learned how central the university's lab had been to the antiquities trade before the department shut down its commercial service. Giacomo Medici even said he had been a regular customer. When Professor Pollard's injured arm prevented him from opening the lab's attic door that afternoon, I missed a chance to comb through papers about hundreds, if not thousands, of artifacts made of clay. The names of clients, Polaroid photographs of each object, and the lab's conclusion of

whether the vases and statues were genuinely ancient—all of this was for the taking.

These archives probably also contained records of privately held objects that had never been published or exhibited. Maybe a second Sarpedon chalice was among them.

I called Professor Pollard to say I would take the files off his hands.

"They're gone," he said.

Just before Christmas 2005 the lab had sent the entire archive, including the index, to be destroyed at a facility specializing in the disposal of confidential papers. The lab's move from its Victorian row house to the modern science complex had triggered a discussion within the university on what to do with the boxes of papers. The university's lawyers had advised the scientists to get rid of the files because they contained private information on who had tested artifacts, what was held by whom, and what was fake or genuine. Destroying the records was the final step in severing Oxford from a business it should never have had in the first place.

"It's the end of an era," Professor Pollard said.

I needed another source of documents to solve the riddle of the supposed second kylix. Luckily, von Bothmer did leave behind a written record. It wasn't the diary entry of the dying man who wanted to make everything clear, but it was close. It was the body of von Bothmer's scholarly work. I became obsessed with finding every scrap of scholarly writing that he or anyone else had produced on the Sarpedon chalice. And von Bothmer had been involved, in one way or another, in nearly every important publication of the cup, from its debut as "Anonymous loan" to the Getty, to Bunker Hunt's collection catalog, to the 1990 Sotheby's sale. Before Martin Robertson, the former Oxford professor, published the cup for the Getty, he asked von Bothmer to read the article. Robertson even quotes the Met curator through-

out the piece. If von Bothmer knew at the time that this cup had a match, also by Euphronios, it is hard to imagine why he wouldn't have mentioned it to Robertson.

The most compelling argument that there is just one Sarpedon chalice can be found in von Bothmer's own words, buried in Appendix A3 of a Danish book on ancient pots. The appendices to *Greek Vases in New Contexts* contain excerpts of interviews that Vinnie Nørskov, a professor at Aarhus University, conducted over the course of her research with various curators, including Dietrich von Bothmer. She spent three days with him at the Met in 1997, from December 9 through 11, and in Appendix A3, her first two questions reveal just how central the elusive Sarpedon chalice was to von Bothmer's career:

> *VN:* What have been the most important acquisitions in your years at the Metropolitan?

> *DvB*: First of all, acquiring is not like ordering from a catalog. And secondly, you do not regret pieces you acquire, but only those you do not acquire.

> *VN*: And can you give me examples of such pieces?

> *DvB*: One piece was the cup sold at auction in 1990 with Sarpedon. Since I was still in charge I had something to say, and we tried to buy the cup, having Robin Symes bid for the piece at the auction. We did not get the vase, which was bought by Giacomo Medici.

My jaw dropped when I first read this, long after meeting Medici and seeing his photos of the broken chalice. When I started my research, Nørskov's book, published in 2002, was the only

reference I found to Medici being the anonymous bidder at the 1990 Sotheby's auction. And no book, until now, has revealed what happened to the Sarpedon chalice since. As for Hoving's news of there being two such cups, the way that von Bothmer spoke longingly of the Hunt-Medici kylix—without referring to having seen a separate, nearly identical one in the 1970s—probably proves there simply wasn't a second cup.

Conspiracy theorists (and there's no shortage of them in the antiquities world) would have no trouble brushing aside this academic paper trail as inconclusive. Indeed, some of the evidence is contradictory. In 1973, Hoving described Hecht's cup to journalists as missing its handles and foot, yet the Hunt-Medici cup was missing just part of one handle and its foot was attached, including the portion that bore Euphronios's signature. This discrepancy would back up the argument for two different chalices. However, Hoving now recalls that the cup Hecht offered him was intact—as was the Hunt-Medici cup until it shattered in 1998—undermining the two-cup theory.

Could von Bothmer have known of a second Sarpedon chalice, yet was bound by some agreement with Hecht not to talk about it? Could be, but I don't buy it.

Hoving, who spoke to von Bothmer, is convinced there is another lost chalice to find, so maybe it's out there. But I also know that what makes Hoving a wonderful character, an inspiration as a writer and someone I am thrilled to have met, is his infectious sense of adventure and his insatiable appetite for having a mystery to uncover. He is predisposed to intrigue and to wanting his own exciting life story to get even more interesting. It still might.

Giacomo Medici's odyssey also continued. The court cases, cancer, and financial troubles took their toll on his marriage to Maria Luisa.

They filed for divorce and legally separated while still living together at the Santa Marinella compound. And on March 28, 2008, Italy's Constitutional Court announced its decision that Medici couldn't get his charges dismissed. The first signature at the bottom of the ruling was that of the court's president, Franco Bile, who had applauded the Sarpedon krater's return. Medici's next chance would come with his appeal, a process that has not been resolved.

As a result, Object X remains a mystery. In the spring and autumn of 2008, Medici arranged meetings with Maurizio Fiorilli, trying again to find a way to hand over Object X in exchange for wiping out his 10-million-euro fine. Medici said he was still willing to throw in the Sarpedon chalice, too, if it would seal the deal. As the talks continued, the appeals court judges agreed to keep delaying his case. Medici, in the meantime, gained some freedom. On November 20, 2008, the Italian government issued him a new national identity card, which allows citizens to travel within most of Europe. Soon after, he used that document to obtain a passport. Italy couldn't keep him prisoner inside the country indefinitely. He might even have an easier time coming up with his mysterious object if he could go abroad.

Medici has provided a few more clues about Object X: he once owned this Greek masterpiece and sold it to its current owner a decade ago for about $1 million. He could get his hands on it again within a day, but would have to pay for it. And it could be anywhere in the world, as far away as Australia or as near as Rome. Maybe Object X is the third Sarpedon vase by Euphronios.

Although ending the case matters a great deal to Medici, it has already exposed the urgency of the antiquities looting problem—not just through the evidence found in the investigation, but through all

the unsolved mysteries the illicit trade has created about our past.

The scope of what is lost can be measured in a few ways, including the number of tombs that are lost in order for an illicit excavator to unearth a single prized pot. One Italian tomb raider cracked open 204 tombs over four recent years (a rate of one a week) and made a measly profit of $100,000, meaning that of the 1,764 objects he'd ripped from their archaeological contexts, at most one or two may have been of museum quality.

Many people share the blame, from the tomb robbers to the smugglers and dealers to the museum directors who spend tax-exempt dollars on art whose discovery has led to the loss of knowledge about our past.

The day after the Met's now-former director Philippe de Montebello returned to New York from signing away the Sarpedon krater, he spoke to the *New York Times* and dismissed the importance of the vase's archaeological context, saying that 98 percent of what is known about antiquity is from objects that don't come from digs:

> "How much more would you learn from knowing which particular hole in—supposedly Cerveteri—it came out of?" he asked. "Everything is on the vase."

He was ignoring what any child who watches the Discovery Channel knows. Archaeology is about context and dirt and bones and written records and lab analysis of organic remains. In one case, archaeologists from the University of Pennsylvania analyzed residue on bronze bowls from eighth-century B.C. tombs in Turkey. They discovered the menu from a feast dating from the time of King Midas: spicy sheep or goat, lentil stew, and a fermented beverage made of wine, beer, and honey mead. Such

information would have been lost if the site had been excavated without proper documentation and techniques.

Imagine if the same had been done with the krater and its tomb at Greppe Sant'Angelo in Cerveteri. Although the Euphronios krater may be beautiful, everything *isn't* on it—especially after it was cleaned up and put under glass on Fifth Avenue.

Not that being under glass is a bad thing. It's thanks to museums such as the Met that millions of people get to see great works of art. But the current debate that rages in the art world of "Where should these objects be?" dangerously misses the point. Italy, Greece, Egypt, and the rest of the source countries aren't demanding these vases and statues because they need them in their own, native museums. They are doing it to shut down an illicit trade that thrives today as tomb robbers continue to crack open tombs.

Yes, the *tombaroli* digging that pulled the Sarpedon vases by Euphronios out of the ground is not a lost trade of the 1970s. During 2006, the year when the Met agreed to hand back the krater and other antiquities, the Carabinieri art squad found 216 new illicit digs around Italy and recovered 24,649 looted archaeological artifacts. And those are just the digs they found and the objects they managed to get their hands on.

The bright side is that the police believe the efforts to push museums and collectors to return illegally dug or exported antiquities has diminished demand from the richest buyers in the market, cutting the incentive for tomb robbers to rob. The numbers may tell part of that story: in 2007, the number of illicit digs discovered dropped 4.16 percent to 207, and the number of artifacts recovered rose 16 percent to 28,528. Although the police discovered even more clandestine digs in 2008, when that number jumped 15 percent to 238, they made it harder to traffic any illicit finds, seizing 44,211 artifacts, an increase of 55 percent over the previous year.

The pressure from Italy, Greece, and other countries seems to be having a profound impact on the antiquities market—giving enhanced value to artifacts with old, known histories, and devaluing objects that may have come from recent illicit digs. At an auction I attended at Sotheby's in New York on December 5, 2007, a statuette of a lioness, barely more than three inches high, sold for a record $57.2 million. That was an auction record not just for an antiquity, but for a statue—whether modern or ancient. Why so much? It helped that the lioness, probably from Mesopotamia, had been on loan to the Brooklyn Museum since 1948.

Collectors are increasingly paying a premium for such provenance. At Sotheby's antiquities auctions held in New York from December 2005 through December 2008, buyers paid 184 percent more than the catalog's average estimate for objects that had known histories by 1970 or had records of being published, displayed, authenticated, or associated with a museum. That premium had been lower before Italy started its successful repatriation campaign, averaging just 129 percent from December 2000 through June 2005.

The argument against tomb robbing is a simple one: museums and collectors should respect laws against crimes such as stealing and smuggling. It's not complicated, although it does get confused with other issues; today's battles over recently looted antiquities get mixed in with the related demands by countries including Egypt and Greece for the return of artifacts taken centuries ago, such as the Rosetta Stone—which decoded hieroglyphics for the modern world—or the Parthenon marbles, both of which sit in the British Museum. That's not quite the same thing as museums and private citizens who have built collections with artifacts looted in modern times while breaking modern laws.

When it comes to understanding the fruit of modern tomb raiding, the interesting question isn't "Where should it be?" but

"Where has it been?" These ancient works and the people they've touched have incredible biographies that reveal much more than any single painting on a pot. That's particularly true with the two Sarpedon vases by Euphronios.

For the krater's part, it didn't stop moving after it returned to Italy: from the unveiling ceremony to the television studio to the presidential palace. Then, when the Nostoi exhibit transferred to a smaller space—in the Rome palazzo out of which the Trevi Fountain spouts its famous water—the Euphronios krater peeled off, together with the Getty's painted marble griffins and ceremonial lekanis basin, and headed north to Mantua. There, Sarpedon took the spotlight as the grand finale to a blockbuster exhibit of more than 120 works, called La Forza del Bello, or The Power of Beauty, and subtitled "Greek Art Conquers Italy." The krater, having undergone several identity changes already— from artwork in New York, to stolen property at the Rome Carabinieri station, to a symbol of Italian political cooperation at the unveiling, to TV guest, and to returning hero at the Nostoi exhibit—was transformed again, this time to an object of beauty. Now it was something *bello*.

From March 29 through July 6, 2008, the exhibit occupied most of Mantua's sprawling Palazzo Te, which dates back to 1525 and was designed to resemble an ancient Roman villa. The show moved visitors on an itinerary that took them through the palazzo and its stables, until they reached the final work: the Sarpedon krater.

Set atop a black pedestal, it was enclosed in a glass cube that measured about six feet on each side. The cube itself sat on a hidden platform several feet above the ground. Surrounded by darkness, the spotlighted surface glowed orange. To the right,

the *Iliad* verses detailing Sarpedon's violent death covered an entire wall. This son of Zeus had never been displayed to such effect, perhaps with the exception of the June day in 1972 when the jet-lagged Thomas Hoving, beer in hand, gazed on the image of the bleeding corpse in the morning light of a Zurich garden.

At that moment, in this context, the krater really did display the power of its beauty, just as the exhibit title promised. But if anyone looked closer, at the white lettering pasted onto the floating glass cube, the krater's meaning would transform again. In Italian the label read:

RED-FIGURE CALYX KRATER
(*Euprhonios vase*)
Circa 515 B.C.
Clay
From Greppe Sant'Angelo in Cerveteri
December 1971

For the first time in its incredible journey, the Sarpedon krater was displayed alongside an accounting of its archaeological origins, right down to the date when Armando Cenere, Francesco Bartocci, and the rest of the band uncovered the treasure. With this context, the krater became more than just an object of beauty. It had a story—one that went back to New York, to Zurich, to Rome, to Cerveteri, and, long ago, to Athens. If you were to include the realm of myth, the krater's story went back even further, to Troy, and the death of Sarpedon.

After Mantua, the krater returned to Rome for a couple months before making yet another overseas trip. The Nostoi exhibit inaugurated the new Acropolis museum in Athens. It took twenty-five hundred years, but Euphronios's masterpiece made it back to the place where it was born.

ACKNOWLEDGMENTS

This book is an adaptation of the doctoral thesis I wrote at Oxford, and Professor Chris Gosden, who supervised that work, gets all my thanks for guiding a fun and inspiring process that began in 1996 with a master's program and continued a decade later when he oversaw my dissertation. I first heard about Italian tomb robbers from Professor Peter Mitchell, who helped supervise my master's and deserves credit for planting the seed of this book.

I am indebted to Matt Winkler at Bloomberg News for his support of my academic pursuits. His backing, and that of Reto Gregori and Ron Henkoff, made this project possible.

To turn the thesis into a book, I stripped out references to academic theory. Still, I owe thanks to the scholars whose work framed my thinking, and I have included them in the bibliography. Theoretically speaking, the thesis traces the histories of two Greek vases using an approach that Igor Kopytoff calls the "cultural biography of things." The vases' biographies became entwined in a network with curators, auction houses, smugglers, and museums—and all these actors, including the pots, transformed one another and their identities over time.

Strangely enough, the best model I found for understanding the vases was the exchange of shell jewelry and canoes in the South Pacific. Anthropologist Nancy Munn saw how Gawa islanders became attached to the objects they traded and that those objects, even after they were gone, retained the Gawans'

identities. Canoes and humans accrued fame and other values when they came into contact with each other, just like antiquities and their collectors. I use the word *priceless* in the subtitle of this book (even though the chalice was bought and sold for a price) as a nod to how objects can have many, and conflicting, values.

Turning this into a book would not have been possible without Jennifer Joel at ICM and her assistant, Niki Castle. Jenn is a great agent, dealmaker, and editor. I am indebted to Henry Ferris at William Morrow, who took on this project and whipped the manuscript into shape with style. Peter Hubbard, Laurie McGee, Chris Goff, and others at HarperCollins helped turn the manuscript into a book.

Gail Roche edited my initial magazine stories on antiquities for Bloomberg Markets, along with Ron Henkoff, Charles Glasser, and Matt Winkler. Manuela Hoelterhoff, Jim Ruane, Stephen West, Philip Boroff, Farah Nayeri, Steve Scherer, Jad Mouawad, and Gregory Viscusi also collaborated on antiquities coverage, from Baghdad to Los Angeles.

I will never be able to thank Giacomo Medici enough for opening his archives and being as honest as he could about his past. I appreciate his family's courtesy, especially in light of its personal ordeal. I enjoyed the hours talking to Medici, and (in full disclosure) I also enjoyed two five-liter bottles of olive oil from his trees. I accepted the first because it didn't come close to the value of the meals that I had bought for him. When he insisted that I take the second, I paid for it. He refused cash, but took books: *Loot* by Sharon Waxman and a Bonhams auction catalog.

I had the pleasure of meeting many of the characters in this book. I thank Robert Hecht for his time and Thomas Hoving for his correspondence. Francesco Bartocci, Bruce McNall, Philippe de Montebello, and, most of all, Dietrich von Bothmer had the

courage to talk about their roles and the vases that inspired them. Frances Vieta, a journalist who lived in Rome in the 1970s, was generous with her knowledge and documentation, including the deposition of Armando Cenere and confidential police reports about the 1971 sack of Cerveteri's tombs. Suzan Mazur, who first told me about the chalice, sparked my search to find it.

In Rome, I depended on Paolo Ferri, Maurizio Fiorilli, Giuseppe Proietti, Danny Berger, Maurizio Pellegrini, Daniela Rizzo, several defense lawyers, and Carabinieri art squad members Salvatore Morando and Massimiliano Quagliarella. Elisabetta Povoledo at the *New York Times* and Cecilia Todeschini provided company at the True-Hecht trial in Rome as well as feedback on my work. Stephan Faris drove me on my first trip to Cerveteri. Karl Maier gave book advice. Adam Freeman made sure I did not miss antiquities news during my leave, and I thank Andrew Davis and the entire Bloomberg Rome bureau for their comradeship.

In academia, Lord Renfrew, Peter Watson, and Dr. David Gill provided assistance and, with their research, helped me understand the antiquities trade. At Oxford, Professor Gary Lock and Dr. Dan Hicks of the Institute of Archaeology, Professor Donna Kurtz and Dr. Thomas Mannack of the Beazley Archive, and Professor Mark Pollard of the archaeology lab were indispensable. Colin Dexter, the creator of the Inspector Morse mysteries and a fellow of St. Cross College, gave generous advice over college lunches on crafting crime thrillers.

My work took place in several sanctuaries. I depended on the staffs of Oxford's Sackler Library, the Getty Research Institute, the Villa Giulia, the Archivio Storico Capitolino, and others. At Rome's Bramante cloister, the de Marco family created an island of calm that was ideal for writing. Nancy Klingener and Mark Hedden hosted the signing of the book contract in Key West.

Jolly Uhry and the late Ralph Lawrence at the Calhoun School read us Homer; took us to the Met and Brooklyn Museum; made us stage Greek drama; and taught us how to throw, paint, and fire pottery—pretty much everything I needed to write this book. At Stuyvesant High School, Dr. Patrick Niglio gave me my language skills, and in his English class, Frank McCourt taught me that everyone has a story to tell.

David Temkin, Matthew Rothman, Jon Youngwood, Amy Bach, Sara Calian, and Steven Perelman at Brown gave me the bug for journalism. Professor Kent Weeks at the American University in Cairo invited me to my first dig, at KV5 in the Valley of the Kings, and I am forever thankful to Rotary International for sponsoring my scholarship in Egypt.

On the home front, this was a group effort involving family and friends, particularly Sarah Safer and Alex Bakal, who drove my daughter to school every morning for a year while I worked on this book.

I will thank members of the Echegaray, Granados, Horan, Silver, and Winfield families privately, especially my wife, to whom I have dedicated this book, and my father and mother. There is no way to do justice here to the help and sacrifice from all of them, in some cases over a lifetime.

Finally, I must thank my children for giving me the paternity leave that made this possible, for being curious about "Giacomo's cup," and, most important, for making all my dreams come true.

CAST OF CHARACTERS

The Ancients

EUPHRONIOS—Leonardo da Vinci of ancient Greece, who twenty-five hundred years ago painted the chalice and matching krater depicting the death of Sarpedon in the Trojan War

SARPEDON—Son of Zeus, killed in battle at Troy and depicted on Euphronios's chalice and krater

THE PIONEERS—A group of Athens vase painters, including Euphronios, that popularized the red-figure technique found on the Sarpedon chalice and krater

ETRUSCANS—People from an ancient civilization that inhabited lands north of Rome who imported Greek vases and buried them in tombs

The Excavators and Dealers

GIUSEPPE "PEPPE THE CALABRESE" MONTASPRO—Leader of a 1971 clandestine dig of an Etruscan tomb complex in Cerveteri, Italy

FRANCESCO BARTOCCI—Farmer in Cerveteri and lookout at the 1971 excavation

ARMANDO CENERE—Farmhand in Cerveteri and lookout at the 1971 excavation

GIACOMO MEDICI—Roman art dealer who pulled himself up from poverty by supplying antiquities to private collectors and museums

ROBERT HECHT—American antiquities dealer based in Rome, and then Paris, who counted the world's great museums as his clients

BRUCE MCNALL—Hollywood art dealer and film producer who teamed with Hecht to sell ancient masterpieces

The Curators and Collectors

DIETRICH VON BOTHMER—Metropolitan Museum of Art curator of Greek and Roman art whose career was inspired by a Euphronios vase and who wanted to acquire the Sarpedon chalice to display alongside his museum's famous, matching krater

THOMAS HOVING—Metropolitan Museum of Art director, 1967–1977, whose purchase of the Sarpedon krater by Euphronios triggered a battle over antiquities

MARION TRUE—J. Paul Getty Museum antiquities curator who studied with von Bothmer and got entangled in the international fight over ancient art

PHILIPPE DE MONTEBELLO—Director of Metropolitan Museum of Art, 1977–2008, who faced demands from Italy to return disputed antiquities

BUNKER HUNT—Texas billionaire collector of ancient coins and vases

LEON LEVY AND SHELBY WHITE—Antiquities collectors in New York

The Italian Archaeologists and Investigators

GIUSEPPE PROIETTI—Government archaeologist whose carreer followed the modern paths taken by the most famous vases by Euphronios

MARIO MORETTI—Italy's chief of Etruscan archaeology during the 1971 clandestine dig in Cerveteri

MARSHAL SALVATORE MORANDO—Policeman in Italian Carabinieri art squad who investigated the international antiquities trade

PAOLO FERRI—Prosecutor at the Rome Tribunal who worked to uncover the crimes of the global traffic in ancient art

MAURIZIO FIORILLI—Lawyer and negotiator for the Italian Culture Ministry who confronted museums and collectors

NOTES

When not otherwise indicated in the following, details of Giacomo Medici's life and business dealings come from interviews with Medici, access to his personal files, and from legal documents in his various court cases.

The scene of the looting of the Euphronios krater tomb is based in great part on the author's June 2008 interview with Francesco Bartocci, the last known surviving member of the tomb-robbing gang. Bartocci drew a diagram of how they conducted the dig and took the author to the dig site. His story corroborates and expands on the 1973 deposition and the *New York Times* interview given by another accomplice, Armando Cenere, and for the first time gives the precise find spot for the vase from a participant in the dig. The account of the looting and sale of the vase also draws on written intelligence reports that police gathered from confidential informants at the time and stories printed in Italian newspapers. When those accounts conflict with one another, which they often do, the narrative here sticks with the details most consistently reported and those coming from named sources, such as Francesco Bartocci, Robert Hecht, and Giacomo Medici.

Some descriptions of the Euphronios tomb complex and surrounding landscape as it looked at the time are derived from photos taken before, during, and after the two government excavations of the site from 1972 through 1974, as well as scale drawings and measurements published by the state archaeologist, Giuseppe Proietti.

As the following notes show, the account of Thomas Hoving's purchase of the Euphronios krater for the Met relies on his 1993 memoir, *Making the Mummies Dance,* and an updated version of that book's chapter on the purchase, published online in 2001. Hoving's e-mails to the author are reprinted with Hoving's permission. Additional details of Hecht's purchase and sale of the krater, when told from his point of view, come from Hecht's unpublished eighty-nine-page memoir. The handwritten memoir, which is evidence in Hecht's and Medici's trials, has no page numbers. Like other documents cited here, parts were retranslated into English from the court's Italian version.

Passages from Homer's *Iliad* are adapted from two translations, one by Robert Fagles, Viking Penguin, 1990, and the other by Alston Hurd Chase and William G. Perry Jr., Little, Brown, 1950.

Everything written within quotation marks was heard directly by the author, recounted by interview subjects as having been said at the events in question, or taken directly from court documents, written correspondence, books, and articles.

PROLOGUE: THE ANONYMOUS BIDDER

Eight other vases: Beazley Archive database records for vase numbers 187 (krater, Republic of Italy, formerly Metropolitan Museum of Art), 6203 (kylix at Munich Antikensammlungen), 7501 (fragmentary krater, Republic of Italy, formerly Shelby White and Leon Levy in New York), 200064 (krater at Louvre), 200065 (fragments of krater at Louvre), 200078 (psykter at Hermitage), 200080 (kylix at Munich Antikensammlungen), 200081 (fragments of kylix at Athens National Museum).

Hunt 1979 purchase: Bruce McNall interview with author.

Sotheby's Marion as auctioneer: Georgia Dullea, "At Sotheby's, the Resident Old Master Is the One Wielding the Hammer," *New York Times,* June 22, 1990.

Auction prices and lot descriptions: Sotheby's, *Nelson Bunker Hunt Collection of Highly Important Greek Vases/The William Herbert Hunt*

Collection of Highly Important Greek, Roman and Etruscan Bronzes (June 19, 1990, Auction catalog) (New York: Sotheby's); Sotheby's after sale report.

Auction scene: Author interviews with bidder in Lacoste.

Green sweater: Unpublished photograph of bidder on day of auction, from his private collection.

Met turning down chalice: Thomas Hoving, *Making the Mummies Dance: Inside the Metropolitan Museum of Art* (New York: Simon & Schuster, 1993), p. 327.

Symes bidding for Met: Vinnie Nørskov, *Greek Vases in New Contexts: The Collecting and Trading of Greek Vases—An Aspect of the Modern Reception of Antiquity* (Aarhus, Denmark: Aarhus University Press, 2002), p. 330.

"You do not . . . acquire": Nørskov, 2002, p. 330.

Met, Louvre hoping to borrow chalice: Author interviews with bidder in Lacoste.

Chalice whereabouts listed "unknown": Beazley Archive record, vase number 7043.

CHAPTER ONE: BURYING SARPEDON

Greek exports to Etruscans: John Boardman, *The Greeks Overseas: Their Early Colonies and Trade,* 3rd ed. (London: Thames & Hudson, 1999).

Berlin krater's origins: Beazley Archive record, vase number 200063.

Von Bothmer's arrival at Oxford and routine with Beazley: Dietrich von Bothmer, "Beazley the Teacher," in *Beazley and Oxford, Lectures delivered in Wolfson College, Oxford on 28 June 1985,* ed. D. Kurtz, 5–17 (Oxford: Oxford University Committee for Archaeology, 1985).

Medici's place of birth: Street name from Medici interview with author.

Medici's wartime experience: Author interviews.

Von Bothmer on Queen Mary: U.S. Department of Labor ship's manifest of alien passengers, June 28, 1939, p. 13.

Von Bothmer's education: James Mellow, "A New (6th Century B.C.) Greek Vase for New York," *New York Times Magazine,* November 12, 1972. Dictionary of Art Historians, http://www.dictionaryofarthistorians.org/bothmerd.htm.

Von Bothmer's military service: National Archives and Records Administration, U.S. World War II Army Enlistment Records, 1938–1946, via Ancestry.com.

Von Bothmer's wounding and heroics: Mellow, "Greek Vase for New York."

Von Bothmer's citizenship: Dictionary of Art Historians, http://www.dictionaryofarthistorians.org/bothmerd.htm.

Von Bothmer's promotion and Hoving's hiring: "Von Bothmer Gets New Museum Post," *New York Times,* July 2, 1959.

Hoving's father controlling Tiffany: "BAM 100," *Brown Alumni Magazine,* November–December 2000.

Hoving's education: Thomas Hoving, *King of the Confessors: A New Appraisal* (Christchurch, New Zealand: Cybereditions, 2001), pp. 12–13.

Hoving Meets Hecht in 1956: Hoving interview with author.

Medici's electrician degree: School alumni office.

Medici's army service and digging on base: Medici interview with author, October 26, 2007.

Pesciotti as Medici client: Medici interviews with author and Hecht's memoir, 2001.

CHAPTER TWO: THE TOMB

Hecht's education, postwar activities: Interview with author, May 31, 2006.

Hecht and Medici's first meeting and dealings: Hecht's memoir, 2001.

Hecht's smuggling charges: Italian Supreme Court decision absolving Hecht, October 16, 1978.

"B.H. '68.": Muntoni sentence of Medici, 2005.

Regolini-Galassi tomb: Mario Moretti, *Cerveteri* (Novara: Istituto Geografico de Agostini, 1978); Giuseppe Proietti, *Cerveteri* (Rome: Edizioni Quasar, 1986); and http://mv.vatican.va/3_EN/pages/x-Schede/MGEs/MGEs_Sala02_01_070.html.

Oxen plowing: Wendy Moonan, "Auctioning Antiquities Collected by an Ancestor," *New York Times,* October 14, 2005.

Discovery and sales of first Euphronios vases: Dietrich von Bothmer, "The Subject Matter of Euphronios," in *Euphronios Peintre: Rencontres de l'Ecole du Louvre,* 13–32 (Paris: La Documentation Française, 1992).

Louvre, Hermitage purchase dates: Euphronios peintre a Athenes au VIe siecle avant J.-C. (Paris: Editions de la Reunion des musees nationaux, 1990).

Proietti's university: Résumé provided by his office.

Medici using Oxford tests: Medici interview with author.

House calls: Vernon Silver, "Tomb-Robbing Trials Name Getty, Metropolitan, Princeton Museums," Bloomberg News, October 31, 2005.

Haunting of Sant'Angelo: "Scoperta dai CC. a Cerveteri una favolosa tomba regale," and "A Cerveteri Scoperta La Tomba Del Vaso Di Eufronio," *Il Messaggero,* September 5, 1974; also "Il diavolo degli etruschi è riemerso dalla sua tomba," *Il Tempo,* September 5, 1974, p. 6.

Tomb-robbing scene: See introductory remarks on sources at start of Notes section.

Cenere's background, time at the dig, fragment he saw: Nicholas Gage, "Farmhand Tells of Finding Met's Vase in Italian Tomb," *New York Times,* February 25, 1973, pp. 1, 50.

CHAPTER THREE: THE "HOT POT"

Apartment on Rome's Via Francesco Crispi: Medici alluded to this scenario and address during a lunch interview in Rome on October 26, 2007, and then when he saw the author writing it down said, "Forget you heard that." He later denied the account.

Price Medici paid for krater: Estimated from best information in Carabinieri reports from confidential informants, early 1970s.

Meeting at tombarolo's *house:* Carabinieri art squad report by its commander, Colonel Felice Mambor, to the prosecuting judge, Sica.

Medici's visit to Hecht, sale of krater, and related travel: Hecht's memoir.

"Is this for real?": Hecht's memoir.

Le Colline Pistoiesi for lunch: Hecht's memoir.

Le Colline Pistoiesi mentioned in trial: Court sentence, http://www.narcomafie.it/sentenza_dellutri.pdf.

Hecht's efforts to raise money and sell krater: Hecht's memoir.

Hoving's negotiations and purchase of krater (including quotations and texts of letters and affidavits): Hoving, *Making the Mummies Dance,*

and "Super Art Gems of New York City: The Hot Pot (Parts I–VI)," On Artnet, 2001, http://www.artnet.com/magazine/FEATURES/hoving/hoving6-29-01.asp.

Hoving's hiring: "Von Bothmer Gets New Museum Post," *New York Times,* July 2, 1959.

"If something . . . effort?": Hoving, *Making the Mummies Dance,* p. 308.

Finance police excavation: Giovanni Colonna, "Scavi e scoperti—Cerveteri," in *Studi Etruschi XLI,* p. 540 and tables CXII and CXIII (Florence: Istituto Nazionale di Studi Etruschi e Italici, 1973).

Items recovered by finance police: Richard Walter, "$1m Vase: Magistrate Goes to Looted Tomb," *The Observer,* March 4, 1973.

Found a statue of a lion: "Tulchulca veglia ancora sulle tombe degli Etruschi," *Il Tempo,* September 6, 1974.

Sphinx recovered by finance police and February date and location: "A Cerveteri Scoperta La Tomba Del Vaso Di Eufronio," *Il Messaggero,* September 5, 1974.

"Regarding p. 14 . . . begin": Hoving, *Making the Mummies Dance,* p. 309.

Bürki gluing vase: Hecht's memoir.

"hidden underground": Ministry of Public Instruction notice, March 30, 1972.

"The Met . . . of this": Hecht's memoir.

Von Bothmer's marriage: George Gurley, "I Am Charlotte Bocly," *New York Observer,* October 22, 2006.

Hecht's visit with von Bothmer and family: Hecht's memoir.

"Hundreds . . . just drawn": Hoving, "The Hot Pot," Part I.

"Dietrich . . . me": Hoving, "The Hot Pot," Part I.

Euphronios's times: Ministero Per I Bene Culturale Ambientali, *Capolavori di Euphronios: Un Pioniere della Ceramografia Attica* (Arezzo: Museo Archeologico Nazionale, 1990), introduction.

Kerameikos: John Boardman, *The History of Greek Vases: Potters, Painters, and Pictures.* (New York: Thames & Hudson, 2001), p. 139.

Pioneers: Boardman, *History of Greek Vases,* pp. 83–87.

Euphronios biography: Boardman, *History of Greek Vases,* p. 139.

Process of the decorating vases: Joseph Veach Noble, "The Making of a Greek Vase," in *The Greek Vase,* ed. Stephen L. Hyatt, 1–21 (Latham, NY: Hudson-Mohawk Association of Colleges & Universities, 1981).

A boy, probably an apprentice . . . : A scene of an Athenian potter's shop is painted on a black-figured hydria by the Painter of the Leagros Group, found in the Staatliche Antikensammlungen und Glyptotek in Munich, reproduced in Noble as Figure 19.

Additional details of potting and painting: A scene of an Athenian vase workshop is painted on a red-figured hydria by the Leningrad Painter, found in the Torno collection, Milan, reproduced in Noble as Figure 18.

Greek kilns . . . : A kiln predating Euphronios's time is depicted on a Corinthian black-figure plaque of a potter stoking a kiln, found in the Berlin museum, reproduced in Noble as Figure 24.

June 27, 1972, date of seeing the krater in Zurich: "A Second Work by Master of Vase Comes to Light," *New York Times,* February 24, 1973, p. 15.

"Dietrich . . . is it?": Hoving, "The Hot Pot," Part I.

"No figure . . . image": Hoving, "The Hot Pot," Part II.

"This was . . . encountered": Hoving, *Making the Mummies Dance,* p. 312.

"Sublime!": Hoving, *Making the Mummies Dance,* p. 312.

"My Finnish . . . Beirut": Hoving, *Making the Mummies Dance,* p. 314.

Coins sold for $2.3 million: Hoving, *Making the Mummies Dance,* p. 316.

"If you . . . my 1.3": Hoving, *Making the Mummies Dance,* p. 316.

"For appearances' . . . near-sexual pleasure": Hoving, *Making the Mummies Dance,* p. 318.

Hecht's celebratory meal, krater's airline tickets, and seat: Hecht's memoir.

TWA flight number 831 and value of vase declared with U.S. Customs at $1 million: Nicholas Gage, "How the Metropolitan Acquired 'The Finest Greek Vase There Is,'" *New York Times,* February 19, 1973, pp. 1, 32.

Customs agent admiring the vase and its declared value: Nicholas Gage, "Never Saw Vase Intact, Beirut Dealer Says," *New York Times,* February 22, 1973, pp. 1, 28.

"I'm going to . . . Rembrandt": Hecht's memoir.

"I bet . . . exist": Hecht's memoir.

Hecht's tennis trip: Hecht's memoir.

Name and location of Lew Hoad's tennis camp in Fuengirola: Richard Walter and Peter Deeley, "The Million-Dollar Vase . . . the Men Who Sold It to the Met . . . and Where It May Have Come From," *The Observer,* February 25, 1973, pp. 1–2.

September 12 date of Met committee meeting, and eight of the eleven members being present: David L. Shirey, "Dillon, Metropolitan President, Terms Vase Purchase 'Legal'," *New York Times,* March 1, 1973, p. 55.

"well-known art dealer": Hoving, *Making the Mummies Dance,* p. 319.

No committee members asked questions, Sulzberger's interest: Hoving, *Making the Mummies Dance,* p. 320.

"I don't . . . magazine": Hoving, *Making the Mummies Dance,* p. 320.

Met's payment to Hecht and currency: Hecht's memoir.

Ultraviolet test and timing of Oxford authentication in late September: "A Second Work by Master of Vase Comes to Light," *New York Times,* February 24, 1973, p. 15.

Oxford's dates for krater and testing by Fleming: Hecht's memoir.

Hoving thought . . . "snicker": Hoving, "The Hot Pot," Part III.

Today Show transcript: Karl E. Meyer, *The Plundered Past* (New York: Atheneum, 1973), appendix.

Dates and details of Cerveteri land purchase: Medici and Bruno's filings with the Ministry of Public Instruction, January 19, 1974, and November 10, 1974.

CHAPTER FOUR: SARPEDON'S LOST TWIN

Two factions at AIA meeting: David L. Shirey, "Von Bothmer Quits Archaeology Unit," *New York Times,* May 2, 1973, p. 36.

Rodney Young . . . asked: James R. McCredie e-mail to author, March 6, 2008.

Young excavated at Gordion: http://home.att.net/~gordion/index.html.

"The grave robbers hear . . . despoliation of tombs": Shirey, "Von Bothmer Quits," p. 36.

"They don't like me . . . And I don't like him": Shirey, "Von Bothmer Quits," p. 36.

"He was angry for years": James R. McCredie e-mail to author, March 6, 2008.

Italians learning of and trying to find cup: Nicholas Gage, "2 Inquiries Begun," *New York Times,* February 20, 1973, pp. 1, 19.

Date of Hecht questioning by Carabinieri: "Italian Inquiry on Vase Said to Identify a Thief," *New York Times,* February 23, 1973, pp. 1, 22.

Colonel Felice Mambo called Bob Hecht's home: David L. Shirey, "Hecht Backs Vase Sale; Will Avoid Italy for Now," *New York Times,* February 28, 1973, pp. 1, 34.

"capolavoro," "had never been seen," and "I've never seen . . . thing": Hecht's memoir.

Dialogue in Hecht's sales pitch of kylix to Hoving: Author interview with Hoving.

February 14, 1973, date of Observer's recorded interview with Hoving: "Seller of Greek Vase Flew to See Hoving Last Week," *New York Times,* February 26, 1973, p. 1.

Hoving wondered . . . microphone: Hoving e-mail to author, May 16, 2006.

"Funny thing is . . . give it to us": John L. Hess, *The Grand Acquisitors* (Boston: Houghton Mifflin, 1974), pp. 164–65, and Italian consular cable of intercepted conversation.

Von Bothmer interview with Observer: Walter and Deeley, "The Million-Dollar Vase," and full transcript in Hess, *Grand Acquisitors,* pp. 165–66.

Gage's reporting trail and dinner with Hecht: Hess, *Grand Acquisitors,* pp. 153–54.

"Hot Pot": Hoving, "The Hot Pot," Part III.

"red figured crater which I have had so long": David L. Shirey, "Seller of the Greek Vase Is Named by Met Curator," *New York Times,* February 21, 1973, pp. 1, 34.

"He came to tell me": Gage, "Never Saw Vase Intact, pp. 1, 28.

Commander steamed: "Italian Inquiry on Vase Said to Identify a Thief," *New York Times,* February 23, 1973, pp. 1, 22.

"Hanno le . . . Bene": Hoving, *Making the Mummies Dance,* p. 328.

"sadly and wearily," and interview with von Bothmer: Hess, *Grand Acquisitors,* 1974, p. 164; and John L. Hess, "A Second Work by Master of Vase Comes to Light," *New York Times,* February 24, 1973, p. 15.

Gage's meeting with Cenere: Hess, *Grand Acquisitors,* pp. 161–62; and Gage, "Farmhand Tells of Finding Met's Vase," pp. 1, 50.

Prosecutor and Carabinieri search for tomb, covered with nine feet of soil, on February 25, 1973: "Si chiarisce il 'giallo' del Metropolitan. Il Vaso Greco Fu Trovato Da 4 Tombaroli," *Il Messaggero,* February 26, 1973, pp. 1, 13.

FBI and the New York Police Department jumped into the probe, interrogating von Bothmer: Hoving, *Making the Mummies Dance,* p. 331. Also Nicholas Gage, "Italians Seek F.B.I. Aid on a Greek Cup," *New York Times,* March 2, 1973, p. 42.

But where was it? . . . since: David L. Shirey, "F.B.I. and Police Here Begin Inquiry on Met Vase," *New York Times,* February 27, 1973, pp. 1, 29.

"I want to see . . . the belt": Shirey, "Hecht Backs Vase Sale," pp. 1, 34.
On March 1, . . . : Gage, "Italians Seek F.B.I. Aid," p. 42.
Hoving wondered about his strange look . . . : Hoving e-mail to author, May 16, 2006.

"wanted to get rid of": "Fragments Found in Italy Linked to Museum Vase," *New York Times,* May 8, 1973, pp. 1, 36.

As long as a pack of cigarettes: "Italian Police Sources Describe Fragments Linked to Met Vase," *New York Times,* May 9, 1973, p. 38.

Medici's questioning by Carabinieri: Medici interview with author, October 24, 2007.

Letter with fifteen fragments: "New Vase Fragments Believed Move to Hinder Italian Inquiry," *New York Times,* May 15, 1973, p. 28.

Purchase of Cerveteri land: Medici interview with author, June 20, 2006.

Hecht's arrest warrant: Nicholas Gage, "Warrant Issued for Hecht in Vase Sale," *New York Times,* June 26, 1973, pp. 1, 54.

Roberto's trip: Medici interview with author, November 5, 2005.

"We'll be . . . about us": "Due Commercianti Di Anticaglie Di Porta Portese. Spariti da 12 giorni. La loro autho trovata bruciata," *Il Messaggero,* September 8, 1973, p. 1.

"The trade. . . intersect": "Due Commercianti Di Anticaglie Di Porta Portese," p. 1.

Identity of Turin merchant as Bruno, contact in Taranto as Basile, and Bruno's emissary as Chiselna; deal being for important antiquity: Medici interview with author, January 25, 2008.

Roberto Medici's wife informed about burned car: "Al colloquio con i parenti dei due scomparsi," *Il Messaggero,* September 8, 1973, p. 5.

"All the area targeted . . . Etruscan objects," Civitavecchia, and other details of the investigation into the disappearance: "Il mistero dei due scomparsi a Roma. Li ahnno visti prima e dopo l'incendio dell'auto," *Il Messaggero,* Sunday, September 9, 1973, pp. 1, 5.

Speculation of krater link to disappearance: Medici interview with author, May 31, 2006.

Promotion of von Bothmer, hiring of Montebello: "New Appointments Announced by the Metropolitan Museum," *New York Times,* September 18, 1973.

Montebello biography: http://www.metmuseum.org/press_room/full_release.asp?prid=%7BB88665AC-60DB-4C8D-91A7-8643C3AE6180%7D.

Getty ransom: "Minus One Ear," *Time,* December 24, 1973.

Cerveteri land purchase, boar: Medici and Bruno's filings with the Ministry of Public Instruction, January 19 and November 10, 1974.

Registered letter: Medici interview with author, June 20, 2006.

CHAPTER FIVE: HOLLYWOOD AND DALLAS

Met's in-house investigation: Hoving, "The Hot Pot," Part V.

Fragments not fitting: Paul Hofmann, "Italians Say Fragments Are Not from Met Vase," *New York Times,* January 17, 1974, p. 47.

Carabinieri visited Met with fragments: Hoving e-mail to author.

McNall's start and career: Bruce McNall and Michael D'Antonio, *Fun While It Lasted: My Rise and Fall in the Land of Fame and Fortune* (New York: Hyperion, 2003).

McNall at the Bern auction, meeting Hecht and Medici: McNall and D'Antonio, *Fun While It Lasted,* pp. 25–29.

"Giacomo" with Ugo was Medici: Interviews with Medici, January 17, 2007, and McNall, December 20, 2007.

Medici's trip to World Cup, sale of Sabina in Munich: Medici interview with author, October 18, 2006.

"We saw it . . . clandestine digging": Medici interview with author, June 20, 2006.

Hogs dug up statues: Medici interview with author, January 25, 2008.

Proietti winning 1973 competition: Résumé provided by his office.

Official excavation of Medici's land: "Scoperta dai CC. a Cerveteri una favolosa tomba regale," and "A Cerveteri Scoperta La Tomba Del Vaso Di Eufronio," *Il Messaggero,* September 5, 1974.

During the night . . . 24-hour presence: Eric Salerno ' "Inestimabile' Il Valore Della Statua Di Tuchulca," *Il Messaggero,* September 6, 1974, p. 5.

Entitled to 25 percent: Salerno, ' "Inestimabile' Il Valore Della Statua Di Tuchulca," p. 5.

"Either in . . . this complex": Salerno, ' "Inestimabile' Il Valore Della Statua Di Tuchulca," p. 5.

Tomb site contents: Giuseppe Proietti, "Scave e scoperte—Cerveteri (Una volta a conci radiali nella necropoli monumentale di S. Angelo)," in *Studi Etruschi XLV,* 443–45 (Florence: Istituto Nazionale di Studi Etruschi e Italici, 1977).

First they found two statues: Salerno, ' "Inestimabile' Il Valore Della Statua Di Tuchulca," p. 5.

Twin of sphinx: "A Cerveteri Scoperta La Tomba Del Vaso Di Eufronio," *Il Messaggero,* September 5, 1974.

Two phallic tombstones: "In una tomba etrusca il demone degli inferi," *Paese Sera,* September 5, 1974, p. 6.

Haunting of Sant'Angelo, reaction of workers to demon: "Scoperta dai CC. a Cerveteri una favolosa tomba regale," and "A Cerveteri Scoperta La Tomba Del Vaso Di Eufronio," *Il Messaggero,* September 5, 1974. Also "Il diavolo degli etruschi è riemerso dalla sua tomba," *Il Tempo,* September 5, 1974, p. 6.

Carabinieri sources said krater looted from a minor tomb in complex: Salerno, ' "Inestimabile' Il Valore Della Statua Di Tuchulca," p. 5.

"Since the last century . . . of vases," and date range of fragments: "Forse non raffigura Tuchulcha la statua recuperata a Cerveteri," *Il Momento Sera,* September 11–12, 1974, p. 4.

Moretti theory of tombs used as nineteenth-century warehouses: Gianni Sarrocco, "Il demone Tuchulca spinge alla guerra," *Giornale D'Italia,* September 12, 1974, p. 4.

"Nothing would . . . two centuries earlier": Sarrocco, "Il demone Tuchulca spinge alla guerra," p. 4.

Contained other tombs that were older: "Forse non raffigura Tuchulcha la statua recuperata a Cerveteri," p. 4.

Hoving handing Tut objects: Thomas Hoving, "In Defense of King Tut," *Los Angeles Times,* June 20, 2005.

Tut's U.S. Navy transport: I. E. S. Edwards, *Treasures of Tutankhamun* (New York: Ballantine, 1976), p. 8.

Hoving's rebuke, resignation: Hoving, *Making the Mummies Dance,* pp. 421–23.

Sarrafian killed: Peter Watson and Cecilia Todeschini, *The Medici Conspiracy: The Illicit Journey of Looted Antiquities from Italy's Tomb Raiders to the World's Great Museums* (New York: Public Affairs, 2006), p. xviii.

Newman's testimony and case dropped: Hoving, *Making the Mummies Dance;* and "The Hot Pot."

Medici closing Rome shop in 1978: Medici interview with author, October 18, 2006.

"Looking at dead Sarpedon . . . immortality": von Bothmer, "The Death of Sarpedon," in Hyatt, *The Greek Vase,* pp. 79–80.

McNall starting Summa, deals with Getty's Frel: McNall and D'Antonio, *Fun While It Lasted,* pp. 43–45.

McNall and Hunt meeting: McNall and D'Antonio, *Fun While It Lasted,* pp. 51–54.

"Jewish conspiracy": McNall and D'Antonio, *Fun While It Lasted,* p. 53.

Hunt attempt to corner silver market: McNall and D'Antonio, *Fun While It Lasted,* p. 67; and Dolores Barclay, "For Hunts, parting with silver help saves the day," Associated Press in *Dallas Morning News,* March 30, 1990.

Sale of vases to Hunt, prices, shipping, etc.: McNall interviews with author, November 14 and December 20, 2007.

Arrival of vases at Getty: Curator Karol Wight e-mail to author, January 29, 2008.

CHAPTER SIX: REVERSALS OF FORTUNE

Robertson publishing the vases: Martin Robertson, "Euphronios at the Getty," in *The J. Paul Getty Museum Journal* 9 (1981): 23–24.

Departure of vases from Getty: Curator Karol Wight e-mail to author, January 29, 2008.

Itinerary of Hunt exhibit: Sotheby's, *Nelson Bunker Hunt Collection of Highly Important Greek Vases/The William Herbert Hunt Collection of Highly Important Greek, Roman and Etruscan Bronzes.*

Purchase and trade of the hydria: Medici interview with author, December 20, 2005.

Hydria general history: Boardman, *The Greeks Overseas,* pp. 203–6.

Euphronios's failing eyesight: Boardman, *The History of Greek Vases,* p. 149.

Onesimos-Euphronios purchase by Getty: Muntoni sentence and Getty acquisition records.

Why Medici took a Swiss-based partner: Medici interview with author, January 3, 2006.

Medici, agent for Koutoulakis, sold hydria to Getty's Frel: Medici interview with author, December 20, 2005.

Price and invoice for hydria: September 26, 1983, invoice from Hydra Galerie.

Good client of Sotheby's: Deposition of Oliver Francis James Forge, who worked in the auction house's London antiquities department from 1980 through 1997.

"In keeping . . . eminent authority": Nicholson's February 19, 1999, deposition in Medici's case.

Provenance of twenty plates: Medici interview with author, November 5, 2005.

Gallery opening: Photos of event in Medici's private collection.

Burglary details: May 26, 1986, statement made at the San Felice Circeo police station by Alessandra de Marchi.

Torre Paola history and appearance: http://www.circei.it and http://flickr.com/photos/jenninrome/2732887315/in/set-72157606127594840/.

Sotheby's London antiquities chief calls man at Editions: Guglielmo Muntoni, *Sentenza . . . nei confronti di Giacomo Medici,* etc. (Rome Tribunal Judge's written sentence following his December 13, 2004, conviction of Giacomo Medici on charges of conspiracy and the smuggling and handling of stolen antiquities). Deposited at the Tribunale di Roma on May 12, 2005, p. 20.

Hydra Galerie inventory: Paolo Ferri in the transcript of the June 20, 2001, deposition of Marion True at the Getty.

"Bob, let's make a contract . . .": Medici interview with author, December 20, 2005.

Itinerary and details of Medici's trip: Medici interviews with author.

Rolls-Royce belonged to McNall: McNall, interview with author, said he probably loaned the car and driver to Hecht and Medici.

Hecht getting around in taxis: McNall interview with author.

CHAPTER SEVEN: AUCTION OF THE CENTURY

Questioning of Jacques: June 2, 1987, declaration to the police.

Hunt silver purchases, losses, debts, and bankruptcy: Dolores Barclay, "For Hunts, Parting with Silver Helps Save Day," Associated Press in *Dallas Morning News,* March 30, 1990.

Announcement of Hunt auction: "Sotheby's to Auction the Hunts' Antiquities," *New York Times,* November 23, 1989.

"I hate. . . enjoy them": Barclay, "For Hunts, Parting with Silver,".

"We are . . . frenzy": Mark Tatge, "Coin collectors gathering in NY for auction of Hunts' antiquities," *Dallas Morning News,* June 19, 1990.

Since 1841: Dietrich von Bothmer, "The Subject Matter of Euphronios," in *Euphronios Peintre: Rencontres de l'Ecole du Louvre* (Paris: La Documentation Française, 1992), pp. 13–32.

Mazur's auction preview tour: Suzan Mazur, "The Sotheby's (Pre-Auction) Euphronios Transcript," Scoop.co.nz, January 11, 2006, http://www.scoop.co.nz/stories/HL0601/S00076.htm; and author's correspondence with Mazur.

Green Lacoste, vases spotlighted under glass: Photo from Medici's private collection taken before the auction in the Sotheby's showroom.

Robert Guy's jobs at Princeton and Oxford: Cornelius C. Vermeule (book review of Brunilde S. Ridgway, et al., 1994. *Greek Sculpture in the Art Museum, Princeton University, Greek Originals, Roman Copies and Variants*) in Bryn Mawr Classical Review 95.02.06.

Hecht, Becchina, and Levy's seating at auction: Medici interview with author, January 3, 2006, and January 30, 2007.

Seating of Medici family members, Symes, and Michelides: Medici interview with author.

Bids from telephone and room: Medici interview with author, January 30, 2007.

Medici and Symes bid for fragmentary krater: Medici interview with author, July 28, 2006.

"Giacomo . . . at an auction": Medici interview with author, November 19, 2005.

"We want to buy it": Medici interview with author, July 28, 2006.

Von Bothmer wanted to give "a little bonus": Medici interview with author, January 30, 2007.

Von Bothmer furious with Medici: Medici interview with author, July 5, 2006.

June 25, 1990, resale of fragmentary krater to Levy: Muntoni, 2005 sentence of Medici.

Louvre calling Medici: Medici interview with author, January 3, 2006.

Louvre curator's offer and timing of Sotheby's shipment: Medici interview with author, September 13, 2007.

Von Bothmer retiring and endowment of new job: Vernon Silver, "Met's Antiquities Case Shows Donor, Trustee Ties to Looted Art," Bloomberg News, February 23, 2006.

Levy and White lending fragmentary krater to Met in 1999: Placard next to vase at Met, accession number L.1999.36.1, photographed by author December 2005.

Details of Medici's trip to Louvre: Medici interview with author, September 13, 2007.

Publication of big kylix: Dyfri Williams, "Onesimos and the Getty Iliupersis," in *Greek Vases in the J. Paul Getty Museum Volume 5,* 41–64 (Malibu: J. P. Getty Museum, 1991).

Rizzo's report: Maria Antonietta Rizzo, "Gli Scavi Clandestini a Cerveteri (1982-94)," in *Antichita Senza Provenienza, Atti della Tavola Rotonda, American Academy in Rome, 18 febbraio 1995* (Rome: Ministero per i Beni Culturali e Ambientali, 1995), pp. 15–50.

"The appearance . . . millennia": Rizzo, "Gli Scavi Clandestini a Cerveteri," p. 25.

"Colleagues . . . collecting": Rizzo, "Gli Scavi Clandestini a Cerveteri," p. 28.

CHAPTER EIGHT: SHATTERED

Medici's gallery supplied Apulian vases for July 1985 Sotheby's sale: Peter Watson, *Sotheby's: Inside Story* (London: Bloomsbury, 1997), p. 183.

"worth millions" . . . *"we had left our recorder running":* Watson, *Sotheby's: Inside Story,* p. 188.

Medici and family at hotel on the Costa Smerelda when colleague called: Medici interview with author, October 24, 2007.

Medici's January 17, 1997, arrest and jailing: Medici interview with author, April 1, 2008.

Rizzo delivering two papers: Maria Antonietta Rizzo, "La coppa con Iliupersis al J. P. Getty Museum di Malibu con dedica ad Hercle ed il santuario di Hercle a Cerveteri: storia di una ricontestualizzazione," pp. 65–70, and "La coppa di Euphronios ed Onesimos," pp. 71–83, in *Antichita Senza Provenienza II, Atti del Internazionale, Viterbo—Palazzo del Rettorato, 17–18 ottobre 1997* (Rome: Ministero per i Beni Culturali e Ambientali, 1997).

Rizzo confronting True and True returning cup: Hugh Eakin, "Treasure Hunt: The Downfall of the Getty Curator Marion True," in *The New Yorker,* December 17, 2007, p. 71.

October 27, 1997, Latina court transfers case to Rome: Muntoni sentence of Medici, 2005, p. 6.

Free Port raid details: Alain Baudin, Rapporto Baudin, September 20, 1995. Unpublished police report.

They placed the bags on Shelf 2: Italian inventory in court records.

Ferri's biography: Watson and Todeschini, *The Medici Conspiracy,* pp. 23–24.

Ferri's December 18, 1997, visit to Free Port: Carabinieri report dated December 23, 1997, by Marshals Morando and Dell'Avvocato.

Experts at Free Port inspection: July 15, 1998, memo signed by participants, in Medici's case file.

True going to Italy for return: Eakin, "Treasure Hunt," p. 71.

Medici discovers cup is shattered: October 22, 1999, letter from his lawyer Henri Nanchen to Chancelier d'etat Robert Hensler.

Dialog and action in Medici's return of fragments to Ferri's office: Medici interview with author, December 29, 2007.

Police had stored the objects terribly . . . *"Where is the Euphronios kylix?" and the description of Medici's visit to warehouse:* Medici interview with author, December 29, 2007.

Pellegrini's role: Muntoni sentence of Medici, 2005, and author interviews with Pellegrini.

"If I had . . . found them": Author interview with Medici.

Fate of objects seized in Geneva: Muntoni sentence of Medici, 2005, and author interviews with Medici.

CHAPTER NINE: ACCUSED

Hermitage Rooms . . . "of course": Hoving, "The Hot Pot."

"That's a figment . . . krater": Author interview with Hecht.

Details of raid on Hecht's home: Watson and Todeschini, *The Medici Conspiracy,* pp. 157–61, and author interview with Marshal Salvatore Morando.

Hecht's passport found at Bürki's house: Trial testimony.

Photo of Euphronios krater on Bürki's desk and date of raid: Watson and Todeschini, *The Medici Conspiracy,* pp. 185–87.

Symes saying he bought bronze eagle: Muntoni sentence of Medici, 2005.

February 26, 2003, decision in Lot 540 case: Ruling of Judge Gallucci of the Rome Tribunal and the Rome Court of Appeals verdict of that decision's appeal, April 14, 2005.

Sarcophagus fragment and other items in conviction: Muntoni sentence, 2005, pp. 519, 556–57, 645.

Medici and Ferri's seating in courtroom, timing of verdict, and taking of Medici's passport: Medici interview with author, January 30, 2007.

"The ministry's objective . . . commerce": Interview with author.

CHAPTER TEN: A TRIP TO OXFORD

"The nub . . . does.": Vernon Silver, "Tomb-Robbing Trials Name Getty, Metropolitan, Princeton Museums," Bloomberg News, October 31, 2005.

Medici's anguish, change of mood: Author interviews with Medici.

Description of Medici's house: Based on a visit by the author.

Medici dissecting evidence against him: Interview with author, Rome, November 29, 2005.

Return of three Getty objects: "Vase Seized by ICE From Getty Museum Returned to Italy," U.S. Immigration and Customs Enforcement news release, November 20, 2005; and Vernon Silver, "Three 'Illicit' Antiquities From Getty Museum Returned to Italy," Bloomberg News, November 10, 2005.

Number and nature of objects Swiss turned over to Italy: Muntoni sentence, 2005.

Trucking of antiquities to Rome: Author interviews with Medici.

Temple of Alatri's history: The Villa Giulia National Etruscan Museum: Short Guide, ed. Anna Maria Moretti Sgubini (Rome: L'ERMA di Bretschneider and Ingegneria per la Cultura, 2001), p. 79.

Medici's efforts to see kylix, and his visit to Villa Giulia: Author interviews with Medici and copies of the requests he sent.

Assessment of condition and value of broken kylix: Author interviews with Medici.

CHAPTER ELEVEN: LET'S MAKE A DEAL

Medici's medical condition and efforts to negotiate: Author interviews with Medici.

Italy sent Met evidence on January 12, 2006: Vernon Silver and Stephen West, "Metropolitan Museum Offers to Return 20 Disputed Works to Italy," Bloomberg News, February 2, 2006.

"Incontrovertible evidence": Elisabetta Povoledo, "The Met May Settle with Italy," *New York Times,* November 24, 2005.

"I thought . . . worried": Vernon Silver, "Met Museum's Talks with Italy on Disputed Art Sour, Lawyer Says," Bloomberg News, January 27, 2006.

"Equivalent beauty and importance": Silver and West, "Metropolitan Museum Offers to Return 20 Disputed Works to Italy."

"nationalism and misplaced patriotism . . . vases in Rome": Deborah Solomon, "Stolen Art? Questions for Philippe de Montebello," *New York Times Magazine,* February 19, 2006.

CHAPTER TWELVE: OBJECT X

Object X: Medici interview with author, September 20, 2006.

"The valuation is ridiculous": Medici interview with author, September 20, 2006.

October 5, 2006, meeting with Getty lawyer: Deal Points memo, Meeting of October 5, 2006, Italian Ministry of Cultural Heritage (MiBAC) and the Legal Representatives of the J. Paul Getty Trust (JPG Trust).

Getty paying $18 million in 1988: Jason Felch and Ralph Frammolino, "The Getty's troubled goddess," *Los Angeles Times,* January 3, 2007, p.1.

White signing over krater in November 2007: Interview with White's attorney Antonio Lirosi, March 29, 2008.

"If you go to Sotheby's . . . inappropriate": Rebecca Mead, "Den of Antiquity: The Met defends its treasures," *The New Yorker,* April 9, 2007, p. 60.

On grand piano: Interview with visitor to White's home.

McNall's guilty plea: "Sports Executive Enters Guilty Plea," *New York Times,* December 15, 1994.

McNall's prison experience: McNall and D'Antonio, *Fun While It Lasted,* pp. 237, 284.

"He told me . . . from Giacomo": McNall interview with author, December 20, 2007.

Krater's final days at Met and transport: Author interviews with Fiorilli, Morando, and other participants.

CHAPTER THIRTEEN: THE LAST *TOMBAROLO*

Medici home with flu: Medici interview with author.

Morando touching krater: Morando interview with author.

Bile's age: http://www.cortecostituzionale.it/composizione/giudici costituzionali/presidenti.asp.

Bile presiding three days earlier: Sentenza 72/2008, Constitutional Court of Italy, public hearing of January 15, 2008, sentence deposited March 28, 2008.

Homer passage: The Iliad, Book 16, lines 672–82, translation adapted from Fagles 1990.

EPILOGUE: THE CHALICE

"They're gone . . . era.": Author interview, December 19, 2005.

"VN: What . . . Medici": Nørskov, *Greek Vases in New Contexts,* p. 330.

Divorce: Medici interview with author.

Medici's identity card issued: Card, with issuance date, seen by author.

Medici obtaining passport: Medici interview with author.

"How much . . . on the vase": Randy Kennedy and Hugh Eakin, "Met Chief, Unbowed, Defends Museum's Role," *New York Times,* February 28, 2006.

Feast analysis: "King Midas Feast," news release, University of Pennsylvania Museum of Archaeology and Anthropology, September 12, 2000.

One Italian tomb raider's statistics: Watson and Todeschini, *The Medici Conspiracy,* pp. 267–68.

Statistics from 2006 and 2007: Attivita Operativa 2007, Rome: Carabinieri Tutela Patrimonio Culturale, 2008.

Statistics from 2008: Attivita Operativa 2008 (Rome: Carabinieri Tutela Patrimonio Culturale, 2009).

Sotheby's auction data: Author's doctoral thesis research, University of Oxford, compiled from http://www.sothebys.com. Based on prices paid for 2,657 lots sold from December 2000 through December 2008, compared with the average of the high and low estimate Sotheby's published for each lot.

BIBLIOGRAPHY

Appadurai, A. "Introduction: Commodities and the Politics of Value." In *The Social Life of Things: Commodities in Cultural Perspective,* edited by A. Appadurai, pp. 3–63. Cambridge: Cambridge University Press, 1986.

Beazley, J. D. *Attic Red-Figure Vase-Painters.* 2nd ed. Oxford: Clarendon Press, 1963.

Boardman, J. *The Greeks Overseas: Their Early Colonies and Trade.* 4th ed. London: Thames & Hudson, 1999.

———. *The History of Greek Vases: Potters, Painters, and Pictures.* New York: Thames & Hudson, 2001.

Brodie, N., and C. Renfrew. "Looting and the World's Archaeological Heritage: The Inadequate Response." *Annual Review of Anthropology* 34 (2005): 343–61.

Chippindale, C., and D. W. J. Gill. "Material and Intellectual Consequences of Esteem for Cycladic Figures." *American Journal of Archaeology* 97 (1993): 601–59.

———. "Material Consequences of Contemporary Classical Collecting." *American Journal of Archaeology* 104 (2000): 463–511.

Cuno, J. *Who Owns Antiquity? Museums and the Battle Over Our Ancient Heritage.* Princeton: Princeton University Press, 2008.

Edwards, I. E. S. *Treasures of Tutankhamun.* New York: Ballantine, 1976.

Fitz Gibbon, K., ed. *Who Owns the Past: Cultural Policy, Cultural Property, and the Law.* New Brunswick, NJ: Rutgers University Press, 2005.

Gell, A. *Art and Agency: An Anthropological Theory.* Oxford: Clarendon Press, 1998.

Gosden, C., and F. Larson. *Knowing Things: Exploring the Collections at the Pitt Rivers Museum 1884–1945.* Oxford: Oxford University Press, 2007.

Gosden, C., and Y. Marshall. "The Cultural Biography of Objects." *World Archaeology* 31, no. 2 (1999): 169–78.

Graeber, D. *Toward an Anthropological Theory of Value: The False Coin of Our Own Dreams*. New York: Palgrave, 2001.

Hamilakis, Y. *The Nation and Its Ruins: Antiquity, Archaeology and National Imagination in Greece*. Oxford: Oxford University Press, 2007.

Hecht, R. E. Unpublished, handwritten memoir seized in February 2001 police search of his Paris apartment.

Hess, J. L. *The Grand Acquisitors*. Boston: Houghton Mifflin, 1974.

Homer. *The Iliad*. Translated by R. Fagles. New York: Penguin, 1990.

Hoskins, J. A. *Biographical Objects: How Things Tell the Stories of People's Lives*. New York: Routledge, 1998.

Hoving, T. *Making the Mummies Dance: Inside the Metropolitan Museum of Art*. New York: Simon & Schuster, 1993.

———. "Super Art Gems of New York City: The Hot Pot (Parts I–VI)." Artnet, 2001. http://www.artnet.com/magazine/FEATURES/hoving/hoving6-29-01.asp.

———. *King of the Confessors: A New Appraisal*. Christchurch: Cybereditions, 2001.

Hyatt, S. L., ed. *The Greek Vase: Papers Based on Lectures Presented to a Symposium Held at Hudson Valley Community College at Troy, New York in April of 1979*. Latham, NY: Hudson-Mohawk Association of Colleges & Universities, 1981.

Kopytoff, I. "The Cultural Biography of Things: Commoditization as Process." In *The Social Life of Things: Commodities in Cultural Perspective*, edited by A. Appadurai, 64–91. Cambridge: Cambridge University Press, 1986.

Latour, B. *Reassembling the Social: An Introduction to Actor-Network-Theory*. Oxford: Oxford University Press, 2005.

Malinowski, B. *Argonauts of the Western Pacific: An Account of Native Enterprise and Adventure in the Archipelagos of Melanesian New Guinea*. London: George Routledge & Sons, 1922.

Marcus, G. "Ethnography in/of the World System: The Emergence of Multi-Sited Ethnography." *Annual Review of Anthropology* 24 (1995): 95–117.

Mauss, M. *The Gift*. London: Cohen and West, 1954.

Mazur, S. "The Sotheby's (Pre-Auction) Euphronios Transcript." Scoop.co.nz, January 11, 2006. http://www.scoop.co.nz/stories/HL0601/S00076.htm.

McNall, B., and M. D'Antonio. *Fun While It Lasted: My Rise and Fall in the Land of Fame and Fortune*. New York: Hyperion, 2003.

Meskell, L. *Object Worlds in Ancient Egypt: Material Biographies Past and Present*. Oxford: Berg, 2004.

Meyer, K. *The Plundered Past*. New York: Atheneum, 1973.

Miller, D. *Material Culture and Mass Consumption*. Oxford: Blackwell, 1987.

Ministero Per I Bene Culturale Ambientali. *Capolavori di Euphronios: Un Pioniere della Ceramografia Attica*. Arezzo: Museo Archeologico Nazionale, 1990.

Moretti, M. *Cerveteri*. Novara: Istituto Geografico de Agostini, 1978.

Munn, N. D. *The Fame of Gawa: A Symbolic Study of Value Transformation in a Massim (Papua New Guinea) Society*. Cambridge: Cambridge University Press, 1986.

Nørskov, V. *Greek Vases in New Contexts: The Collecting and Trading of Greek Vases—An Aspect of the Modern Reception of Antiquity*. Aarhus: Aarhus University Press, 2002.

Proietti, G. *Cerveteri*. Rome: Edizioni Quasar, 1986.

Renfrew, C. *Loot, Legitimacy and Ownership: The Ethical Crisis in Archaeology*. London: Duckworth Publishing, 2007.

Richter, G. M. A., and M. J. Milne. *Shapes and Names of Athenian Vases*. New York: Metropolitan Museum of Art, 1935.

Robson, E., W. L. Treadwell, and C. Gosden, eds. *Who Owns Objects? The Ethics and Politics of Collecting Cultural Artefacts*. Oxford: Oxbow Books, 2006.

Sgubini, A. M. M., ed. *The Villa Giulia National Etruscan Museum: Short Guide*. Rome: L'ERMA di Bretschneider and Ingegneria per la Cultura, 2001.

Shanks, M. *Art and the Greek City State: An Interpretive Archaeology*. Cambridge: Cambridge University Press, 1999.

Sotheby's. *Nelson Bunker Hunt Collection of Highly Important Greek Vases/ The William Herbert Hunt Collection of Highly Important Greek, Roman and Etruscan Bronzes* (June 19, 1990, Auction catalog). New York: Sotheby's, 1990.

Strathern, M. *Property, Substance and Effect: Anthropological Essays on Persons and Things*. London: The Athlone Press, 1999.

Thomas, N. *Entangled Objects: Exchange, Material Culture and Colonialism in the Pacific*. Cambridge, MA: Harvard University Press, 1991.

Von Bothmer, D. "Beazley the Teacher." In *Beazley and Oxford,* edited by D. Kurtz, 5–17. Oxford: Oxford University Committee for Archaeology, 1985.

———. "The Death of Sarpedon" (abstract). In "Seventy-Fourth General Meeting of the Archaeological Institute of America." *American Journal of Archaeology* 77, no. 2 (April 1973): 207.

———. " The Death of Sarpedon." In *The Greek Vase: Papers Based on Lectures Presented to a Symposium Held at Hudson Valley Community College at Troy, New York in April of 1979,* ed. S. L. Hyatt, 63–80. Latham, NY: Hudson-Mohawk Association of Colleges & Universities, 1981.

———. *Greek Vase Painting*. New York: The Metropolitan Museum of Art, 1987.

Watson, P. *Sotheby's: Inside Story*. London: Bloomsbury, 1997.

Watson, P., and C. Todeschini. *The Medici Conspiracy: The Illicit Journey of Looted Antiquities from Italy's Tomb Raiders to the World's Great Museums*. New York: Public Affairs, 2006.

Waxman, S. *Loot: The Battle Over the Stolen Treasures of the Ancient World*. New York: Times Books, 2008.

Wealth of the Ancient World: The Nelson Bunker Hunt and William Herbert Hunt Collections. Fort Worth, TX: Kimbell Art Museum, in association with Summa Publications, Beverly Hills, CA, 1983.

Weiner, A. *Inalienable Possessions: The Paradox of Keeping-While-Giving*. Berkeley: University of California Press, 1992.

INDEX